T0338700

Multidisciplinary Perspectives on New Media Art

Celia Soares
University Institute of Maia (ISMAI), Portugal & Polytechnic Institute of Maia (IPMAIA), Portugal

Emília Simão
Escola Superior Gallaecia University (ESG), Portugal & Portuguese Catholic University (FFCS–UCP), Portugal

A volume in the Advances in Media, Entertainment, and the Arts (AMEA) Book Series

Published in the United States of America by
 IGI Global
 Information Science Reference (an imprint of IGI Global)
 701 E. Chocolate Avenue
 Hershey PA, USA 17033
 Tel: 717-533-8845
 Fax: 717-533-8661
 E-mail: cust@igi-global.com
 Web site: http://www.igi-global.com

Library of Congress Cataloging-in-Publication Data

Names: Soares, Celia, 1974- editor. | Simão, Emília, 1976- editor.
Title: Multidisciplinary perspectives on new media art / Celia Soares and
 Emília Simão, editors.
Description: Hershey, PA : Information Science Reference, [2020] | Includes
 bibliographical references and index. | Summary: "This book explores the
 intersections between new media, artistic practices and digital
 technologies. It also examines theoretic and practical explorations of
 new media art based on multidisciplinary approaches"-- Provided by
 publisher.
Identifiers: LCCN 2019057528 (print) | LCCN 2019057529 (ebook) | ISBN
 9781799836698 (hardcover) | ISBN 9781799836704 (paperback) | ISBN
 9781799836711 (ebook)
Subjects: LCSH: New media art.
Classification: LCC NX456.5.N49 M85 2020 (print) | LCC NX456.5.N49
 (ebook) | DDC 709.05/1--dc23
LC record available at https://lccn.loc.gov/2019057528
LC ebook record available at https://lccn.loc.gov/2019057529

This book is published in the IGI Global book series Advances in Media, Entertainment, and the Arts (AMEA) (ISSN: 2475-6814; eISSN: 2475-6830)

British Cataloguing in Publication Data
A Cataloguing in Publication record for this book is available from the British Library.

All work contributed to this book is new, previously-unpublished material.
The views expressed in this book are those of the authors, but not necessarily of the publisher.

For electronic access to this publication, please contact: eresources@igi-global.com.

Advances in Media, Entertainment, and the Arts (AMEA) Book Series

ISSN:2475-6814
EISSN:2475-6830

Editor-in-Chief: Giuseppe Amoruso, Politecnico di Milano, Italy

MISSION

Throughout time, technical and artistic cultures have integrated creative expression and innovation into industrial and craft processes. Art, entertainment and the media have provided means for societal self-expression and for economic and technical growth through creative processes.

The **Advances in Media, Entertainment, and the Arts (AMEA)** book series aims to explore current academic research in the field of artistic and design methodologies, applied arts, music, film, television, and news industries, as well as popular culture. Encompassing titles which focus on the latest research surrounding different design areas, services and strategies for communication and social innovation, cultural heritage, digital and print media, journalism, data visualization, gaming, design representation, television and film, as well as both the fine applied and performing arts, the AMEA book series is ideally suited for researchers, students, cultural theorists, and media professionals.

COVERAGE

- Data Visualization
- Color Studies
- Geometry & Design
- Design Tools
- Computer aided design and 3D Modelling
- Visual Computing
- Gaming
- Blogging & Journalism
- Fine Arts
- Traditional Arts

IGI Global is currently accepting manuscripts for publication within this series. To submit a proposal for a volume in this series, please contact our Acquisition Editors at Acquisitions@igi-global.com or visit: http://www.igi-global.com/publish/.

Titles in this Series

For a list of additional titles in this series, please visit:
http://www.igi-global.com/book-series/advances-media-entertainment-arts/102257

Describing Nature Through Visual Data
Anna Ursyn (University of Northern Colorado, USA)
Information Science Reference • © 2021 • 330pp • H/C (ISBN: 9781799857532) • US $195.00

Well-Being Design and Frameworks for Interior Space
Valeria Minucciani (Politecnico di Torino, Italy) and Nilüfer Saglar Onay (Politecnico di Torino, Italy)
Information Science Reference • © 2020 • 292pp • H/C (ISBN: 9781799842316) • US $165.00

Contemporary Art Impacts on Scientific, Social, and Cultural Paradigms Emerging Research and Opportunities
Janez Strehovec (Institute of New Media Art and Electronic Literature, Ljubljana, Slovenia)
Information Science Reference • © 2020 • 177pp • H/C (ISBN: 9781799838357) • US $145.00

Navigating Fake News, Alternative Facts, and Misinformation in a Post-Truth World
Kimiz Dalkir (McGill University, Canada) and Rebecca Katz (McGill University, Canada)
Information Science Reference • © 2020 • 375pp • H/C (ISBN: 9781799825432) • US $195.00

Cultural, Theoretical, and Innovative Approaches to Contemporary Interior Design
Luciano Crespi (Politecnico di Milano, Italy)
Information Science Reference • © 2020 • 459pp • H/C (ISBN: 9781799828235) • US $195.00

Handbook of Research on Combating Threats to Media Freedom and Journalist Safety
Sadia Jamil (Khalifa University, UAE)
Information Science Reference • © 2020 • 408pp • H/C (ISBN: 9781799812982) • US $265.00

For an entire list of titles in this series, please visit:
http://www.igi-global.com/book-series/advances-media-entertainment-arts/102257

701 East Chocolate Avenue, Hershey, PA 17033, USA
Tel: 717-533-8845 x100 • Fax: 717-533-8661
E-Mail: cust@igi-global.com • www.igi-global.com

Editorial Advisory Board

Table of Contents

Chapter 9

Detailed Table of Contents

Chapter 1
Contemporary Imagetics and Post-Images in Digital Media Art: Inspirational
Artists and Current Trends (1948-2020)..1
 Jose Alberto Raposo Pinheiro, CIAC, Portugal

Scientific studies have contributed, over the last years, to an expansion of the Image concept, in articulation with new developments in Computational Media, based in a stratification around technical digital properties, which frame its existence to the form of digital information – extending it beyond a visual surface idea. Biometric data, artificial intelligence, bitcoin, glitches or machine learning are examples of instantiation tools used by artists to explore elements of mediation included in Post-images. This chapter addresses today's perspectives in Contemporary Imagetics emerging from the field of Digital Media Art (DMA), curating contributions from classic postproduction techniques to computational media instantiations and contextualizing imagery creation practice in DMA.

Chapter 2
The New Media vs. Old Media Trap: How Contemporary Arts Became
Playful Transmedia Environments ..25
 Patricia Gouveia, LARSyS, Interactive Technologies Institute, Faculdade
 de Belas-Artes, Universidade de Lisboa, Portugal

This chapter explores the legacy of both modernism and postmodernism in contemporary arts and how it helped shape our current environments and practices in transmedia contemporary arts. It also explores popular modernism aesthetics based simultaneously in cathartic narrative and flow participatory interaction to explore new media discourse about the role of digital arts and artists. The aim is to promote an understanding of the current arts practices that no longer promotes the artificial divide between new media or media arts and contemporary arts. Changes in the intercultural museum and in higher education can no longer sustain

this segregation, which is a product of old and new media specificity and narrow notions of specialization.

Chapter 3
Software-Based Media Art: From the Artistic Exhibition to the Conservation

Celia Soares, University Institute of Maia (ISMAI), Portugal &
Polytechnic Institute of Maia (IPMAIA), Portugal
Emília Simão, Escola Superior Gallaecia, Portugal & Portuguese
Catholic University, Portugal

This chapter illustrates the reaction to the preservation and conservation of software-based media art and summarizes the crucial ideas and questions that involve this emergent area of conservation. The chapter analyzes the role in which conservators explore the impact of the method, attitudes to change, technology obsolescence, and the influence of the how the artist imagines and understands their practice on the conservation of these works as they enter the exhibition space. In addressing the conservation of software-based media art, this chapter highlights the variety of knowledge and expertise required: expertise that is personified in the teamwork of those who support these functions. The author completes the chapter by recommending that developing and maintaining these efforts has become a crucial part of the software-based media conservator's role.

Chapter 4
The Confluence Between Materiality and Immateriality in Site-Specific

Frederico Dinis, CEIS20, Portugal

Aiming to explore the diverse nature of sound and image, thereby establishing a bridge with the symbiotic creation of sensations and emotions, this chapter intends to present the development and the construction of a proposal for the confluence between materiality and immateriality in site-specific sound and visual performances. Using as a focal point sound and visual narratives, the author tries to look beyond space and time and create a representative atmosphere of sense of place, attempting to understand the past and sketching new configurations for the (re)presentation of identity, guiding the audience through a journey of perceptual experiences, using field recordings, ambient electronic music, and videos. This chapter also presents the development of an experimental approach, based on a real-time sound and visual performance, and some critical forms of expression and communication that relate or incorporate sound and image, articulating concerns about their aesthetic experience and communicative functionality.

Chapter 5

*Rodrigo Assaf, Digital Creativity Centre, School of Arts, Portuguese
 Catholic University, Portugal*
*Sahra Kunz, CITAR, School of Arts, Portuguese Catholic University,
 Portugal*
*Luís Teixeira, CITAR, School of Arts, Portuguese Catholic University,
 Portugal*

Despite all the technological advances in the field of computer graphics, the uncanny valley effect is still an observed phenomenon affecting not only how animated digital characters are developed but also the audience's reaction during a film session. With the emergence of computer-generated images being used in films, this chapter aims at presenting a multidisciplinary approach concerning the uncanny valley topic. This phenomenon is mainly explained by several psychological theories based on human perception; however, this chapter contributes to the discussion presenting a communication perspective based on the uses and gratification theory connected to the genre theory proposed by Daniel Chandler. In addition, the authors discuss how the technological evolution in rendering is helping out artists to cross the valley, which ends up being unveiled only by motion. As a result of this technical evolution, it is proposed a new animation art style category defined as quasi-real.

Chapter 6
Patrick Pennefather, University of British Columbia, Canada
Claudia Krebs, University of British Columbia, Canada
Julie-Anne Saroyan, Small Stage, Canada

The research and development of an augmented reality (AR) application for Vancouver-based dance company Small Stage challenged a team of students at a graduate digital media program to understand how AR might reinvent the audience-dancer relationship. This chapter will chronicle the AR and choreographic development process that occurred simultaneously. Based on the documentation of that process, a number of insights emerged that dance creators and AR developers may find useful when developing an AR experience as counterpart to a live dance production. These include (1) understanding the role of technology to support or disrupt the traditional use of a proscenium-based stage, (2) describing how AR can be used to augment an audience's experience of dance, (3) integrating a motion capture pipeline to accelerate AR development to support the before and after experience of a public dance production.

Chapter 7

Art has a power different from all other human actions; it can produce a variety of human emotions like nothing else. The main purpose of this chapter is to study the relation between media arts and emotions. Virtual environments are increasingly being used by artists; the use of immersive environments allows the media art artist to go further than express himself, allows that through contemplation and interaction the participant also becomes part of the artistic artefact. Immersive environments can induce emotional changes capable of generating states of empathy. Considering an immersive environment as a socio-technical system, where human and non-human elements interact, establishing strong relationships, the authors used actor-network theory as an approach to design an immersive artifact of digital media art. The use of neurofeedback mechanisms during the participant's exposure to immersive environments opens doors to new types of interaction, allowing to explore emotional states to generate empathy.

Chapter 8

This chapter describes the development of a prototype of a serious video game and its maintenance platform for the geo-education in the Arouca Geopark Territory. This serious video game, which is the focus of this project, aims to assist the guides in their visits to the Arouca Geopark, providing an educational and modular tool. It was possible to supply some needs of the Arouca Geopark, identifying which

components are necessary for this platform and which tools must be used for its development. A functional prototype of this platform was developed and subjected to usability tests, the results of which were positive and revealed great acceptance by the intervening group. With the development of this technology, it is intended that the guides and visitors of Arouca Geopark can enjoy an educational tool, able to help guides to provide more stimulating guided tours, thereby improving visitors' retention of information.

Chapter 9

As mobile technology sustains exponential growth and spread to all aspects of our everyday life and smartphone computational power increases, new promises arise for cultural institutions and citizens to use these tools for promoting cultural heritage. This survey proposes to review available smartphone applications (apps) relating to cultural heritage in three different contexts: cities, street art, and museums. Apps were identified by searching two app stores: Apple's App Store and Google Play (Android). A data search was undertaken using keywords and phrases relating to cities, street art, and museums. A total of 101 apps were identified (Google Play only= 7, Apple App Store only = 26, both Google Play and Apple App Store = 61, Apple Web Store and Web App = 6). Apps were categorized into the following categories: museums (39), street art (30), and cities (32). The most popular features are photos (96%) and maps (79%), and the most uncommon the 360 (4% – only in museums apps), games (6%), and video (15%).

Preface

New media are gaining importance in both academic and artistic world, especially if extended to the new media arts. The conceptualizations of media art, new media art and digital media art, the exploration of crossing practices and hybrid experiences, the use of digital and analog as convergent tools, among other, opens wide range of emerging research and experience based on the intersections between new media, artistic practice and digital technology.

In an attempt to contribute to this very broad subject, the editors of *Multidisciplinary Perspectives on New Media Art* do not intend to present a technical book but a compilation of several topics, bringing innovative insights, reflections, experiences, conclusions but also raising questions.

This multidisciplinary book contains nine chapters that reflect an extensive and detailed approach of different perspectives, explored and discussed through the vision of experts - artists, university professors and reference academics and dedicated to peers and students interested on this vast world of new media art.

Scientific studies have brought, over the last years, various perspectives to the concept of image -a growing expansion, in articulation with new developments in computational media, based in a stratification around technical digital properties, which frame its existence to the form of digital information - therefore, extending it beyond a visual surface concept. The first chapter, "Contemporary Imagetics and Post-Images in Digital Media Art: Inspiring Artists and current Trends (1948-2020)," explores morphogenesis issues in contemporary imagetics emerging from the field of digital media art and curating artist's contributions, from classic postproduction techniques to computational media.

The second chapter, "The New Media vs. Old Media Trap: How Contemporary Arts Became Playful Transmedia Environments," inquires the legacy of both modernism and postmodernism in contemporary age and how it helped shape current environments and practices in transmedia contemporary arts. It also explores popular modernism aesthetics based simultaneously in cathartic narrative and flow participatory interaction, to inquire new media discourse about the role of digital arts and artists, and also the importance of understanding the current arts practices,

which no longer promotes the artificial divide between new media or media arts and contemporary arts.

In the third chapter, "Software-Based Media Art: From the Artistic Exhibition to the Conservation Models," the authors discuss the reaction to the preservation and conservation of software-based media art and summarizes the crucial ideas and questions which involve this emergent area of conservation. This chapter also analyzes the role in which conservators explore the impact of the method, attitudes to change, technology obsolescence and the influence of the how the artist imagines and understands their practice on the conservation of these artworks as they enter the exhibition space. In addressing the conservation of software-based media art / digital media art, this approach highlights the variety of knowledge and expertise required for the whole process.

Aiming to explore the diverse nature of sound and image, thereby establishing a bridge with the symbiotic creation of sensations and emotions, the fourth chapter, "The Confluence Between Materiality and Immateriality in Site-Specific Sound and Visual Performances," presents the development and the construction of a proposal for the confluence between materiality and immateriality in site-specific sound and visual performances. Using as a focal point sound and visual narratives, the author tries to look beyond space and time, and create a representative atmosphere of sense of place, attempting to understand the past and sketching new configurations for the (re)presentation of identity, guiding the audience through a journey of perceptual experiences, using field recordings, ambient electronic music, and videos. This chapter also presents the development of an experimental approach, based on a real-time sound and visual performance, and some critical forms of expression and communication that relate or incorporate sound and image, articulating concerns about their aesthetic experience and communicative functionality.

Despite all the technological advances in the field of computer graphics, the Uncanny Valley effect is still an observed phenomenon affecting not only how animated digital characters are developed but also the audience's reaction during a film session. The fifth chapter, "The Presence of the Uncanny Valley Between Animation and Cinema: A Communication Approach," brings forward a multidisciplinary approach concerning the Uncanny Valley topic, exploring the emergence of computer-generated images being used in films. This phenomenon is mainly explained by several psychological theories based on human perception, however, this chapter contributes to the discussion presenting a communication perspective based on the uses and gratification theory connected to the genre theory proposed by Daniel Chandler. In addition, the authors discuss how the technological evolution in rendering is helping out artists to cross the valley, which ends up being unveiled only by motion. As a result of this technical evolution, it is proposed a new animation art style category defined as quasi-real.

The sixth chapter, "Reimagining the Audience-Dancer Relationship Through Mobile Augmented Reality," brings a research and development of an Augmented Reality (AR) application for Vancouver-based dance company *Small Stage*, challenging a team of students at a graduate digital media program to understand how AR might reinvent the audience-dancer relationship. Though this chapter, authors chronicle the AR and choreographic development process that occurred simultaneously, based on the documentation of that process, a number of insights emerged that dance creators and AR developers may find useful when developing an AR experience as counterpart to a live dance production. These include understanding the role of technology to support or disrupt the traditional use of a proscenium-based stage, describing how AR can be used to augment an audience's experience of dance, integrating a motion capture pipeline to accelerate AR development to support the before and after experience of a public dance production.

Art has a different power from all other human actions considering the large variety of emotions that arouses in human beings, and the main purpose of the seventh chapter, "Creating Emotions Through Digital Media Art: Building Empathy in Immersive Environments," is to discuss the relation between media art and emotions. Artists are increasingly using virtual environments and the use of immersive environments allows going further than the expression itself, it allows contemplation, interaction and also participation when someone also becomes part of the artistic artifact. Immersive environments can induce emotional changes capable of generating states of empathy. Considering an immersive environment as a socio-technical system where human and non-human elements interact, establishing strong relationships, the authors used *Actor-Network Theory* as an approach to design an immersive artifact of digital media art. The use of *neuro-feedback* mechanisms during the participant's exposure to immersive environments opens doors to new types of interaction, allowing emotional states to generate empathy.

The eight chapter, "A Serious Game for Geo-Education in the Arouca Geopark Territory," describes the development of a prototype of a serious video game and its maintenance platform, for the Geo-education in the Arouca Geopark Territory, in Portugal. This serious video game, aims to assist the guides in their visits to the Arouca Geopark, providing an educational and modular tool. It was possible to supply some needs of the Arouca Geopark, identifying which components are necessary for this platform and which tools must be used for its development. With the development of this technology, it is intended that the guides and visitors of Arouca Geopark, can enjoy an educational tool, able to help guides to provide more stimulating guided tours, thereby improving visitors' retention of information.

The last chapter, "Mobile Applications in Cultural Heritage Context: A Survey," presents a study based on smartphone applications related to cultural heritage in cities, street art, and museums. The presented study identified 101 applications from

App Store and Google Play and applied a data search using keywords and phrases relating to cities, street art and museums, concluding that mobile technology sustains exponential growth and spread to all aspects of our everyday life, smartphones computational power increases and new promises for cultural institutions and citizens in using these tools for promoting cultural heritage.

This book validates the idea that new media art is transversal to several thematic: contemporary art; cyberculture; postmodernism; digital art; gratification theory; audience relationship; augmented reality; computer animation; new media and artworks preservation; audiovisual and multimedia artworks and artistic performance; videogames, applications and so on.

Hybridity is today a feature of art: 21^{st} century artworks, artifacts, pieces, performances, installations and other formats often take the form of complex combinations based in old concepts reframed or in emergent ones.

The digital cross with the analog, the spectator become part of the artwork, different media converges, the virtual and the organic interact and different identities, worlds and experiences are created. Creative arts and new media have proliferated in recent years and many innovative and inspiring experiences are the result of high-quality work and this book also intends to offer guidance and ideas on how to make creative projects.

The pervasive centrality of technology in contemporary art (in technologic devices, strategies of composition, textures, exhibition models, and media outcome) is evident from a semiotic, social, financial and an aesthetic point of view. It has its peculiar expression in new media art practices, from multimedia installations to live media, from net art to rich media, immersive art or hypertext.

The role of information technologies in the arts research is explored in the unity of artistic and aesthetic, conceptual and technological issues through this set of nine chapters attempts to help understand the trends in this area and shows perspectives that only technological approaches are not enough to respond. We believe that *Multidisciplinary Perspectives on New Media Art* can be an interesting tool for researchers, students and artists interested in different styles, reflections and perspectives about the central theme.

Chapter 1

Contemporary Imagetics and Post-Images in Digital Media Art:
Inspirational Artists and Current Trends (1948–2020)

Jose Alberto Raposo Pinheiro

(iD) https://orcid.org/0000-0002-6707-3138
CIAC, Portugal

ABSTRACT

Scientific studies have contributed, over the last years, to an expansion of the Image concept, in articulation with new developments in Computational Media, based in a stratification around technical digital properties, which frame its existence to the form of digital information – extending it beyond a visual surface idea. Biometric data, artificial intelligence, bitcoin, glitches or machine learning are examples of instantiation tools used by artists to explore elements of mediation included in Post-images. This chapter addresses today's perspectives in Contemporary Imagetics emerging from the field of Digital Media Art (DMA), curating contributions from classic postproduction techniques to computational media instantiations and contextualizing imagery creation practice in DMA.

DOI: 10.4018/978-1-7998-3669-8.ch001

INTRODUCTION

A century ago, artistic movements such as Constructivism and Dadaism configured a spirit for Images as objects made/manufactured, in opposition to the pictorial capture of the camera. John Heartfield, one of the first artists to use Photomontage as a tool to illustrate visual concepts, considered himself a "monteur"/builder, opposing the idea of craftsmanship: an artist who worked with image creation would be a "mechanic", an "engineer" (Newhall, 1984), assuming a role in a mechanical art — such as typography, photography and film — that would replace handicrafts. Rodchenko, Moholy-Nagy, El Lissitzky, Hannah Hoch, Raoul Hausmann, Hans Arp, Max Ernst, Kurt Schwitters, George Grosz or Paul Citroen are names that can be connected to a period in which experimentation within the medium was part of the essence of the work of Art. Looking at these imagery records, a transversal condition could be observed, if we focus not on the image surface, but also in its creation model — based in experimentation. These artists followed a pattern of construction of images, assuming an artistic and cultural practice that used technological readjustment of experimentation processes within the medium, expanding the cultural nature of Art creation. That resulted from the introduction of tools and techniques from the Darkroom, like Photomontage and Collage, as much as from the unstable social and political environment of that period.

Is it possible to find a similitude in present Digital Media Art (DMA) practices? Like those XXth century artists, contemporary imagery creators use experimentation and digital tools to break away from patterns and create new approaches in Art that reflect today's trends and conceptual paths, pushing further the idea of Image.

This chapter addresses imagery creation practices in Digital Media Art (DMA) contemplating its properties and methodologies in a way to better understand the role of mediation resulting from processes derived by the use of computational media in Contemporary Imagetics. We start by reviewing an initial period of electronic image, exploring the correlation between research/image and framing these Imagetics in an initial research phase characterized by Post-production techniques and questions about the remediation properties in images. Artistic contributions from the past were curated, sampling award winning artworks, renowned international festivals and prizes. Independent work that has a focus in hybridization within the digital medium was also included, to broaden the spectrum of artworks, as we'll see.

After a conceptual review, we initiate a second framework for artifacts that can include two concepts derived from previous research (Pinheiro, 2018) as creative mechanisms: "Expression in the Structure" and "Borderline tools".

As new developments are opening important perspectives in the field of image making regarding DMA, contextualizing imagery studies within this scope would

benefit this sector in the support of creation models that could contemplate today's Image properties and methodologies as an expansion to its visibility/fruition.

ON IMAGETICS

We start by analyzing the technical/computational conditions underlying the emergence of these image artworks. The scope of this first survey was to integrate artworks and their associated technology in a way that could benefit an historical perspective. First experiments in electronic imagery can be traced to 1946, after the creation of the Electronic Numerical Integrator and Computer (ENIAC), at the University of Pennsylvania. The first research developments in the use of electronics to generate images can be attributed to Laposky, in the 1950s. Ben F. Laposky developed a cathode ray device that created a visual record of the electrical current in a fluorescent screen. This device was called Oscilloscope. Laposky used it in the generation of abstract visual art ("electrical compositions"). One of the first electronic representations was made by Russel A. Kirsch, in 1950, using a scanner device designed by him and his colleagues at the National Bureau of Standards. The representation was materialized using an oscilloscope (Mitchell, 1992: 4). Years later, in 1966, Leon Harmon and Ken Knowlton created "Study in perception", a nude figure that used 8 frames of 35mm microfilm (Figure 1).

Figure 1. Leon Harmon e Ken Knowlton, Study in perception: 1966
Source: Wands, 2007: 22

Electronic image was a center for amazement and experimentation that brought a sense of magic to the Science scene, with great expectations emerging from it. A succession of inventions contributed to this: i) The first "instant" camera, SX-70, by Edwin H. Land, Polaroid's founder; ii) the magnetic capture systems, such as the

VTR (videotape recorder) or the APS (Advance Photo System — a photographic mini-lab); iii) In 1959, the metal oxide semiconductor (MOS) by Atalla and Kahng at Bell Labs; iv) In 1969, the CCD sensor (Charge-coupled Device) by William Boyle and George Smith of AT&T Bell Labs, which would allow an exposure to be transferred to the surface of a semiconductor: v) In 1973, the first large CCD chip: 100x100 pixels by Fairchild Semiconductor International; vi) In 1975, the Bayer filter for Kodak, by Bryce Bayer, which allowed pixels to be arranged in a photo-sensor grid; vii) In 1985, the first 1.3 megapixel sensor; viii) In 1981, Canon's MAVICA (magnetic video camera); ix) In 1991, the DCS system by Kodak; x) In 1994, Apple's Quicktake 100, developed with Eastman Kodak (launched in February 17, 1994 — one year before its own system, the Kodak DC40) (Lipkin, 2005; Wands, 2006). These and other combined electronic and digital Image enhancements would impact artistic production processes, as we'll see.

The first artifacts that can exhibit this expression of electronic imagery in Arts occurred in 1968. The Cybernetic Serendipity exhibition at the Institute of Contemporary Arts (ICA, London) had the presence of John Whitney, one of the fathers of computer animation. Part of the exhibition was constituted by oscilloscopes and digital plotters. Jean Tinguely's painting machines were also present—analog machines that explore the "do it yourself" concept ("meta-matics"). The Computer Art Society foundation was created in England, to encourage the use of computers as creative medium. ARPANET, formed in 1969 — the first network prototype developed by the US Department of Defense —was often used for digital experiments. The 1970's brought a collective approach to digital image research, resulting from amplified investment of countries in the development of large laboratories for creative experiences, normally associated with scientific tests. In 1970, Xerox Corporation promoted in Palo Alto (PARC - Palo Alto Research Center) the experimental development of computer applications for graphics — generating new visual possibilities that would be explored by General Electric's 1970 "Genigraphics" — the first high resolution system for developing color graphics. In 1975, Benoit Mandelbrot (IBM) developed the concept of fractal geometry, which allowed instantiation of natural forms through mathematical descriptors. In 1977, a personal computer, Apple II, brought the first digital experiences to many artists. The development of digital artworks was enhanced, moving digital Art tools closer to artistic hands. In spite of all the developments for personal users, this decade would also be marked by the scaling of collective research. The creation of several professional organizations, such as SIGGRAPH, founded in 1973, or Ars Electronica, founded in 1979, characterize an era of artistic creation arising from the experimentation within these scientific groups. In 1981, IBM developed the first personal computer to provide artists with a color palette along with a more favorable resolution for digital artistic development. In 1985, AT&T developed TARGA, a

16-bit graphics card, enabling 32,000 colors, bringing projection of photographic resolutions and enabling the development of the Photoshop software (1990) by Adobe Systems, leading artists in the experimentation of digital imaging techniques (Lipkin, 2005; Wands, 2006)

This was the time for many bitmap image tools to emerge, giving birth to new digital creation processes in Imagetics. In an article published in 2001, Alvy Ray Smith, the creator of one of the first Paint systems, described the history of the painting tools in a computational context integrated in the American Film Academy Awards — portraying a visitation of his historical journey through the evolution of editing/painting programs associated with the first forms of human-machine interaction in the area of Imagetics. Smith's take presents an integration of terms and technologies, helping to understand the lines that guided these researchers. For instance, one of his initial concerns was to distinguish between two ideas: a software program and a creation system. Smith argued that a digital software and a digital system had different functions: while the software would serve to simulate the use of a brush on canvas, the system would do a simulation of painting as an initial metaphor to seduce artists into the new "digital domains", but after this first moment it could push further the borders of previous material techniques (Smith, 2001).

If we observe Smith's relation with Shoup (the creator of another of the Paint programs), we can find the experimental characteristics in which this particular evolution was established: Smith understood Shoup's explanations of his concept only when he tried the concept in a practical way, revealing difficulties to share abstractions. Shoup created not only the Superpaint software but also the hardware, building the frame buffer — "a kind of computer memory specialized in retaining images" (Smith, 2001: 5), that is, the development of a type of memory essential to completion of digital graphic editing operations. The frame buffer was an image memory that allowed representation of content to be projected on screen — a screen memory. Black and white was the color mode present in this first digital explorations. Later, Superpaint explored home television screens, associating the operative elements of painting with the RGB possibilities of televisions.

An analysis of Smith's development process was important as a case study to establish an unstable environment in Digital Art development. But looking at examples of the explorers of the 1970's today, it is notorious the fact that they were dealing with a creative medium. To establish a record, Smith used a VHS tape with recordings of his screen, which he called "VidBits"[1] (Figure 2). Those consisted of examples of interaction, imagery, animation, achieved through the new digital medium.

It is possible to relate to most of the characteristics of the processes that we find in Smith's description as we explore other Science/Arts researchers and their relation to the media they explore. These developments would insert digital image

Figure 2. First examples of images created using digital technology at NYIT (New York Institute of Technology and saved in VHS as sales pitch videos ("Vidbits"): a) egg.on.toast (s.d.); b) darth.vader (1978); c) colorblob (1977); d) colorweb; e) bleu.drop (1975); f) mandarin.tut
Source: Smith, 2001: 9

in a first phase of Remediation, as we'll see: an attempt to bring previously learned image patterns to the computational medium, that is, an instantiation marked by the knowledge resulting from previously learned analog techniques, coming from the photographic realms of Collage and Photomontage. The techniques from the Darkroom were mimicked and transformed into digital tools that replicated previous mechanisms — a new materialization of processes in a digital ground. This theory has echo in Grusin & Bolter's (2000) idea of Remediation — the process from which any "new media" uses the processes of a previous "old media".

(...) All current media function as remediators and that remediation offers us a means of interpreting the work of earlier media as well. (...) In the first instance, we may think of something like a historical progression, of newer media remediating older ones and in particular of digital media remediating their predecessors. (Grusin & Bolter, 2000: 55)

In a first phase, new media would be capacitated to expand old media, accentuating positive functions. Here, digital photography would mimic and expand chemical photography's possibilities. As the new medium acts as remediator of old media, it recovers characteristics from previous ones, resulting in different combinatory aspects.

A CLASSIC PERSPECTIVE

Classic examples of post-images were used to set a base for analyzing patterns, using post-production techniques as instantiations. At this time, it was possible to configure a common ground, through which we could observe DMA Post-images, resulting from sampled Artworks. Initially, the focus was directed to Language and Aesthetics. Some authors write about the need to construct reality through the image, since this helps us explore history: image as a Truth value, a true referent (Barthes, 1980; Flusser, 1998). Benjamin (1936) considered Photography to always be in our subconscious as "historical proof of reality", a precursor of Opinion Creation before Television.

However, from the point of view of the cultural acceptance of Image Editing, Post-images are also a field for debate on forgery ("fake"), which often rest on a desire to reveal the Truth, to overcome the Lie that Images sustain, a process in which some researchers are involved seeking to trace the algorithmic lines of manipulative interventions — that is, algorithmically looking into digital images to detect the interventions that were introduced digitally (as in Kee and Farid, 2011) — an idea also explored in some photographic practices in Art.

An artistic perspective from a Post-image point of view would start by observing Keith Cottinghamm's attempts to portrait multiple views of the Human figure — multiple "personas" at the same instant. Cottingham explored representation through digital photomontage in order to envision the exploration of self multi-perspectives. "Untitled (Triple)" (1992) gave him Ars Electronica's Award of Distinction in 1994.

Other authors, like Flusser (1998), wrote about the rupture in the way we look at the world, regarding the transition traditional image/technical image. Jeff Wall, a canadian artist, created a reconstruction of an inspirational painting to give birth to a narrative expression of Remediation. In "A sudden gust of wind (after Hokusai)", from 1993, we can observe a groundbreaking composition that depicts a spontaneous moment, narrating it as if it was a movie. The process of staging different parts of the image and then bringing them together digitally conceived a powerful storytelling and revealed a cultural construction process explored in a manipulative component — an approach that could set a perspective for the universe of post-images. Wall used digital techniques to replicate a Japanese painting, through conceptual exploration and methodic organization. Heidegger, through the notion of "poésis", had conceived the artist as an organizer of the "Gestell" process, intermediating and questioning Technique (Heidegger, 2012: 36).

The fact that all these processes are framed in a machinic way — using computational media to interact with parts of Images — proposes a newer materiality for images, allowing us to use a virtual display of thoughts that pushes reality further. An example of this is brought to life by Daniel Lee's portraits in his collection

"Manimals". "1949 – Year of the Ox" (1993) is a visual creation that portraits the impact resulting from a man/animal hybridization.

And other perspectives emerging from epistemological questions could also be amplified by Post-images. Pioneers of digital Imagetics Antony Aziz and Sammy Cucher created in 1994 a dystopian series in which they digitally removed eyes and mouth, covering these areas with skin — questioning identity, or its loss ("Chris", 1994). Memories of grief/loss were staged by Mary Frey in the artwork "In her Bedroom", from 1997. Frey shows us the absence from loss that reflects human existence and our connection to those who are near — losing someone is a perspective we can envision thru digital techniques using Image language. Gerald van der Kaap's "12th of never" (1999) uses multiplication to instantiate presence, like if a new instance of Self could appear in the same place. Emerging from this background of unreal creatures or scenes, there's also the work of Margi Geerlinks. Fantastic compositions dealing with surreal and conceptual Ideas were seen in the language developed in "Untitled (Girl Knitting Baby), in 1997-98, creating new dimensional realities that speak about social problems.

Many other concepts were explored from digital perspectives in Imagetics. Artists like Rauschenberg explored appropriation of other author's Artworks and conceptual abstraction (Robert Rauschenberg, in Dark Horse of Abstraction, 1995). Rauschenberg used a classic Jackson Pollock's painting to fill the space of a race track horse jumping an obstacle ahead of the other contestants, marking texture as a condition to access an abstract world.

A step further would also find artistic concepts like a "readymade" in the digital realm. Ken Gonzales-Day's "Untitled #36 (Ramoncita at the Cantina)" (1996) relates to the artists that influenced him, pointing to an idea of appropriation, from a narrative point of view, with a representation of an historical context.

These remix/hybridization perspectives that flow through artworks also allow us to find explorations in post-image aesthetics. In Michael Wright's "The light" (1992) we observe an example of low-resolution video ambience that is used to obtain mediated portraits with a unique vision. Liu Wei, "Forbidden city Series nr1" (2000) integrates symbolic content and chromatic expression between past and present. Jeff Wall explores, in "The flooded grave" (2000), digital editing mechanisms to impact the staging he created: in a cemetery in Vancouver, the ocean seems to have invaded a recently opened grave (starfish, sea urchins, algae). Like other artists, Jeff Wall uses postproduction to direct this conceptual image. The incorporation of elements of fantasy and creativity in real contexts is used by Patricia Piccinini in "Last Day of the Holidays" (2001): a boy playing with his skateboard finds a figure that looks like a creature coming out of a science-fiction movie, bringing an insertion of these elements into normal daily existence.

We can find examples of Digital images that use representations of time, like in Anna Ursyn's "Monday Morning" (1995), a day-to-day narrative, exploring the perspective of her work routine based on daily observation. Victor Anderson suggested in "Time" (2002) the idea of movement being generated through digital editing.

The resulting pattern, framed as a specific evolution in post-images that use instantiation through conceptual perspectives with classic post-production techniques (1992-2002) can be resumed as follows (Table 1).

Table 1. Results of instantiation with initial digital imagery techniques (subject/ method approach)

Instantiation	Author	Title	Year
Human Perspectives	Keith Cottingham	"Untitled (Triple)"	1992
Video aesthetics	Michael Wright	"The light"	1992
Staging	Jeff Wall	"A sudden gust of wind (after Hokusai)"	1993
Mutation	Daniel Lee	"1949 – Year of the Ox"	1993
Identity	Antony Aziz and Sammy Cucher	"Chris"	1994
Time-frame	Anna Ursyn	"Monday Morning"	1995
Absense	Mary Frey	"In her Bedroom"	1997
Surreal	Margi Geerlinks	"Untitled (Girl Knitting Baby)"	1998
Texture	Robert Rauschenberg	"Dark Horse of Abstraction"	1995
Readymade	Ken Gonzales-Day	"Untitled #36 (Ramoncita at the Cantina)"	1996
Multiply	Gerald van der Kaap	"12th of never"	1999
Stage	Jeff Wall	"The flooded grave"	2000
Symbolic	Liu Wei	"Forbidden city Series nr. 1"	2000
Real/Unreal	Patricia Piccinini	"Last Day of the Holidays"	2001
Motion	Victor Anderson	"Time"	2002

Source: (see Figures 3 and 4)

After collecting and analyzing these traces of remix and hybridization, it was possible to broaden the perspective of a nucleus of media artifacts that allowed reading this past and consolidating a pattern of cultural production around digital processes.

In a first technical analysis, a formulation that consubstantiates the use of digital tools subjected to the context of post-images in Digital Media Art results in a diverse spectrum of artworks that generate a Universe similar to a "cultural mosaic" described by Moles (1971). Computational hybridization revealed developments that

related DMA's connection to the evolution of scanning methods, digital photography techniques, 3D algorithms, photo-editing software and digital remix.

A MEDIATED PERSPECTIVE

Machado (1993:34) developed the concept of "semiotic machines" as "those dedicated primarily to the task of representation". These machines, considered Machado, were so eloquent that they could "speak" — have their own voice —, creating "modes of perception", "due to the particular way of creating the world of which they are mediation sensitive and for their specific resolution of the problem of codification of that same world". Machado considered these devices as technical intermediators to the production of content or symbolism. Other authors, like McLuhan, focused on the need to look at characteristics and processes emerging from Media — also indicating that each medium would have its obstacles to communication, its nature: "The medium is the message". Thus, the set of different permissions presented by each medium would configure a variation in the form of representation, which has implications while transmitting and decoding content. In short, the vision proposed by Mcluhanists drives us to a point from where we should look at vehicles or channels, through which the message is transmitted: its media. McLuhan opposed previous studies (Lazarsfeld, Schramm, Katz) in which attention was mainly directed to the effects of media or its content through an analysis of messages, a framework in which the impacts from transmissive vehicles were not taken into account, in the context of Mass Communications. A resemblance between this analysis and the issues that we are addressing in images can be noted. Flusser's take reflected over an increasingly less discursive and increasingly synthetic approach to images (Flusser, 1998). Kember and Zylinska (2012, in Kuck and Zylinska, 2016) note the role of Image as a complex and hybrid entity that can simultaneously assume an economic, social, cultural, sociological or technical face. This role is seen as "photomediation". The authors argue that there was always an aspect of mediation in Photography, but that this is now accentuated by the fact that we are currently in debate and partnership with technologies that recreate aspects of intelligence (namely artificial intelligence), which can instantiate a new debate on the role of the link between man/machine in creative operations, intensifying this duality. Manovich (2002) identified mediation as an incorporation by software, being embedded in the interface concept: Digital Media rely on past artifacts and his processes of articulation and expand the previous aspects thanks to new developments in the medium. Other authors (like Santaella, Dubois) address this question as the medium's own conditions. The idea of intermediation can also be evident in paths of hybridization and assembly of

archived files, in a logic of digital management of cultural digital products as assets, in areas like stock photography.

The implicit mediation task, addressed by many authors, involves procedural understanding, focusing in analysis of their role as media objects. One of the emphasized aspects is the way in which new mutational elements have an impact on media objects that we produce and share, especially considering the role of hybridization. If we observe this aspect in post-images, we can find an accentuating presence of structures that make use of a machinic extension in photographic production tools, in the form of multiple types of artificial intelligence, which are conditioning factors of the acts, methodologies and processes we refer to — algorithms, machine learning, artificial neural networks, and others. We can also find these elements in fruition aspects as i) the choices made by indexing "bots", ii) the several types of Big Data filtering software or iii) those points in which a "programmed vision" (an expression used by Chun, 2013) is established as a condition of creative perspectives.

Therefore, it would be beneficial to contextualize imagery studies contemplating its current properties and methodologies, trying to better understand the role of the computational nucleus of images that serves us as reference. Our suggestion was to generate a concept that could frame these perspectives: the concept of Post-image, presented in previous work. More than considering that there is a simulation paradigm, from which software mimics historical creative processes with the objective of creating facilitation "from analog to digital", as it is often mentioned, we should realize that software issues are a conscious result of a choice by software development actors or teams, which then condition the properties of a given image. A post-image characteristic is that properties are not only represented on a certain visual surface, but present themselves after being aggregated in the form of digital information, having a dependency from its generative software.

Arnheim (2004) suggested, back in the 1950's, a practice intended to introduce an expressive aspect in the structure of an artistic piece: the "Expression embedded in the structure" (Arnheim, 2004: 449). This framework considered taking into consideration the elements of the process and techniques that emerged from it, or that were placed in it through circumstances specific to the creative and generative involvements resulting from the concrete work. As mentioned by Arnheim, using architectural work as subject, this would allow us to see that it is desirable not to be stuck in the formalism of technique, instead using the resulting space to embark in the exploratory path as a way to obtain "Structural Expressive Configurations" (SEC) (Pinheiro, 2018). Human-machine relationship in the DMA context is a process that can be intensified through artificial entities that channel new outputs. Several tools open up new possibilities for digitally integrating various types of contents in the creation of new cultural media. The range of Science hybridizations that can be

observed in new technical imagery studies pushes the formulation of a concept to fit this need to use tools whose potential could be explored or established within the limits of the post-image concept and/or linked to specific group cultures as a source of paradoxes, and as a starting point for experiments associated with representation/creation through the computational medium.

In a following stage, we expanded this adding to SEC the concept of "Borderline tools" (Pinheiro, 2018). "Borderline tools", as previously defined, are those tools set in an experimental context, belonging to unconsolidated fields, or having been forgotten or considered less interesting by mainstream sectors. This notion was set in previous work with digital tools and reflected the need to look at pathways of technology that were assumed unquestionable, but derive from an overwhelming commercial or industrial process, leaving behind technical instances because of strategic options, as we can find in Cubitt (in Veigl, 2011: 33). The interest was focused on tools that configured an escape from the most used art creation systems, exploring technological fringes and making a mix that allows to revive the role of tools in the technical and cultural boundaries. We explored fields of computational analysis that articulated machine and visual content: video analysis, computer vision, neuro-image and data, image analysis through deep learning, facial analysis of expressions/gestures, machine learning, robotic vision, tomographic image analysis, recognition of human activity, cellular image analysis, event-driven perception use by robots, deep learning applied to image, computer vision for audiovisual media, among many others. Taking these stratified fields as "Borderline Tools" allowed new tasks and expression modes in creation. These artist experimentation elements (machinery and methodologies) also conditioned the development of post-images, opening space to a model of representation in Contemporary Imagetics.

A BIGGER PICTURE

In 2001, Manovich was trying to answer the question "What is new Media" by transposing five properties that would define his subject: Numeric representation, Modularity, Automation, Variability, Transcoding (Manovich, 2001: 27). These choices would define Software as the ultimate condition to whatever was created by these New Media — a software centered philosophy that serves as a solution and also starts new problems. In fact, other authors started crediting instead Hardware (Chun), Social interaction (Lovink), Networks (Thacker), or other perspectives of computational media. In the Post-image ecosystem, these perspectives could be gathered by the idea that artists are exploring new paths of creation by using their medium's characteristics as a way to broadening the artwork and, at the same time, reflecting contemporary issues. Just as Modern Art relied on contemporary

technologies, such as cinema, photography or mass media, Digital Media Art would reflect the pulverization of interfaces, image possibilities, software, databases, networks, sensors/actuators or others.

Following this path, we could start by observing Nancy Burson's "Beauty composites" (1982) as a first example for exploring mediation possibilities around a development from the 1980's, resulting from an emerging digital technique: morphing — used to transform one image into another, merging the faces of movie stars like Bette Davies, Audrey Hepburn, Meryl Streep, Marilyn Monroe, Jane Fonda or Sophia Loren, exploring the idea of universal face. Initial explorations would suggest widening the scope of artworks, taking new directions and being opened to Machado's clues in the understanding of the current artistic role in the organization of several "differentiated talents, equating sensitivity and rigor, discipline and creative anarchy" (Machado, 1993: 33). In Jochem Hendricks "EYE" (2001) it is possible to observe the used of the concept of "drawing with the eyes". Hendricks recorded the movement of the eyes along a page (currently known as eye tracking from browsing) and transposed that movement into visual Art, exploring this instantiation as a technique — using resources from his medium. In this process we observed the mix and multiplication with other media, originating objects that simulate the original surface, accentuation of characteristics that configure the machinic component — processes within the scope of convergence, transmediality, miscegenation of techniques, following conceptual paths described by Santaella (2003) or Jenkins (2006). In 2016, Sony Photography Awards shortlisted Manuel Velásquez Tobar used algorithms from face recognition systems to generate portraits, based in biometrical data from the image and the voice of the subject, which were then morphed into a mathematical representation[2]. He called these images "Portraitgraphs Series".

Hoezl and Marie (in Bohr and Sliwinska, 2018) define contemporary imagery as algorithmic, distinctive from previous visual geometric representations: the optics paradigm of Geometry. This study presented the identity of "an operative image" (idem: 134), suggesting concepts like Hardimage/Softimage as representations from the past, and the idea of a "Postimage" as a collaboration between humans, animals (integrated in algorithms like "swarm" patterns and others), data, autonomous machines and algorithms. Laurent Mignonneau & Christa Sommerer (2015) humorously make use of an English expression to present an automatic portrait generator — "Portraits on the Fly"[3]. When the subject stands in front of a screen, a black and white swarm of flies starts to generate, driving the insects to the necessary point from which a picture from the fly pattern starts to make sense.

And if an insect creates a necessary disturbance in this reflection, what about plants? Anna Ridler created, in 2019, an art installation called "Mosaic virus"[4], represented in a panel of three Netherlands tulips, each one in a different screen with a black background, depicting 17th century Dutch still life flower paintings. Although

the images seemed to be static photographs, they were in fact Artificial Intelligence generated post-images that bloomed and expanded petals in reaction to an algorithm that read current bitcoin market value, revealing sudden interconnections between contemporary economy facts and a recreated nature.

These observations broadened the artwork spectrum to include a new morphogenesis approach that could generate an analysis of Contemporary Imagetics that couldn't be integrated in previously available frameworks. For instance, in "The Art of Cybersecurity"[5] (2019), Brendan Dawn fabricates abstract images representing cybersecurity threats. The project was sponsored by a cybersecurity company. The metrics used were the result of analyzing five key sectors in American cyber data, using Houdini and Processing applications to create an algorithm that deals with the information visually.

This instantiation uses a remediation of aspects found in the software/data information that is precise and clean. In other cases, artists explore the opposite: the machine error. Kim Albrecht explores graphic machine errors and computer glitches in the "Risograph prints"[6] ("Distinction Machine", 2019). Albrecht forces a 3D error in computational Science knows as "Z-fighting" to reveal patterns generated by electricity flowing within silicon circuits. The error is used to allow an expression of the electricity in the machine.

In other cases, researchers/artists try to teach the machine using Machine Learning to develop Art frameworks. In "Learning to See: Gloomy Sunday", Memo Akten uses Machine Learning algorithms to train the machine into reconstructing content from a previous image, similar to the human visual cortex. The machine tries to identify what it sees, but, like us, human beings, can only process the reconstruction within the knowledge it has. This allows the user to benefit from the properties available to that machine's cultural environment to experiment with objects and generate post-images that resemble reality landscapes[7].

Other experimental works, like "GauGAN" — from team of artists/engineers at NVIDIA Taesung Park, Ming-Yu Liu, Ting-Chun Wang, Jun-Yan Zhu —, can generate complex landscapes from basic sketches using GAN - Generative Adversarial Networks. In this case, the team of researchers works on making two networks compete against each other in trying to identify if an image is real or fake, using the initial data set provided. Drawing in the left window generates detailed realistic landscapes in the right window. It is possible to select materials to apply in each area, like roads, sky, mountains, wood or water. The final effect mimics complex landscapes[8].

The results (Table 2) present a diffused pattern that considers instantiation of elements not by subject but stratified around technology aspects.

Resuming the two approaches that were followed, it is possible to verify that the first one takes advantage of the initial technological developments in computer

Table 2. Results of instantiation with Art/Science approach (algorithm/method approach)

Instantiation	Author	Title	Year
Morphing algorithms	Nancy Burson	"Beauty composites"	1982
Eye movement tracking	Jochem Hendricks	"EYE"	2001
Image capture, swarm algorithms	Laurent Mignonneau & Christa Sommerer	"Portraits on the Fly"	2015
Face recognition and biometric data	Manuel Velásquez Tobar	"Portraitgraphs Series"	2016
Artificial intelligence and Bitcoin technologies	Anna Ridler	"Mosaic Virus"	2018
Cybersecurity metrics	Brendan Dawn	"The Art of Cybersecurity"	2019
Z-fighting, Glitch	Kim Albrecht	"Risograph prints"	2019
Machine learning	Memo Akten	"Learning to See: Gloomy Sunday"	2020
Generative Adversarial Networks	Taesung Park, Ming-Yu Liu, Ting-Chun Wang, Jun-Yan Zhu	"GauGAN"	2020

Source: (See Figure 5)

editing, noting the presence of remixed images as a transversal act, exposing us to a changing reality that rises from the use of visual tools with a key idea condensed around image post-production. In this context, it refers to types of creative or technical interventions, constituted after taking, capturing or generating the images. Plummer associates it with "editing acts, such as improving or cleaning a photograph, or the deliberate creative process that occurs after an image is edited and before it is printed" (Plummer in Hacking, 2012: 530). Image post-production can be used to brighten shadows or highlights, create basic conceptual modifications, change aspects in coloring and texture; or it can totally challenge the image's natural sustainability, often making use of graphic elements, illustration or typography.

A second approach emerges from within algorithmic media, resulting from technical interventions generated by artists or scientists' work, associated to fusions, remixes, hybridizations of key elements derived from Science that are conceptually framed by an Art concept. Image creation was instantiated by key technologies derived from Art/Science processes that use Morphing algorithms, Eye movement tracking, Image capture, Swarm algorithms, Face recognition, Biometric data, Artificial intelligence, Bitcoin technologies, Cybersecurity metrics, Glitches generated by computer errors in Z-fighting related processes, Machine learning and Generative Adversarial Networks. The stratification around an instantiation of technology resulting from aspects of Science/Art takes computational code as central

element of production, starting from a concept/idea and assuming diverse creative/ conceptual aspects in each artwork: errors from computational media elements, influences from the implementation of Science generated questions, problems related to Ethics, Economics, Existential, Self-representation, and others. This practice followed Arnheim's vision of addressing the idea of an "Expression embedded in the structure", intending to introduce an expressive aspect in the structure of an artistic piece, which can often be subjected to elements of the process/techniques that emerge from the process, or that are placed in the process through specific circumstances of the creative and generative involvement resulting from the concrete digital work. This "expression", often originated from the human interaction with digital media, is based in experimentation and can be intensified through conceptual paths, being a center for experimentalism — an essential ladder to the "poèsis" that Heidegger proposed.

CONCLUSION

This chapter aimed at contextualizing imagery creation practice in Digital Media Art (DMA) contemplating its contemporary properties and methodologies in a way to better understand the role of mediation resulting from processes derived by the use of Computational Media in Contemporary Imagetics.

History aspects and Artwork collection were used in an initial stage to review Artist's contributions from the past and obtain a stratification around an instantiation of Technology resulting from a first post-photographic stage. Curating these Post-images with the objective of seeking morphogenesis issues in Artifacts and methodological processes related to Contemporary Imagetics resulted in an initial collection and analysis of digital imagery techniques that pointed to developments that related Digital Media Art to the evolution of scanning methods, digital photography techniques, photo-editing software and digital remix. This historic perspective configures remediation processes that take the photographic medium and use new editing techniques to explore creative paths.

The concept of "Structural Expressive Configuration" (SEC) was introduced as a connector to address Post-image machine inner dependencies in the Digital Media Arts field. Arnheim called it "Expression embedded in the structure" — an expressive aspect introduced in the structure of an artistic piece. This framework took into consideration the elements of the process and techniques that emerged from it. These images had properties shaped by digital information. The representation on a visual surface and an analyses of the result were incomplete without reviewing artist's processes and ideas and overcoming a simulation paradigm, through which software mimics historical processes — a characteristic that can be noted at the

start of Remediation processes, in which Medium issues are a conscious result of choices made by Software development agents. Those options and paths, taken in Software development, condition constant properties in the Artwork: these images express conformation to pre-conditions embedded in the digital Medium, through which it materializes. It is also possible to verify that these processes also condition drafting, creation, broadcasting, projecting or the exhibition of the work.

A group of media artifacts emerging from digital processes that followed computational code as a central element of creation — included in the concept of Borderline tools (BT) — was curated, using previous observation of new fields in Image Research that expanded the initial nucleus of images resulting from the first stratification. This second imagery body could both reflect the attempts to articulate machine and visual content, and display the SEC/BT characteristics: reveal a concept/idea, assume diverse creative/conceptual aspects/properties coming from tools/methods that could condition the artwork creation and/or fruition. With this approach, it was possible to amplify an initial imagetic body of research. A separation between both observations (subject/theme, algorithm/method) allowed morphogenesis notes that gave two perspectives on the way images were also being created in a Contemporary universe of Imagetics, as we've seen.

A last and promising part of these perspectives was connected to the initial observations, in which we looked at Dada/Constructivist artists. SEC/BT embedded Media properties emerging from digital artifacts can be explored in Art/Science configurations that can provide an expansion to the Post-image field and also be used as a DMA practice in a similar way of previous Collage/Photomontage artists.

FUTURE RESEARCH DIRECTIONS

Emerging Science/Art research is booming at universities and Art Festivals around the world and generating debate. But there are Research/Development limits in the current model. Although post-images are extensively used in Art environments, imagetic research in Art/Science would benefit from concrete actions to instantiate a more conceptual work, improving creation models that promote the Artist's role in this collaboration. Also, more efficient diffusion mechanisms to display these artworks are needed.

Future research within Contemporary Imagetics in DMA should consider not only westernized examples, but a comprehensive and robust worldwide analysis into digital imagery artifacts. Local curations exploring new remediations and new faces of these post-images could also be a path to bring into the spotlight examples of lost or less known artworks locally scattered.

To follow up this research, we should broaden its scope and continue to debate principles associated with post-images, as a body that reflects the profusion of possibilities that they now incorporate, looking for the combinatory amplitude that reinforces remediation in aspects related to remodeling and reform of methods and approaches to Contemporary Imagetics.

ACKNOWLEDGMENT

The author would like to thank the support of CIAC, Research Center in Arts and Communication from Algarve University and Open University, Portugal.

REFERENCES

Arnheim, R. (2004). *Art and Visual Perception: A Psychology of the Creative Eye*. University of California Press.

Barthes, R. (2012). *A Câmara Clara*. Edições 70.

Benjamin, W. (2008). *The Work of Art in the Age of Mechanical Reproduction*. Penguin.

Bohr, M., & Sliwinska. (2018). *The Evolution of the Image: Political Action and the Digital Self*. Routledge.

Chun, W. (2013). *Programmed Visions: Software and Memory*. The MIT Press.

Fineman, M. (2012). *Faking It: Manipulated Photography Before Photoshop*. Yale Univ. Press.

Flusser, V. (1998). *Ensaio sobre a fotografia: para uma filosofia da técnica*. Relógio D'Agua.

Grusin, J., & Bolter, R. (2000). *Remediation: Understanding New Media*. MIT Press.

Hacking, J. (2012). *Photography: The Whole Story*. Thames and Hudson.

Heidegger, M. (2012). *Ensaios e conferências*. Editora Vozes.

Kee & Farid. (2011). A Perceptual Metric for Photo Retouching. *Proceedings of the National Academy of Sciences of the United States of America*. doi:10.1073/pnas.1110747108

Kember, S., & Zylinska, J. (2014). *Life after New Media: Mediation as a Vital Process*. The MIT Press.

Lipkin, J. (2005) *Photography Reborn: Image Making in the Digital Era*. Academic Press.

Machado, A. (1993). *Máquina e Imaginário: O Desafio Das Poéticas Tecnológicas*. Editora da Universidade de São Paulo.

Manovich, L. (2001). *The Language of New Media*. MIT Press.

Mitchell, W. (1994). *The Reconfigured Eye: Visual Truth in the Post-Photographic Era*. MIT.

Moles, A. (1971). *Arte e Computador*. Edições Afrontamento.

Newhall, B. (1984). *The History of Photography: From 1839 to the Present*. The Museum of Modern Art.

Paul, C. (2003). *Digital Art*. Thames & Hudson Ltd.

Pinheiro, J. (2013). *Pós-publicidade : contributo para o estudo do registo de pós-produção fotográfica no domínio da publicidade*. https://repositorioaberto.uab.pt/handle/10400.2/2667

Pinheiro, J. (2018). *Imagética contemporânea e pós-imagem: a marca do software e o uso de ferramentas borderline no caso uturn*. https://repositorioaberto.uab.pt/handle/10400.2/7785

Rush, M. (2005). *New Media in Art*. Thames & Hudson.

Santaella, L. (2003). *Culturas e Artes Do Pós-Humano*. Paulus.

Smith, A. (2001). Digital Paint Systems. *An Anecdotal and Historical Overview*, *23*. doi:10.1109/85.929908

Veigl, T. (2011). *Imagery in the 21st Century*. The MIT Press.

Wands, B. (2007). *Art of the Digital Age*. Thames & Hudson.

KEY TERMS AND DEFINITIONS

Artificial Intelligence: A type of intelligence displayed by machines, in which a process of mimicking human thought attributes, like learning or solving problems.

Biometric Data: Information data from the human body, such as height, fingerprints, body measurements, temperature, etc.

Bitcoin Technology: A digital currency that doesn't have a physical center or location, but instead is based in a peer-to-peer network.

Borderline Tools: Those set in an experimental context, belonging to unconsolidated fields, or having been forgotten or considered less interesting by mainstream sectors. This notion derives from previous work with digital tools and reflects the need to look at pathways of technologies that we assume as unquestionable, but derive from an overwhelming commercial or industrial process that leaves behind technical instances because of strategic options.

Cybersecurity Metrics: Data produced by computer security institutions in the process of protecting networks of computers from external attacks.

Eye Tracking: Technology to measure eye gaze as a person looks at a screen.

Face Recognition: Technology that allows to identify people in a video frame through the analysis of facial shape or texture.

Generative Adversarial Networks (GAN): Machine learning framework in which two neural networks compete against each other to win within a gaming environment using a supervised learning pattern.

Glitch: A temporary fault in a computer system; interference; for a brief moment a system displays visual errors in screen; some examples of "glitch" are distorted screen or noise effects.

Machine Learning: Computer algorithms that use data to train and automatically improve over experience.

Morphing Algorithms: Technology to transform a visual object into another, used for instance to change an image of a person into another through digital techniques based in image dissolving.

Neural Network: Artificial network composed of nodes.

Structural Expressive Configuration (SEC): A framework to explore remediation mechanisms in Digital Media Art, derived from Arnheim's "Expression embedded in the structure" (Arnheim, 2004, p. 449). This framework considers expressive elements from the process of creation in the digital medium. It explores poetic elements that emerge from the medium or that were placed in it through circumstances specific to the creative involvement with the medium.

Swarm Algorithms: Computer systems that are inspired by collective intelligence of nature: the collective patterns of movement in species, like fish, birds, ants, flies could be examples.

ENDNOTES

[1] Smith (2001). Smith used a VHS tape with aspects of the screen work, which he called VidBits. It consisted of examples of interaction, imagery and animation, achieved through new digital ways. This VHS tape was exhibited at the MOMA in New York.

[2] Available from https://www.worldphoto.org/sony-world-photography-awards/winners-galleries/2016/professional/shortlisted/conceptual/manualat15/03/2020

[3] Available from https://www.youtube.com/watch?v=Qfe7xc0Mhs4at15/03/2020

[4] Available from https://vimeo.com/338726032at15/03/2020

[5] Available from http://brendandawes.com/projects/artofcybersecurityat15/03/2020

[6] Available from https://distinctionmachine.kimalbrecht.com at 15/03/2020

[7] Available from https://www.youtube.com/watch?v=kwDPmsCJmUwat15/03/2020

[8] Available from https://www.youtube.com/watch?time_continue=119&v=p5U4NgVGAwg&feature=emb_titleat15/03/2020

APPENDIX

Image Instantiation With Focus in Digital Imagery Technics

Figure 3.
a) Human Perspectives — Keith Cottingham, "Untitled (Triple)" (1992) (Rush, 2006)
b) Video aesthetics — Michael Wright, "The light" (1992) (Wands, 2006)
c) Staging — Jeff Wall, "A sudden gust of wind (after Hokusai)" (1993) (Hacking, 2012)
d) Mutation — Daniel Lee, "1949 – Year of the Ox" (1993) (Lipkin, 2005)
e) Identity — Antony Aziz and Sammy Cucher, "Chris" (1994) (Hacking, 2012)
f) Time-frame — Anna Ursyn, "Monday Morning" (1995) (Wands, 2007)
g) Absense — Mary Frey, "In her Bedroom" (1997) (Lipkin, 2005)
h) Surreal — Margi Geerlinks, "Untitled (Girl Knitting Baby)" (1997-98) (Lipkin, 2005)
i) Texture — Robert Rauschenberg, "Dark Horse of Abstraction" (1995) (Paul, 2003)

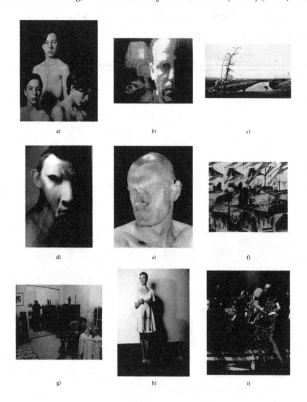

Image Instantiation With Focus in Science/Art Relation

Figure 4.
j) Readymade — Ken Gonzales-Day "Untitled #36 (Ramoncita at the Cantina)" (1996) (Paul, 2003)
k) Multiply — Gerald van der Kaap "12th of never" (1999) (Paul, 2003)
l) Stage — Jeff Wall, "The flooded grave" (2000) (Hacking, 2012)
m) Symbolic elements — Liu Wei, "Forbidden city Series nr. 1" (2000) (Wands, 2006)
n) Real/Unreal —Patricia Piccinini, "Last Day of the Holidays" (2001) (Paul, 2003)
o) Motion - Victor Anderson, "Time" (2002) (Wands, 2006)

j) k) l)

m) n)

o)

Figure 5.

p) Morphing algorithms — Nancy Burson, "Beauty composites" (1982) (Paul, 2003).

q) Eye movement tracking — Jochem Hendricks "EYE" (2001) (Paul, 2003).

r) Image capture, swarm algorithms — Laurent Mignonneau & Christa Sommerer "Portraits on the Fly" (2015). Available from http://www.interface.ufg.ac.at/christa-laurent/WORKS/FRAMES/ FrameSet.html at 15/03/2020.

s) Face recognition and biometric data — Manuel Velásquez Tobar "Portraitgraphs Series" (2016). Available from https://www.worldphoto.org/sony-world-photography-awards/winners-galleries/2016/ professional/shortlisted/conceptual/manual at 15/03/2020

t) Artificial intelligence and Bitcoin technologies — Anna Ridler "Mosaic Virus" (2018). Available from https://vimeo.com/338726032 at 15/03/2020

u) Cybersecurity metrics — Brendan Dawn "The Art of Cybersecurity" (2019). Available from artist's website: http://brendandawes.com/projects/artofcybersecurity at 15/03/2020

v) Z-fighting, Glitch — Kim Albrecht "Risograph prints" (2019). Available from artist's website: https://distinctionmachine.kimalbrecht.com at 15/03/2020

w) Machine learning — Memo Akten "Learning to See: Gloomy Sunday" (2020). Available from https://www.youtube.com/watch?v=kwDPmsCJmUw at 15/03/2020

x) Generative Adversarial Networks — Taesung Park, Ming-Yu Liu, Ting-Chun Wang, Jun-Yan Zhu "GauGAN" (2020). Available from https://www.youtube.com/watch?time_continue=119&v=p5U4N gVGAwg&feature=emb_title at 15/03/2020

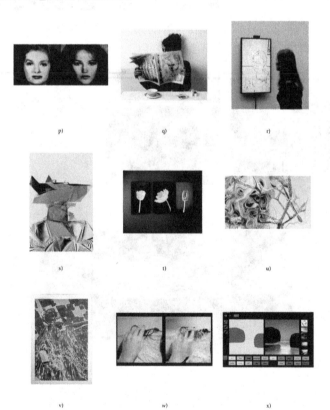

Chapter 2
The New Media vs. Old Media Trap:
How Contemporary Arts Became Playful Transmedia Environments

Patricia Gouveia
LARSyS, Interactive Technologies Institute, Faculdade de Belas-Artes, Universidade de Lisboa, Portugal

ABSTRACT

This chapter explores the legacy of both modernism and postmodernism in contemporary arts and how it helped shape our current environments and practices in transmedia contemporary arts. It also explores popular modernism aesthetics based simultaneously in cathartic narrative and flow participatory interaction to explore new media discourse about the role of digital arts and artists. The aim is to promote an understanding of the current arts practices that no longer promotes the artificial divide between new media or media arts and contemporary arts. Changes in the intercultural museum and in higher education can no longer sustain this segregation, which is a product of old and new media specificity and narrow notions of specialization.

DOI: 10.4018/978-1-7998-3669-8.ch002

INTRODUCTION TO A PLAYFUL TRANSMEDIA WORLD

At the end of the second decade of the XXI century we can consider that finally contemporary arts became playful transmedia environments where artists use several media to convey their ideas and concepts about the world we are living. Postmodernist digital revolution with its procedural arts and simulation systems have finally a space merged with contemporary arts. As I stated elsewhere "arts that are no longer "post", "new" or mere digital "folklore" (Lialina & Espenschied, 2009: online) but transmedia, proper of a certain kind of *trans modernism"* (Gouveia, MAAT *Playmode* Exhibition Publication, 2019, p. 9). As Josephine Berry Slater suggests in a Post-Net Aesthetics Conversation in London, quoting Peter Osborne, contrasting to the modern orientation, where it was important to point out the "new" in order to cut off from the past, there is now a desire to mix multiple modernities and modernisms. The different styles happen at once and mix past and present in a dynamic of open and meaningful senses (Slater quoted in Cornell & Halter, 2015, p. 415). Modern aesthetics, based on industrial revolution and liberal economy, promoted specialization and several separate categorizations everywhere. With an evident will to treat modern specialization "disease" postmodern sensibilities emerged with its possible cure explicit in its remix culture, flow aesthetics and politics (Bolter, 2019). Inspired by video gaming, rock and roll, Marshall McLuhan medium specificity and Steve Jobs style the two faces of the same coin (modern and postmodernism) arrive paradoxically, at the beginning of this century, as a kind of popular modernism (Bolter, 2019) which merges several media in micro narratives of the self. Identities became playful and fluid in our current ludic culture (Frissen, Lammes, De Lange, De Mul and Raessens, Ed: 2015) where artists take advantage of social media and its participatory advantages to tell their stories.

The modern art world of the XX century promoted arts specificities and autonomy and followed modernist artificial divides such as art versus science, art versus crafts, art versus design, among so many other problematic detachments. At the end of the XX century post modernism aesthetics, aware of the specialization disease, propose the generalist view as a conceptual framework to overcome the malicious cancer at the heart of the art world. The proposed therapy, like chemotherapy, was also problematic and the organism was just falling to survive. It now seems that finally modernism and post modernism aesthetics gave rise to a merge territory where artists are no longer with their backs turned to scientists, engineers, historians and cultural critics. Sometimes they even became scientists, engineers, historians and cultural critics. As Florian Cramer states, art autonomy "has arguably never been as contested as it is today, whether in the field of art theory, artistic practice, or cultural politics (Cramer, 2019, online). We live in a complex systemic world where people need to collaborate and enter a matrix of possible paths. Fluid identities

create nomadic spaces where interaction and participation seem to be the main goal. Plasticity fight coherent narratives and unique truths. As Geert Lovink asks in his book *Sad by Design, On Platform Nihilism*, "(…) who dares to refer to "new" media anymore? Only innocent outsiders occasionally mention this once promising term" (Lovink, 2019, p. 4).

In this chapter we consider the postmodern condition of Jean-François Lyotard as a continuation, another face of modernism. Postmodernism, in contrast to modernism, opens the way for a transmedia aesthetic where both tendencies coexist. If for modernism the new, the cut with tradition, the end of history and the great narratives were part of the creative poetics, in transmedia aesthetics the remixing of languages, media platforms and systems of play and game reign in a recurrent parody of the capitalist system. Contemporary artists use marketing tools, digital networks and critical retro engineering technologies to mix analog and digital arts in a *transinternet art* (Slater quoted in Cornell & Halter, 2015, p. 415) filled with situations that remind us of the nineties *net.art* aesthetics. Elsewhere we define transmedia practices as the process of creating a story world across multiple platforms using multimedia and cross media content (Gouveia, 2018b). Digital and/or computer generated art, states Domenico Quaranta, "came about in the early sixties as an artistic response to the emergence of the computer and digital media, and as an articulation of one of the most interesting moments in the history of contemporary art – the one that, as it is widely recognized, shaped the contemporary art world and the very notion of contemporary art as we know it. (…) And yet, when things started being more codified and less experimental, Digital art found out that there was little or no room for her in the art world shaped by the artistic revolution she was part of" (Quaranta, 2018, online). Meanwhile internet became a mass medium and artists and poets start using it as their source of creation, production, and dissemination.

BACKGROUND

Modern and Postmodern Legacies

To the presuppositions that define modernity, namely the belief in industrial progress and scientific reality, in the subjective subject as holder of unquestionable qualities and, simplifying, the belief in an ideology/doctrine in which the same system of ideas is constituted as a theory or as a doctrine (Morin, 1999, p. 118) postmodernism claimed a new system of ideas, paradigms, self-proclaimed, in some cases, as opposed to modernism. Blanka Vavakova considered, at the end of the last century, the case of J. Habermas as paradigmatic of a conception of postmodernism "as an anti-modern ideology of neo-conservatives, which compromises the project

of modernity and, with it, the possibility of achievement the social hopes it had engendered" (Vavakova, 1988, p. 103).

We consider the postmodern condition of Jean-François Lyotard as a continuation, another face of modernism (Lyotard, 1989). Postmodernism, in contrast to modernism, opens the way for a transmedia playful aesthetic, a critique of cynical reason (Sloterdijk, 2011). Thus, postmodernism is a cut, a change within the same paradigm, with the system of ideas characterized by modernity, or, in the context of a rupture, in which the reverse of modernism itself is valued and principles in nothing coincident with modern ideology are exalted. What seems to be valued by postmodern sensibility, grounded in a staunch critique of individualism and modern rationalism, is the consciousness of a multiplicity of realities as opposed to the objective reality of science. Postmodern sensibility aims to challenge the domain of reason and technique, dear to the modern soul, aims to create an awareness of the importance of other types of knowledge (magical, artistical, poetical…). For this purpose, postmodern authors criticize the devaluation of a metaphorical knowledge that is distorted by the legitimation of a rational conscience which emphasizes metonymy. Meaning as metonymy, or the alteration of the natural meaning of the terms, using the cause instead of the effect, of the whole by the part, of the contingent by the content and vice versa.

The postmodern condition leads us to distrust in "meta-narratives" for these are an effect of sciences progress and legitimize a possible reality among many others. The postmodern condition fights the belief that there is only one explanation, as if this were the only possible and definitive reality, and, therefore emphasizes multiplicity. Jean-François Lyotard draws attention to the existence of many different language games, a "heterogeneity of elements" which are revealed "in a society that reveals less of a Newtonian anthropology (such as structuralism or systems theory) and more to a pragmatic of language particles" (Lyotard, 1989, p. 4). Games of words and senses make the language evolve and science itself draws on narrative discourse to justify the meanings it advocates. Thus, we find a "recurrence of the narrative in the scientific" (Lyotard, 1989, p. 64) that transforms the mistrust of science in relation to narratives into mere nonsense, since they legitimize their discourse through narrative discourse.

A statement as a multiplicity of possible statements seems to be at the basis of the postmodern reality at the end of last millennium. What is intended is not to promote successive innovations, avant-garde novelties, but rather to provide an interpretation among many other possibilities. With a critical emphasis on the modern cult of the new and the consequences of the aesthetics of ceaseless change, alienated by a positivist ideology that placed great emphasis on the future to the detriment of the past and the present, postmodernism "tries to reduce the distance that has opened between art and life, either by introducing a brutal reality or by art

reality itself" (Vavakova, 1988, p. 111). Ambiguities and ambivalence reigned at the end of the twenty century and the same "political ambiguities can be found in internet activism since the 1990s. Political autonomy has always been one of the internet activism's major driving force (…)." (Cramer, 2019, online) Postmodern aesthetics are just another side of the same coin and avant-garde ideas reappear as a certain type of digital activism.

Far from merely privileging autonomy, modernist art, except in the realist fashion, had sought a liberation from reality, but also from the church, the aristocracy and the bourgeoisie on the rise, in which the imagination appears as the main vehicle for the artist to represent her/himself. The modern cult for the new is replaced by postmodernity as a cult of the simulacrum, in which, according to António de Sousa Ribeiro, the subject abandons [her]himself to things, in a decomposition that allows different reproduction techniques to become vehicles of aesthetic universalization (Ribeiro, 1988, pp. 137-46). In this context, postmodernity disputes the modern politicization of the arts, which promoted an aestheticization of politics, like those aesthetics of propaganda used by fascism, and put forward a program that emphasize digital technologies as an opportunity for participation (Bolter, 2019, loc. 3055 of 4599: kindle). According to Bolter, "the advent of computer games and later social media have also helped make flow into a media aesthetic that rivals the traditional catharsis of film and dramatic television. Flow and catharsis constitute a spectrum in today's media culture. (…) Strong narrative is associated with catharsis, just as weak narrative is associated with media and flow." (Bolter, 2019, loc. 3132 of 4599: kindle). To understand and identify similarities and differences in film and gaming was part of our previous research (Gouveia, 2009; 2010). At that time, we could unfold paradoxical relations between narrative and action and how both could work together in interactive pieces. Our goal was to understand the relationship between systems of representation and systems of simulation. Narrative construction, catharsis arches and linear progression with a beginning, a middle and an end, merged with flow and action moments. These strategies where present in gaming, in general, and in alternate reality games, in particular, merging analogue and digital interactive narratives and creating a vaster territory of storytelling. Story consistence was part of a vaster universe of narrative bits and remixes in a transmedia open and systemic environment. Gameplay environments and its procedural aesthetics delivered flow moments enhanced by game mechanics, actions without consequences, and short stories without historical references.

According to Alvin Toffler since the fifties of the last century, industrial society, already in crisis, was submerged in six distinct principles, namely, **specialization** (the one that knows more and more about less and less things), **standardization** (the principle of homologation), **synchronization** (the rhythm of the machine), **concentration** (division into proper spaces), **maximization** (to increase gross

domestic product even if ecological and social catastrophes are to be caused) and, finally, **centralization** (the nation-state) (Toffler, 1992, pp. 49-64). These principles were articulated by integrating agents, often invisible or camouflaged, who defined the structure of the second wave industrial system. In social and human terms, the costs of unrestrained progress and industrialization of part of the planet began to not only generate numerous social asynchronies but also enhanced the problem of the use of non-renewable fuels. The modern superhuman is then called into question and the doctrine of progress seemed fallacious. In contrast, nowadays, "various forms of social media are suited for both individual identity construction (telling your own story) and political or social engagement (telling a collective story), and social media bring the same characteristics of weak narrative and flow to both these domains. The distinction between the individual and the group becomes less and less clear" (Bolter, 2019, loc. 3362 of 4599: kindle). Thus, politics of surveillance merged with politics of sousveillance and subvert themselves in emancipatory logics of narcissistic exposure for the network. According to Paula Roush, surveillance through external video recordings of the individual by organizations gives rise to sousveillance, personal recordings of people who watch over themselves (Roush, 2010). As Geert Lovink states, we share, through social networks and online platforms "judgements and opinions, but no thoughts" (Lovink, 2019, p. 29). It is time to abandon old oppositions and to embrace a consistent curatorial research that allows us to overcome pressing problems in our world. Lovink warns, "The easy opposition of Californian utopians vs. Euro pessimists has been superseded by larger planetary issues such as the future of work, climate change and political backlashes (Lovink, 2019, p. 25).

For the third wave civilization (Toffler, 1992) the notion of space and time is no longer correlated with Newton's theory of causation (cause / effect), in which time and space are linear. The scientific discovery of a time "which does not flow inexorably forward at the right pace indicated by clocks and calendars, but which can be distorted by nature, the final product being different depending on where we are measuring it. At the latter extreme, super collapsed objects - black holes - can completely deny time, making it immobilize in its immediacy" (Toffler, 1992, pp. 296). Flow as the aesthetic principle of social media merges with hacktivism (Bolter, 2019, loc. 3435 of 4599: kindle) and identity as remix. As Bolter states, while the essay gives us a coherent story of identity the social media page tends to offer us a fluid identity that adapt easily to moments and circumstances (Bolter, 2019, loc. 3184 of 4599: kindle). Being online requires a different kind of storytelling which contrasts with Hollywood film (Bolter, 2019, loc. 3200 of 4599: kindle).

Einstein had already proved the possibility of compressing time and thus of operating a transformation in the linearity characteristic of the absolute conception of modernity. Time as absolute value is replaced by a consciousness of a certain

relativism of the time and space notion. In this context, we do not have access to a single time but to an infinity of successive, alternative and plural times. By questioning the idea of time that used to come before the Third Wave (Toffler, 1992) a change in the notion of space operates through the recognition of the existence of different possible maps.

Ideas and concepts about occasional relationships and discontinuous situations with their sudden transformations, which alter the whole structure and organization of the world, opened a path to theories of systems, catastrophes, and the cybernetic notion of feedback loop. On the one hand, if we take the change of paradigm as certain in the mid-fifties of the last century and consider the postmodern paradigm autonomously, we find several affinities between postmodernism and a Third Wave sensibility, in which it is valued "plurality, tolerance, pacifism, green sensibility, [and] tribalism (...)". On the other hand, there are undeniable "(...) tendencies to deepen the ideas of modernity, such as equality and democracy." At the same time we find a "tendency to refuse the elements of the logic of modernity that have proved disastrous for the living conditions of individuals in modern societies, or inadequate to serve cultural regulators in the new techno-industrial and economic realities of these societies" (Vavakova, 1988, p. 115).

Thus, postmodern sensibility fits paradoxically into a modern, anti-modern, modern or non-modern universe. We find vestiges of a modernist sensibility in postmodernism, namely in the reuse of romantic myths in artistic discourse. This romantic perseverance is, according to Blanka Vavakova (1988), less evident than it seems since postmodern artists when they claim the reunion of art and life are essentially demystifying the role of specialists in relation to art. What the postmodern artist wants to question is the role of certain agents or consecration specialists of the artistic media (critics, conservatives, gallery owners, etc.) by drawing attention and rehabilitating the everyday, the superficial and random discourse in artistic practices. Since artistic practices become aware of the vulnerability of different discourses and theories postmodern artists consider that the institutions that have the power to consecrate art objects offer an "already felt" image instead of promoting an image that prevails through a "make-feel", an open and meaningful experience. In this sense cultural agents are criticized by promoting a doctrine type perspective in which dominates a closed structure and something totalitarian.

According to Michel Maffesoli there is something tragic in postmodern sensibilities. The screenagers [and contemporary digital artists] seem to have an instinctive repulsion for power and manipulation, whether economic, political or scientific. Digital kids have more confidence in the natural propensity of common or social self-organization than in any linear, organized hierarchical structure. The children of chaos seek a mystical mode where "the experience of being" reigns over centered systems (Maffesoli, 2001. pp. 68-69). Western "egocentrism" gives way to

an oriental "lococentrism" typical of the Japanese. While "egocentrism" emphasizes the individual as unity, in lococentrism the most important value is place, the experience of place (Maffesoli, 2001, p. 92). The errand of the nomad in perpetual motion. Digital screens made people even more static with a wandering needing. Tell us Maffesoli: "There is an initial commitment to encircle the wanderer, the deviant, the marginal, the foreigner, then to domesticate, to establish in a residence the man without condition of nobility, thus deprived of adventures" (Maffesoli, 2001, p. 82). We live in a world where digital networks give us data from far away in a third person disembodiment way and mode. Ubiquity becomes an illusion even in first person systems such as those using virtual reality apparatus (Gouveia, 2016). Even in "a twentieth-first-century art form that will weave together the three-great twentieth-century arts: cinema, jazz, and programming" (Lanier 2017, p. 3), in virtual reality we are still receiving data from "other space" and not completely immersed in our embodied surroundings. We can create new worlds and feelings to explore through simulation and synthesis in first or third-person perspectives but there is still a long way to travel before reaching the mirage of ubiquity.

Contemporary artists faced with the illusion of ubiquity tend to reinforce a vintage sensibility where they emphasize and appreciate handmade and organic materials, "although influenced by the digital revolution, many artists still cherish and rely on crafting material objects" (Voon, 2015, online). Following Daniel Miller quoted in Claire Voon's review named "Faced With Digital Ubiquity, Artists Still Cherish Crafting Materials", "as Daniel Miller, a professor of material culture at University College London, contends in his essay "Technology and Human Attainment": "We have not become more or less human. We are simply now that form of humanity that co-exists with this collusion of digital and analogue forms." Transmedia aesthetics are based in this relation between digital and analog forms, a certain going back to previous creative methodologies which mix several media in a coherent and clear concept that sometimes expose the fear of becoming less human.

Previous research in systems and interdisciplinary theories applied to digital arts and games from the author of this chapter (Gouveia, 2008; 2010) can contextualize the reader in terms of using different fields to achieve an integrative model. Our previous approach was inspired by Katherine N. Hayles (1999, 2001, 2002), Richard Coyne (2001) and Steven Johnson (2005), among many other proponents of cybernetics and information theories. In our perspective embodiment needs a holistic understanding which cannot remain subjected to representation. To understand digital embodied experiences, we need to go beyond representation. Agreeing with David Ceccheto (2011), in Mark Hansen's media theory embodiment remains subjected to representation and therefore it is insufficient to explain what is happening in transmedia contemporary arts. According to Mark Coeckelbergh, "we have always been Postdigital" (Coeckelbergh 2020, online).

For the purpose of this chapter the author aim is to go back to literature of the eighties, with an historical perspective about modernism and postmodernism, rescuing "history as the next stage in the continuum of physics to chemistry to biology" (Harari, [2011] 2015, p. 445) and so avoiding unique readings, even though when these perspectives mix various fields. The intention is to foster dialogues between people from various disciplines to promote teamwork and to avoid a-historical views which mix modern and postmodern trends without proper contextualization in a populist fashion. An integrative model presupposes a collaborative approach from different *sapiens* and not another view about technology or the world as "sapiens are incapable of breaking free of their biologically determined limits" (Harari, [2011] 2015, p. 445). For one hand, specialization make us blind and dependent on other experts whose knowledge is also limited to a tiny field of expertise. For the other, postmodern generalizations can be problematic in their superficial approach to different fields. Considers Harari, "the human collective knows far more today than did the ancient bands. But at the individual level, ancient foragers were the most knowledgeable and skillful people in history" (Harari, [2011] 2015, p. 55). It seems that with modern societies and their mathematical language previous "free association and holistic thought" gave away to "compartmentalization and bureaucracy" (Harari, [2011] 2015, p. 146). As "biology is willing to tolerate a very wide spectrum of possibilities. It is culture that obliges people to realize some possibilities while forbidding others" (Harari, [2011] 2015, p. 164). Culture can erase and close systems of thought at a faster pace, biology is slow. For that purpose, humans need to be aware of the impact of their behaviors and cultural choices. The modern age, according to Harari, "witnessed the rise of a number of new natural-law religions, such as liberalism, Communism, capitalism, nationalism and Nazism (Harari, [2011] 2015, p. 254). Like in Béla Tar's movie, *Werckmeister Harmonies* (Tarr, 2000), subjects wander the apocalyptic atmosphere of streets, during the communist Hungarian era, in a melancholy of resistance, showing the journey of helpless citizens as a dark circus comes to town destabilizing their lives and generating irrational fears that promote mysterious revolutions.

In reacting against the excesses and inadequacies of modernity, postmodernism proves to be contrary to the modern representation of the subject and insists on proposing a plurality of subjects living in a world that does not value change, relegated to the category of permanence, living in a world that values the conservation of what exists, without believing in utopias and ideologies. The postmodern subject will perhaps be the *Man without Qualities* who had a father full of qualities and who lives skeptical and distrustful before any great patriotic action in which the consciousness of its mediocrity looks for ghost's in a dead world. Ulrich, the main character of the above quoted book, wanders incredulously in a space where science laughed in a sneaky way (Musil, n.d., p. 368). In a distraction typical of those who

preach "the error to the truth, the shadow to the prey, and even the lie to the true" (Leenhardt, 1988, p. 123). The movie *A Ghost Story* (Lowery, 2017) could be a good example of this phantasmagoric wandering around nothingness.

MAIN FOCUS OF THE CHAPTER

The Digital Plenitude in Playful Transmedia Contemporary Environments

The desecration of art, "we must spit upon the altar of art every day," said Marinetti in the Futurist Manifesto of 1909, was after all a criticism, produced in the context of an elite art seen and understood by specialists who legitimized at that time artistic discourse. This strategy is also recurrent and resurface in postmodernity. By adopting a conception of the world in which everything is valid, we open the way to emptiness and meaninglessness. Postmodernity or inconclusive modernity (Fiz, 1986, p. 294) was not in a sense relegated to the category of appendage of modernism? Or, in other words, postmodernism, as a decadence of the modernist period, was not responsible for a certain resistance of the contemporary art world in adopting new media arts? Those arts that merge the digital revolution of the nineties and Toffler's Third Wave theories with both modern and postmodern sensibilities? That is precisely what we propose to discuss in the context of this chapter.

According to Jay David Bolter in his book *The Digital Plenitude: The Decline of Elite Culture and the Rise of New Media* (The MIT Press, 2019) two major developments in the second half of the twentieth century helped shape today's media culture. On one hand we find "the rise of digital media: websites, video games, social media, and mobile applications, as well as all the remediations of film, television, radio and print that now appear in digital form." On the other, the author suggests, we lost "our collective belief in what we might call Culture with a capital C." For Bolter, since the fifties of the twenty century we start to develop a suspicion about "traditional hierarchies in the visual arts, literature, and music" and this was "accompanied by a decline in the status of the humanities – literary studies in particular, but also history and philosophy." The above quoted author tells us: "This is an open secret: we all know implicitly that it has happened, but seem unwilling to acknowledge the consequences. We know that the words "art" and "culture" do not have the significance that they had a few decades ago. We can no longer assert with confidence that one form of art is better than another: that classical music is better than rap, that the novel is a better form of expression than the graphic novel, or that film is a more profound medium than video games" (Bolter, 2019, loc. 178 and 199 of 4599: kindle).

In our contemporary world we can no longer assume that there is a center and a unified culture. In this context arts became less easy to organize and structure in a coherent way. Instead of a unified group of media, with the introduction of digital technologies, we find a diversity of formats and sensibilities that merge modern and postmodern ideas in multiple platforms. Digital technologies are part of a vast media ecology that merges analogue and digital spaces, the physical and the virtual are no longer separate, and, as we state elsewhere (Gouveia, 2018b), our contemporary worlds are full of transmedia projects where artists propose a mixture of strategies to convey their messages.

Still according to Bolter, "the condition of media culture today is a plenitude – a universe of products (websites, video games, blogs, books, films, television and radio programs, magazines, and so on) and practices (the making of all these products together with their remixing, sharing, and critiquing) so vast, varied, and dynamic that is not comprehensible as a whole. The plenitude easily accommodates, indeed swallows up, the contradictory forces of high and popular culture, old and new media, conservative and radical social views. It is not only the size of our data universe that makes it a plenitude, but also its complexity in relation to our ability to access and assimilate it" (Bolter, 2019, position 306 from 4599). In a response to the complexity of Big Data systems and their opacity simplifications and readings are necessary to avoid manipulation. Suggests Lovink, "(…) We need to design for freedom, a freedom that actively undermines the technological pressures to lead a predictable life. If this does not occur, we may find ourselves living under a regime of social credit" (Lovink, 2019, p. 40).

For Wendy Chun in her book *Updating to Remain the Same, Habitual New Media*, "new media erode the distinction between the revolutionary and the conventional, public and private, work and leisure, fascinating and boring, hype and reality, amateur and professional, democracy and trolling" (Chun, 2017, p. 12), merging what we should not merge in a "combination of gossip with politics" (Chun, 2017, p.13) that blur distinctions to hide the postindustrial neoliberal economy and its capacity to generate crises and explore fear. Arts based research might help avoid manipulation in general and it can also expose fragile human conditions and promote ethical behaviors. It can open an uncharted territory of connections and processes which are no longer supported by a single route. Art loses its capital A and give rise to many forms of making arts.

Art, for Bolter, also loses its capital A with the decline of elite modernism and with it the losing of a certain "shared belief in the centrality of art and literature and their power to redeem culture, a conviction of both romanticism and modernism" (Bolter, 2019, loc. 380 of 4599: kindle). Thus, during the last half of the twenty century we assist, as Bolter states, to a rise in popular modernism discourse, a type of mixture between Bauhaus design, Rock culture and Marshall McLuhan (1936-

80) ideas on medium/media specificity and centrality. The rhetoric of popular modernism (Bolter, 2019, loc. 550 of 4599: kindle) is still alive today and defines our contemporary media culture in the twenty first century. The essence of the medium and art specificity was part of the twenty-century mantra and both concepts assert the artist as central to the society progression.

The Dada movement attempt to create an anti-art, which turns itself into a certain kind of art, is still alive in new media and digital arts discourses at the end of the nineties. If Dada movement still took art seriously new media artists did the same when they position themselves against the contemporary art system. Counter and disruptive powers of the same type where well alive during the nineties in Net.Art, ROM art, software art, systems art, game art, generative art, among other possible designations. A common trend in gaming and playful strategies (Gouveia, 2019; cf. also 2018a) seems to connect this movements but interaction opened for new experiences of participation and connection. If remix is a response to the aim of original statements from previous romantic and modern movements it is also a critique of earlier media as "parochial, limited and hierarchical especially because of the absence of participation." (Bolter, 2019, loc. 596 of 4599: kindle) Following Bolter, "the modernism of the twenty century was the cultural matrix not only for extraordinary art, architecture, music, and film, but also for the extreme politics of fascism. Popular modernism today gives us not only remix and video games, but also the sort of popular fascism that goes under the name of populism." (Bolter, 2019, loc. 636 of 4599: kindle) Thus, popular modernism is a form of decadence of both modernism and postmodernism and its massive dissemination happens in a moment where the core ideas of the avant-garde and popular modernism are fading.

We live in a world where both fragments of modernism and post modernism coexist in a myriad of shapes but perhaps, we are about to embrace the concept of plasticity as a more comprehensive and integrated way of thinking about the world. The noun and the adjective plastic mean both to model. The adjective means, on the one hand, something susceptible to change form, malleable - clay, earth - by another that has the power to give shape - as the fine arts or plastic surgery. Both meanings designate the character of what is plastic, that is, what is susceptible of receiving and giving form. Plasticity is, for Catherine Malabou, the domain of art, the art of modeling the sculptor. Fine arts have as their purpose the elaboration of forms. In this context, we find architecture, design and painting but also, by extension, a plasticity that designates aptitude for training in general, for modeling by culture and education. We talk about the newborn's plasticity, about the plasticity of the child's behavior. Plasticity also characterizes flexibility, malleability (brain plasticity) and an organism's ability to evolve and adapt (Malabou, 2000). This concept also explains the regenerative capacity that organisms exhibit when exposed to the accident. Plastic matter is a synthetic material capable of assimilating different forms and properties

according to the uses for which it is intended. The plasticity of the term leads us to extremes, to a sensitive fissure which is the taking of form (the sculpture) and denial of any form (the explosive).

Plasticity can be a fundamental concept for framing contemporary arts and its practices in a time of convergence and connection. Through the articulation of traditional fine arts, as sculptor and painting, but also photography, cinema, television, music and radio, with new media the relationship between analog and digital spaces merge. In a transmedia dialogue we can promote a convergence of spaces where galleries and museums coexist with internet and the world wide web. If transmedia practices are characterized by the process of creating a fictional world using any disposable media to convey and express concepts through forms it can be useful to understand what is going on in our present days. These days artists create sculptures with real life video projections or paintings generated from digital software, among many other possibilities, and this allow us to broaden the discussion around media specificity and to place the emphasis on the discourses and languages created. At the second decade of the twenty first century we can consider that, finally, contemporary arts have become transmedia environments where artists use various means and media to summon their ideas and concepts about the world in which we live, where artists merge with scientists and people from other fields to create shared views and projects, to create a future where humans can survive. Only plasticity can emphasize habits and memory to overcome creepy new media and combat exhaustion (Chun, 2017, p. 17) because we all became characters in a drama called Big Data (Chun, 2017, p. 23). Crises are moments that demand real-time responses and decisions and new media became crisis machines where we interact more and more in a playful way without any conscience of the reward system implicit in it. Users or players decisions became like actions in a videogame where we can test reality at our own pace.

Arts based research in education is fundamental to generate transmedia development in terms of content creation, production and dissemination. Arts based research is instrumental to increment critical thinking and problem-based creation and solving. Arts based research is the territory of plasticity. In a 2018 report about education in USA universities and colleges authors instigate educators to promote an integration of disciplines to avoid the specialization "disease" and to overcome popular modernist trends, namely, a fascination with the "new" and a disdain of tradition merged with the breakdown of hierarchy and a focus in technology and style. According to this report, "an important trend in higher education: efforts to return to—or in some cases to preserve—a more integrative model of higher education that (…) will better prepare students [in future] for work, life, and citizenship" (Skorton & Bear, 2018, p. 10). Proponents of this study propose a model of integrative knowledge where both new and old strategies of education are present. Thus, "it is

old in that it is rooted in a long-standing tradition of integration in education. It is new in the way it *intentionally* seeks to integrate knowledge to meet the challenges and opportunities of the twenty first century." (Skorton & Bear, 2018, p. 10) Besides universities and colleges, museums also seek integration and inclusive strategies to engage their visitors.

Nowadays, museology focus in interculturalism as a type of dialogue and interaction to create social cohesion and identification between cultural communities. It reinforces "the importance of shared space, education, arts and cultural programming, illuminating aspects of shared history, culture and identity" (Quinn, 2017, p. 21). Facing and addressing problems such as racism, poverty or discrimination, museum exhibitions are currently often organized by "thematic rather than ethnographic lines and concentrate on exploring elements of cultural exchange and similarities between cultural communities or they explore the impact of a particular theme in a range of different cultural communities" (Quinn, 2017, p. 24). The intercultural museum practice is committed to impact social justice and to generate activism and it is miles away of romantic ideas about autonomy and authenticity. We can consider interculturalism as the movement in the identities of groups and individuals towards hybrid and multiple identities, a generalized feature of globalized urban spaces (Oliveira, 2017, p. 20). Thus, interculturalism seems nowadays to be the institutional framework language disseminated worldwide.

In the exhibition *Playmode* at MAAT Museum in Lisbon (2019), co-curated by the author of this chapter, the aim of the artwork's selection was to research the use of gaming and playful concepts in contemporary arts. For that purpose, the authors selected a group of works that inquire the above-mentioned concepts without any concern about media specificity. In this selection the aim was to mix several artworks in a dialogue about the impact of gaming and play in our society in a transmedia manner, to tell viewers/players a story about the ludification of our present culture and society. As the authors of the book *Practicable, From Participation to interaction in Contemporary Art*, the curators wanted to go back "to the mainstays of contemporary art from the 1950s to the present, examining artistic practices that integrate the most forward-looking technologies, disregarding the false division between artworks that are technologically mediated and those that are not. *Practicable* proposes a historical framework to examine art movements and tendencies that incorporate participatory strategies, drawing on the perspectives of the humanities and sciences." (Bianchini & Verhagen, 2016, book presentation). The curators of *Playmode* also wanted this approach when they created and developed the project for MAAT Museum in Lisbon.

Though we believe new media art is far from integrated in the Portuguese mainstream artworld, as stated in the exhibition publication (Gouveia, 2019), the curators also believed we can no longer sustain this division between new and old

media in practicable and conceptual terms for other purposes besides historical archives. In future we can present an exhibition about the impact of the digital revolution in Portuguese arts, or elsewhere since the final decades of the twenty century. This division could be useful for historical purposes, but the exhibition should focus on the impact of digital technologies in a broader sense, besides media specificity. In these terms we would consider performances, interactive and kinetic sculptures, films, gaming, among many other possibilities. We probably will choose a group of artists who were underrepresented in Portuguese museums and that's something we still should consider in historical terms, but that exhibition should organize itself around works from different media and emphasize stories, myths and narratives from that period where internet was new, because these days we are living in a world where the internet is not anymore a new medium but a mass medium. We should think about the legacy of net.art but these days artists respond to social media and face a democratization of creativity without precedents. Art worlds demonstrated few tolerance and patience for practices that live outside the lines of its own dialogue but the "future of net.art would be the dispersion of the category's legacy into a wide range of practices: open-source sharing, gallery installations, live performances, cinema screenings, talks, and publications." (Cornell & Halter, 2015: xviii) Diversity of supports and media, a storytelling and marketability capacity joined digital vernacular expressions and pop culture language with amateurism and low-fi aesthetics. That's where we are now.

Cory Archangel's *Super Mario Clouds*, Seth Price's PDF "Dispersion", to mention just a few art works, present in explicit ways the rich multi-platform approach that became the dominant paradigm in the current century. For Price, in his text "Dispersion", art is like a professional field like science in its dependence of refereed forums and journals (Price, 2015, p. 52). The artist criticizes the administrative tendency or deep malaise of the dead archive praising the popular one and defending "market mechanisms of circulation, distribution, and dissemination" which "become a crucial part of the work, distinguishing such a practice from the liberal-bourgeois model of production, which operates under the notion that cultural doings somehow take place above the marketplace" (Price, 2015, pp. 54-55). A good example of this trend is the "famous new media artist" Jeremy Bailey, who "offers hilarious parodies about new media vocabularies" (Olson, n. d., Bailey website intro) and present in a playful way his multiple personas.

As Seth Price suggests, in the above quoted text, in the last thirty years we have seen a transformation in arts where expanded fields emerged even though the ambiguity and stubbornness of contemporary modern and postmodern mindset tried to avoid it. Contemporary identities are fluid and dynamic and artists use nowadays irony and critical thinking in playful ways which sometimes are hard to grasp. Maybe the difficulties that *The Guardian* critic, Adrian Searle, found in Hito Steyerl's last

exhibition at Serpentine Gallery in London are just an example of the aesthetics of transmedia practices of our time. In his review for the above-mentioned newspaper of Steyerl's exhibition he considers "that much of the experience is meant to be horrible" as Hito Steyerl purposely remixes a complicated splicing of fact and fantasy, social reality and grim futurology," and, in doing so, "Steyerl sucks us in. But don't get too seduced, she seems to be saying. Along with the fun stuff and the pretty flowers in the gallery, life for many people is hell. Hear their voices, walk with them." (Searle, 2019, online) As we stated elsewhere "For some people, the global network or the interconnection of black boxes has created their only chance of gaining a voice, but maybe we prefer not to hear them. (…) These people scream too loud and they speak foreign languages. They are scary, like the boogeyman. They have the tools and they know how to use them. Like hackers and gamers, we cannot control them anymore" (Gouveia, 2018a, p.109). Interconnected sandboxes replace white cubes (the gallery and the museum) and black boxes (the screen and its windows) and opened the path for do-it-yourself (DIY) or do-it-with-others (DIO) synergies, kits of possibilities "where each person can freely build ideas and concepts, imprinting their prototypes with ideologies or critical world views. It's up to each one of us to judge, with our own battery of ideology, if we are going to be on one side or the other. White or Dark Internet? White or Black Google? Mainstream or Indie? Which pill are you going to take? Our matrix of possible choices is not as real as it seems to be" (Gouveia, 2018a, p. 109).

According to Bolter, "identity politics during recent decades could be a kind of collective narcissism, in which each group is encouraged to interpret the political and social universe as a reflection of its own identity." (Bolter, 2019, loc. 3123 of 4599: kindle) Intercultural exhibitions currently are often organized by "thematic rather than ethnographic lines and concentrate on exploring elements of cultural exchange and similarities between cultural communities or they explore the impact of a particular theme in a range of different cultural communities." (Quinn, 2017, p. 24) As we considered previously in this chapter the intercultural museum practice is committed to impact social justice and to generate activism and it is miles away of romantic ideas about autonomy and authenticity, which can help promote dialogues among different cultures and communities. Museums and galleries can explore elements of cultural exchange and similarities between cultural communities using a thematic approach or they can explore the impact of one theme in a range of different cultural communities. Polish artist Artur Żmijewski (born 1966 in Poland) is a photographer and filmmaker who make workshops where he asks people with different cultural and religious background to interact for some days. His work, according to The Swedish History Museum website, where we had the opportunity of seeing Żmijewski video *Them* (*Single-channel video, 26 min 30 sec, colour, sound,* 2007) in 2017, "often deals with existential traumas in society and

individuals, especially in relation to historic events. He often stages situations with groups of people and documents how they react and interact with each other." In this context, "Them is a film documenting an experiment for which Żmijewski convinces representatives of four organizations, all in the public eye of contemporary Poland, to participate in a seven-day workshop to negotiate their disparate, if not opposing, beliefs and political convictions. Each of these factions has secured a reputation as an ideologically uncompromising political group. Members of the neo-nationalist Union of Polish Youth, elderly women representing fundamentalist Catholics, Jewish youth, and left-wing activists of a younger generation each formulate their respective viewpoints through creating a symbol for their ideologies and paint it on a large sheet of paper. They agree to react to each other's creations initially with comments and critiques which soon turn into physical interventions, leading participants to alter each other's work by painting over, cutting into and burning it. These actions escalate gradually, with a sense of inevitability, into an open confrontation." (The Swedish History Museum website, 2017, online) The Swedish History Museum works with artists in a dynamic manner to inspire renewal perspectives on history and culture. The intercultural museum could be instrumental to increment and solidify democracies around the globe.

Digital media and its procedural culture contrasts with mechanization as it enhances and develops a certain kind of measurement science where big data rules. It also uses gaming parametrization as a way of procedural thinking. Gamers and artists no longer care about final statements or coherent narratives, instead they invest in processes and they want to raise questions and awareness about the world we are living. But not all gamers and artists think in this way and controversies about racism, sexist, among others, are common these days. Democracies seem to be in danger of losing their power and freedom is never guaranteed. Totalitarian regimes gave rise to democracies but also democracies developed into totalitarian regimes, which is scary because the current political democratic scenario in western countries might offer us dystopias as millenniums with no historical knowledge despise utopias and the great narratives of the past.

ISSUES, CONTROVERSIES, PROBLEMS

The Dangers of a Playful World

Simulation systems are based on procedural rules meaning that the system has a cybernetic mechanism of inputs and outputs, we do something, and the system responds to our actions accordingly. In this feedback loop we are rewarded, and our dopamine levels can increase. Interactivity is not only about possible open

interpretations, as in films, but also mainly responsive. We interact therefore we are. Then we have the possibility of replay the sequence with newer actions in mind. We can replay a movie to see if we can think about other possible interpretations, but the movie will remain similar each time we see it. It won't change. On the contrary, an interactive installation, an interactive video or game can give us a different sequence each time we interact with it and we can test many different things and possibilities. With open simulations we can create a new environment each time we interact, and we can connect with several people around the world. It opens borders and create synergies. For some people that means liberty to create their own content and to interact with others freely. For other people that can be a territory of oppression where they lose their leading figures. When everybody is creating content, no one rules, and no one is the center. When we cross this tendency of collaborative creation and diluted authorship with anonymous undefined intentions, we can find constructive and destructive examples. We can find Guerrilla Girls performances with the aim of exposing "gender and ethnic bias as well as corruption in politics, art, film, and pop culture" (Guerrilla Girls Website, n. d.) or we can observe 2014 gamer Gate controversies where journalists and game designers where persecuted because they uncovered sexist behavior among gaming communities. Contemporary arts have also a lifelong tradition of sexism, as the collective of artists Guerrilla Girls reported recurrently, but to persecute people without any foundation belongs to dictatorial movements that we must pursue if we want to consolidate democracies and preserve our freedom.

FUTURE RESEARCH DIRECTIONS

An understanding of modern and postmodern legacies in digital contemporary culture is fundamental to generate critical thinking about the world we are living and to understand our current contemporary arts global scenario. Our aim is to develop a transmedia approach to design future museum exhibition concepts, organized by themes, in an intercultural manner. We also would like to apply the same principles to higher education curricula to generate integrated knowledge and expertise. An arts-based research approach can be instrumental to both areas (museology and higher education) as in itself merge a capacity to create and identify problems (artistical skills) with a design approach (design skills) to solve these problems. An artistical approach should question the time we are living and generate critical debates following this exploratory methodology with a capacity to design possible solutions for the identified problems.

CONCLUSION

Our main goal in this chapter was to inquire modern and postmodern legacies in transmedia contemporary culture and to show how these legacies, although sometimes contradictory and paradoxical, are still present today in our contemporary arts culture. Even though they are losing their impact as separate forces they emerge in an integrative model in transmedia practices. The transition to a different paradigm, defined by globalization and interculturalism, hybridism and openness to dialogue, roaming and nomadism, which has been going on for more than 20 years, begins, in the second decade of the twenty-first century, to gain impact. We still find many of the trends present in last century discourses but, as we stated previously in this chapter introduction, at the end of the second decade of the XXI century we can no longer consider that contemporary arts are not playful transmedia environments where artists use several media to convey their ideas and concepts about the world we are living. Postmodernist digital revolution with its procedural arts, simulation systems, appreciation of tradition merged with new age tendencies and technologies have finally a space merged with contemporary arts. The internet is now an online mass medium and, unlike the real world, it is borderless.

REFERENCES

Antos, Z., Fromm, A. & Golding, V. (Eds.). (2017). Museums and Innovations. Cambridge Scholars Publishing.

Bianchini, S., & Verhagen, E. (Eds.). (2016). Practicable, From Participation to interaction in Contemporary Art. Cambridge, MA: MIT Press.

Bolter, J. D. (2019). *The Digital Plenitude: The Decline of Elite Culture and the Rise of New Media*. MIT Press. doi:10.7551/mitpress/9440.001.0001

Cecchetto, D. (2011). *Deconstructing affect: Posthumanism and Mark Hansen's media theory*. OCAD University Open Research Repository Faculty of Liberal Arts & Sciences. Retrieved August 24, 2019, from https://journals.sagepub.com/doi/abs/10.1177/0263276411411589

Chun, W. (2017). *Updating to Remain the Same, Habitual New Media*. MIT Press.

Coeckelbergh, M. (2020). *The Postdigital in Pandemic Times: a Comment on the Covid-19 Crisis and its Political Epistemologies*. Academic Press.

Cornell, L., & Halter, E. (Eds.). (2015). Mass Effect, Art and the Internet in the Twenty-First Century. Critical Anthologies in Art and Culture, The New Museum, NY.

Coyne, R. (2001). *Technoromanticism, digital narrative, holism, and the romance of the real* (2nd ed.). MIT Press.

Cramer, F. (2019). *What is Autonomy? From art to Brexit to Tesla Cars*. Academic Press.

Fiz, S. M. (1986). Del Arte Objectual al Arte de Concepto – Epílogo sobre la sensibilidad "Postmoderna". Madrid: Akal.

Gouveia, P. (2009). Narrative paradox and the design of alternate reality games (ARGs) and blogs. *IEEE Consumer Electronics Society's Games Innovation Conference 2009 (ICE-GIC 09) Proceedings*, 231-38. 10.1109/ICEGIC.2009.5293585

Gouveia, P. (2010). Artes e Jogos Digitais, Estética e Design da Experiência Lúdica. Universitárias Lusófonas.

Gouveia, P. (2016). Gaming and VR Technologies, Powers and Discontents. Videojogos'16 Proceedings.

Gouveia, P. (2018a). From black boxes to sand boxes, disruptive processes in gaming culture. In From Bits to Paper. Art Book Magazine.

Gouveia, P. (2018b). Transmedia experiences that blur the boundaries between the real and the fictional world. In Trends, Experiences, and Perspectives on Immersive Multimedia Experience and Augmented Reality. IGI Global.

Gouveia, P. (2019). Play and games for a resistance culture. In *Playmode Exhibition Publication* (pp. 8–27). MAAT, Fundação EDP.

Guerrilla Girls. (n.d.). Retrieved May 5, 2019, from, https://www.guerrillagirls.com/

Harari, Y. N. (2015). Sapiens, A Brief History of Humankind. Penguin Random House.

Hayles, N. K. (1999). *How we became posthuman*. The University of Chicago Press. doi:10.7208/chicago/9780226321394.001.0001

Hayles, N. K. (2001). The Condition of Virtuality. In P. Lunenfeld (Ed.), *The Digital Dialectic* (3rd ed.). MIT Press.

Hayles, N. K. (2002). *Writing Machines*. MIT Press. doi:10.7551/mitpress/7328.001.0001

Johnson, S. (2004). *Emergence, the connected lives of ants, brains, cities, and software*. Scribner.

Lange, M., Raessens, J., Mul, J., Frissen, V., & Lammes, S. (Eds.). (2015). Playful Identities, The Ludification of Digital Media Cultures. Amsterdam University Press.

Lanier, J. (2017). *Dawn of the New Everything a Journey Through Virtual Reality.* The Bodley Head.

Leenhardt, J. (1988). A Querela dos Modernos e dos Pós-Modernos. In Moderno e Pós-Moderno. Revista de Comunicação e Linguagens, Edição do Centro de Estudos de Comunicação e Linguagens (CECL).

Lialina, O., & Espenschied, D. (2009). *Digital Folklore, to Computer Users with Love and Respect.* Retrieved May 2, 2019, https://digitalfolklore.org/

Lovink, G. (2008). *Zero Comments: Blogging and Critical Internet Culture.* Routledge. doi:10.14361/9783839408049

Lovink, G. (2019). *Sad by Design, On Platform Nihilismo.* Pluto Press. doi:10.2307/j. ctvg8p6dv

Lowery. (2017). *A Ghost Story.* Werckmeister Harmonies.

Maffesoli, M. (2001). *Sobre o Nomadismo, Vagabundagens Pós-modernas.* Editora Record.

Malabou, C. (2000). *Plasticité.* Paros, Editions Léo Scheer Beau.

Morin, E. (n.d.). *As Grandes Questões do Nosso Tempo.* Lisboa: Edições Notícias.

Musil, R. (n.d.). *O Homem Sem Qualidades.* Lisboa: Edições Livros do Brasil.

Oliveira, N. (2017). *Do multiculturalismo ao interculturalismo. Um novo modo de incorporação da diversidade cultural?* Academic Press.

Price, S. (2015). Dispersion. In Mass Effect, Art and the Internet in the Twenty-First Century. The New Museum.

Quaranta, D. (2018). Art numerique: un art contemporain. In *Les presses du réel.* Espace multimédia Gantner.

Quinn, M. (2017). Intercultural Museum Practice: An Analysis of the of the Belonging Project in Northern Ireland. In Museums and Innovations. Cambridge Scholars Publishing.

Ribeiro, A. S. (1988). Para uma Arqueologia do Pós-Modernismo: A "Viena 1900". In Moderno e Pós-Moderno. Revista de Comunicação e Linguagens, Edição do Centro de Estudos de Comunicação e Linguagens (CECL).

Roush, P. (2010). From Webcamming to Social Life-Logging: Intimate Performance in the Surveillant-Sousveillant Space. In O. Remes & P. Skelton (Eds.), *Conspiracy Dwellings, Surveillance in Contemporary Art* (pp. 113–128). Cambridge Scholars Publishing.

Searl, A. (2019). *Much of the experience is meant to be horrible': Hito Steyerl review*. Academic Press.

Skorton, D., & Bear, A. (Eds.). (2018). The Integration of the Humanities and Arts with Sciences, Engineering, and Medicine in Higher Education: Branches from the Same Tree. Washington, DC: The National Academies Press.

Slater, J. (2015). Post-Net Aesthetics Conversation, London, 2013: Part 3 of 3. In L. Cornell & E. Halter (Eds.), *Mass Effect: Art and the Internet in the Twenty-First Century*. Cambridge, MA: The MIT Press.

Sloterdijk, P. (2011). *Crítica da Razão Cínica*. Edições Relógio de D'Água Editores.

The Swedish History Museum. (2017). Retrieved May 5, 2019, from, https://historiska.se/history-unfolds-en/artists/artur-zmijewski-2/

Vavakova, B. (1988). Lógica Cultural da Pós-Modernidade. In Moderno e Pós-Moderno. Revista de Comunicação e Linguagens, Edição do Centro de Estudos de Comunicação e Linguagens (CECL).

Voon, C. (2015). *Faced With Digital Ubiquity, Artists Still Cherish Crafting Materials*. Academic Press.

Chapter 3
Software–Based Media Art:
From the Artistic Exhibition to the Conservation Models

Celia Soares

https://orcid.org/0000-0002-3439-6416

University Institute of Maia (ISMAI), Portugal & Polytechnic Institute of Maia (IPMAIA), Portugal

Emília Simão

https://orcid.org/0000-0003-2746-8925

Escola Superior Gallaecia, Portugal & Portuguese Catholic University, Portugal

ABSTRACT

This chapter illustrates the reaction to the preservation and conservation of software-based media art and summarizes the crucial ideas and questions that involve this emergent area of conservation. The chapter analyzes the role in which conservators explore the impact of the method, attitudes to change, technology obsolescence, and the influence of the how the artist imagines and understands their practice on the conservation of these works as they enter the exhibition space. In addressing the conservation of software-based media art, this chapter highlights the variety of knowledge and expertise required: expertise that is personified in the teamwork of those who support these functions. The author completes the chapter by recommending that developing and maintaining these efforts has become a crucial part of the software-based media conservator's role.

DOI: 10.4018/978-1-7998-3669-8.ch003

INTRODUCTION

Usually, software-based media artworks integrate the experimentation of art through contemplation over time, according to the temporal logic of the medium in which it is reproduced. These days, many artists are employing laptops and keyboards, creating works with mouse clicks and code lines instead of brushes, paint, clay and other traditional materials associated with artistic creation. Some of those creations are called "time-based media art," which describes works that occur over time, such as film, video, or computer-based art.

This approach forces museums and art galleries to study new ways to conserve and preserve the work for these artists. The challenge occurs forced by the rapid changes in technology and it takes an entire team to tackle the long-term preservation plan for software-based artworks.

The digital art preservation and conservation has a double approach among the main players: documentation and technology preservation. Documentation intend as an extended document anthologies, compilations and it expands the artwork contextualization, trying to improve and ensure efficient access to entire work. All the reports are important and based on it and it is possible to ensure the persistence of objects over the time.

Technology preservation forces us to think of two distinct but complementary areas that cannot be dissociated: we need to preserve the support (medium) but we also need to preserve digital content, this means that both must be viewed in the same way and granted its future existence. For many years museums seams to ignore this reality but finally, multidisciplinary teamwork are now starting to allow and assure that artworks stays accessible for long time regardless its origin.

It is important to make certain that components (CPU, hard drive, memory, etc) although invisible in artistic creation, do not fail. If we can think in the pass that one CD or DVD may be used to data storage, the technology obsolescence alerts for volatility and remember us that we cannot be stuck on a support.

Meanwhile computer technology continued to advance, languages like HTML5, Python Processing, JavaScript, C#, XML and Perl are in use and allow us to interact with development libraries and environments. Operating systems evolved, database formats are changing every day and the data access is now distributed. It would be difficult to predict that an artwork (computer-based) created today would survive intact so it could be exhibited, as the creator originally constructed, in the next year or 5 or 10 years from now (Paul, 2019).

For all these reasons, it is essential to explore preservation and conservation process and think ways and models for their accomplishment.

CONSERVATION MODELS

It is extremely important begin by ensuring that software-based media art are not simply objects which involve analogue or digital media components, but that they are artworks (Laurenson, 2016). This determines where attention is directed, the ethical framework in which the work is treated, the context in which the work was created and is displayed, and also the significance of the relationship between the developer/creator and the artwork. The question 'what kind of product we are trying to preserve?' is essential to conservation subject and our capability to answer to that question for specific software-based media works depends on understanding: the importance of the hardware and the media; the importance of the software system; the mindsets to change; the impact of obsolescence on the artifacts; the influence on conservation of an artist's practice and the knowledge required to produce the artwork.

The preservation forces to think about a long-term strategy, for this reason some museums have outlined some scenarios for defining work teams. There are four main models that are gain preeminence to describe how the software-based media art preservation needs are dealt with. The first model is based on a specialist conservation department, where conservators are specifically hired to assume the timed-based media artworks conservation. In the second model, the curators retain the responsibility for software-based media artworks conservation. The third model is considered a cross-disciplinary model, where an internal team responds collaboratively to the software-based media artworks needs including, conservators, representatives, and freelance specialist. And finally, in the fourth model, an external entity operates with a group of museums to support the software-based artworks.

In common these models have curators, conservators, and collection managers working collaboratively with specialists (technicians and artists) (Tanner & Huang, 2019).

The role played by the conservator-restorer when working with software-based media art is similar to other artworks, the major difference is the type of knowledge required.

The activity of the conservator-restorer (conservation) consists in technical examination, preservation, and conservation-restoration of cultural property (ICMCC, 1984). The examination process is the preliminary procedure taken to determine the documentary significance of an artwork, original structure and materials, the extent of its deterioration, alteration, and loss, and also the documentation of these findings. In this case, software-based media art is important to verify the artwork as one and the different layers must be examined.

Preservation is the action taken to retard or prevent depreciation of/or destruction to cultural properties by control of their environment and/or treatment of their structure

to maintain them as nearly as possible in an unchanging state. When preserving software-based artwork, it is crucial to predict obsolescence of technological equipment and take the necessary measures.

Restoration is an action taken to make a deteriorated or damaged artifact understandable, with minimal sacrifice of aesthetic and historic integrity. In this case is especially important avoid artwork losses.

Conservators are persuaded to look for consequences in the technology used, programming language, and artist's coding style to determine conservation and preservation strategies. In contrast, programmers judge code primarily by its quality. For instance, programmers will often judge code by its sophistication (whether it is well written), whether it is concise (as opposed to verbose), whether it makes best use of the hardware it is intended to run on, and whether the code is clearly written and appropriately annotated, with good documentation. In computer programming, will often conduct code reviews to evaluate and assess the quality of code while it is under development and upon completion to assist programmers and to give feedback. This is like having an editor to review a manuscript before publication.

When software developers have to do a code intervention to treat obsolete or nonoperational code, their prime criterion in choosing a technology or programming language is not certainly its long-term sustainability or correspondence to the original code or language, but the ability of the technology to offer a smooth and efficient performance of the desired functions within a realistic development timeframe (Engel & Phillips, 2019).

Different programming languages are planned and considered to serve distinct purposes and support distinct functionalities, the quantitative and qualitative efficiency of expression can be elevated in one language over another. For software-based artwork examinations in this research, computer scientists and software developers had to understand, to interpret and evaluate code all the way through a conservator's eyes, i.e. to respect the unique style and character of the code as it was conceived and imagined by the artist, no matter the quality of the code itself. Programmers collaborating with conservators on the treatment of this software-based artwork had to be reassured that they would not be judged mostly by the quality, programming elegance and efficiency of the finished renovation code according to external standards of the art world. Instead, by their ability to understand and treat an artwork in a way that is respectful of and realistic and authentic to its original characteristics, i.e. not just in regard to obvious behaviors of the work, but to its basic technologies.

DIGITAL ART CONSERVATION

In museums and art galleries, there are four key moments that can be singled out: acquisition, display (and the related maintenance processes), storage and intervention (Falcão, 2019). The main problem resides when the artwork becomes obsolete, not the artwork itself, which is timeless, but the technology that supports it.

When a museum gets a digital artwork, it is assumed that it will be presented with no further improvements. This work and its theoretical and technological foundations are now preserved in time. In effect, it is a legacy system and we do not expect upgrades.

From a software engineer perspective, legacy systems are studied to be acknowledging that the human factor is essential to the system's function (Ransom, Sommerville & Warren, 1998). The components of a legacy system may be projected as a pile of encapsulated layers, with each layer depending on the layer immediately below for its resources and interacting with that layer. The top layer is the experience, which directly attracts the viewer and is responsible for calling the visitor's attention. In bottom is the software artistic itself, that causes this experience. The artistic layer relies on the services supplied by the support software layer to run (e.g. operating system, database, networking protocols, etc.). And the physical layer (hardware) provides all the components required by the layers above (e.g. CPU, video card, sound card, network adapter, sensors, etc.). In theory its possible to replace one layer without interfere with another layer. In practice, this process rarely succeeds. One simple change requires subsequent modifications and with hardware changeability, many modifications are required even on artistic layer.

These questions impose the need to train professionals capable to ensuring the acting, preservation, and conservation of artistic projects. Media conservation was first formally created in 1999 at University of the Arts in Bern, Switzerland -with this formation it is possible to assure digital artwork conservation. Specific training in software-based art conservation is still not available, but some degrees now offer options to choose related subjects and are encouraging students to research in the area. Currently have a background in computer science or engineering and have then trained in conservation or learned about conservation is part of a job. Working in the context of software-based art means understanding hardware, software and the overall technical environments needed to run it, as well as aspects of display, either in the gallery or in a browser on a computer screen.

Usually there are four types of maintenance that digital artwork may go through (Nosek & Palvia, 1990): perfective maintenance, used to improve software functionality, in reaction to demanded modifications; corrective maintenance, used to correct errors, identified within the software; adaptive maintenance used to modify the software in response to adjustments within the software environment;

and preventative maintenance used to perform software updates, to improve its future maintainability without changing its requirements.

Preventative maintenance on artworks offers the possibility to convert a digital artwork into a format that will improve its maintenance and consequent longevity. The main goal is to define the artwork independent of its implementation platform, that is, to represent the artwork at a conceptual level higher than source code. Reinforce preventative maintenance have two major advantages, important to point. First, the artwork is entirely characterized and designed at an abstract level and it is completely clear what the system does and how it does, without analyzing exhaustively the source code that may be poor documented. For adaptive maintenance of an artwork, this suggests a more efficient method for understanding the function of each used component. And second, it places the conceptual model and design in a time-independent state. When the original artwork arrives to the museum, it was previously implemented in a certain technology. This placed it in a time-dependent state that decreases its ability to be adaptable to the future technology on a short or larger period, since its design and implementation become less compatible with future hi-tech innovations. In contrast, a time-independent representation can be turned into whatever technology is available that befits its implementation, because its whole structural and behavioral systems, and processing details (e.g. data structures, algorithms) are specified in a collection of statements devised for human understanding and not bound to any technological substrate, these conceptual representations of software may be transformed into functioning software employing programming languages.

The success on preventive maintenance may be related to documentation quality. The software quality not only includes source code, and data, but it also must consider system analysis, installation, and implementation documents.

This process can be applicable to conservation of timed-based artworks. The main goal of contemporary digital art conservation practice is to capture an artwork's key properties, so it may be recognized, maintained, preserved, and displayed at a future date by using an extended set of documents (Yeung, Greenberg & Carpendale, 2008).

This extended notion of artwork uniqueness is a collection of concepts and artifacts representations preventative maintenance, and is the beginning for a formal identification and documentation, using the principles and practices from reverse engineering.

Reverse engineering is a maintenance strategy in which a system is analyzed to identify its component parts, and the interrelationships among those parts for the purpose of either creating representations of the system in another form or representations at a higher level of abstraction (Chikofsky & Cross, 1990). Reverse engineering commonly involves recovering system design. Its goal as a maintenance

strategy is to capture an artwork's identity, and transform it into a maintainable collection of representations that embody its functional, design.

A strategy to preserve long-time is offered for conserving software-based digital art in timeless artworks based on software engineering practice. Software engineering is a meticulous process and formalized practice approach to preservation that involves all stakeholders, including: artists, curators, and conservators; offering a large range of methodologies and marks and steps of rigor that may be adapted by organizations of all sizes to promote a preservation strategy (Marchese, 2013).

To ensure viable preservation decisions, not only the artwork's significant properties, but also criteria for a productive long-term preservation are essential on the development strategy. This will facilitate the correlation of preservation strategies between different types of artworks (Roeck, Rechert & Noordegraaf, 2018).

Media artworks often take the form of complex installations, combining audiovisual components (software and hardware) with sculptures, objects, and photographic components, amongst others (Real, 2001). Information technologies allow introducing to the visitor/spectator those objects, stored in funds and not previously available. Information technologies in the context of the exhibition activities and in practice can provide invaluable assistance in improving the methods of presentation of museum collections (Rosa, 2015).

It is possible to divide and combine strategies to produce, maintain and preserve better efficient based-software artworks.

The stability of the software is measured in terms of its complexity, and the reduction of the changes rate. Even if on preservation of artworks no new features are usually included, it might be required to adapt the software to new hardware equipment. The more changes one software suffers, higher is the risk that problems or variations from the significant properties are launched. Preservation actions should therefore try to stabilize the software artifact and reduce its change rate.

The installation process of the artwork / of connecting peripherals, install the support hardware and configure software.

The major goal of preservation is the presentation of the artwork, the preservation is intended to extend the artwork life cycle. If the installation is very fragile or complex or if it is difficult to find the right settings to adjust it to the physical space, the risk is higher that it will not match the significant properties.

For these reasons, the ease of installation and the stability of the installation process can be considered important success factors for long-term preservation.

The adaptability to new hardware may be one essential criterion if hardware abstraction is an imperative means to facilitate future preservation actions. The more autonomous the software is from the hardware, the simpler it will be to transfer it to new hardware solution in the future. Even a successful transfer from a hardware device to a new one sometimes requires coding interventions.

Resistance to software obsolescence and adaptability to changed network protocols will be another criterion. The resilience regarding obsolescence of software applications and programming languages is consequently another important factor for the long-term preservation of software-based artworks. As any hardware transformation or adjustment can lead to a change of software requirements and configuration, preservation measures that prepare the artwork for protection it from such changes support long-term preservation. For projects web-based artworks, the independent concept of protocols is relevant to achieve more independence from changing Internet and data protocols.

The easiest maintenance and functionality tests focused on monitoring the actual state of artworks should specify the most appropriate means of continued care to use in different software-based artifacts. Maintenance is another, despite being more technical term for this, and is essential for the continuation of technology-based art, in general, the change will be such as to adapt the elements of the class so that they maintain or improve their performance to a changing environment (Madhavji, Fernandez-Ramil & Perry, 2006).

The aging process of software-based artworks is not innate in the software, but instead in the interdependencies of software with hardware and external data sources and protocols. The external environment of the software-based artwork will continue to change, even if the software artifact itself does not. When an artist conceives an artwork, it is supposed to remain immutable, this process will eventually lead to its dysfunction, if no maintenance is carried out. Maintenance process prepares the artwork to be installed at any given time without having to start a renovation project first. Through these small maintenance actions, the artwork's functionality is automatically monitored and big surprises regarding its functionality are prevented. Ease of maintenance and of function tests can be expressed in time spent on these maintenance activities each year, considering the time saved for large scale restoration work.

The scalability of preservation strategy organized as an tailor-made approach to the preservation of software-based artworks projects are expensive and consumes lots of time and resources. More generic solutions such as virtualization ore emulation are wanted to assure that all the needs are accomplished. Specific hardware requirements might avoid this approach, but some solutions might lend themselves to a more generic approach. This would facilitate their conservation, maintenance, preservation and change management documentation. Just a few emulators would have to be preserved, instead of preserving and migrating many different software environments. The emulator maintenance cost could be shared between all the artworks and in this way share all the resources.

It is possible to support the digital conservation process on the Rational Unified Process (RUP), seen as an iterative software development framework created by

the Rational Software Corporation. RUP is not a single concrete rigid process, but rather an adaptable process framework, intended to be tailored by the development organizations and software project teams that will select the elements of the process that are appropriate for their needs. It is a theoretical model that is used to both examine software's architecture and formally deconstruct it. Software architecture represents the highest-level abstraction of a software system's structure. It can be defined as the set of constructs needed to reason about the software system, comprising its component parts, the relations between them, and the properties of both components and relations.

Unified Modeling Language (UML) does not implement 4+1 view introduced by Philippe Kruchten in 1995, but the UML can be used to document all the process. It gives guidelines on what diagrams should be used for modeling what view in software development (Craig, 2011). UML specification defines two major kinds of UML diagram: structure diagrams and behavior diagrams. Structure diagrams show the static structure of the system and its parts on different abstraction and implementation levels and how they are related to each other. The elements in a structure diagram represent the meaningful concepts of a system, and may include abstract, real world and implementation concepts. These diagrams are not utilizing time related concepts, do not show the details of dynamic behavior. However, they may show relationships to the behaviors of the classifiers exhibited in the structure diagrams

Behavior diagrams show the dynamic behavior of the objects in a system, which can be described as a series of changes to the system over time.

Documentation is a fundamental component of any system. Software engineering provides a systematic methodology for creating and maintaining documentation to support communication, preservation of system and institutional memory, and processes such as system auditing.

DOCUMENTATION

Examining and documenting the physical state of an object is an important part of understanding its overall condition. The process of examination and documentation will alert conservators to any problems that need immediate or future attention. The main goal of the documentation created in software-based media conservation is to have a record of the materials that compose an artwork: the artwork's production processes, information about past and present displays and of course, any interventions that may have changed them. Software-based media conservation is still defining the best form for this information to be captured and used (Phillips, 2015).

During treatment process, the conservation professional should maintain dated documentation that includes a record or description of techniques or procedures involved, materials used and their composition, the nature and extent of all alterations, and any additional information revealed or otherwise ascertained (AIC, 1994).

Each component is important to digital system representation as a software-based artwork. Each one may operate at a different level of abstraction or within a context. The requirements, the architecture/design, the source code, the manuals and all the complementary material are components with major importance in this area.

The requirements are the statements that identify the characteristics and capabilities of a software-based artwork. This is the conceptual foundation for what has been created viewed as a system abstraction. Requirements documentation presents the conceptual view of what the system is expected to do. It is written to be understood by all the stakeholders who comprise an art museum's business practice.

The architecture is a software overview that includes the software's relationship to its environment and construction principles used in design of the software components. Usually, a system's architecture is documented as a collection of diagrams or charts that show its parts and their relations. Architecture/Design documentation operates like an architect's sketch of a building, showing all its components and how they fit together, it supposed to serve to the developer as the blueprints serves to the engineer.

The source code, the algorithms collection and interfaces are documented in the development process for the creator must be reinforce when some changes are made. Normally, comments may be embedded within the system's source code and/ or parts of external documentation.

The manuals are documents, hypermedia, training videos, installation tutorials, formation manuals, etc. used for the end-user, system administrators, and support staff. Technical documentation represents the part of the artwork, conveying information about how the artwork is constructed.

Finally, the complementary materials represent everything else related to the system. This includes legal documents, design histories, scholarly books, installation plans, drawings, models, documentary videos, websites, etc.

Further assisting an artwork's conservation this documentation could also support research, enabling art historians to understand an artist's working process and evolution of practice and even the technological evolution associated with the work. A computer system's structure reflects the conceptual space in which the artist had been working at the time the art was created.

The number of software components, their hierarchy, and the connections among them, should give an idea of how the artist viewed a representation problem, and how it was transformed into a computer system. An analysis of documentation should bring in answers to questions about authorship, educational context, skill, expertise, aesthetics, development process, technical context, and conceptual foundations.

If software is written by the artist himself or by someone recruit for that work, it is possible to check who has influenced the artist conceptually or in a way technologically. The documentation tells us the written quality of program if it was created for an experienced programmer and how well the system is designed and conceived, if it possess a sophistication and maturity comparable to any other artwork, and what were the design strategies used by the artist. Finally, in documentation it's possible to acquire what were the development tools available at the time the artwork was created, and what theories of computing did the artist use to achieve the final goal.

Conservation is an integral process of collections management aiming to preserve cultural heritage objects in the best possible condition. Object conservation procedures require detailed and accurate documentation in textual or visual records, which provide valuable information for the future researcher, curator, or conservator. Furthermore, conservation requires the awareness of cultural, historical, and scientific information from sources both internal and external which in turn influence the ways in which conservators must approach their work. This integration of different information forms the body of knowledge, relevant to thoughtful decisions on treatment and care of cultural heritage objects. Taking into consideration the diversity of conservation information and associated information sources, the integration cannot be regarded as an inconsequential task. Therefore, knowledge organization, especially in a concepts level, is necessary (Moraitou & Kavakli, 2018).

The conservation professional has a commitment to produce and maintain accurate, complete, and permanent records of examination, sampling, scientific investigation, and treatment (AIC, 1994).

It is important to recognize that there are multiple difficulty layers encountered when attempting to analyze digital objects concerning detail, but also another one to do with scale. The notion of the digital object is a pillar of everyday life in mainstream digital preservation: indeed, it is a concept that is fundamental to the way we approach this whole domain (Rinehart, 2007).

Appropriation art and post-production can benefit from the practice of documenting all intervention processes that occur during the life of a software-based artwork. The process of exploring, collecting, archiving, manipulating, and reusing huge amounts of visual material produced by popular culture and advertising (Clements, 2012). Producing new artworks based on existing artworks as started with Marcel Duchamp continues to be explored by the Internet generation including artists who continue to develop contemporary artistic processes and methodologies that include the creation of personal archives, often populated with information and parts from existing archives. The media conservators expressed a desire to include process history as part of the chain of events already attached to digital objects (Griesinger, 2016).

An algorithm source code and respective data associated are crucial documentation to the conservation process. On how much more documentation is required to provide

a sufficient representation of a digital artwork to guarantee the best conservation and preservation methodology is an important question that persists among researchers. This is an open question for any software engineering project and also digital media artist, and remains in case we want to focus on software-based artwork, dependent on factors such as project scope, difficulty, complexity and projected organization lifecycle.

It may be argued that it is not the artist's obligation and duty to provide appropriately documentation for artwork creation; but if modern curatorial practice is an signal of what the future will be distant, the following consequence is most likely to take place. Software-based artwork selection will not only be based on its importance to the museum or to the art gallery but also the availability of resources, such as human resources, time, skills, and cost required for its installation and maintenance will be an extra factor to choose the work. A software-based artwork that could be the best illustration of a theme or style must be replaced in an exhibition by a minor effort, because its specific documentation remains insufficient for its recreation. It is conceived at this time that a digital creator must shares a certain responsibility for the long-term lifecycle preservation of an artwork.

The software engineering conceptual process of analyzes design and build is consistent with artistic practice and may be used to give response to this issue. Software engineering best practices work at a distinct level. Digital media artists are able to choose alternatives like their traditional complements for maintaining their artwork's project durability. Safest practices exist for the development of computer software in different ways. For instance, the use of standard software design styles, data structures, algorithms, and the careful comments attachment into source code represent programming best practices and can be an advantage for digital artwork. The tools and instruments used by software engineers during the analysis and design phases of software development, allow software analyst plainly to sketch out a system's architectural design.

Including these design representations with a software-based artwork source code expands it figurative and representative details to include the requirements, analysis, and technical documentation categories discussed above and improve the simplicity of understanding the work.

It should provide a sufficient explanation of the software-based artwork identity as well to accept it to be reinvented at some future time if the other conservation strategies fail.

Traditional artists who use archival media and follow appropriately established best practices for creating a stable physical software-based artwork generate works with a high probability of passed the test of long-time lifecycle. For those artists who deliberately choose to work in a non-archival way, the long-term preservation and ultimate exhibition of their works is a problem with an indeterminate solution.

It should be remembered that major museums and art galleries have aesthetically significant artworks that cannot be exhibited because of their fragility or degree of deterioration.

In this context a computer system's documentation should supply comprehensive information about its capabilities, architecture, design details, features, and limitations and improves the capability to extend the life cycle of artworks.

CONCLUSION

The exhibition of contemporary digital art, software-based artworks, at some time in the future remains an open problem, the resolution key to which will come from hard work by artists, conservators, and curators. It has been recommended here that the use of software engineering practices will provide a method for transitioning from the conservation practices used for traditional art to methods more appropriate for computer-based media artworks. This process will support digital art research as well, by organizing an artwork's elements in such a way as to enhance approachability by art historiographers and researchers. Finally, digital media art creators who wish to adjust software engineering techniques to their artistic creation design process will be able to extend the duration of their artwork in time.

Software-based artwork conservation is built on the experience and best practices developed for time-based media and over the years, a growing number of museums, and not only contemporary art museums, are cooperating to share practice and assistance.

The behavior of an interactive, software-based artwork may be too complex to describe it so specifically, that the software could be replicated from it. In addition, as the source code contains a set of extended code lines, the conversion into pseudo-code and from there into a new programming language would be expensive, and the result would most probable diverge from the use of the original source code.

There is no obvious a winner formula from the above evaluation of preservation strategies mainly due to the fact, that the carried-out emulation version relies on virtualized hardware and remains computer architecture dependent, for performance reasons. These practical reasons led to the classification of the source code as a significant property.

The most important benefit of the emulated or virtualization version, essentially a result process of combining migration and emulation, is that transfer to new hardware is possible without specific knowledge of the software-based artwork in contrast to the migration, where this is required. Consequently, the type of technical knowledge is less relevant for its conservation. The easiest maintenance and functionality tests

focused on monitoring the actual state of artworks should specify the most appropriate means of continued care to use in different software-based artifacts.

Among the research the conservation principles, one concept that remains most challenging for implementation is the requirement of conservation professionals to supervise delegated conservation work. In the case of software-based artwork, the specialist expertise may be so separated from current conservation skill sets that management is not easily realized. Interdisciplinary communication can be especially interesting and difficult, as conservators and software engineers often use different terminology and gravitate towards different treatment approaches. But, without this commitment to develop a mutual language and concepts, conservation professionals may currently not be able to understand, communicate and collaborate effectively with the developers and programmers to ensure that conservation conscience inform and guide the investigation and treatment of digital media arts.

Ideally, conservators of software and software-based artwork would combine training in programming with graduate degree in art conservation. To enable conservation supervision of delegated programming work, emerging conservators of contemporary art should be trained within their curriculum to understand basic principles and approaches in computer programming languages and systems architecture. Similar interfaces between conservation and other disciplines, such as art history or conservation science, are already being merged in conservation training. Only by expanding this multidisciplinary field of art conservation incorporate the next generation of contemporary art production in software-based artworks.

REFERENCES

AIC (American Institute for Conservation of Historic and Artistic Works). (1994). *Code of Ethics and Guidelines for Practice*. Retrieved May 1, 2020 from http://www.conservation-us.org/ethics

Chikofsky, E. J., & Cross, J. H. (1990). Reverse engineering and design recovery: A taxonomy. *IEEE Software*, *7*(1), 13–17. doi:10.1109/52.43044

Clements, J. (2012). Time Out: An exploration of the possibilities for archived time-based media as a tool for exploration within a fine art practice-based research enquiry. *Journal of Media Practice*, *13*(3), 239–253. doi:10.1386/jmpr.13.3.239_1

Craig, L. (2011). *An Introduction to Object-Oriented Analysis and Design and Iterative Development*. Academic Press.

Engel, D., & Phillips, J. (2019). Applying conservation ethics to the examination and treatment of software-and computer-based art. *Journal of the American Institute for Conservation, 58*(3), 180–195. doi:10.1080/01971360.2019.1598124

Falcão, P. (2019). *Preservation of Software-based Art at Tate*. Academic Press.

Griesinger, P. (2016). Process history metadata for time-based media artworks at the Museum of Modern Art, New York. *Journal of Digital Media Management, 4*(4), 331–342.

ICMCC (International Council of Museums Committee for Conservation). (1984). *The Conservator-Restorer: A Definition of the Profession, Section 2.1*. Retrieved May 10, 2020 from www.icom-cc.org/47/ about-icom-cc/definition-of-profession/

Laurenson, P. (2016). Old media, new media? Significant difference and the conservation of software-based art. In *New collecting: Exhibiting and audiences after new media art* (pp. 73–96). Routledge. doi:10.4324/9781315597898-4

Madhavji, N. H., Fernandez-Ramil, J., & Perry, D. (Eds.). (2006). *Software evolution and feedback: Theory and practice*. John Wiley & Sons. doi:10.1002/0470871822

Marchese, F. T. (2013). Conserving software-based artwork through software engineering. In *2013 Digital Heritage International Congress (DigitalHeritage)* (Vol. 2, pp. 181-184). IEEE. 10.1109/DigitalHeritage.2013.6744752

Moraitou, E., & Kavakli, E. (2018). Knowledge Management Using Ontology on the Domain of Artworks Conservation. In *Digital Cultural Heritage* (pp. 50–62). Springer. doi:10.1007/978-3-319-75826-8_5

Nosek, J. T., & Palvia, P. (1990). Software maintenance management: Changes in the last decade. *Journal of Software Maintenance: Research and Practice, 2*(3), 157–174. doi:10.1002mr.4360020303

Paul, C. (2019). *The Myth of Immateriality-Presenting & Preserving New Media*. Academic Press.

Phillips, J. (2015). Reporting iterations: a documentation model for time-based media art. *Revista de historia da arte, 4*, 168-179.

Ransom, J., Somerville, I., & Warren, I. (1998, March). A method for assessing legacy systems for evolution. In *Proceedings of the Second Euromicro Conference on Software Maintenance and Reengineering* (pp. 128-134). IEEE. 10.1109/ CSMR.1998.665778

Real, W. A. (2001). Toward guidelines for practice in the preservation and documentation of technology-based installation art. *Journal of the American Institute for Conservation, 40*(3), 211–231. doi:10.1179/019713601806112987

Rinehart, R. (2007). The media art notation system: Documenting and preserving digital/media art. *Leonardo, 40*(2), 181–187. doi:10.1162/leon.2007.40.2.181

Roeck, C., Rechert, K., & Noordegraaf, J. (2018). *Evaluation of preservation strategies for an interactive, software-based artwork with complex behavior using the case study Horizons (2008) by Geert Mul.* iPres 2o18.

Rosa, C. (2015). Preserving New Media: Educating Public Audiences through Museum Websites. Art Documentation. *Journal of the Art Libraries Society of North America, 34*(1), 181–191. doi:10.1086/680572

Tanner, E., & Huang, M. (2019). Planning for Time-Based Media Artwork Preservation at the Philadelphia Museum of Art. Art Documentation. *Journal of the Art Libraries Society of North America, 38*(2), 229–261.

Yeung, T. A., Greenberg, S., & Carpendale, S. (2008). *Preservation of Art in the Digital Realm.* iPRES.

KEY TERMS AND DEFINITIONS

Adaptability: Is a feature of a system or of a process, adaptability metrics involving human level of confidence and can be simplified to that extent in real life situations.

Algorithm: In computer science, an algorithm is a finite sequence of well-defined, computer-implementable instructions, typically to solve a class of problems or to perform a computation.

Artifact: An object made by a human being, typically one of cultural or historical interest.

Conservation: Focuses on protection and care of tangible cultural heritage, including artworks, architecture, archaeology, and museum collection. Is the hands-on act of working directly with the object to preserve its current condition.

Conservator: A person responsible for the repair and preservation of things of cultural or environmental interest, such as buildings or works of art.

Curators: A keeper or custodian of a museum or other collection.

Digital Art: Is an artistic work or practice that uses digital technology as part of the creative or presentation process.

Hardware: Includes the physical parts of a computer and supports the software execution.

Legacy Systems: A legacy system is outdated computing software and/or hardware that is still in use.

Maintenance (Software): Is the process of modifying a software product after it has been delivered to the customer. The main purpose of software maintenance is to modify and update software application after delivery to correct faults and to improve performance.

Obsolescence: Digital obsolescence is a situation where a digital resource is no longer readable because of its archaic format. There are two main categories of digital obsolescence: Software: the software needed to access the digital file becomes obsolete.

Operating System: Is system software that manages computer hardware, software resources, and provides common services for computer programs.

Peripherals: A peripheral device is defined as a computer device, such as a keyboard or printer, that is not part of the essential computer.

Preservation: Is the non-invasive act of minimizing deterioration and preventing future damage of the object or artifact.

Programming Language: A programming language is a vocabulary and set of grammatical rules for instructing a computer or computing device to perform specific tasks.

Restoration: The action of returning something to a former owner, place, or condition.

Scalability: Is an attribute of a tool or a system to increase its capacity and functionalities based on its users' demand. Scalable software can remain stable while adapting to changes, upgrades, overhauls, and resource reduction.

Software: Is the set of instructions that can be stored and run by hardware, is a collection of data or computer instructions that tell the computer how to work through its own language.

Software-Based Artwork: Is a work of art where the creation of software, or concepts from software, play an important role.

Unified Markup Language (UML): Is a general-purpose, developmental, modeling language in the field of software engineering that is intended to provide a standard way to visualize the design of a system.

Chapter 4

The Confluence Between Materiality and Immateriality in Site–Specific Sound and Visual Performances

Frederico Dinis
CEIS20, Portugal

ABSTRACT

Aiming to explore the diverse nature of sound and image, thereby establishing a bridge with the symbiotic creation of sensations and emotions, this chapter intends to present the development and the construction of a proposal for the confluence between materiality and immateriality in site-specific sound and visual performances. Using as a focal point sound and visual narratives, the author tries to look beyond space and time and create a representative atmosphere of sense of place, attempting to understand the past and sketching new configurations for the (re)presentation of identity, guiding the audience through a journey of perceptual experiences, using field recordings, ambient electronic music, and videos. This chapter also presents the development of an experimental approach, based on a real-time sound and visual performance, and some critical forms of expression and communication that relate or incorporate sound and image, articulating concerns about their aesthetic experience and communicative functionality.

DOI: 10.4018/978-1-7998-3669-8.ch004

INTRODUCTION

The artistic reality composed by new media and its consequent relational complexity is increasingly challenging the established currents and artistic forms.

Projects developed according to a hybrid methodology and largely executed as work in progress can be understood as another form of research practice, in a practice-as-research approach that leaves behind the context of traditional art and drives the creation of new approaches.

These practices of artistic creation, reflection and research promote alternative forms of perception as a potential instrument for transforming existing ontologies and create their own spaces necessary for in-depth artistic observations close to the language of creation.

One of the formats that have always stood out for breaking the rules of the prevailing artistic movements is performance art. Thanks to the appropriation and expansion of technology to other media, multimedia performance has gained prominence in creative practice since it has become decentralized from the body and the performer by opening up to other media, such as sound or image.

The concept of performance can be understood through different perceptions arising from different disciplinary approaches, artistic areas or cultural contexts. It's because of a certain amount of misunderstanding and incoherence of the concept that performance presents a major research and exploratory potential. It even departs from its different conceptions and provides personal readings on the confluence between the sound and the visual as a theme for creative recognition.

Taking as starting point a collection of artistic practices and live performances, developed through an experimental project consisting of soundscapes and film excerpts where sound and visual narratives were constructed and mixed live, the author felt the need to explore this dialogue between sound and image in order to develop and build a personal proposal for creation in the context of contemporary performance, based on real-time sound and visual articulation.

This chapter aims to present this personal proposal, exploring the diverse nature of sound and its relationship to the visual establishing a bridge with the representation of feelings and emotions. To achieve that, the author pretends to answer the following research questions: (i) what is the function of site-specific sound and visual performance in the process of recalling? (ii) how can the relationship and the diverse nature of sound and image engage the public in the remembrance of local atmospheres while linking them to wider horizons?

To accomplish this the author, start from a set of artistic practices which are related with electronic ambient music and deconstruct some notions related with the development of this musical style, from its historical vanguards to the current new

expansion of electronic ambient music, which decisively influences the proposal for creation presented in the chapter.

This chapter starts by providing general definitions, considerations, and views about electronic ambient music, multimedia performances, and sound and visual confluence in memory representation.

To build an archeology of electronic ambient music the author draw on relevant literature, approaching texts, theoretical contexts, and sound works, especially highlighting the relevance of the work developed by Erik Satie (1866-1925), Arnold Schoenberg (1874-1951), Luigi Russolo (1885-1947), Edgard Varèse (1883-1965), Pierre Schaeffer (1910-1995), John Cage (1912-1992) and Karlheinz Stockhausen (1950-1990), composers whose extreme approaches are of great importance in further development of all electronic music. Regarding the foundations of contemporary electronic music, the author will take as central the work developed by Tangerine Dream (1967-), Kraftwerk (1970-) and YMO (Japan, 1978-1993), fundamental influences for contemporary electronic ambient music.

It is also identified and discussed a path, within the scope of the creators and artistic movements related with performance art, that contextualizes contemporary multimedia performances, using a set of anthologies (Packer & Jordan, 2001; Harries, 2002; Tofts et al., 2002; Wardrip-Fruin & Monfort, 2003), and also observing the new expansion of multimedia performance, with the appearance of new approaches and projects in recent years, like the ones by William Basinski (1958), Murcof (2002-), Ryoji Ikeda (1966-) or Carsten Nicolai (1965-).

The author also seeks to reflect on the importance of sound and visual confluence in the representation of memory, thus linking and relating concepts, purposes, and coherence of artistic practices that use these two media, presenting a drift on the main ideas of performance and performativity (Wolf, 1993; Packer & Jordan, 2001; Carlson, 2004; Klich, 2007; Féral, 2008) and the recognition of the influence of local contexts and sense of place (Heidegger, 1971; Lippard, 1997; Harrison, 2008), on the importance of immersive abilities and the narrativity of this sound and visual articulation (Rutsky, 1999; Puttnam, 1999; Packer & Jordan, 2001; Chapple & Kattenbelt, 2006; Mendes, 2011) and the recognition of audio-visuality (D'Annuzio, 1983; Chion, 1994; Pallasmaa, 2014) and memory (Halbwachs, 1925; Merleau-Ponty, 1964; Nora, 1984-1994; Banu, 1987; Connerton, 1989; Hiss, 1991; Taylor, 2003; Hirsh, 2008; Schneider, 2011) as key elements to describe processes that move between past and present, and community and individual.

At the end of the chapter, the author presents a proposal for an artistic creation of a sound and visual performance, that promotes an alternative perspective of artistic practice, reflection, and research, related with the confluence between materiality and immateriality and based on a site-specific research-creation project entitled *an essence of a legacy* (Frederico Dinis, 2019).

STATE OF THE ART

As a starting point for developing these sound and visual narratives for memory representation, there is a set of important artistic practices, related to electronic ambient music, which relies much more on atmospheric textures than on rhythmic variations. The author also outlines the artistic movements related to performance art, which contextualize contemporary multimedia performances and involve alternative aesthetics that are technologically innovative and reflect on the importance of sound and visual confluence in memory representation, linking and relating concepts, purposes, and coherence of artistic practices that use these two media.

Electronic Ambient Music

In this topic the author will give a brief explanation of the history of electronic ambient music, reviewing and deconstructing concepts associated with the development of this musical style, established within electronic music since its avant-garde days at the end of the 19th and the beginning of the 20th centuries.

To outline this basic archeology of electronic ambient music the author highlights the relevance of the work developed by composers whose approaches are of great importance in the further development of contemporary electronic music.

In the end, the author presents a basic discography of electronic ambient music to complement the explanation about the development of this musical style.

The Avant-Garde

The origin of electronic music in general and electronic ambient music, in particular, can be found in the first musical compositions and sound experiments conducted by Erik Satie (France, 1866-1925), Arnold Schoenberg (Austria, 1874-1951) and Luigi Russolo (Italy, 1885-1947), due to the influence that these composers had on the work of other artists in subsequent years.

The compositions of Erik Satie are well-known for their mellowness and charm conveyed by their purity of sound and bear no strong allegiance to any particular musical aesthetic.

Another key figure to understanding the changes in musical composition who inspired the first electronic experiments was Arnold Schoenberg. Schoenberg based his work on the dissolution of tonality in music, making this feature of his compositions a logical and inevitable step in the evolution of Western music, breaking with established boundaries.

If breaking the rules in the construction of the first musical compositions of Satie and Schoenberg were crucial to the origins of the first experiments in electronic music, the sound experiments of Luigi Russolo were decisive for its practice.

Russolo, considered by many to be the first artist of noise music, in his manifesto, *L'Arte dei Rumori* (translated to *The Art of Noise*), argues that the industrial revolution gave modern humans an increased ability to appreciate more complex sounds ({1913}1967), emphasizing that the traditional confinement of music to melody would be replaced in the future by noise music (Chilvers & Glaves-Smith, 2009).

As Hegarty (2007) states, "although the works of Russolo have little resemblance to contemporary noise music, its pioneering creations cannot be ignored as being fundamental steps to the evolution of various musical genres either," (2007, p. 13-14) including electronic music of a more experimental nature.

The First Experiments

While avant-garde music emerged seeking to break established boundaries, but working within the traditional musical structures, the first experiments in electronic music began to challenge the idea of what could be considered music, pushing back the barriers of sound experimentation.

In this relentless pursuit of breaking rules and experimenting with new forms, the works of Edgard Varèse (France, 1883-1965), Pierre Schaeffer (France, 1910-1995), John Cage (USA, 1912-1992) and Karlheinz Stockhausen (Germany, 1950-1990) were of crucial importance in the further development of electronic music.

As Russcol (1972) points out:

Schaeffer, having as a starting point sound sources equivalent to visual images, completely changes the procedures of musical composition and makes the experience of concrete music consist of the construction of these sound objects, not with the resource, the numbers and seconds of the metronome, but with chunks of time pulled out of the cosmos. (1972, p. 85)

Always challenging the concept of "music", John Cage "remained on the leading edge of both playful and profound experimentalism for the greater part of his career, collaborating with and influencing generations of composers, writers, dancers, and visual artists" (Rodman, n.a.).

It was thanks to the work of Stockhausen, Varèse, Schaeffer, and Cage, among others, and their incessant search for new sound experimentations that other alternatives opened to the emergence of electronic music as is known today.

The Foundations of Electronic Music

The foundations of contemporary electronic music are based on the work of three projects that revolutionized the way electronic music began to be seen, and thus influenced almost all projects related to the various styles of this genre. These were the works of Tangerine Dream (Germany, 1967-), Kraftwerk (Germany, 1970-) and YMO (Japan, 1978-1993).

German producers of a very imaginative electronic music style, Tangerine Dream were pioneers in the new era of more atmospheric-oriented electronic music, as pointed by Stump (1997, p. 9-10)

While Tangerine Dream innovated musically with their soundscapes linked with the advent of the space age, Kraftwerk became the greatest influence on electronic music produced in the 80s and 90s thanks to their minimalist and fully electronic sound.

As stated by Cunningham (2010, p. 50) The distinctive sound of Kraftwerk was revolutionary and had a lasting effect on many genres of modern music, popularizing electronic music.

While in Germany Tangerine Dream and Kraftwerk revolutionized electronic music, in Japan YMO broke the rules with their techno-pop sound, as outlined by Milburn (2013, p. 113).

With the early use of synthesizers, sequencers and electronic percussion, YMO continues to be a ground-breaking inspiration on modern electronic music today.

Whether through the atmospheric and space soundscapes of Tangerine Dream, the minimal and electronically robotic, hypnotic sounds of Kraftwerk, or the sampled, sequenced and synthesized sounds of YMO, contemporary electronic music would never be the same without this revolution in the works of these three projects.

The (Re)Birth of Electronic Ambient

If Kraftwerk are the greatest influence on electronic music in general, the origin of ambient electronic music is linked to the release of the album *Ambient 1: Music for Airports* (1978) by Brian Eno (England, 1948-). *Ambient 1: Music for Airports* was designed to be played in a public space.

According to Buck (2008):

Airports are the modern point of departure and they are places where reunions occur and separations begin as people move back and forth. Airports are also places of (…) boredom and tension. So he (Brian Eno) took all of this into considerations: a work that would reassure people (…) that would give a spirit of hope and trepidation and calm all mixed together. (…)

Like Cage before him, Eno played with the listeners awareness of their surroundings by not only increasing the space within each of the pieces, but also extending the length between the sections to an exaggerated level. Unsure of when pieces stopped or started it allowed the listener to go further into this immersive sound world. (2008, n.a.)

Ambient 1: Music for Airports was a step forward in the development of contemporary music and is based solely around texture; this was a work about listening and how to hear.

If the use of melody, rhythm, harmony or lyrics was not necessary for the construction of this work, and especially in the development of this (new) music genre, then it is because the use of them is not necessary.

Despite the dissemination of electronic ambient music, the search for new sounds has been constant and has motivated new approaches seeking the same goal: to engage listeners in perceptual environments that carry them to places never imagined.

The Growth of Electronic Ambient Music

Electronic ambient music produced in the first decade of the 2000s embodied little innovation following its boom during the previous two decades, except for works by Murcof (Mexico, 2002-), Alva Noto (Germany, 1993-), and Vladislav Delay (Finland, 1997-).

As stated by Kun (2004, p. 276), Murcof's works combine contemporary minimalist orchestration with melancholy techno to create sound atmospheres, close to devotional. These are works with mysterious and atmospheric sounds that lead the listener to sterile and lunar landscapes, propelling the models of ambient electronics to new contemplative experiments.

Within a more experimental IDM and ambient stream, Alva Noto features untitled sound collages, built from the real sound of electrical noise and clicks, amplified and organized in a series of discrete movements that moves beyond mere ambient electronic music to a new experimental domain, as presented by Knowles (2006, p. 17).

Also noteworthy is the work of producer Vladislav Delay, whose style combines distortions, analog silencers, and noise, creating austere, minimalist compositions that emphasize bass and percussion lines, and the intense use of sound effects, as Strachan (2010, p. 5) claims.

These three approaches, although semantically bordered in ambient electronic music, already demonstrate a great creative diversity in the search for new sounds and gave rise to an artistic practice that strongly influenced the following years.

New Paths for Electronic Ambient Music

From the second decade of the 2000s onwards, electronic music and IDM have been expanded with new projects, including Forest Swords (England, 2009-), Old Apparatus (England, 2010-) and The Haxan Cloak (England, 2009-) with sounds that intersect electronic ambient music.

In Forest Swords (aka Matthew Barnes) debut work, it is revealed that this is an odyssey that steeped into a tempting mysticism of almost unknown sounds where Barnes engages the listeners in his cacophonic textures, which are the constitution of his sound reality.

The perfect blend of unnatural sound textures, organic melodies, and vocals dragged from Old Apparatus's debut work unfolds like a haunted deep dream, sounding like the music built in an underground bunker, hidden away from the world, where the raw material original are just vague memories.

Finally, The Haxan Cloak's debut work makes the most of the length of the themes, thus developing a true narrative, where sound creation is built using negative spaces, labyrinth compositions and synth-based melodies, which explode from tranquility to chaos.

Summing up, despite the growth of electronic ambient music, the search for new sounds has been constant and has driven new currents that seek the same goal: to engage listeners in perceptual atmospheres, which transport them to places never imagined.

Table 1 presents a basic discography to complement the previous explanation about the development of electronic ambient music.

Multimedia Performance

Having presented a brief archaeology of electronic ambient music it is important to highlight pathways within the artistic movements related to performance art to contextualize contemporary multimedia performances in history, from futurism and the avant-garde to new approaches towards the visual reconstruction of the sound phenomenon.

To mark out this route the author assumes as the key concept for multimedia to be the combination of forms or types of media, as proposed by Packer & Jordan (2001).

Multimedia performances are distinguished by involving alternative aesthetics and technological innovations and are decentralized from the body or the performer, expanding out to other media, such as sound, light, movement, and image.

At the end of the exposition of a path through multimedia performance, the author introduces a list of some of the most influential works and creations that complement the explanation about the development of this type of performance.

Table 1. Electronic ambient music basic discography

Year	Authors/Composers	Title
1887	Érik Satie	*Trois Sarabandes + Trois Gymnopédies*
1912	Arnold Schoenberg	*Pierrot Lunaire*
1917	Luigi Russolo	*Gran Concerto Futuristico*
1948	Pierre Schaeffer	*Études de bruits + Étude Pathétique*
1952	John Cage	*4' 33"*
1958	Edgard Varèse	*Poème Électronique*
1963	Jean-Claude Risset	*Fantasie pour Orchestre*
1969	Pierre Henry	*Noire à Soixante & La Noire à Soixante*
1969	Pierre Henry	*Granulométrie*
1972	Tangerine Dream	*Zeit*
1974	Kraftwerk	*Autobahn*
1974	Tangerine Dream	*Phaedra*
1975	Kraftwerk	*Radio-Activity*
1978	Brian Eno	*Ambient 1: Music for Airports*
1978	Yellow Magic Orchestra	*Yellow Magic Orchestra*
1984	Manuel Gotching	*E2-E4*
1992	Aphex Twin	*Selected Ambient Works 85-92*
1992	Biosphere	*Microgravity*
1993	Autechre	*Incunabula*
1993	Brian Eno	*Neroli*
2001	Biosphere	*Substrata 2/Man with a Movie Camera*
2002	Loscil	*Submers*
2002	Murcof	*Martes*
2002	William Basinski	*The Disintegration Loops*
2004	Murcof	*Utopía*
2011	Alva Noto + Ryuichi Sakamoto	*Summvs*
2012	Vladislav Delay	*Kuopio*
2013	Forest Swords	*Engravings*
2013	Old Apparatus	*Compendium*
2013	The Haxan Cloak	*Excavation*
2015	Alva Noto + Ryuichi Sakamoto	*The Revenant*
2015	Max Richter	*Sleep*

Source: Frederico Dinis, 2019

A Genealogy of Multimedia Performance

"Theater, dance, and performance art have always been interdisciplinary, or multimedia, forms" and the background of multimedia "performance practices can (…) be traced through decades, even centuries of performance history", as Dixon (2007, p. 39-40) states.

A large number of anthologies were published at the turn of this millennium presenting historically important texts that predicted or influenced the theory and practice of the new media.

These publications include *Multimedia: From Wagner to Virtual Reality* (2001) from Randall Packer & Ken Jordon, *The New Media Book* (2002) from Dan Harries, *Prefiguring Cyberculture: An Intellectual History* (2002) from Darren Tofts, Annemarie Jonson & Alessio Cavallaro, and *The New Media Reader* (2003) from Noah Wardrip-Fruin & Nick Montfort. The latter juxtaposes texts by technology pioneers and media theorists with texts by artists, thus drawing historical parallels between their thoughts and works.

Besides the importance of these anthologies, it is also important to highlight the contribution of Richard Wagner and his notion of *Gesamtkunstwerk*, or total work of art, presented in his work *The Artwork of the Future* ({1849}, 2001). His vision resulted in the creative unification of several art forms that included theater, music, song, dance, dramatic poetry, design, light and visual arts.

So, multimedia "performance is an extension of a continuing history of the adoption and adaptation of technologies to increase performance and visual art's aesthetic effect and sense of spectacle, its emotional and sensorial impact, its play of meanings and symbolic associations, and its intellectual power", as Dixon (2007, p. 40) also points out.

Futurism and the Avant-Garde at the Beginning of the Twentieth Century

There are clear parallels between the twentieth-century avant-garde movements, such as futurism, with the 1990s digital age since, as Rutsky argues (1999), both appeared in comparable periods of a technological revolution.

Dixon (2007) corroborates this view by arguing that both futurism and digital technologies were initially presented as life philosophies, but later proved to be technological developments that quickly became outdated, consequently requiring a greater effort to avoid their own technical difficulties, limitations, and clichés. But, also according to Dixon (2007), futurism forms a conceptual and philosophical basis for contemporary multimedia performance, constructivism provides the mathematical model and formal methodology, and the remaining avant-garde movements in Europe

(Dadaism, Surrealism, Expressionism and the Bauhaus) provided the sources of inspiration for artistic expression style.

Live Art and Expanded Art

After the forefront of the early twentieth century, it is important to link and relate live art and the concept of happening with the development of multimedia performance.

Here the author highlights John Cage's vision, described in his manifesto *The Future of Music: Credo* ({1958}, 1961), which was based on the idea that "wherever we are, what we hear is mostly noise. When we ignore it, it disturbs us. When we listen to it, we find it fascinating. The sound of a truck at fifty miles per hour away. Static between the stations. Rain." (1961, p. 25). Cage intended to apprehend and control these sounds and to use them not as sound effects but as musical instruments, taking up the claim of Russolo ({1913} 1967) and Cowell (1996).

Also important were Allan Kaprow's new approaches to performance with their happenings, live events where artists publicly performed what they normally only performed privately, thereby increasing the viewer's responsibility as he became an integral part of happening, experiencing it simultaneously (Kaprow, 1966).

Although these artistic movements are not directly linked to multimedia performance, many of the works developed have been developed through the combination of media or media types, expanding aesthetic meanings that are reflected in many later artistic languages.

The Advent of New Media

Like political and social history, the history of performance has involved gradual and incremental evolutions, punctuated by intense periods of sudden change.

In this chapter, the author advocate three periods of more radical evolution, (i) one associated with futurism in 1910, (ii) performance associated with different means in 1960, and (iii) experimentation with the use of computers in performance, in 1990.

While the first and last periods were inspired by the development of new technologies, the proliferation of multimedia performances in the middle period is associated with the development of the simultaneous use of various media and, above all, greater artistic inspiration associated with various ideological changes. and cultural (Dixon, 2007).

It is important to reflect on these changes, linking and relating the artists, works and associated purposes, to understand the development of multimedia performance in this period.

Visual Reconstruction of Sound Phenomena

The 2000s saw a new expansion of multimedia performance in an attempt to visually reconstruct the sound phenomenon. This attempt was based on three different approaches: sound having the visual as its source; the visual having sound as its source and the visual generated algorithmically.

Concerning the sound with the visual as its source, the work of William Basinski (USA, 1958-) should be mentioned. He chooses images and then creates "haunting and melancholy soundscapes" exploring "the temporal nature of life, resounding with the reverberations of memory and the mystery of time" (Basinski, n.a.)

Concerning the visual having sound as its source, the work of Murcof and Simon Geilfus (Belgium, 1985-) should be highlighted, where the soundscapes of Murcof, marked by minimalism and melodic electronic elements, combine with the visuals developed by Simon Geilfus exploring the use of projected light and its influence on the perception of the viewer.

Finally, in the exploration of the visual generated algorithmically, mention should be made of the works of Ryoji Ikeda (Japan, 1966-), Carsten Nicolai (Germany, 1965-), and cyclo (Gemany, 2001-). These works have as their starting point the sounds and the visualization of sound phenomena using algorithms that correlate sound and image variables, showing textures that are developed using software based on sound data analysis.

Table 2 presents a list of some of the most influential works and creations that contextualize contemporary multimedia performance within the scope of the creators and artistic movements related to performance art.

Sound and Visual Confluence in Memory Representation

Having presented a brief archaeology of electronic ambient music and a genealogy of multimedia performance it is essential to reflect on the importance of sound and visual confluence in the representation of memory, linking and relating concepts, purposes, and coherence of artistic practices that use these two media.

Sound and image define a wide range of creative exploration whose approach involves a confrontation of forms of analysis. On the one hand the search for correspondence, or a common denominator between sound and image as an aesthetic matter and its structure oriented to the figurative. On the other hand, the principles of audio-visuality (Chion, 1994), the mutual influence and the effects on the construction of time and space in audio-visual media.

In some artistic practice articulation between sound and image is required to allow, as a whole, some kind of reality in order to add a more subjective perception of the event. Perception seen as a system used to experience surroundings is the basis of

Table 2. List of some of the most influential works and creations in contemporary multimedia performance

Year	Authors/Performers	Title
1849	Richard Wagner	*Gesamtkunstwerk*
1914	Winsor McCay	*Gertie the Dinosaur*
1922	Karel Capek	*R.U.R. (Rossum's Universal Robots)*
1922	The Factory of the Eccentric Actor	*The Wedding*
1927	Paul Claudel	*Le Livre de Christophe Colomb*
1952	Black Mountain College	*untitled*
1961	John Whitney	*Catalog*
1964	Wolf Vostell	*You*
1966	Tisha Brown	*Homemade*
1969	John Cage & Ronald Nameth	*HPSCHD*
1974	Moving Being	*Dreamplay*
1987	Laura Farabough	*Bodily Concessions*
1987	Merce Cunningham	*Hand-drawn*
1991	Damien Hirst	*In an out of love*
1998	Talking Birds + London Musici Trio	*Recent Past*
1999	Bud Blumental & Fernando Martín	*Rivermen*
1999	Dziga Vertov Performance Group + Talking Birds	*Girl with a Movie Camera*
1999	Paul Sermon & Andrea Zapp	*A Body of Water*
2000	Christian Ziegler	*Scanned*
2000	Sophia Lycouris	*String*
2001	Bud Blumenthal	*Les Entrailles de Narcisse*
2001	Igloo	*In Winter1 Space2*
2004	Laterna Magika	*Odysseus*
2006	Ryoji Ikeda	*Test pattern*
2009	cyclo	*id*
2009	Murcof + Simon Geilfus	*Cosmos*
2011	Ryoichi Kurokawa	*Syn*
2012	Ryoji Ikeda	*Superposition*
2012	Vitor Joaquim + Thr3hold	*Geography*

Source: Frederico Dinis, 2019

the recognition of the importance of audio-visuality and memory, as key elements to describe processes that move between past and present, and the influence of local contexts and sense of place on memory representation.

Sound and Image Articulation

As art is a mechanism that stimulates emotions and senses, so multimedia is an extension of these same emotions and senses focused on the individual, and allowing them to experiment sensations that would not otherwise be within reach.

As Wardrip-Fruin (2006) argues, when sound and image capture both directions at the same time in a single aesthetic and narrative sense, they give it synchronicity that in addition to capturing the viewer's attention, directs him to new interpretations. So, sound and image become expressive processes, because it is these that most contribute to the meaning and manifestation of the artwork

The proposal presented in this chapter for the development of these new settings for the representation of memory is based on the coordination of sound and the visual. This takes into account the dialogue between electronic ambient music and video so that the viewer has a contemplative immersion in a perceptual environment that takes him to imaginary places through the creation of new narratives.

These new narratives are constructed by changing the momentary reality by manipulating sound clips, prepared in advance and created using sound collections (field recordings) made locally, and sound textures developed specifically for presentation space.

The success of these new narratives also depends on making the visual atmosphere more powerful using sound, thereby producing a denser immersive reality that the simple direct capture of reality does not offer.

This denser reality also reflects the complementarity of space and time, explored in its site-specific dimension. Consideration of this embodiment of performativity space and the largest contingency assumed in the relationship between sound and image allows a kind of added reality, or more subjective one, perceived as a multimedia performance event.

Performance and Performativity

This personal approach to sound and visual performance is based on the concept of performance and multimedia performance, bringing to the discussion the concept of performativity.

The concepts of performance and performativity can be explained through different understandings, which result from different disciplinary approaches, artistic areas or cultural contexts (Carlson, 2004).

For the scope of the present work is assumed that the notions of performativity are linked to art as a network of exchanges between artistic and public action, based not only on the meaning of representation, but on the approximation between art and life, and the dilution of borders that configure them.

Some lack of understanding and conceptual coherence in the consolidation of the concepts of performance and performativity end up enhancing multimedia performance, namely the exploration of different conceptions, thus providing a personal reading about the interconnection between visual and sound as a creative theme for exploration.

Looking at their most common definitions, multimedia and performance are not two concepts between which one can immediately find a relationship. In general, multimedia means the combination of media or media types (Packer & Jordan, 2001). Performance defines a physical performance or a performance in front of an audience (Carlson, 2004).

In this chapter, the concept of multimedia performance followed is the one proposed by Klich (2007) which presents it as a space where a performer may not be present, but where a high degree of performativity and energy is achieved, decentralizing it from the body/performer and expanding it to other media, namely sound and image.

As argued by Féral (2008) the notions of performativity are linked to art as a network of exchanges between artistic and public action, guided not only by the sense of scenic representation but also in the approximation between art and life, in the dilution of the boundaries that shape them.

So, the illusion of a performance created in non-corporeal presentations is of a narrative. So, as Wolf (1993) defends these presentations of narratives evoke a performance in the mind of the spectator.

Local Contexts and Sense of Place

For this non-corporeal presentation is essential to recognize the influence of local contexts and sense of place to reinforce and dilute the boundaries between place, memory, and artwork.

According to Lippard (1997, p. 7), the "place is a portion of land/town/cityscape seen from the inside, the resonance of a specific location that is known and familiar (…that is) the external world mediated through human subjective experience". Lippard (1997) argues that since our sense of identity is fundamentally tied to our relationship to places and the histories they embody, the uprooting of our lives from specific local cultures and places have contributed to the waning of our abilities to locate ourselves.

This is emphasized by Heidegger (1971) because "when we speak of man and space, it sounds as though man stood on one side, space on the other. Yet space is

not something that faces man. It is neither an external object nor an inner experience. It is not that there are men, and over and above them space".

Harrison (2008) also highlight this by stating that in the fusion of place and soul, the soul is as much of a container of place as the place is a container of soul, both are susceptible to the same forces of destruction.

So, according to Lippard (1997, p. 7) sense of place is "the geographical component of the psychological need to belong somewhere, one antidote to a prevailing alienation".

But how can this local context immateriality, expressed by the sense of place, can be converted into materiality, expressed by sound and visual confluence? By apprehending and perceiving the sense of place, and by materializing the intangible. However, how to apprehend and perceive the place? And how to materialize the intangible?

Taking as a starting point a collection of previous artistic practices and live performances, entitled *sinuous sensations hypnotic emotions*[1] (Frederico Dinis, 2014-2017), the author claim that to perceive the sense of place is necessary to learn, read, interact and explore the local context.

As to how to materialize the intangible the solution is to record routines and activities and develop storyboards and mind maps that help to better understand the information collected in the place. This process transforms perception and immateriality into materiality, that is into sound and visual confluence.

As Merleau-Ponty (1964) points out perception is not a sum of visual, tactile, and audible givens. We perceive totally with my whole being: we grasp a unique structure of the thing, a unique way of being, which speaks to all our senses at once. This is also claimed by Hiss (1991) with the definition of simultaneous perception, which is the system we use to experience our surroundings.

Ontology and Aesthetics

To build this sound and visual confluence proposal it is also important to discuss the nature, principles, and principle of sound and visual performance. This implies finding new aesthetic contours and new contaminations, associated with the experience of sound and visual performance.

Technological and artistic evolutions over time have allowed a fusion of various arts allowing artists to play and develop a particular aesthetic whose fundamental elements are movement, light, and music. By combining moving images and sound synchronously, the aesthetic experience has become much more intense.

Indeed, by creating a tuning between media, in this case, sound and image, one also creates tuning between senses and it is from this tuning that experience can create an immersive effect.

This effect that the famous German composer of the nineteenth century, Richard Wagner, tried to produce in the spectator through what he called *Gesamtkunstwerk*, that is, a work of total art, a concept very similar to the concept of multimedia, as proposed by Packer & Jordan (2001).

Gesamtkunstwerk is made from the integration of various arts, such as music, theater or dance. And in the same way, multimedia is made up of various media such as video or sound.

Media and Intermediate

As previously presented, Paker & Jordan (2001), studying the multimedia phenomenon, seek to define this concept as the gathering of the following characteristics: integration, interactivity, hypermedia, immersion, and narrativity.

Integration is how it all starts by combining artistic forms with technology creating a hybrid form of expression. Interactivity according to Paker & Jordan (2001) concerns the ability to manipulate and use the means to communicate with others. Hypermedia means the ability to separate the elements of each medium from other elements in the sense of personal association. Immersion refers to the experience of entering a simulation or suggestion of a three-dimensional environment. And finally, narrativity is based on the aesthetics and formal strategies that derive from earlier concepts, which result in nonlinear narratives and presentations through the media.

Technological means in artistic expression meet Wagner's idea of a total artwork since they allow the integration of different arts in the same work, and it is in this sense that the new media thus enable dialogue and communication between different artistic realities.

At the same time, these technological and multimedia means are auxiliary means of reproduction of the artistic object, becoming themselves artistic objects, distinct art forms and autonomous linked only by ties of descent from the other arts.

No other factor influenced artistic avant-garde like technology. Not only has it fueled the imagination of artists, but it has also penetrated to the very core of the artwork itself (Rutsky, 1999). But, as emphasized by Puttnam (1999), technological media and multimedia should be seen as a bridge between art objects and not as artistic destiny.

Closely associated with media is the concept of intermediate that designates communicational practices developed simultaneously in or for different media or using media and devices common to different media (Mendes, 2011).

This idea is reinforced by Chapple & Kattenbelt (2006) when they argue that intermedia is a space where borders are softened and where we are between and in the middle of a mixture of spaces, means, and realities. Chapple & Kattenbelt (2006) also reinforce that intermediary becomes a process of transformation of thoughts

and processes in which something is formed through performance. Basically as a re-perception of the whole, which is reconstructed through performance.

Art is a mechanism of stimulation of emotions and senses and multimedia, through media and intermediate, is an extension of these same emotions and senses in the individual, allowing to experience sensations that would not be within reach otherwise.

Audio-visuality

The use of different media is restricted in this proposal for the creation of site-specific performances to sound and visual confluence as activating the performativity of the public memory. This memory allows the current creation of an absence, so it can be said that all memory seems to imply a work of representation.

Since this work of representation, as Ricoeur (2004) argues, also has an inherent process of remembering, which precedes a process of construction of sounds and images. Sounds that are imagined ears, images that are thought to have already been visualized, and sounds and images understood as auxiliaries in the living experience of the construction of memory.

To this process of representation is added another level of understanding with the interference of the sense of place since, as D'Annunzio (1983) argues, the richest experiences [in spaces] happen long before the soul realizes that when we begin to open our eyes to the visible, we have long been advocates of the invisible.

Thus, it can be assumed the importance of the atmosphere of a place that gives it its unique perceptive character and identity, as corroborated by Pallasmaa (2014).

These dimensions of understanding, sound, images, and place can also be associated with audio-visuality, as proposed by Chion (1994), as a place of images and sounds. On the one hand, the sound shows the picture differently than the picture alone, on the other hand, the picture makes the sound heard differently than if the sound we're playing in the dark, thus reinforcing the importance of sound and visual confluence as the performativity of memory activator.

Memory Representation

Starting from the theme of memory (Ricoeur, 2006), as a phenomenon that allows the present creation of an absence, it can be stated that all memory work seems to imply a work of representation. To this one is also inherent a process of recollection, which precedes a process of construction of sounds and images. Sounds that were imagined to have been heard, images that were thought to have already been visualized, and sounds and images that were understood as auxiliaries in the living experience of the (re)construction of memory.

The work of memory has been the subject of inquiry by the sciences that seek to understand how we process our experience in the world. Today the advent of technology puts us before the same need to perceive how and what we register of the mass of information within our reach, but above all, what role memory has in the configuration of individual and collective identities.

Throughout the last century, several authors have talked about collective memory (Halbwachs, 1925), memory theaters (Banu, 1987), memory-habit (Connerton, 1989), memory places (Nora, 1984-1994) and more recently built-in memory (Taylor, 2003), post-memory (Hirsh, 2008) and memory as a continuous performative act (Schneider, 2011) to describe processes that move us between past and present, community and individual, in a word, between specific types of performativity.

The looking for the understanding of how memory works and what it represents for the individual and for the collective in which it is inserted, had consequences in the reappraisal of certain human practices and representations, namely in new media arts.

The topic of memory intersects performance arts and new media arts precisely through the performativity dimension. It can be seen active in the power of testimony, in the materialities of the real, in the non-separation of public and private, in the prevalence of the process that connects artists and spectators in the encounter/confrontation of memories, and also in the confluence between materiality and immateriality.

One example of this confluence is embodied in a perceptual experience of a sound and visual performance, entitled *an essence of a legacy* (Frederico Dinis, 2019), which had as its starting point the apprehension of memories and the history of the Imagery of Barcelos, emphasizing concepts such as memory, local context, site-specific and sense of place.

SOUND AND VISUAL PERFORMANCE AS A PROPOSAL FOR ARTISTIC CREATION

After providing general concepts, purposes, and works related to electronic ambient music and multimedia performances, and reflecting on the importance of sound and visual confluence in memory representation, the author now presents a personal proposal for artistic creation of a sound and visual performance based on a site-specific research-creation project entitled *an essence of a legacy* (Frederico Dinis, 2019).

For this explanation, the author clarifies the sound and visual approach used on the research-creation project, characterizes the territory related to the Imagery of Barcelos[2], and describes the approach used during the public presentation, presented at the Pottery Museum of Barcelos, on the 18th May 2019.

This proposal tries to promote an alternative perspective of artistic practice, reflection, and research, related to the confluence between materiality and immateriality.

Sound and Visual Approach

The sound and visual approach of *an essence of a legacy* fit in the conception of an audio-visual symphony, representative of the territory related to the Imagery of Barcelos, with influence in the so-called city symphony films, a genre of avant-garde films from the beginning of the century. These films were particularly influenced by modern art, Cubism, Constructivism, and Impressionism, being a genre of films that moves in the frontiers of documentary and avant-garde film, narrative film and experimental cinema.

In city symphony films the main actor is the territory itself, reflecting the sensations and emotions of those who inhabit it and extolling the rhythm, the syncopated cadence, of their lives.

The most recognized films of this genre are Walter Ruttman's *Berlin: die Symphonie der Grosstadt* (1927), filmed and edited as a visual poem, and Dziga Vertov's *The Man with a Movie Camera* (1929), built on the form of a visual symphony (Michelson, 1984).

an essence of a legacy aimed to explore and celebrate the creative, cultural and historical diversity of the territory related to the Imagery of Barcelos while, at the same time, to create a figurative record of this territory as it is today. This audio-visual symphony was presented during a real-time sound and visual performance, at the Pottery Museum (Barcelos) on the 18th of May 2019, in a personal approach to performance that reinforced the concept of performance (Packer & Jordan, 2001) and audio-visuality (Chion, 1994).

Contemporary visual and sound performances can be characterized by qualities of immersion, intermediary, and narrativity, characteristics that were used in this performance as focal points to structure the analysis and the creation of the same.

With perception, memory, and imagination in constant interaction, the scope of the sound and visual performance fuses with images of memory and fantasy from other places, thus making them real in the total sense of experience, and proposing a multiple and non-linear vision of the past, present, and future of the territory related to the Imagery of Barcelos.

The main theme of the project was the legacy of the community related to the Imagery of Barcelos, addressed through five aspects: the raw material of the imagery, the artisans' place/workshop, the potter's wheel, the artisans and the final imagery produced. For each of these aspects, a set of emotions/sensations was defined that inspired the construction of the sound and visual narratives.

Figure 1 presents the sound and visual narratives guidelines for the real-time sound and visual performance *an essence of a legacy*, based on the research-creation model defined by Dinis (2017).

Figure 1. Sound and visual narratives guidelines for the real-time sound and visual performance an essence of a legacy.
Source: Frederico Dinis, 2019

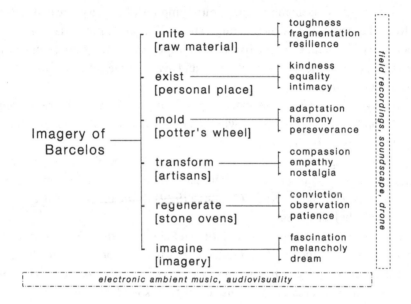

The real-time sound and visual performance purpose was to promote a personal re-reading of a territory that mirrors a representation of the reality or the imaginary of a way of life, to reinvent the tradition through a metaphorical representation of the memories and the cultural identity of the territory related to the Imagery of Barcelos, and to create a figurative record of this territory as it is today.

Imagery of Barcelos

The Imagery of Barcelos is a certified handicraft product and it is one of the most productive craftsmanship sectors in the municipality. It started as a subsidiary activity of pottery, when potters, on their free time and using small pieces of clay, would mould little figures with a whistle or music instrument attached to the base for children to play.

Figure 2 presents the pioneers of this handicraft product, usually known as the Imagery of Barcelos.

Figure 2. Pioneers of the Imagery of Barcelos: Rosa Ramalho (1888–1977), Rosa Côta (1901-1983), Ana Baraça (1904-2001), Maria Esteves (1911-2013), Maria Sineta (1915-1996), and Domingos Lima "Mistério" (1921-1995).
Source: Barcelos Pottery Museum, 2019

Rosa Ramalho (1888) Rosa Côta (1901) Ana Baraça (1904)

Maria Esteves (1911) Maria Sineta (1915) Domingos Lima (1921)

The Imagery of Barcelos is incomparable to any other product due to its unique features and is based on solid foundations, that are the result of knowledge and specialization developed throughout times and that are still very alive today. The most common pieces, as shown in Figure 3, are religious and festive nature related, those

relating to everyday life, the bestiary (devils, grotesque, shapeless and ambiguous figures), among others.

Figure 3. Imagery of Barcelos, 1950.
Source: Barcelos Pottery Museum, 2019

an essence of a legacy was developed in a double sense: (i) the territory related with the Imagery of Barcelos as an element that seeks to portray sensations and creativity of a unique place, embracing its memory, its history, and its identity; and (ii) the territory as a space of memory that remembers and imagines other possible places.

Starting with some of the identifying characteristics of the territory related to the Imagery of Barcelos an audio-visual symphony was (re)created which promoted a personal reading of the territory and mirrors a representation of the reality or the imaginary of a way of life that reinvents the tradition and expresses the memories and the cultural identity of the place. For the choice of the local contexts, a personal exercise of (re)interpretation of the identifying characteristics of the territory of Barcelos was developed, using the research-creation model defined by Dinis (2017), being chosen some places that symbolize figuratively these characteristics.

The narratives were developed taking as its starting point the identity characteristics, reflecting on the importance of the site-specific and sense of place, considering the mapping between features and spaces (Dinis, 2016). This mapping searched to deconstruct spaces and places, microcosms of unusual perspectives and immaterial dimensions of the memory of the territory related to the Imagery of Barcelos, and tried formulas that guarantee the discovery and the deepest recognition of the territory, reconstructing it crossing these identity characteristics with local contexts.

An Essence of a Legacy **Real-time Performance**

an essence of a legacy was a real-time sound and visual performance inspired by the art and creativity of the Imagery of Barcelos, whose identity is a symbol of the creative capacity of a community, that tried to transport the public to new dimensions of the territory related to the Imagery of Barcelos, through the exploitation of its sound and visual aspects.

For the development of *an essence of a legacy*, fieldwork was developed (see Figures 4, 5, 6 and 7) to collect and record video footage of the territory related to the Imagery of Barcelos, which was later worked to create the videos used in the visual component. The sound component was developed according to the emotional states that the images wanted to transmit and were based on the fusion between sounds collected and recorded in the territory and the creation of electronic ambient music pieces.

Figure 4. Fieldwork: raw material.
Source: Frederico Dinis, 2019

This audio-visual symphony was developed through visual and sound narratives (guidelines in Figure 1), structured in such a way to preserve and exhibit, simultaneously, a visual and sound collection of the territory related to the Imagery of Barcelos, maintaining a connection with a past of memories and meanings.

an essence of a legacy visual and sound atmospheres were later approached during a real-time sound and visual performance, presented at the Pottery Museum of Barcelos, on the 18th of May 2019, for the community and general public, emphasizing

Figure 5. Fieldwork: moulding clay.
Source: Frederico Dinis, 2019

Figure 6. Fieldwork: handicraft production.
Source: Frederico Dinis, 2019

some states presented simultaneously in sound, image, and place itself, seeking to transport the public to a new perceptual dimension (see Figures 8, 9, 10 and 11).

The performer of the presentation was not only the operator of the media used, but represents also the mediator, creator, and consequently the real-time narrator, building the sound and visual narratives.

In the public presentation of *an essence of a legacy*, time and space were altered, pointing to other (unknown) places, and momentarily transforming the presentation place into a space full of new meanings and memories.

Figure 7. Fieldwork: artisans' workshop.
Source: Frederico Dinis, 2019

Figure 8. Performance at the Pottery Museum (Barcelos) on the 18th May 2019.
Source: Frederico Dinis, 2019

As argued by Dinis (2016), through the real-time presentation of *an essence of a legacy*, it was possible to confirm that the function of site-specific sound and visual performance in the process of remembering was a mediator, and the relationship of sound and image also involved the public in the remembrance of local atmospheres escaping from the commonplace of daily corporeality.

Figure 9. Performance at the Pottery Museum (Barcelos) on the 18th May 2019.
Source: Frederico Dinis, 2019

Figure 10. Performance at the Pottery Museum (Barcelos) on the 18th May 2019.
Source: Frederico Dinis, 2019

Figure 11. Performance at the Pottery Museum (Barcelos) on the 18th May 2019.
Source: Frederico Dinis, 2019

FUTURE RESEARCH DIRECTIONS

This research-creation seeks to deepen and question the creation, production and presentation of sound and visual performances related with the specificity of each territory; to foster a new creative context through the interaction between traditional arts and crafts and new media arts, and to involve the place and the public in an innovative and meaningful way.

Through the development and presentation of this site-specific sound and visual performance the chapter presented some experimental approaches and critical forms of expression and communication that relate or incorporate sound and visual mediums, bringing forward some concerns about the aesthetic experience and communicative functionality, and how the relationship between sound, image and heritage can have an effect on artistic culture and new contemporary site-specific performances.

Future research is needed to explain how the relationship and the diverse nature of sound and image can involve the public in the remembrance of local atmospheres while linking them to wider horizons.

But, as emphasized by Daniels & Naumann (2010), the audio-visual research, the intersection of art, science, and technology, reveals itself as one of the greatest modern experimentation fields, unfinished and unending.

CONCLUSION

As mentioned before, the concepts of performativity and performance can be explained through different understandings, which result from different disciplinary approaches, artistic areas or cultural contexts. It is this lack of conceptual coherence that promotes its potential, namely in the exploration of different conceptions and in order to provide a personal reading on the connection between visual and sound as a theme of creative exploration.

Instead of seeking to stabilize these concepts, the author highlights the importance of the notions of performance and performativity (Wolf, 1993; Packer & Jordon, 2001; Carlson, 2004; Klich, 2007; Féral, 2008). The opening of multimedia performances to other media, such as sound and image, promotes a discussion about the importance of the immersive capacities and narratives of this new sound and visual articulation, in the light of the concepts proposed by Rutsky (1999), Puttnam (1999), Chapple & Kattenbelt (2006) and Mendes (2011).

When sound and image capture two senses at the same time in a single aesthetic-narrative sense, there is an articulation that, in addition to capturing the viewer's attention, directs them to new interpretations through their perceptions (D'Annuzio, 1983; Chion, 1994; Pallasmaa, 2014).

To promote the articulation between sound and image, site-specific performances were developed, inspired by the memory and identity of local contexts. These hade as their starting point the perception and interaction with spaces, emphasizing the influence of local contexts and sense of place (Heidegger, 1971; Lippard, 1997; Harrison, 2008), and memory (Halbwachs, 1925; Merleau-Ponty, 1964; Nora, 1984-1994; Banu, 1987; Connerton, 1989; Hiss, 1991; Taylor, 2003; Hirsh, 2008; Schneider, 2011), as key elements to describe processes that move between past and present, and community and individual.

In addition to incorporating field recordings and soundscapes, the sound and visual articulation seek to represent the characteristics of the places, including some of their more particular cultural and identity aspects.

In these performances, the local context circumscribes their aura and memory, and the audience projects their own emotions and mental products of perception about the creation, creating performativity dynamics and relational experiences with the public.

It is thus a personal approach to site-specific sound and visual performance that seeks to develop an emotive relational component that will lead the public to create their own narrative and sound and visual articulation.

Using a site-specific research-creation project, entitled *an essence of a legacy* (Frederico Dinis, 2019), the author presents a personal proposal for artistic creation of a sound and visual performance. This proposal tries to promote an alternative

perspective of artistic practice, reflection, and research, related to the confluence between materiality and immateriality.

The real-time presentation of the performance was based on the research-creation model defined by Dinis (2017) and the narratives were developed taking into account the mapping between features and spaces (Dinis, 2016).

With the real-time presentation, the author concluded that the site-specific sound and visual performance can act as a mediator, through plasticity, in the materiality of interactions between artwork, sounds, images, place, and audience, and that the involvement of the public escapes from the commonplace of daily corporeality, creating mechanisms of continuous movements, diluting seemingly permanent boundaries and starting from bodily experience as a motto for spatial transgression.

REFERENCES

Banu, G. (1987). *De l'esthétique de la disparition a la poétique de la mémoire. Le Théâtre dans la Ville*. Éditions du CNRS.

Basinski, W. (n.d.). *About the Artist*. Retrieved from http://www.mmlxii.com/about/, Jan 19, 2019.

Buck, J. (2008). *Brian Eno - Ambient 1: Music For Airports*. Retrieved from http://www.musthear.com/music/reviews/brian-eno/ambient-1-music-for-airports

Cage, J. (1961). The Future of Music: Credo {1958. In J. Cage (Ed.), *Silence: Lectures and Writings*. Wesleyan University Press.

Carlson, M. (2004). What is performance? In H. Bial & S. Brady (Eds.), *The Performance Studies Reader*. Routledge.

Chapple, F., & Kattenbelt, C. (Eds.). (2006). *Intermediality in Theatre and Performance*. Rodopi.

Chilvers, I., & Glaves-Smith, J. (2009). *A Dictionary of Modern and Contemporary Art*. Oxford University Press. doi:10.1093/acref/9780199239665.001.0001

Chion, M. (1994). *Audio-vision: Sound on screen*. Columbia University Press.

Connerton, P. (1989). *How Societies Remember*. Cambridge University Press. doi:10.1017/CBO9780511628061

Cowell, H. (1996). *New musical resources*. Cambridge University Press. doi:10.1017/CBO9780511597329

Cunningham, D. (2010). Kraftwerk and the Image of the Modern. In S. Albiez & D. Pattie (Eds.), *Kraftwerk: Music Non-Stop*. Continuum.

D'Annunzio, G. (1983). Contemplazioni della morte {1912}. In Water and Dreams: An Essay on the Imagination of Matter. Dallas: The Pegasus Foundation.

Daniels, D., & Naumann, S. (Eds.). (2010). *Audiovisuology: Compendium* (Vol. 1). Verlag der Buchhandlung Walther König.

Dinis, F. (2016). [re]presentation of memory spaces using sound and visual articulation. In POST-SCREEN: Intermittence + Interference. Lisboa: Edições Lusófonas/CIEBA-FBAUL.

Dinis, F. (2017). [re]definitions: Experiências percetivas na performance 'site-specific' através da articulação sonora e visual. In F.M. Oliveira (Ed.), Conceitos e dispositivos de criação em artes performativas. Coimbra: Imprensa da Universidade de Coimbra.

Dixon, S. (2007). *Digital performance: a history of new media in theater, dance, performance art, and installation*. The MIT Press. doi:10.7551/mitpress/2429.001.0001

Féral, J. (2008). Entre Performance et Théâtralité: le théâtre performatif. *Théâtre/Public, 190*, 28-35.

Halbwachs, M. (1992). *On collective memory*. The University of Chicago Press.

Harries, D. (2002). *The New Media Book*. British Film Institute.

Harrison, R. P. (2008). *Gardens: An Essay on the Human Condition*. The University of Chicago Press. doi:10.7208/chicago/9780226317861.001.0001

Hegarty, P. (2007). *Noise/Music: a history*. Continuum International Publishing Group.

Heidegger, M. (1971). Building Dwelling Thinking. In *Poetry, Language, Thought* (A. Hofstadter, Trans.; pp. 143–162). Harper & Row.

Hirsch, M. (2008). The Generation of Postmemory. *Poetics Today, 29*(1), 103–128. doi:10.1215/03335372-2007-019

Hiss, T. (1991). *The Experience of Place: A New Way of Looking at and Dealing with our Radically Changing Cities and Countryside*. Vintage Books.

Kaprow, A. (1966). *Assemblage, environments & happenings*. H. N. Abrams.

Klich, R. (2007). *Multimedia theatre in the virtual age* (PhD dissertation). School of Media Film and Theatre, University of New South Wales.

Knowles, J. (2006). Alva Noto. *Filter, 62*, 17–19.

Kun, J. (2004). File Under: Post-Mexico. *Aztlán, 29*(1), 271–277.

Lippard, L. (1997). *The Lure of the Local: Senses of Place in a Multicultural Society*. The New Press.

Mendes, J. M. (2011). *Introdução às intermedialidades*. Escola Superior de Teatro e Cinema/IPL.

Merleau-Ponty, M. (1964). *The Primacy of Perception and Other Essays on Phenomenological Psychology, the Philosophy of Art, History and Politics*. Northwestern University Press.

Michelson, A. (1984). *Kino-Eye: The Writings of Dziga Vertov*. University of California Press.

Milburn, K. (2013). Futurism and Musical Meaning in Synthesized Landscapes. *Kaleidoscope, 5*(1), 109–116.

Nora, P. (Ed.). *(1984–1992). Les lieux de Mémoire*. Gallimard.

Packer, R., & Jordan, K. (Eds.). (2001). *Multimedia: from Wagner to virtual reality*. Norton & Company.

Pallasmaa, J. (2014). Space, Place, and Atmosphere: Peripheral Perception in Existential Experience. In C. Borch (Ed.), *Architectural Atmospheres: On the Experience and Politics of Architecture*. Birkhäuser. doi:10.1515/9783038211785.18

Puttnam, D. (1999). Keynote speech. In CADE 99 (Computers in Art and Design Education) Conference. University of Teesside.

Ricoeur, P. (2004). *Memory, History, Forgetting*. The University of Chicago Press. doi:10.7208/chicago/9780226713465.001.0001

Rodman, M. (n.d.). *Artist Biography*. Retrieved from https://www.allmusic.com/artist/john-cage-mn0000183867/biography

Russcol, H. (1972). *The liberation of sound: an introduction to electronic music*. Prentice-Hall.

Russolo, L. (1967). *The Art of Noise: futurist manifesto*. London: A Great Bear Pamphlet by Something Else Press.

Rutsky, R. L. (1999). *High techne: art and technology from the machine aesthetic to the posthuman*. University of Minnesota Press.

Schechner, R. (2003). *Performance theory*. Routledge. doi:10.4324/9780203361887

Schneider, R. (2011). *Performing Remains: Art and War in Times of Theatrical Reenactment*. Routledge. doi:10.4324/9780203852873

Strachan, R. (2010). Uncanny Space: Theory, Experience and Affect in Contemporary Electronic Music. *Trans. Revista Transcultural de Música, 14*, 1–10.

Stump, P. (1997). *Digital Gothic: A Critical Discography of Tangerine Dream*. SAF.

Taylor, K. (2003). Cultural Landscape as Open Air Museum: Borobudur World Heritage Site and Its Setting. *Humanities Report, 10*(2), 51–62.

Tofts, D., Jonson, A., & Cavallaro, A. (Eds.). (2002). *Prefiguring Cyberculture: An Intellectual History*. The MIT Press.

Wagner, R. (2001). The artwork of the future {1849. In R. Packer & K. Jordan (Eds.), *Multimedia: from Wagner to virtual reality*. Norton & Company.

Wardrip-Fruin, N. (2006). *Expressive processing: on process-intensive literature and digital media* (PhD dissertation). Brown University, Providence, RI.

Wardrip-Fruin, N., & Montfort, N. (2003). *The New Media Reader*. The MIT Press.

Westgeest, H. (2008). The Changeability of Photography in Multimedia Artworks. In H. Van Gelder & H. Westgeest (Eds.), *Photography between poetry and politics: the critical position of the photographic medium in contemporary art*. Leuven University Press.

Wolf, W. (1993). *Ästhetische Illusionen und Illusionsdurchbrechung in der Erzählkunst*. Niemeyer. doi:10.1515/9783110927696

ENDNOTES

[1] *Sinuous sensations hypnotic emotions* were a practice-as-research Ph.D. project that aimed to explore the diverse nature of sound and its relation to the image, framed in the area of sound and visual performance. The full info about the project is available at https://fredericodinis.wordpress.com/performance/sshe/.

[2] Barcelos is a city and a municipality in Braga District in the Minho Province, in the north of Portugal.

Chapter 5
The Presence of the Uncanny Valley Between Animation and Cinema:
A Communication Approach

Rodrigo Assaf
iD https://orcid.org/0000-0002-6999-1848
Digital Creativity Centre, School of Arts, Portuguese Catholic University, Portugal

Sahra Kunz
CITAR, School of Arts, Portuguese Catholic University, Portugal

Luís Teixeira
iD https://orcid.org/0000-0002-1206-4576
CITAR, School of Arts, Portuguese Catholic University, Portugal

ABSTRACT

Despite all the technological advances in the field of computer graphics, the uncanny valley effect is still an observed phenomenon affecting not only how animated digital characters are developed but also the audience's reaction during a film session. With the emergence of computer-generated images being used in films, this chapter aims at presenting a multidisciplinary approach concerning the uncanny valley topic. This phenomenon is mainly explained by several psychological theories based on human perception; however, this chapter contributes to the discussion presenting a communication perspective based on the uses and gratification theory connected to the genre theory proposed by Daniel Chandler. In addition, the authors discuss how the technological evolution in rendering is helping out artists to cross the valley, which ends up being unveiled only by motion. As a result of this technical evolution, it is proposed a new animation art style category defined as quasi-real.

DOI: 10.4018/978-1-7998-3669-8.ch005

INTRODUCTION

By exploring the eeriness of dolls and waxworks, the English term 'uncanny' was translated from the German word *'unheimlich'* in Sigmund Freud's work about the strangeness feeling of ordinary things (Freud, 1919). Although the literal translation of the German word is 'unhomely' or 'not native', Freud explained that the concept of uncanny goes beyond what is not familiar, i.e., not everything that is new is necessarily frightening.

This psychological experience of feeling something strangely familiar is still the subject of many researchers looking to understand and explain this phenomenon. In an attempt to do that, Masahiro Mori, a Japanese roboticist, developed a theory in 1970 in which he related human likeness with the perceived feeling of familiarity (Mori & Minato, 1970). He noticed that when more human features were added to objects or robots, the degree of resemblance to a healthy human being started to increase, but, when almost reaching the similarity of a real human, with a certain level of realism, the perceived familiarity inverted, forming the shape of a valley, generating a negative effect on observers reported as uncanniness.

Thus, the Uncanny Valley is referred to as an area when a robot, or an observed object, almost appears like a healthy human being, simulating the individual's complex details from a nearly complete realism. Moreover, it also represents a strange or a negative sensation, perceived by the observer, from realizing the target is not a real human being.

Although Mori's work was developed targeting robots, his Uncanny Valley concept is also applicable to other domains (Kätsyri, Förger, Mäkäräinen & Takala, 2015), such as virtual characters (Tinwell & Grimshaw, 2009) which are generated by artists using specific computer graphics software. These characters, reported as being computer-generated images (CGI), are widely used in films due to the emergence of more accessible computer graphics software technology, the internet as a medium of spreading knowledge, faster graphics cards with graphics processing unit (GPU) for managing complex three-dimensional polygonal scenes and the growth of streaming video services like Netflix and Amazon Prime, which always demand the development of new content.

The computer graphics field has been evolving fastly since 1973 when it was first used to aid visual narratives in films like *Westworld* by Lazarus and Crichton (1973). Its digital artists developed a pixelated technique to visually indicate the Yul Brynner's gunslinger robot point of view. After that, novel solutions never stopped emerging and became usual in the cinema world. In that context, it is relevant to highlight some of those advances that were seen in the following films like *Star Wars* (Kurtz & Lucas, 1977), which introduced the innovative computer-controlled motion photography allowing a more precise use of miniatures and models. In *The*

Abyss (Hurd, Ling & Cameron, 1989), the developers introduced the concept of a photorealistic fluid morphing, in a 75 seconds footage generated by a computer, bringing life to a creature. The awarded film *Who Framed Roger Rabbit* (Spielberg et al., 1988) successfully combined traditional cell animation with miniatures and live-action with a level of seamless integration that had never been achieved before. In *Death Becomes Her* (Bradshaw, Starkey, & Zemeckis, 1992), the filmmakers used a human skin created in CGI software to be replicated and incorporated on real actors. In *Jurassic Park* (Kennedy, Molen & Spielberg, 1993), photorealistic CGI dinosaurs were created, and an actor's face was replaced with a CGI one. For the film *Terminator 2: Judgment Day* (Cameron et al., 1991), rendering and lighting techniques were enhanced in order to simulate a mercury-like character that reflected its environment. *The Matrix Revolutions* (Wachowski et al., 2003) demonstrated an incredible concern to develop realistic-seeming virtual humans. Thus, the film researchers analyzed not only facial movement and composition but also hair, body, and clothing. They developed several techniques to achieve an outstanding visual effect. In *Avatar* (Cameron et al., 2009), the performance capture was used with the introduction of head-mounted cameras into the process, giving actors better freedom of movement on the stage and allowing the body and facial tracking to happen together. The virtual characters had their facial animation driven by the data from these head-mounted cameras. Recently, the film *Gemini Man* (Bell et al., 2019) created a method of de-aging its main actor. Artists have replaced the real actor face, using tracking marks, with his own younger face, which was digitally created. The last highlight is the film *The Lion King* (Favreau et al., 2019), which used an innovative virtual production process with elements including virtual reality. Because of the possibility of realistic render achievements, the visual effects team aimed at creating a live-action film and do not agree with an animation technique classification.

Thus, the art of making and using CGI characters for films relies not only on the visual appearance but on motion and the visual perception it provokes on the audience. Those are keys aspects to simulate the real. It is possible, for example, to use realistic CGI rendered characters in a film, that wouldn't be perceived as not real actors for most of the people, but at the moment they would start moving not accurately, that immersion would be broken rising the feeling of something strangely familiar on the audience. The literature mentioned films like *Beowulf* (Rapke, Starkey, & Zemeckis, 2007) and *The Polar Express* (Zemeckis et al., 2004) which coped with the Uncanny Valley effect (Hetherington & McRae, 2017). Those are cases of realistic CGI characters that were animated using motion capture technology device, which records actions of human actors in the form of digital data to be used on digital character models in 2D or 3D computer animation.

In this context, and according to Mori's graph (Mori, 1970), there is a different emphasis when movement is added regarding the Uncanny Valley zone. The effect on human likeness and familiarity has higher amplitudes, and consequently, the valley becomes deeper and harder to be crossed. This challenge is clearly a consequence of the fundamental dimensions of animation (MacGillivray, 2007), a sequence of observed images, with a defined motion during a certain time, making it more complex than a single image observation.

Based on Mori's theory of higher animation amplitude in the uncanny zone, this chapter aims first at reviewing the various approaches to the Uncanny Valley theory found in the literature. Second, contributing to this topic by presenting a communication perspective, based on the uses and gratification theory connected to the genre theory proposed by Chandler (2000). It is discussed the concept of animation as a genre classification and the consequences of that. Last, debating the technological momentum of rendering engines and the three-dimensional modeling software to propose that the valley has already been crossed from a still image perspective, but it is still not climbed out when motion is added to simulate a human being. Also, this leads to another proposal by the authors concerning the art style generated by this mentioned technological approach. A quasi-real art style classification where the CGI characters from recent films are located.

As an observation, the word *realistic* is used, for the purposes of this study, to indicate an artist's objective to create a character perceived as believably human-like (Sommerseth, 2007) or an ordinary scene seen as being real and not computer-generated.

BACKGROUND

There are many plausible theories explaining the Uncanny Valley effect (Kätsyri et al., 2015), even though, many authors (MacGillivray, 2007; Tinwell & Grimshaw, 2009) reported a lack of empirical evidence to sustain some of them. According to MacDorman and Chattopadhyay (2016), the Uncanny Valley has been empirically investigated since 2005, but the hypothesis remains controversial. Mori's hypothesis is challenging to be empirically tested (Cheetham, 2017), and it involves multiple possible variables to explain it.

Human perception, which consists of the acquisition, interpretation, selection, and organization of the information obtained by individuals' senses, is seen as key to understanding the eerie feeling caused by virtual characters situated in the Uncanny Valley area (MacGillivray, 2007). Even though the following theories are mainly based on human perception, it was also found in the literature other perspectives in regards to the Uncanny Valley effect.

Uncanny Valley Theories

One of the initial ideas concerning the Uncanny Valley is based on Mori's conception that the Uncanny Valley effect was a survival instinct for self-presentation, in which the negative reactions could protect individuals from threats, diseases, danger or even death (Mori & Minato, 1970; Mori, MacDorman & Kageki, 2012).

Other possible explanations found in the literature are related to category perception, which is referred to as a phenomenon where the observed category influences the observer's perception. Goldstone and Hendrickson (2010) showed, in an experiment, that individuals have better skills in perceiving perceptual differences between things belonging to divergent categories rather than the same ones. Nevertheless, critics were found concerning this theory applied to the Uncanny Valley (Kätsyri et al., 2015). The relation between the human-likeness dimension and its perception has no a priori reason to be perceived categorically as well the possible existence of other factors or variables in addition to categorization.

Categorization is the effort to categorize whether an entity or a character, is real or not. This could be ambiguous, or difficult, and is one of the earliest suggested theories trying to explain the negative affinity in the Uncanny Valley area (Kätsyri et al., 2015). Yamada, Kawabe and Ihaya (2013) suggested that this difficulty in categorizing the entity or character is connected to negative evaluation *regardless of whether the object is human-related or not.* Schoenherr and Burleigh (2014) suggested that the Uncanny Valley would be caused by a primary response to unfamiliar categories instead. A negative effect is produced on individuals or a group, with none or a lower frequency of a category exposure. It was also found that the process of categorizing what humans see could be classified as uncertain. This phenomenon concerns the change of the entity's observed category (MacDorman & Chattopadhyay, 2016), which can be morphed from a certain time into another category, causing a negative effect on the audience. Due to highly complex details, CGI characters, which aim for imitating a real human with no success, usually end up altering from a prominent virtual character to an identical real human in different moments.

Independent from the categorization hypothesis, MacDorman, Green, Ho and Koch (2009) presented in their research a theory concerning the perceptual mismatch. It is a discrepancy, or an inconsistency, of a specific human feature on a non-human entity or vice versa. An example given by Kätsyri et al. (2015) was *artificial eyes on an otherwise fully human-like face,* which is a divergence from human norms, in a human-like character.

A recent study published by MacDorman and Chattopadhyay (2016) described that the conflict concerning whether features from an observed person are real or not is caused by inconsistent levels of realism. This theory is based on a possible

violation of the neurocognitive expectancies that could lead to a negative emotional assessment. A negative emotional effect, caused by the Uncanny Valley phenomenon, is a consequence of a psychological discomfort known as cognitive dissonance.

Tinwell, Nabi and Charlton (2013) raised another vision with regards to the Uncanny Valley occurrence. They looked for a correlation between personality traits associated with psychopathy, perceived from the upper facial animation in human-like virtual characters. They found out that those perceived traits were a strong predictor of reported uncanniness.

Finally, Grinbaum (2015) presented a social science perspective, based on the work of the French philosopher René Girard, connecting it with the Uncanny Valley event. Girard developed an interpretative theory about the dynamics of desire, which is more complex than a relationship between one subject, a human, and the desired object. Instead, desire emerges from a triangular dynamic between two subjects and an object. The subjects, or individuals, become perfect doubles and end up imitating each other's desire for that object. Therefore, robots or virtual characters in the Uncanny Valley zone are not perfect doubles but categorized as monstrous doubles.

Uses and Gratifications Theory

Uses and gratifications (UG) is a socio-psychological theory and an audience-centered approach, developed to understand why and how people actively seek out specific media to satisfy certain needs. It is an extension of needs and motivation theory from Maslow (1970), in which humans are considered active seekers looking to satisfy a hierarchy of needs.

One of the key assumptions of this theory is that users are rational beings, active and free to choose their desired media to fulfill their needs with gratifications (Grissa, 2017). Also, the authors from UG theory (Katz, Blumler, & Gurevitch, 1974) assumed that the media choice is goal-oriented, however, this assumption generated criticism because sometimes habits or the power of media influence is not considered. People are often considered victims of the powerful forces of mass media (West & Turner, 2009), furthermore, gratifications or motivations may change over time. When a media becomes a habit, the audience does not seek gratifications in order to select a media. It is also important to mention that the audience has enough self-awareness and is responsible for connecting the need for gratification with a specific medium among others. The value judgments of media content can only be evaluated by them.

The UG theory has five general categories of needs and several connected gratifications (Katz, Haas, & Gurevitch, 1973):

- **Cognitive:** The user seeks information, or to gain knowledge.
- **Affective:** The user seeks for emotion, pleasure, or feelings.

- **Social:** The user desires to make connections.
- **Personal Integrative:** The user seeks for credibility, stability, or status.
- **Tension Release:** The user seeks for escaping, or relaxing.

Furthermore, there is a relevant perspective that might generate different results and analyses (Rauschnabel, 2018), which is the consideration of the discrepancy of gratifications sought (GS) versus gratifications obtained (GO). The research of Bae (2018) was driven by a lack of studies that attempted to address the difference between them. The gratifications expected, or sought, can be different from the gratifications obtained, and this discrepancy explains the frustration phenomena of users with high-expectations over a media. The author reported a relation between GS and GO, where user satisfaction became greater when GO exceeded GS.

Therefore, the connection with this theory lies in the audience, who watches a film to satisfy a need looking for specific gratifications. In addition, the film choice is linked with a chosen genre, which is the next topic to be covered.

Genre Theory

The French word genre, which came originally from Latin meaning 'kind' or 'class', is a term widely used in many mass media to categorize and then create a distinction among them. According to Chandler (2000), genres can be determined by the presence of multiple characteristics such as the plot or narrative structure, the character's role and motivations, basic themes or topics, the geographical or historical settings, the iconography, and the film technique.

A film genre classification can be particular, present a wide variation, and be detailed. As an example, the IMDb (2019), the massive online internet film database fed by the online community, has presented the main genre definitions used like action, horror, romance, and many more of a total of 28 classification genre names. Also, in the music media, it is possible to find several genre classifications that are commonly used to aid music seeking and categorization in streaming services like YouTube or Spotify.

Despite the existence of numerous genres in many kinds of media, Chandler (2000) pointed out that classifying and creating a taxonomy *is not a neutral and 'objective' procedure*. Some studies also (Fowler 1989; Wales 1989) goes in the direction of arguing the no existence yet of many genres and subgenres even with a large list of them been used. Thus, the process of classifying and identifying a genre, in any medium, may create theoretical disagreements concerning the method used and is considered an abstract conception (Feuer, 1992). Also, according to Gledhill (1985), genres are not discrete systems.

A genre can overlap and mix features, which can be something specific but not unique, triggering the discussion of its classification. While communication theorists are discussing the quality criteria for grouping a media, Chandler (2000) raised the question about how genres are really set thinking of their final purpose as a justification after observing that the public, in general, creates their own genre labels differently from academia theorists.

Thus, the genre is not something immutable, it is always being negotiated and changed (Buckingham, 1993), also, it establishes a relationship between producers and the audience (Chandler, 2000) being a mechanism to help users choosing their media and connect with their expectations.

A COMMUNICATION PERSPECTIVE

'Animation', which is a word that originally came from the Latin anima, is considered a broad concept of creating movement from the static (Luz, 2010). For Blair (1994:6), *Animation is both art and craft; it is a process in which the cartoonist, illustrator, fine artist, screenwriter, musician, camera operator, and motion Picture director combine their skills to create a new breed of artist - the animator.* It can be conceptually considered a medium or a film technique (Manovich, 2002) and can be created with different techniques like hand-drawn style, rotoscoping, stop-motion, cut-outs, 3D animation, and many more. Also, it has the possibility of containing many distinct narrative structures, character stereotypes, themes, and other genre characteristics mentioned.

However, Bordwell (1989) raised the question whether animation is a film genre or a mode, noticing that any kind of theme may be in any genre. According to Chandler (2000), a film technique is a possible characteristic applied to define a genre, and furthermore, some films genre classification can be connected to its content and some to its form. As an example of that, in a film genre classification, it is common to consider animation as a film genre. This is reflected in the massive online internet film database, the IMDb (2019), which contains approximately 293.169 registered animation titles sharing a common 'animation' genre and 83 million registered users who are able to feed the database information. This collective of individuals, a community, defining a genre was once argued by the theorist Andrew Tudor (Tudor, 1974) who stated that genre is *what we collectively believe it to be*. For Manovich (2002), the boundaries of actual digital cinema and animation are blurred and in the opposite direction, he argues that cinema is actually a subgenre of animation.

Thus, by considering the animation a film genre, as a result of the popular classification, it is interesting to notice that the majority of mainstream animated films usually seek a non-adult audience for targeting, resulting in the adoption of a

similar type of stylistic/aesthetic conventions in their development. This connection between the producer of content and the target audience also drove the common-sense categorization of animation as a genre, disregarding the fact it might contain different elements, creation techniques, and styles.

In order to search for traces of that, it is possible to find the number of 1.933 registered animation films at the IMDb database (2019) in which were given a US parental guidance certificate in the form of a rating seal. Those film ratings, five in total, were determined by the Classification and Rating Administration (CARA), via a board comprised of an independent group of parents that can be found in the US parental guidance system (FilmRatings, 2019). They are identified as general audiences (G), parental guidance suggested (PG), material inappropriate for children under 13 (PG-13), adult material (R), and under 17 years old not admitted (NC-17). So, from the total of 1.933 animation films US parental guidance certified in the IMDb database (2019), only 114 of them were R rated, and no single record was found with an NC-17 classification. This collected data is one evidence concerning the mentioned target audience (non-adult) chosen by the majority of animation films found.

Pursuing a communication perspective, it is possible to create a link between the audience's expectations and their experienced reward, as an outcome from a genre choice. The use of the socio-psychological theory of uses and gratifications, for that matter, is considered a successful framework that can be applied as a predictor of media use (Bae, 2018). Accordingly, in order to establish this connection, it is vital mentioning the emergence of visual effects and the regular use of realistic CGI characters in films, which are not genre classified as animation. Even aiming at building convincing virtual characters, filmmakers may not prevent the audience from still experience the Uncanny Valley effect on the screen.

The issue of a CGI based film is when it enters into the realm of realism, in other words, when it is intended to replace the real image unsuccessfully, crossing the border from being perceived as a live-action scene, produced with real footage, to an animated one. This is still noticeable in present days even with the advances in rendering technology, which is a mathematical engine, commonly present in animation software, responsible for generating images ranging from a cartoon to a realistic style simulating colors and real material's behaviors. Then, the previously needs and gratifications expected when selecting a film genre is conflicted by the recognition of another genre, which is commonly identified as being animation. Moreover, there are even more cases of animated genre films, which are extremely realistic in terms of scenarios and property objects, that seem a live-action film, but in contrast, leave traces of a computer-generated film presenting perceived CGI characters located in the Uncanny Valley zone bringing again the conflict of a non-animation versus an animation genre gratification.

In this context, it is essential to mention the existence of a discrepancy between gratification sought versus obtained (Bae, 2018) and its consequences. This could shed a light on the frustration phenomena of users around the negative effect of the Uncanny Valley perception from a communication point of view. Thus, the dilemma is not only focused on the change of genre and the expected gratifications but also on the common-sense perception that animation targets at the non-adult audience considering that most of the mainstream animation feature films are not targeting adults. For Wells (2002), animation has suffered a long history of negligence in academia and is usually considered basically an entertainment form aimed at children.

It follows that the adoption of the artistic style, generated by a render engine, is key to categorize whether the animated sequence is an animation genre or not. For example, Beowulf (Zemeckis et al., 2007) and The Polar Express (Zemeckis et al., 2004) were films within an artistic style classified as semi-realistic (Kätsyri, Mäkäräinen, &Takala, 2017). However, due to present improved render calculations, the threshold of new CGI films being easily classified as an animation genre is shrinking. Accordingly, for the purpose of this work and reflecting the product of contemporary technological innovations (Kunz, 2015), the authors propose the quasi-realism term as the actual momentum for representing this new frontier between real and the quasi-real mixed details on animation generated by computers. Despite having no relation, it is important to recognize the existence of this proposed term in the philosophy field, where quasi-realism is an anti-realist non-cognitive meta-ethical theory studied by Blackburn (1993).

In the next section, it is proposed that with the actual render technology, artists have already crossed the Uncanny Valley concerning still rendered images.

CROSSING THE VALLEY

Render engines are evolving quickly, seeking to simulate realistic material features, to be used by artists, with real behaviors to simulate skin, reflections, hair, refractions and many more physical attributes. With better-distributed algorithms, these engines are taking the advantages of GPU and CPU for generating fast results providing artistic possibilities never experienced before. Currently, it is possible to quickly generate previews of CGI scenes with millions of polygons, helping designers to manage how lights and materials behave in the scene, before creating the final rendering. This allows them to have more control over the scene and is referred to as the pre-visualization stage, in which the creative team discusses ideas and final looks for an animation shot faster than previously workflows.

All this evolution has been driving the quality enhancement of digital images, and it is also noticed the decline process overtime of the human ability to distinguish if

an image is computer-generated or a photograph (Farid & Bravo, 2007, 2012; Fan, Ng, Herberg, Koenig, & Xin, 2012; Holmes, Banks, & Farid, 2016). In an attempt to explore this topic, Fan et al. (2012) made a survey with 60 images (20 images with 3 shading variations) in which participants were asked to answer if they were CGI images or photos. They found out the existence of four CGI images in their survey that were judged by over half of the participants as photos, indicating they seemed more like photos than CGI images.

In the same perspective, Holmes (2015), also pursued to explore the theme of how realistic a CGI image may get. The survey considered 30 different face images with two versions each, a real photograph, and a CGI correspondent of it matching the age, gender, race, pose, and accessories. The 30 CG images were rendered between 2013 and 2014 and were composed of 15 male and 15 female faces with six random variations of pixel resolution, from 100 to 600 pixels. A total of 250 observers participated in the experiment through a questionnaire and, interestingly the maximum resolution didn't correlate with observer best accuracy rates for CGI images. Also, the most realistic rendered CGI images had the lowest averaged accuracy rates overall six resolutions. There was a case of the CGI image of the actor Russell Crowe, in which 76,7% of observers thought the image was wrongly real, and curiously, no example had 100% of the right answers.

Not only academia is exploring the advances of this theme. In a recent online survey promoted by Autodesk (2019), a computer graphic developer software company, users were invited to vote if a certain image was computer-generated or not. For this test, there were eight previously selected images mixed between real and CGI made. Although this survey had no scientific applied method (any user could take the test more than once), the results were interesting especially due to a large number of answered questions. From a total of 96.824 participants, only 4.310, or 4,4% of them, guessed the right answers for all the eight images. With a rate of 59%, most of the users got less than 50% of the right answers.

Considering this evolution, the authors propose then that CGI images have already crossed the valley when considering still objects or virtual characters with no motion. Although this render engine revolution played an important role in this departure, it is also essential to highlight the advances of computer graphics software, which has incorporated more accurate and complex tools dealing with realistic simulations and modeling techniques to get accurate representations of hair and fur, clothes, skin wrinkles, muscles, and other features. All this advance can be observed in the impressive artwork from the digital artist Hadi Karimi (2019). He showcased a rendered image (Figure 1) of the music artist David Bowie, totally digital made using 3D modeling software and a render engine. Wrinkles, fur, hair, skin details, texture, specular, materials, and even the jacket's folds were accurately represented in his work.

Figure 1. David Bowie (1977).
(© 2019 Hadi Karimi. Used with permission.)

Concerning moving virtual characters, the Uncanny Valley zone is a more challenge place to be crossed. Despite the possibilities of using accurate, physically-based shaders (PBS), highly detailed geometries and colors for simulating a real scene, humans have a sophisticated ability to perceive motion in other humans. Furthermore, under a person's skin, there are hundreds of muscles acting in coordination with the skeleton giving a certain movement to it. These systems (blood, muscles, and bones) incorporated inside real people are possibly digitally simulated by actual artists in a still pose artwork. Still, they represent a more significant challenge for a motion approach.

In a scientific work, pursuing to understand this different perception of the Uncanny Valley regarding animation or still images, Dill et al. (2012) created a survey asking six questions about ten characters presented in a still and animated form. They wanted to know if the participants previously knew the characters of the survey, then, if the characters were CGI or real, their level of realism, how the participants felt about those images, and last, if the participants felt any discomfort and in which part of the face mainly caused the most strangeness feeling. The still images were grabbed from the animation footage and they obtained 95 responses. As expected, the research outcomes showed that animated characters presented higher

levels of discomfort against the same characters in a still image form, or in other words, the Uncanny Valley zone when a motion was added had higher amplitudes making it harder to be crossed.

ETHICAL AND PSYCHOLOGICAL ASPECTS

Society is already facing a new social media era dealing with a large amount of information daily. High-speed connection using 4G or 5G technologies and the emergence of advanced smartphones made possible the popularization of multimedia content such as images and videos. With all the development of graphic software and new artificial intelligence algorithms, it is common to cope with fake videos and information shared by users on social media.

This is a recent concern theme known as fake news, which is often supported by multimedia contents, aimed at increasing their credibility. Fake videos can be generated by 3D CGI software, like creating a VFX film or by artificial intelligence algorithms that may use a type of neural network known as a generative adversarial network (GAN), for example (Marra, Gragnaniello, Cozzolino, & Verdoliva, 2018). These algorithms usually merge two real videos combining a face from one video into a body of another video generating the deep fake footage. As mentioned in a research conducted by Holmes (2015), the people's ability to recognize by visual perception if an image is real or CGI (fake) is low depending on the rendering quality. Besides, a similar study pursuing to discover if a photo was doctored or not demonstrated that individuals correctly classified only 62% of them (Nightingale, Wade & Watson, 2017). Thus, in order to improve those results, researches are facing this challenge by using a machine learning approach, which demonstrated detection accuracies beyond 90% (Cozzolino, Gragnaniello, & Verdoliva, 2014).

The literature also showed other methods developed to overcome this new dangerous phenomenon of fake videos. Li, Chang, and Lyu (2019) developed a new method based on the detection of eye blinking in the videos, which is described to be a psychological feature not well represented in synthesized fake videos. A secure image watermarking architecture was proposed by Alipour, Gerardo, and Medina (2019). Last, Yang, Li, and Lyu (2019) developed a method to unveil fake videos based on inconsistent head poses.

Although scientists are running to be one step ahead of the fake videos, its consequences are still unknown and dangerous. Hsu, Lee, and Zhuang (2019) mentioned that this topic might cause severe problems for society, affecting people's security through political and commercial activities. Also, fake videos could threaten national security, and the disinformation campaign may be harmful to democracy.

CONCLUSION

Motion is still the main responsible factor for unveiling the Uncanny Valley in a CGI production with virtual characters, nevertheless, it is essential to highlight some factors that contributed to overcoming the valley in a static image perspective: first, the constant technological evolution of render engines and computer graphic software, second, the hardware GPU revolution which made calculations faster and more accurate, in order to produce higher detailed images, and last, the share of knowledge from the digital art community through the internet.

Working with computer graphics aiming at art development is a broad and challenging field in which can involve professionals with different expertise. Artists and developers are the most common designations used in the industry in order to classify types of interests and contents. Thus, having such a wide variety of specific fields implies that learning CGI tools and software is not easy and demands time. At the beginning of the launch of personal computers, in which few people had access to computers, 3D software was a resource for just a few people and it was rare finding a CGI animation school or an instructor. Even in the actual days, with a new scenario of existing many schools, studying CGI software can be expensive, and a privilege for some. However, a community of digital artists emerged from the spread of the internet connection and the rise of video services sharing classes and knowledge. This growth played an important role in evolving the area, making people exchange challenges and results accelerating the CGI evolution.

The artistic style proposed in this chapter, quasi-realism, is based on the technological momentum where CGI still images are not recognizable anymore as being computer-generated, i.e., the valley has been crossed, opposing when motion is added. It is intended to be a didactic way of classifying a CGI image art style that almost crossed all the boundaries of a real pixel representation.

Although there is a lack of empirical evidence of a correlation between a film failed box-office and the presence of CGI characters in the Uncanny Valley zone, one can argue that this could be a reasonable factor to explain that failure (Kunz, 2015). According to Tinwell and Grimshaw (2009), once a CGI character is perceived as a not real human, the audience tends to be less forgiving highlighting the inaccurate movements or images in the animated sequence.

Despite the avoidance of CGI artists, creating a character in the Uncanny Valley area on purpose can be beneficial for designing a less empathetic villain (Schwind, Wolf, & Henze, 2018), or for engaging the audience into an immersive experience of the subconscious mind. The Canadian animator, Chris Landreth proposed in his animation short called Subconscious Password (Landreth, 2013), the usage of the Uncanny Valley as a portrait of people's subconscious processes, having created a realistic approximation of actual people. Also, the film produced by James Cameron,

Alita (Cameron, Landau, Valdes, & Rodriguez, 2019), is a recent example of a film that coped with the Uncanny Valley zone on purpose, presenting a realistic character with exaggerated eyes proportion.

ACKNOWLEDGMENT

This research is a result of the project CCD - Centro de Criatividade Digital (NORTE-01-0145-FEDER-022133), supported by Norte Portugal Regional Operational Programme (NORTE 2020), under the PORTUGAL 2020 Partnership Agreement, through the European Regional Development Fund (ERDF).

REFERENCES

Alipour, M. C., Gerardo, B. D., & Medina, R. P. (2019). A Secure Image Watermarking Architecture based on DWT-DCT Domain and Pseudo-Random Number. *ACM International Conference Proceeding Series*, (4), 154–159. 10.1145/3352411.3352436

Austin, S. (Producer), Cameron, J. (Producer), Hurd, G. A. (Producer), Kassar, M. (Producer), Rack, B. J. (Producer), & Cameron, J. (Director). (1991). *Terminator 2: Judgment Day* [Motion Picture]. United States: TriStar Pictures.

Autodesk. (2019). *Fake or Photo* [Website]. Retrieved February 4, 2019 from https://area.com/fakeorphoto

Bae, M. (2018). Understanding the effect of the discrepancy between sought and obtained gratification on social networking site users' satisfaction and continuance intention. *Computers in Human Behavior*, *79*, 137–153. doi:10.1016/j.chb.2017.10.026

Bell, B. (Producer), Benattar, R. (Producer), Bruckheimer, J. (Producer), Capone, S. (Producer), Ellison, D. (Producer), Goldberg, D. (Producer), Granger, D. (Producer), Guangchang, G. (Producer), Lane, J. (Producer), Lee, D. (Producer), Murphy, D. (Producer), Oman, C. (Producer), Reid, M. (Producer), Stenson, M. (Producer), & Lee, A. (Director). (2019). *Gemini Man* [Motion Picture]. United States: Paramount Pictures.

Blackburn, S. (1993). *Essays in Quasi-Realism* (Vol. 1). Oxford University Press.

Blair, P. (1994). *Cartoon Animation*. Walter Foster.

Bordwell, D. (1989). *Making Meaning: Inference and Rhetoric in the Interpretation of Cinema*. Harvard University Press.

Boyd, S. J. (Producer), Denise, D. (Producer), Goetzman, G. (Producer), Hanks, T. (Producer), McLaglen, J. (Producer), Rapke, J. (Producer), Starkey, S. (Producer), Teitler, W. (Producer), Tobyansen, P. M. (Producer), Allsburg, C. V. (Producer), Zemeckis, R. (Producer), & Zemeckis, R. (Director). (2004). *The Polar Express* [Motion Picture]. United States: Castle Rock Entertainment.

Bradshaw, J. (Producer), Starkey, S. (Producer), Zemeckis, R. (Producer), & Zemeckis, R. (Director). (1992). *Death Becomes Her* [Motion Picture]. United States: Universal Pictures.

Buckingham, D. (1993). Children Talking Television: The Making of Television Literacy. London: Falmer Press.

Cameron, J. (Producer), Breton, B. (Producer), Kalogridis, L. (Producer), Landau, J. (Producer), McLaglen, J. (Producer), Tashjian, J. (Producer), Tobyansen, P. M. (Producer), Wilson, C. (Producer), & Cameron, J. (Director). (2009) *Avatar* [Motion Picture]. United States: Twentieth Century Fox.

Cameron, J. (Producer), Landau, J. (Producer), Valdes, D. (Producer), & Rodriguez, R. (Director). (2019). *Alita: Battle Angel* [Motion Picture]. United States: Twentieth Century Fox.

Chandler, D. (2000). An Introduction to Genre Theory. The University of Wales. doi:10.1057/jors.1996.182

Cheetham, M. (2017). Editorial: The Uncanny Valley Hypothesis and beyond. *Frontiers in Psychology*, 8(October), 1–3. doi:10.3389/fpsyg.2017.01738 PMID:29089906

Cozzolino, D., Gragnaniello, D., & Verdoliva, L. (2014). Image forgery detection through residual-based local descriptors and block-matching. In *2014 IEEE International Conference on Image Processing (ICIP)* (pp. 5297–5301). 10.1109/ICIP.2014.7026072

Dill, V., Flach, L. M., Hocevar, R., Lykawka, C., Musse, S. R., & Pinho, M. S. (2012). Evaluation of the uncanny valley in CG characters. Lecture Notes in Computer Science, 7502, 511–513. doi:10.1007/978-3-642-33197-8-62

Fan, S., Ng, T. T., Herberg, J. S., Koenig, B. L., & Xin, S. (2012). Real or fake? Human judgments about photographs and computer-generated images of faces. *SIGGRAPH Asia 2012 Technical Briefs, SA 2012, 1*(212), 3–6. doi:10.1145/2407746.2407763

Farid, H., & Bravo, M. J. (2007). Photorealistic rendering: How realistic is it? *Journal of Vision (Charlottesville, Va.)*, *7*, 9.

Farid, H., & Bravo, M. J. (2012). Perceptual discrimination of computer generated and photographic faces. *Digital Investigation*, *8*(3-4), 226–235. doi:10.1016/j.diin.2011.06.003

Favreau, J. (Producer), Bartnicki, J. (Producer), Bossi, D. (Producer), Gilchrist, K. (Producer), Peitzman, T. C. (Producer), Schumacher, T. (Producer), Silver, J. (Producer), Taymor, J. (Producer), Venghaus, D. H., Jr. (Producer), & Favreau, J. (Director). (2019). *The Lion King* [Motion Picture]. United States: Walt Disney Pictures.

Feuer, J. (1992): Genre study and television. In Channels of Discourse, Reassembled: Television and Contemporary Criticism. London: Routledge.

FilmRatings. (2019). Retrieved January 15, 2019 from http://www.filmratings.com

Fowler, A. (1989). Genre. In E. Barnouw (Ed.), *International Encyclopedia of Communications* (Vol. 2, pp. 215–217). Oxford University Press.

Freud, S. (1919). The 'Uncanny'. In *The Standard Edition of the Complete Psychological Works of Sigmund Freud, Volume XVII (1917-1919): An Infantile Neurosis and Other Works*, (pp. 217-256). Academic Press.

Gledhill, C. (1985). Genre. In P. Cook (Ed.), *The Cinema Book*. British Film Institute.

Goldstone, R. L., & Hendrickson, A. T. (2010). Categorical perception. *Wiley Interdisciplinary Reviews: Cognitive Science*, *1*(1), 69–78. doi:10.1002/wcs.26 PMID:26272840

Grinbaum, A. (2015). Uncanny valley explained by Girard's theory. *IEEE Robotics & Automation Magazine*, *22*(1), 150–152. doi:10.1109/MRA.2014.2385568

Grissa, K. (2017). What "uses and gratifications" theory can tell us about using professional networking sites (E.G. Linkedin, Viadeo, Xing, Skilledafricans, Plaxo...). In R. Jallouli, O. R. Zaïane, M. A. Bach Tobji, R. Srarfi Tabbane, & A. Nijholt (Eds.), *Lecture Notes in Business Information Processing* (Vol. 290, pp. 15–28). Springer International Publishing., doi:10.1007/978-3-319-62737-3_2

Hetherington, R., & McRae, R. (2017). Make-Believing Animated Films Featuring Digital Humans: A Qualitative Inquiry Using Online Sources. *Animation*, *12*(2), 156–173. doi:10.1177/1746847717710738

Holmes, O., Banks, M. S., & Farid, H. (2016). Assessing and improving the identification of computer-generated portraits. *ACM Transactions on Perception, 13*, 7:1–7:12.

Holmes, O. B. H. (2015). *How realistic is photorealistic?* doi:10.1109/TSP.2004.839896

Hsu, C. C., Lee, C. Y., & Zhuang, Y. X. (2019). Learning to detect fake face images in the wild. *Proceedings - 2018 International Symposium on Computer, Consumer and Control, IS3C 2018*, 388–391. 10.1109/IS3C.2018.00104

Hurd, G. A. (Producer), Ling, V. (Producer), & Cameron, J. (Director). (1989). *The Abyss* [Motion Picture]. United States: Twentieth Century Fox.

IMDb. (2019). Retrieved January 15, 2019 from https://www.imdb.com/

IMDb Database. (2019). Retrieved January 15, 2019 from https://www.imdb.com/search/title?genres=animation&certificates=US%3AR,US%3ANC-17.

Karimi, H. (2019). *Hadi Karimi Website.* Retrieved December 4, 2019 from https://hadikarimi.com/

Kätsyri, J., Förger, K., Mäkäräinen, M., & Takala, T. (2015). A review of empirical evidence on different uncanny valley hypotheses: Support for perceptual mismatch as one road to the valley of eeriness. *Frontiers in Psychology, 6*, 1–16. doi:10.3389/fpsyg.2015.00390 PMID:25914661

Kätsyri, J., Mäkäräinen, M., & Takala, T. (2017). Testing the 'uncanny valley' hypothesis in semirealistic computer-animated film characters: An empirical evaluation of natural film stimuli. *International Journal of Human Computer Studies, 97*, 149–161. doi:10.1016/j.ijhcs.2016.09.010

Katz, E., Blumler, J., & Guretvich, M. (1974). Uses of Mass Communication by the Individual. In J. G. Blumler & E. Katz (Eds.), *The Uses of Mass Communications: Current Perspectives on Gratifications Research* (pp. 19–32). Sage Publications.

Katz, E., Haas, H., & Gurevitch, M. (1973). On the Use of the Mass Media for Important Things. *American Sociological Review, 38*(2), 164. doi:10.2307/2094393

Kennedy, K. (Producer), Molen, G. R. (Producer), & Spielberg, S. (Director). (1993). *Jurassic Park* [Motion Picture]. United States: Universal Pictures.

Kunz, S. (2015). The problem of realism in animated characters – has the uncanny valley been crossed? *International Conference in Illustration & Animation*, 74–86. Retrieved from http://repositorio.ucp.pt/handle/10400.14/19661%5Cnhttps://www.academia.edu/11899468/The_problem_of_Realism_in_animated_characters_has_the_Uncanny_Valley_been_crossed

Kurtz, G. (Producer), Lucas, G. (Producer), & Lucas, G. (Director). (1977). *Star Wars* [Motion Picture]. United States: Twentieth Century Fox.

Landreth, C. (2013, May 23). *Welcome to the Uncanny Valley: A sneak peek at Chris Landreth's new film, Subconscious Password* [Blog post]. Retrieved November 20, 2019, from https://blog.nfb.ca/blog/2013/05/23/chris-landreth-uncanny-valley-subconscious-password/

Lazarus, P. N. (Producer), & Crichton, M. (Director). (1973). *Westworld* [Motion Picture]. United States: Metro-Goldwyn-Mayer.

Li, Y., Chang, M. C., & Lyu, S. (2019). In Ictu Oculi: Exposing AI created fake videos by detecting eye blinking. *10th IEEE International Workshop on Information Forensics and Security, WIFS 2018*, 1–7. 10.1109/WIFS.2018.8630787

Luz, F. C. (2010). Digital animation: Repercussions of new media on traditional animation concepts. Lecture Notes in Computer Science, 6249, 562–569. doi:10.1007/978-3-642-14533-9_57

MacDorman, K. F., & Chattopadhyay, D. (2016). Reducing consistency in human realism increases the uncanny valley effect; increasing category uncertainty does not. *Cognition*, *146*, 190–205. doi:10.1016/j.cognition.2015.09.019 PMID:26435049

MacDorman, K. F., Green, R. D., Ho, C. C., & Koch, C. T. (2009). Too real for comfort? Uncanny responses to computer generated faces. *Computers in Human Behavior*, *25*(3), 695–710. doi:10.1016/j.chb.2008.12.026 PMID:25506126

MacGillivray, C. (2007). How psychophysical perception of motion and image relates to animation practice. *Computer Graphics, Imaging and Visualisation. New Advances, CGIV*, *14*(10), 81–88. doi:10.1109/CGIV.2007.48

Manovich, L. (2002). *The language of new media*. MIT Press.

Marra, F., Gragnaniello, D., Cozzolino, D., & Verdoliva, L. (2018). Detection of GAN-Generated Fake Images over Social Networks. *Proceedings - IEEE 1st Conference on Multimedia Information Processing and Retrieval, MIPR 2018*, 384–389. 10.1109/MIPR.2018.00084

Maslow, A. H. (1970). *Motivation and personality* (2nd ed.). Harper & Row.

Mori, M., MacDorman, K. F., & Kageki, N. (2012). The uncanny valley. *IEEE Robotics & Automation Magazine*, *19*(2), 98–100. doi:10.1109/MRA.2012.2192811

Mori, M., & Minato, T. (1970). The Uncanny Valley, Translation. *Energy*, *7*(4), 33–35. doi:10.1109/MRA.2012.2192811

Nightingale, S. J., Wade, K. A., & Watson, D. G. (2017). Can people identify original and manipulated photos of real-world scenes? *Cognitive Research: Principles and Implications*, *2*(1), 30. doi:10.118641235-017-0067-2 PMID:28776002

Rapke, J. (Producer), Starkey, S. (Producer), Zemeckis, R. (Producer), & Zemeckis, R. (Director). (2007). *Beowulf* [Motion Picture]. United States: Paramount Pictures.

Rauschnabel, P. A. (2018). Virtually enhancing the real world with holograms: An exploration of expected gratifications of using augmented reality smart glasses. *Psychology and Marketing*, *35*(8), 557–572. doi:10.1002/mar.21106

Schoenherr, J. R., & Burleigh, T. J. (2014). Uncanny sociocultural categories. *Frontiers in Psychology*, *5*(OCT), 1–4. doi:10.3389/fpsyg.2014.01456 PMID:25653622

Schwind, V., Wolf, K., & Henze, N. (2018). Avoiding the uncanny valley in virtual character design. *Interaction*, *25*(5), 45–49. doi:10.1145/3236673

Sommerseth, H. (2007). Gamic realism: Player perception, and action in video game play. *Proceedings of Situated Play, DiGRA 2007 Conference*, 765–768.

Spielberg, S. (Producer), Hahn, D. (Producer), Kennedy, K. (Producer), Marshall, F. (Producer), Starkey, S. (Producer), Watts, R. (Producer), & Zemeckis, R. (Director). (1988). *Who Framed Roger Rabbit* [Motion Picture]. United States: Touchstone Pictures.

Tinwell, A., & Grimshaw, M. (2009). Bridging the Uncanny: An impossible traverse? *Proceedings of the 13th International MindTrek Conference: Everyday Life in the Ubiquitous Era*, 66–73. 10.1145/1621841.1621855

Tinwell, A., Nabi, D. A., & Charlton, J. P. (2013). Perception of psychopathy and the Uncanny Valley in virtual characters. *Computers in Human Behavior*, *29*(4), 1617–1625. doi:10.1016/j.chb.2013.01.008

Tudor, A. (1974). *Image and Influence: Studies in the Sociology of Film*. George Allen & Unwin.

Wachowski, L. (Producer), Wachowski, L. (Producer), Berman, B. (Producer), Forbes, D. (Producer), Hill, G. (Producer), Mason, A. (Producer), Oosterhouse, P. (Producer), Popplewell, V. (Producer), Richards, S. (Producer), Silver, J. (Producer), Wachowski, L. (Director), & Wachowski, L. (Director). (2003). *The Matrix Revolutions* [Motion Picture]. United States: Warner Bros.

Wales, K. (1989). *A Dictionary of Stylistics*. Longman Wellek.

Wells, P. (2002). *Animation: Genre and Authorship. Short Cuts Series: Introduction to Film Studies* (Vol. 99). Academic Press.

West, R., & Turner, L. H. (2009). *Understanding interpersonal communication: Making choices in changing times*. Wadsworth/Cengage.

Yamada, Y., Kawabe, T., & Ihaya, K. (2013). Categorization difficulty is associated with negative evaluation in the "uncanny valley" phenomenon. *The Japanese Psychological Research*, *55*(1), 20–32. doi:10.1111/j.1468-5884.2012.00538.x

Yang, X., Li, Y., & Lyu, S. (2019). Exposing Deep Fakes Using Inconsistent Head Poses. *ICASSP, IEEE International Conference on Acoustics, Speech and Signal Processing - Proceedings,* 8261–8265. 10.1109/ICASSP.2019.8683164

ADDITIONAL READING

Alexander, O. R., Lambeth, M., Jen-Yuan Chiang, W., Ma, W.-C., Wang, C.-C., & Debevec, P. (2010). The digital Emily project: Achieving a photorealistic digital actor. *IEEE Computer Graphics and Applications*, *30*(August), 20–31. doi:10.1109/MCG.2010.65 PMID:20650725

Bryant, J., & Oliver, M. B. (2009). *Media effects: Advances in theory and research*. Routledge. doi:10.4324/9780203877111

Courtland, R. (2015). Review: The Uncanny Valley. *IEEE Spectrum*, *52*(2), 26. doi:10.1109/MSPEC.2015.7024503

MacDorman, K. F., Green, R. D., Ho, C. C., & Koch, C. T. (2009). Too real for comfort? Uncanny responses to computer-generated faces. *Computers in Human Behavior*, *25*(3), 695–710. doi:10.1016/j.chb.2008.12.026 PMID:25506126

Mäkäräinen, M., Kätsyri, J., & Takala, T. (2014). Exaggerating Facial Expressions: A Way to Intensify Emotion or a Way to the Uncanny Valley? *Cognitive Computation*, *6*(4), 708–721. doi:10.100712559-014-9273-0

Mousas, C., Anastasiou, D., & Spantidi, O. (2018). The effects of appearance and motion of virtual characters on emotional reactivity. *Computers in Human Behavior*, *86*, 99–108. doi:10.1016/j.chb.2018.04.036

Tinwell, A. (2014). The Uncanny Valley in Games and Animation (1st ed.). New York: A K Peters/CRC Press. doi:10.1201/b17830

West, R. L., & Turner, L. H. (2010). *Introducing communication theory: Analysis and application*. McGraw-Hill.

KEY TERMS AND DEFINITIONS

CGI: It stands for computer-generated imagery. The application of computer graphics designed to aid the creation of images, or a sequence of them, for all kinds of media.

GPU: It stands for a graphics processing unit and is located in the computer graphic card. Calculations and final rendered images are generated faster when using GPU.

Live-Action Film: Films that are made using traditional cameras and human actors. It uses mainly photography instead of animation or computer-generated images.

Physical-Based Materials: Materials that simulate real physical properties.

Quasi-Real: A proposed new artistic style term to aid the classification of the new frontier between real and the almost real details on images generated by computers.

Realistic Graphics: A term to defy an art style category in which a rendered image or video attempts to simulate a real-life scene.

Rendering: The final product, or an image synthesis, generated by the computer software after several calculations are done from a computer graphics file.

Subsurface Scattering: It is a mechanism of light transport, depending on the material, where the light penetrates the surface of a translucent object and is scattered leaving it at a different position. It is normally used to simulate human skin.

Chapter 6

Reimagining the Audience– Dancer Relationship Through Mobile Augmented Reality

Patrick Pennefather
Ⓘ https://orcid.org/0000-0002-1936-1872
University of British Columbia, Canada

Claudia Krebs
University of British Columbia, Canada

Julie-Anne Saroyan
Small Stage, Canada

ABSTRACT

The research and development of an augmented reality (AR) application for Vancouver-based dance company Small Stage challenged a team of students at a graduate digital media program to understand how AR might reinvent the audience-dancer relationship. This chapter will chronicle the AR and choreographic development process that occurred simultaneously. Based on the documentation of that process, a number of insights emerged that dance creators and AR developers may find useful when developing an AR experience as counterpart to a live dance production. These include (1) understanding the role of technology to support or disrupt the traditional use of a proscenium-based stage, (2) describing how AR can be used to augment an audience's experience of dance, (3) integrating a motion capture pipeline to accelerate AR development to support the before and after experience of a public dance production.

DOI: 10.4018/978-1-7998-3669-8.ch006

INTRODUCTION

An increasing number of contemporary dance artists, choreographers and dance producers are integrating mobile technologies to create an experience of dance that appeals to the needs of emerging audiences. Sharing our experiments and explorations will advance our use of different technologies to extend the experience of the performative to a multiplicity of physical and virtual stages. The case study presented in this article depicts the use of Augmented Reality to interconnect an outdoor public event with a before and after experience. The creation of mixed realities, may lead to a different conception of an artistic creation that resonates with new audiences, who want to engage with our work in different ways.

CHAPTER OVERVIEW

This chapter will present a review of some technological methods that have supported proscenium-based contemporary dance works and those that have attempted to disrupt them. In the first part of the chapter, we underline how the traditional use of the proscenium more than any other type of stage, in dance and other performance traditions has informed how dance is seen. Choreographers, dance makers, producers and videographers have used technology in creative ways but most continue to perpetuate a separation between audience and dancer. In the second part of the chapter, we review early performative initiatives that have disrupted the distinction between audience and dancer, and how these have inspired the integration of technology to generate new types of audience interactions. In the third part of the chapter we detail the emergence of 3D capture technologies that have allowed dance creators to think of dance and dancer from multiple perspectives. In the final part of the chapter we describe an Augmented Reality (AR) research creation process that integrated the motion capture of dancers in order to present a 360-degree perspective, informed by a consideration of the before, during and after experiences of a public dance event. The integration of an AR application proposes an interconnected dance experience encompassing physical and virtual interactions useful to dance creators who want to draw new audiences to engage with their art in different ways and through multiple perspectives.

INTRODUCTION

Our use of Augmented Reality (AR) was motivated by a need to engage and in some cases re-engage emerging and often neglected audiences who want to "[engage] in the

arts differently." (Cohen 2013). We aspire to offer opportunities for those potential audiences who are not necessarily "walking away from the arts so much, but walking away from the traditional delivery mechanisms". Emerging audiences are interested in engaging interactively with dance and dancer beyond the typical venues where dance is produced. It may be beneficial for dance-creators to understand how technology has supported the popular *delivery mechanism* of proscenium-based performances. Equally beneficial will be to gain deeper understanding of less familiar initiatives that provided audiences with multiple perspectives of dance, in some ways more resonant with *theatre in the round* staging. For those interested in experimenting with different technologies when considering collaborations with software developers in the creation of interactive work that reimagines the audience-dancer relationship, the descriptive AR application development process in the second section of the chapter might also be useful.

TECHNOLOGY TO ENHANCE THE PROSCENIUM-BASED STAGE

While contemplating the use of emerging technologies like Augmented Reality (AR) to reimagine audience interactions with a performance, we need to understand two inter-connected forces. The first and most influential informing how dance is perceived, is the traditional staging of dance and other art forms including theatre that continues to dominate the performing arts scene; a perspective that creates a clear distinction between performer(s) on stage and a captive audience watching them. The second is how contemporary dance forms have been captured and represented through a variety of different media including photography, film, video, 360 video, and sensor-based technologies.

The Enduring Influence of Proscenium-Based Performance

When Isaac (1971) wrote the *Death of the Proscenium Stage*, chronicling the replacement of late 19th Century proscenium stages with early cinemas, he does not reflect on the similarities that both mediums proposes, particularly in terms of the constructed separation between an audience and what that audience watched. The relationship most dance creators have envisioned in the past two centuries when devising choreography is well described by Strindberg, where performers "are integrated into a three-dimensional physical and imaginary space behind the proscenium arch, considered as an immanent unit, and spectators are conceived as voyeurs peeping through a keyhole" (Imre, 2005, p. 44). Figure 1 below depicts a typical proscenium based stage, as opposed to a thrust stage with audiences on

Figure 1. The proscenium arch above the stage in Chicago's Auditorium Building. Adapted from United States Library of Congress's Prints and Photographs division, JW Taylor, photographer, 1887.

either side of the stage, or theatre-in-the-round, a more rarely used type of stage that the audience surrounds.

To provide captive audiences with increasingly enhanced 'keyholes', the development of technology in the performing arts has been informed by the evolving arts of stagecraft for different types of stages (scenic design, costume, lighting, props, sound, video and projection). Over the years, and influenced by cost, expertise in operation, and how reliable different technologies have been, some technologies have been integrated into regular use while others have faded into obscurity. While projection seems to have become common to many productions, sensors that allow dancers to trigger audio-visual cues, projection mapping, Augmented Reality (AR) and Mixed Reality have yet to become mainstays. These are still exploratory technologies that for a number of reasons have not yet become persistent in use. An early example of augmenting dance performance with projection reveals experiments

by Alwin Nikolais "well known for his dance pieces that incorporated hand painted slides projected onto the dancer's bodies on stage" (Brockhoeft et al., 2016, p. 398). The work of Nikolais is significant as it points to early experimentation of projecting two dimensional images onto the dancer's body. This, as opposed to its more common usage throughout the 20th century of projecting pre-rendered static or video images "behind performers on stage to create the illusion of interactivity" (p. 397) or to create environment, location, mood and historical period. The idea of integrating projected two dimensional objects, scenes and/or characters onto the real-world of the stage using any combination of screen, scrim, curtain, walls, set pieces or the stage itself as projected surface is common to dance and other performance traditions. The use of projection to augment performance has evolved to allow creators to *map,* or position specific projected images onto a variety of different shaped surfaces including actors. Projection mapping was first used in productions like Sondheim and Lapine's musical *Sunday in the Park with George* (1984). That evolution has included experimentation with the technology of interactive spatial AR (Wellner, 1991) that uses cameras to track the interaction of a performer with a projected image or video mapped to specific objects (Beira, Carvalho, & Kox, 2013; Clay et al, 2014; Lee et al., 2015; Bokaris et al., 2020). Sparacino et al. constructed "an interactive stage for a single performer [that allowed technicians] to coordinate and synchronize the performer's gestures, body movements, and speech, with projected images, graphics, expressive text, music, and sound" (p. 2). The Dance and Engineering in Augmented Reality (DEAR) collective demonstrated the capacity for AR to augment performance. They used "live scenes using visible projection of media onto dynamics surfaces in the real world" (Korostelev et al., 2011) and allowed dancers to have real-time interaction with moveable panels. Most concerted efforts over the years by dancers, choreographers, producers, film makers and technology developers, have been focused on creating experiences that support the performers' world on the stage behind the proscenium. Those impulses continue to delineate a boundary between the performer on the stage and audiences who have been trained to observe at a distance, "subject to strict behavioral regulations [sitting] silently and undisturbed in the darkness of the auditorium" (Imre, 2005, p. 44). While dance has been presented on thrust stages offering front and side views of a performance, the prevailing contract remains; an audience receives what a performer projects. Even difficult to locate dance performances within theatrical productions on theatre-in-the-round stages abide by the same established division. Some theatre productions that integrate choreography within a production seem to engage more in faking "an in-the-round feel by modifying a proscenium theatre, either using a thrust or adding seats onstage" (Snook, 2015). Regardless of the desire to erode or make vanish the fourth wall however, creators integrating different types of technological innovations in different venues have at times had to accept the affordances and

constraints of a proscenium, informed by the complex computational tasks upon which the performers and performance depend. Emerging technologies to enhance stagecraft need to be operated from a low-risk controlled environment and need to be consistent in their own performance. A rule of play with performance is that if a technology is not stable and threatens the staging of a work, then it will not be used no matter how astonishing.

Capture Technologies and the Reinforcement of the Audience-Performer Dichotomy

The influence of proscenium-based dance has directly informed how dance has been captured and presented to viewers on different types of screens. Most technological advances in this capacity have, since the early days of Edison, Muybridge, and others been applied to replicate the proscenium view of dance for a viewing audience that does not need to do much to watch. This is evident in early attempts to 'capture the dance' in order to experience it through pre-recorded 'keyholes'. Eadweard Muybridge's Dancing Woman (1887), shows one of the earliest attempts to capture the motion of a dancer using Chronophotography (Figure 2), a method that was used to rapidly photograph successive phases of motion using multiple cameras, in effect slowing down the dance to its frame by frame representation. In Figure 2, we notice the perspective of the dancer that epitomizes a similar proscenium-based perspective.

Figure 2. Woman Dancing (Fancy): Plate 187 from Animal Locomotion.
Adapted from Museum of Modern Art, New York City, USA by Eadweard J. Muybridge, 1887

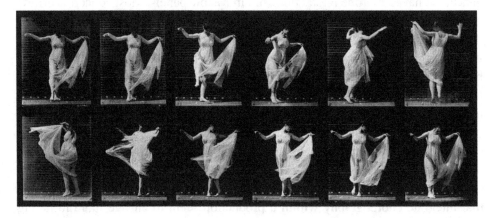

Muybridge demonstrated that the everyday motion of typical human activities could be dissected into a series of stills. When pieced together with a zoopraxiscope

or other mechanical device, a moving representation of all those captured images was displayed. Since that time, the representation of dance has evolved through a variety of different types of 'keyholes'. Screens, mediating the live dancer have included photography, film, television, projection on a multitude of surfaces, computer monitors, tablets, mobile devices and head-mounted displays (Virtual Reality (VR) and Mixed Reality (MR) devices). With the exception of experimental dance films and some music videos presenting dance artists in different types of locations (warehouse, beach, industrial wastelands), with close-ups on different body parts, as part of a narrative journey, and using all types of visual effects, the dominant use of film and video continues to present full-bodied dancers from a front perspective and on a proscenium stage, with all energy focused by a performer to the camera representing a seated audience member. Despite advances in technology, as early as the turn of the 21st Century, Dixon (1999) writes of dance's transposition to computer screen, commenting that "the computational proscenium returns drama to its traditional roots within a fixed box frame" (p. 138). In that same year Merce Cunningham's Biped (1999), used a process of "optical motion capture devices to record the moving bodies of dancers". These were transferred into digital 3-D representations, manipulated, and finally the dancers performed along with the projected animations" (Capristo, 2012) on a proscenium-based stage. While viewers may be afforded different viewing angles of dance and a variety of locations through the lenses of Virtual Reality, the dancer is shot from the front, maintaining either a proscenium or thrust perspective offering 180-degree video. If an VR user looks behind or too far left or right they will only see black. Case Western Reserve University's dance production (Robinson, 2017), offered audience members head-mounted displays (Microsoft's Mixed Reality Hololens) to observe and augment live dance on a typical proscenium stage. While compelling from the point of view of creating a hybrid MR experience, the audience relationship with the dancer transpired through a more modernized head mounted *keyhole*. The Hololens offers users a limited field of view when superimposing virtual images onto the real world. The depiction in Figure 3 while not precisely correct in the percentage of the image that can be seen, gives an idea of the area a hologram might occupy when looking through the lens onto the real world.

Leveraging technology to change stagecraft but not straying too far from the traditional convention of enhancing the performance for a captive audience seems to be a common recurring theme. This is why the persistent reinvention of audience-dancer relationships leveraging technology does not necessarily result in a new audience experience. To understand how to engage audiences differently, we would benefit from knowing some of the experiments that artists have engaged in, in opposition to the audience-performer relationships that proscenium-based stages reinforced, and how these forged new interactions regardless of the technology used to do so.

Figure 3. Small Stage Canadian National Arts Centre touring shot courtesy of Small Stage 2017

DISRUPTING PROSCENIUM-BASED PERFORMANCE

The separation between audience and performer has been challenged across the arts and has been well-documented for over a century. Clowns, pantomimes, vaudeville and cabaret performers, have led the charge, often engaging in behaviors and interactions that disrupt the boundaries of the proscenium. Early 20th Century inspirations, like Brecht's dialectal theatre motivated a variety of artists across culture, time and performing traditions to experiment with breaking the fourth wall, usually by actors engaging audience members in dialogue, re-arranging the set in front of an audience, disregarding the boundaries between stage and audience, and blurring the line between the world in the play and the world outside of it by disrupting narrative flow. The resurgence of theatre-in-the-round stages in 20th Century North America, like Seattle's Penthouse Theatre (1940), proposed a new type engagement with an audience in 360, offering them multiple perspectives of the same staged play. The breaking of the fourth wall has been instigated in film, as early as McLane's (1918) silent film *Men Who Have Made Love to Me*, many of the movies by Stan Laurel and Oliver Hardy during their Roach era (1926-1940), addressing the viewing audience from both silent and spoken movies, and the antics of Charlie Chaplin in *The Great Dictator* (1940), as if present in the viewer's current reality. Although pantomime and mime traditions have experimented with breaking the divide between stage and performer, the early emergence of dance creators disrupting the proscenium convention is not as well-known historically. We can trace early experiments that may have fueled the courage required to disrupt audience

expectations from impresario Diaghelev's Ballets Russes, and choreographer Nijinsky challenging ballet convention in league with Stravinsky (1913). Indeed, if a riot did in fact occur on May 13th, 1913, it was a combination of events that challenged the convention of ballet itself, if not through audience/performer relationship, then definitely through challenging norms and expectations of what an audience should expect in the theatre. A combination of "strange, stamping movements and awkward poses defied every canon of gracefulness" while "Stravinsky's score for *The Rite of Spring* contradicted every rule about what music should be" (Hewitt, (2016). The disruption of the audience-performer relationship seemed to thrive, however, predominantly in non-conventional theatrical environments whose staging, such as black box theatres afforded new interactions. These included what we might categorize as site-specific locations nowadays such as restaurants, pubs, community halls, churches and any number of public indoor and outdoor spaces, in addition to mobile theatre initiatives tasking audiences with moving around several sites to experience the work.

When New York critic Anderson (1974) commented on the typical context of experiencing a dance performance where "one is always conscious that the dancing is happening behind the proscenium arch; the proscenium arch, in fact, serves very noticeably as a picture frame", Trisha Brown (Floor of the Forest, 1970, and Roof piece, 1971) had already begun challenging the idea of the proscenium by removing it as an obstacle, transporting dancer and audience to site-specific locations where dance could be experienced from different sight lines. Pina Bausch was another dance artist "acclaimed for breaking through the fourth wall, having her dancers intrude on the people in Row A, shake their hands, [and] ask them for money" (New Yorker, 2002). Another early pioneer in this regard, was Forsythe, particularly with Ballett Frankfurt (1980-2004) where his company persistently broke the fourth wall and blurred the lines between audience and performer. In his later work in art galleries (1991-2018), he deconstructed ideas of what constituted a show. Still relevant since its first appearance in 1999, contemporary Israeli choreographer Ohad Naharin attempts to break the fourth wall with "Minus 16" (Ballet BC, 2017): at the end of the performance, dancers bring audience members on stage and perform with them, effectively eliminating the boundaries between observer and observed, between performer and audience. This participatory approach can provide a more immersive experience for those audience members brought onto the stage. Managing the conventions demanded of creators in typical proscenium based theatrical venues, dance creators like Naharin attempt to disrupt the 'picture frame' of the stage that divides audience and performer, by breaking that fourth wall and in so doing offering audiences a less formal and different perspective of dance.

Disrupting the Traditional 'Picture Frame' of Dance With Technology

Nowadays, and more than ever before, dance producers have access to affordable and ubiquitous technologies and non-proscenium site-specific spaces allow new relationships with audiences. There exist some documented disruptive experiments that are worth mentioning. One example occurred as early as 1966 in a staging of Steve Paxton's Physical Things, a collaboration with engineer Dick Wulf (Valverde 2004, as cited in Risner & Anderson, 2008, p. 114). Paxton tasked audience members to provide the sound score that cued dancers in terms of duration and phrasing (p. 114), by manipulating audio devices that created different sounds "dependent upon the audience member's movement" (p. 114). New genres of artistic hybrid creations integrating postmodern dance forms and film in the late 20th Century, have contributed to the erosion of dance being associated solely with the live proscenium stage. More recently, the ubiquitous nature of the internet has opened the opportunity for "dancers from different locations to perform for live audiences in real time across time zones" (Parrish 2007, p. 1383). As Brockhoeft et al. report "interactivity in performance can even extend past the artist's control and be given to the audience" (p. 398). The author's recount the work of Toenjes and Reimer (2015) and their Laboratory for Audience Interactive Technologies that tasked "audience members…to download an application to their phones [allowing] them to directly impact and interact with the show changing certain visualizations or triggering cues". Small Stage's 'Jukebox' installation at the Fun Palace: Carnival of Mixed Realities (2019) offered audiences the opportunity to co-curate short dance works before they were presented interacting with a host to choose from a selection of audio, projected images, lighting and dance. At the same event, some audience members were ushered into a secret booth where they were challenged to maintain focus on a Burlesque dancer through a window as they were bombarded with text messages. The moment audience members turned their attention to the iPad in front of them, the dynamics and emotion of the dance would shift, often resulting in the dancer leaving the staged booth disappointed. Offering different types of interactions on different types of stages to audiences have afforded multiple perspectives of dance. Virtual Reality platforms like Facebook, YouTube and Google are experimenting with placing the user at different places on the stage to view live performances and presentations from various locations and perspectives. VR also offers performative potential. One example is the installation *Eve, Dance is an Unplaceable Place* by Margherita Bergamo and digital artist Daniel González Franco, centered around a contemporary dancer wearing a VR headset who draws in spectators to interact through touch. The pioneering work of fourth wall disruptors paved the way for increased opportunities to look at dance in a different way. The growth and popularity

of computing technologies and with it, access to and increasingly affordable 3D technologies have inspired dance creators to experiment with representing a dancer in three dimensions, stripping bare the typical front view perspective of the dancer.

CAPTURING MOTION IN THREE DIMENSIONS

Beyond the contestable '3D'ifying' of dance on a typical 2D screen, and the longer history of 3D animation of dance, which once relied on the animator's ability to recreate pre-recorded film and video of real dancers to inspire motion, more recent technologies such as motion capture have proposed a different type of reframing. Motion capture is an "animation technique [that] measures a dancer's position and orientation in three dimensional space in real time, while recording the data in a computer" (p. 125). That data includes "location, speed, duration and various movement qualities" (p. 125) often as part of an interactive system (Naugle, 2001, 2006).

It offers an alternative to merely representing the dance in two dimensions through traditional video capture. In its early application in dance, motion capture was predominantly explored as a utilitarian tool in order to support the choreographic process, in the archival of work and the ability to recall choreographic sequences from a 3D perspective. Experiments in motion capture began more than 30 years ago with internationally recognized New York based choreographer Bill T. Jones. Ghostcatching represented dance in a more abstract way using motion capture and fusing "dance, drawing, and computer composition" as a digital art installation (Jones, Kaiser and Eshkar's (1999). Integrating motion capture into a live dance performance, Jones commented that motion capture "may change the dancer's predicament de rigueur by invigorating a self they didn't know they had" (Dils, 2002, p. 95). The dancer's perspective of themselves is augmented, observing their motion from multiple angles they are no longer a two dimensional representation of self. The same is true for the viewer's perspective. As Risner and Anderson (2008) write "the audience–performer relationship is expanded from a one-sided conversation into a dialogue" (p. 49). Motion capture has evolved dramatically over the years with innovations in performance capture inclusive of facial and finger capture, as well as different types of capture systems. There have been incredible developments across media, from video games to 3D animation. In terms of the use of motion capture in performative settings, capture and tracking techniques have been experimented with on a live dancer wearing a motion capture suit, in order to represent them as another type of character, projected on a screen to a live audience. Meador et al.'s (2004) interdisciplinary creation experimented with "dance performance featuring live-motion capture, real-time computer graphics, and multi-image projection"

(p.1). Meador's team were experimenting with new audience-dancer relationships, allowing audiences to experience the dance in a variety of real and virtual formats simultaneously. Clay et al.'s (2014) innovative work "explored 3D stereoscopy as a display technique for augmented reality and interaction in real time on stage" (p. 21) using an xSens motion capture suit with seventeen sensors mapping the joints of the body. While the performance was presented in a traditional proscenium-based stage at least attempts were made for virtual content to 'reach out' to audiences wearing 3D glasses. Beyond the use of motion capture in the live staging of dance, we were interested in using the technology to create a new type of dancer. That dancer could have meaning beyond the confines a proscenium-based stage, their traditional 2D passive representation on a screen, and could be accessed by anyone with a mobile device.

A CASE STUDY OF AUGMENTED REALITY APPLICATION DEVELOPMENT

For reasons of affordability and increased access, marker-based augmented reality applications on mobile devices offers dance creators and software developers familiar development pipelines that may accelerate technological integration. Knowing this, and having knowledge of the traditional audience-dancer relationship, and the context in which that relationship has been reinforced, the goal of the AR application project was to investigate new potential interactions through the use of augmented reality in an outdoor public space. Small Stage, a dance production company dedicated to experimenting with and producing public engagement with dance, wanted to explore how AR dancers could complement a series of summer dance productions in an outdoor venue. This part of the chapter will discuss the development of the AR application as a case study by: 1) describing the parallel development of the AR application and the choreographic process for the live outdoor event; 2) present the investigation as a case study and; 3) detail evolving research questions.

Designing for AR While the Dances Were Created

In most design processes there is a phase dedicated to ideation, brainstorming and exploration and while the tools to achieve this may be different, a similar process occurs in the development process of modern dance. A choreographer and/or dance creator develop material in a rehearsal space, source music, conduct research into the underlying story, theme, inspiration, in order to generate ideas that will support their choreographic creation. Part of the ideation phase of the development team consisted in working with dancers while the choreography was still in development.

Rather than working with a completed choreographic routine, the team was presented with four dances-in-progress consisting of small sections, exploring initial ideas and sequences that were under a minute in duration. To accelerate the virtualization of the dance sequences to be used in a marker-based AR application, the development team enlisted an established motion capture studio.

Figure 4. The Sawmill Motion Capture Studio by Sean Conroy 2018

Motion capture was thought to speed up the process as time would be saved animating movement since the studio would also provide an existing rig, and initial clean-up of the captured data. The animation team was introduced to Motion Builder software in order to fine tune the rig, preparing it for animation within Maya and import into the Unity 3D game engine. These sequences were rehearsed prior to bringing them to the studio for capture. The dance producer, acted as a bridge between the physical and digital worlds persistently considering how the AR motion captured dance might fit into the live dance production itself. All elements of the live choreography, AR software development and the integration of the physical and the virtual co-existed in a prototypical phase; each influenced by the other.

Case Study Research

An increasing number of scholarly texts have surfaced that document the iterative experimentation of AR with dance (Franz et al., 2016; Clay et al., 2012, 2014; Sparacino et al., 1999), in order to detail the process, or discuss the parallel development of a dance production along with the emerging technology that supports that live production. Context-specific emerging technology development is difficult to replicate as each case study is informed by the vision of the choreographer and in-the-moment decisions of the development team in terms of how they will integrate art with design and programming, and what they believe they will be able to co-construct. While the MDM team was being mentored with the development of the AR application by supervisor and the Small Stage team, inquiry into the design process was not focused on investigating a pre-determined occurrence of a phenomenon in a controlled environment. Research was aligned with Case Study research, originated by Stake (1982) whereby a number of phenomena are explored in context and assertions made are specific to the context in which research is conducted generating naturalistic generalizations "as a product of experience" (Stake, 1978, p. 6). In the Small Stage case study, an intentional design approach was not possible. Transparency about the uncertainty of how the AR application would eventually be integrated within the live dance production kept the development and choreographic teams open to all possibilities. The research process complemented that of many live dance productions; a shifting pendulum between an intention to have our audience experiences pre-defined, and the acceptance that audiences will interpret the meaning of our work however they might.

Evolution of Research Questions

Research questions that guided the development team evolved from being concerned with the application development process to an increasing concern of the user experience. That focus allowed the team to identify an idealized hybrid user/audience member who might: 1) be interested in attending the outdoor dance event, and 2) have exposure to an AR application before, during and after the live dance work. With an initial focus on development we began with this question: *How can a motion capture pipeline be integrated into augmented reality dance application for a live production?* The team quickly realized the answer to this question had already been proposed by many developers, artists and scholars through a variety of publications (Parrish, 2007; Alaoui et al., 2013; Clay et al., 2014). Motion capture (MoCap) can save time for animators when it comes to rigging and developing a sequenced animation. In relation to the representation of dance virtually, it is important to note that MoCap had its own limitations, predominantly based on a limit of a 15-joint

skeleton that the capture of motion was rigged to. Capturing the articulation of the fingers on the hand, for example has been a persistent historical challenge in the MoCap field that is still in progress despite advances in glove sensors. Beyond the MoCap pipeline and how it might accelerate a 3D visualization of choreographed dance, the software development team needed to understand how the virtual dancer in the AR application would be inter-connected with the live dance. Collaboration with Small Stage afforded us the opportunity to persistently consider the integration of the physical and virtual worlds of the production. An AR app offered very specific affordances and constraints including representation and accuracy of movement, and how it would fit in to the larger scale live dance production. The following research question became more central to the investigation reflecting a greater integration of both the development and choreographic process: *How can an AR dancer inter-connect audiences to the live dance experience before, during and after a series of performances*? Answering this question with Small Stage allowed all of us to better understand the role of the virtual dancer within the bigger picture, which, was to exist within an independent mobile application that users could access before, during and after the public performances. It also helped to scope what we could do in the limited time period of three weeks, the technologies that would be employed, and what we needed to have ready for application to be publishable as it would be downloaded prior to the live event. In addition, Small Stage's mandate to engage the public compelled the software development team to identify a hybrid audience/ user: an audience member experiencing the physical reality of the dance around them and the virtual one experienced through some type of screen. *What new interactions and experiences would an AR dance application offer audience-goers before and after an outdoor dance production*?

INSIGHTS FROM THE AR APPLICATION DEVELOPMENT PROCESS

Several insights emerged from the development of the AR dance experience and its integration in the vision of the live Small Stage production. These include recommendations to: (a) redefine notions of audience by decomposing their entire experience, (b) identify and design for usability through persistent user-testing of the AR application; (c) design audience experiences before and after the live dance event; (d) inter-connect the virtual and real dances and dancers through the use of motion capture; (e) experiment with the representation of a live dancer in the virtual, and (f) leverage an integrated AR experience to propose new audience interactions.

Redefine the Audience/User in Context

Designing for users is a familiar process in many software development processes but the language tends not to be used in live performance traditions. We refer to the humans that engage with our interactive applications as users and those who watch a typical dance show as an audience. When creating dance for traditional proscenium-based audiences the interaction points are not that complex. Most of the time the audience is seated, quiet and well behaved. The dancer's responsibility is to offer their craft and project their performances to a seated audience usually positioned in front and on either side of the dancer. Lighting is pre-determined and called as a series of fixed cues. Music, whether live or pre-recorded is also cued. While some choreographers encourage and expect dancers to improvise to music, they are usually familiar with the musical form as they would have rehearsed with it prior to the performance. When it comes to reinventing the audience-dancer relationship during a person's before, during and after experience of an outdoor dance event, it will benefit us to identify multiple types interaction points with that dance; each audience member experiencing the dance performance from a different perspective simultaneously. In the process we combined choreographic, performative and technological languages to define a new type of inter-connected performative and mediated experience. Some audience members began their journey as mobile AR users prior to experiencing the live dance event, and others after they finished watching the performance. All those who downloaded the application would have a memento of the event in virtualized form, that they could interact with anywhere and anytime they wished. We also needed to understand potential features the application would offer that would inspire people to download and use the application.

Identify and Design for Usability

Human-centered design tools common to application development such as user-experience driven prototyping were central in the user experience design. The AR process integrated a user-centric approach centered on identifying usability issues that the AR audiences might have with a mobile device, when used as a complement to an outdoor dance performance. User-tests gave the team insights on the development environment (Unity 3D), operating system, how to design interactions in outdoor lighting conditions, the look/feel representation of the dancer, accuracy of motion as reflected in real-world dance, integration of music, best type of physical marker that would trigger the AR dancer, duration of the experience, size of virtual dancer in relation to screen size, and more. Testing for usability intersected many times with the intended audience experience the team designed for. As an example, remaining true to the intent of reinventing the audience-dancer relationship, the team chose a

360-degree view of the dancer. This design decision challenged the convention of a virtual dance contained solely within a 180-degree proscenium or thrust view. This design decision allowed audiences viewing the live production to also access the virtual dancers through the AR application and watch excerpts of the dance from whatever perspective they chose.

Design Audience Experiences Before and After the Live Performance

As the development team more closely understood the AR audience's possible journeys, they reflected on the design and identified two major interaction points; before and after the live performance. At the onset of the project, Small Stage was unsure of whether or not the application would be published. Identifying why we wanted audiences to interact with the application prior to experiencing the live dance production challenged the MDM team to design a scalable prototype that the Small Stage team could eventually publish and offer to their extensive audience base. Part of the reason to rapidly prototype an AR application was an identified need for audiences to have access to the application ahead of a performance, in order to give them a glimpse of what the live production might be like. As Small Stage made clear, access to the free application ahead of time also became a marketing tool to offer to existing followers and to attract new types of audiences to attend the live event. This is somewhat related to initiatives being taken by other dance creators turning to "Viber chats, vlogs and Periscope live streams to give audiences an honest look into their lives" (Ouelette, 2016). In the case of Small Stage, for those unable to access the live event, the application was a strategic method of inclusion and access. Spontaneous street walkers who might not have known of the AR application nor the dance production ahead of time were also identified by Small Stage. These types of users inspired Small Stage to activate the AR application in a pre-show talk pointing audiences to printed QR codes in the surrounding area that linked to the Google Play and Apple Store. Once the connection between the virtual and physical worlds of dance was forged, audiences knew that they had an application to take home with them; virtual dancers as a memento of the live production. AR audiences could use the business card size Small Stage markers to trigger a reminder of the real dances anytime they wanted. During the post-show experience audiences that formed after the performances had already begun, were guided to download the application and "take the dancers home" in between each work. While the application was primarily designed with a before and after experience in mind, the performances created an opportunity to regularly introduce new audiences to the application, extending the number of downloads and creating new Small Stage followers in the process. In this way the live event increased the opportunity for audiences to experience the

AR application and the AR application introduced potential users to the experience of the live dance production.

Inter-connect the Virtual and Real Dances and Dancers Through the Use of Motion Capture

The use of motion capture afforded a powerful mimetic tool that functioned to inter-connect the gestural vocabulary common to both the virtual and the real dances. If AR audiences experienced the virtual dancer prior, they would then be able to see recurring movement patterns and through motion effects of water and fire, connect each dance to specific elements. If AR audiences experienced the virtual dancer after, they would have a virtualized version of what they had just seen to keep and re-trigger, show friends and to remind them of the real world dance experience.

Experiment With the Representation of a Live Dancer in the Virtual

Tempting as it was to use a generic rigged human model to convey the captured motion of each dancer, the team, guided by Small Stage, discovered that it was far more interesting to leverage a variety of Unity particle effects to convey meaning that reflected the inspirational themes of the Elements (water, fire, air).

Figure 5. First prototype of AR dance shows more traditional representation of dancer and stage with front view limitation by Sean Conroy, 2018

In doing so, AR audiences were exposed to a version of the dance that was not trying to simply emulate or provide references to the live performance. The AR

dances were an artistic work by themselves, similar in the gestural vocabulary of the live dances, yet different enough to stand on their own.

Leverage an Integrated AR Experience to Propose New Audience Interactions

Figure 6. (overleaf) AR application in use showing a rotatable stage placed on a table viewed from above of a particle effected dancer by Sean Conroy, 2018

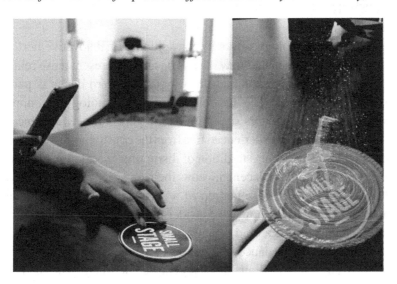

The choice to use AR as a key part of the entire audience/user experience for the project afforded the opportunity to disrupt a more traditional perception of the project solely being perceived by audience/user as similar to a typical proscenium-based experience. While the site-specific nature of the Small Stage production also contributed to that disruption, the virtual dance in its 360-degree perspective introduced our hybrid audiences to an entirely different way to experience dance. Unlike a traditional performance, the AR audience was transformed into co-curator. There were a number of ways in which this was achieved. First, they chose the angle of view through which virtual dance was seen as compared to having little choice when viewing a staged live performance. Our co-curators could also experiment with the distance of the phone from the marker, shifting the dancer's dimensions, getting a close-up look at the details, and experiencing the virtual dance with any real-world background they wanted. The AR audience was provided more points of interaction than simply watching a dance performance. While the AR dance

consisted of a triggered routine and the screen between the virtual dancer and AR audience could be interpreted as a new type of proscenium, the virtual dance could be seen anywhere, from a lying, seated or standing position and on any surface. Audiences could pause the dance, observe it from different angles in 360 degrees. This reinvented relationship with live dance and virtual dancer provoked the AR audience to experience an inter-connected dance production in a completely different way; one not constrained by time or place.

CONCLUSION

Regardless of what technology offers in conventional or innovative performance environments, there has been and may always be an ever-present tense relationship between technological innovation and the way that modern dance is performed, presented and experienced. The use of emerging technology to support live dance productions offers creators opportunities to generate new audience-dancer relationships. For dance to be experienced free from the constraints of the proscenium, dance creators need to continue a tradition of disrupting expectations for audiences who may have become complacent in how their experience of dance has been designed. The augmented representation of a dancer in 360 engage an audience differently and transforms the how we consider the stage, performer and audience. Our emerging audiences are a kind of newly empowered co-curator who can now create the stage, summon the dance at their convenience and superimpose it in three dimensions onto any real-world surface. They can decide where, when and how they want to experience or re-experience parts of a choreographed routine they found memorable. An augmented reality dancer adds to a transforming landscape of dance. Through this case study, the process of capturing dance using motion capture was instrumental in accelerating the pipeline, and provided Small Stage with a living choreographic record of the process itself. Equally important, the intentional use of AR as a critical component of a live dance experience created a new performative ecosystem that bridged the real and the virtual, and engaged the public in a new way. Launched with Small Stage's outdoor Summer Series, the application interconnected audiences to the dancers in the real world. With the combination of an outdoor site-specific production of dance staged as theatre-in-the-round and an augmented perspective of a dancer free from the constraints of a proscenium-based perspective, a new inter-dependent dance event was prototyped and tested offering an experience of dance accessible to both older and newer generations of audiences.

REFERENCES

Alaoui, F., Jacquemin, C., & Bevilacqua, F. (2013). Chiseling bodies: an augmented dance performance. In *CHI'13 Extended Abstracts on Human Factors in Computing Systems* (pp. 2915–2918). ACM. doi:10.1145/2468356.2479573

Anderson, J. (1974). *Critics Notebook of the Proscenium Arch and how it Affects Dance*. Retrieved from https://www.nytimes.com/1979/09/04/archives/critics-notebook-of-the-proscenium-arch-and-how-it-affects-dance.html

Beira, J., Carvalho, R., & Kox, S. (2013). Mixed reality immersive design: a study in interactive dance. In *Proceedings of the 2013 ACM international workshop on Immersive media experiences* (pp. 45-50). 10.1145/2512142.2512147

Bokaris, P. A., Gouiffès, M., Caye, V., Chomaz, J. M., & Jacquemin, C. (2020). Gardien du Temple: An Interactive Installation Involving Poetry, Performance and Spatial Augmented Reality. *Leonardo*, *53*(1), 31–37. doi:10.1162/leon_a_01569

Brockhoeft, T., Petuch, J., Bach, J., Djerekarov, E., Ackerman, M., & Tyson, G. (2016). Interactive augmented reality for dance. In *Proceedings of the Seventh International Conference on Computational Creativity* (pp. 396-403). Academic Press.

Budgwig, S. (2013). *Site-specific Dance*. Retrieved from https://brooklynrail.org/2014/09/dance/site-specific-dance

Capristo, B. A. (2012). *Dance and the use of technology* (Doctoral dissertation). University of Akron.

Clay, A., Couture, N., Nigay, L., De La Riviere, J. B., Martin, J. C., Courgeon, M., & Domengero, G. (2012). Interactions and systems for augmenting a live dance performance. In *2012 IEEE International Symposium on Mixed and Augmented Reality-Arts, Media, and Humanities (ISMAR-AMH)* (pp. 29-38). IEEE. 10.1109/ISMAR-AMH.2012.6483986

Clay, A., Domenger, G., Conan, J., Domenger, A., & Couture, N. (2014). Integrating augmented reality to enhance expression, interaction & collaboration in live performances: A ballet dance case study. In *2014 IEEE International Symposium on Mixed and Augmented Reality-Media, Art, Social Science, Humanities and Design (ISMAR-MASH'D)* (pp. 21-29). IEEE. 10.1109/ISMAR-AMH.2014.6935434

Conroy, S. (2018). *The Sawmill Motion Capture Studio: Small Stage in Session*. Academic Press.

Dils, A. (2002). The ghost in the machine: Merce Cunningham and Bill T. Jones. *PAJ a Journal of Performance and Art*, *24*(1), 94–104. doi:10.1162/152028101753401820

Dixon, S. (1999). Remediating theatre in a digital proscenium. *Digital Creativity*, *10*(3), 135–142. doi:10.1076/digc.10.3.135.3240

Elephant. (2019). *The dance troupe testing the limits of technology*. Retrieved from https://elephant.art/86172-2/

Franz, N. P. S., Sudana, A. O., & Wibawa, K. S. (2016). Application of basic Balinese dance using augmented reality on Android. *Journal of Theoretical & Applied Information Technology*, *90*(1).

Gee, D. (2017). Ohad Naharin's Minus 16 is a Masterwork of his. *Style*. https://vancouversun.com/entertainment/local-arts/ohad-naharins-minus-16-is-a-masterwork-of-his-style

Gomide, J. V. B. (2012). Motion capture and performance. *Scene*, *1*(1), 45–62. doi:10.1386cene.1.1.45_1

Hewitt, I. (2016). *The Riot at the rite: The premiere of the Rite of Spring*. Accessed from https://www.bl.uk/20th-century-literature/articles/the-riot-at-the-rite-the-premiere-of-the-rite-of-spring

Imre, Z. (2005). *Theatre, theatricality and resistance: some contemporary possibilities* (Doctoral dissertation).

Isaac, D. (1971). The Death of the Proscenium Stage. *The Antioch Review*, *31*(2), 235–253. doi:10.2307/4637444

Jones, B. T., Kaiser, P., Eshkar, S., Girard, M., & Amkraut, S. (1999, July). Ghostcatching. In *ACM SIGGRAPH 99 Electronic art and animation catalog* (p. 143). ACM. doi:10.1145/312379.312948

Katiyar, A., Kalra, K., & Garg, C. (2015). Marker based augmented reality. *Advances in Computer Science and Information Technology*, *2*(5), 441–445.

Lee, J., Kim, Y., Heo, M. H., Kim, D., & Shin, B. S. (2015). Real-time projection-based augmented reality system for dynamic objects in the performing arts. *Symmetry*, *7*(1), 182–192. doi:10.3390ym7010182

Meador, W. S., Rogers, T. J., O'Neal, K., Kurt, E., & Cunningham, C. (2004). Mixing dance realities: Collaborative development of live-motion capture in a performing arts environment. *Computers in Entertainment*, *2*(2), 12–12. doi:10.1145/1008213.1008233

Muybridge, E. J. (1887). Woman Dancing (Fancy): Plate 187 from Animal Locomotion. Museum of Modern Art.

Ouellette, J. (2016). *Breaking the Fourth Wall*. Retrieved from https://www.dancemagazine.com/breaking-the-fourth-wall-2307007996.html

Pennefather, P., Ryzhov, V., Danenkov, L., Saroyan, J., Rosenbaum, L., Desnoyers-Stewart, J., Stepanova, K., Alzate, H., Yueh, S., Pabon, F., & Ripoli, L. (2019). *Fun Palace: Carnival of mixed realities*. Centre for Digital Media.

Risner, D., & Anderson, J. (2008). Digital Dance Literacy: An integrated dance technology curriculum pilot project. *Research in Dance Education, 9*(2), 113–128. doi:10.1080/14647890802087787

Robinson, D. (2017). *Dancing with holograms: CWRU stages first-of-its-kind mixed-reality dance performance using Microsoft HoloLens*. Retrieved from https://thedaily.case.edu/dancing-holograms-cwru-stages-first-kind-mixed-reality-dance-performance-using-microsoft-hololens/

Ross, L. (2011). *Spectacular Dimensions-3D Dance Films*. Retrieved from http://sensesofcinema.com/2011/feature-articles/spectacular-dimensions-3d-dance-films/

Snook, R. (2015). *Theatre in the round*. Retrieved from http://dictionary.tdf.org/theatre-in-the-round/

Sondheim, S., & Lapine, J. (1991). *Sunday in the Park with George*. Hal Leonard Corporation.

Sparacino, F., Wren, C., Davenport, G., & Pentland, A. (1999). Augmented performance in dance and theater. *International Dance and Technology, 99*, 25–28.

Taylor, J.W. (1887). *Chicago Auditorium Building, interior from balcony*. United States Library of Congress's Prints and Photographs division.

The New Yorker. (2002). *Play it again*. Retrieved from https://www.newyorker.com/magazine/2002/01/14/play-it-again

Wellner, P. (1991, November). The DigitalDesk calculator: tangible manipulation on a desk top display. In *Proceedings of the 4th annual ACM symposium on User interface software and technology* (pp. 27-33). 10.1145/120782.120785

Chapter 7
Creating Emotions Through Digital Media Art:
Building Empathy in Immersive Environments

Paulo Veloso Gomes
 https://orcid.org/0000-0002-3975-2395
LABRP, School of Health-Polytechnic of Porto (UP), Portugal

Vítor J. Sá
 https://orcid.org/0000-0002-4982-4444
Portuguese Catholic University (UCP), Portugal

António Marques
 https://orcid.org/0000-0002-8656-5023
LABRP, School of Health-Polytechnic of Porto (UP), Portugal

João Donga
 https://orcid.org/0000-0002-8701-2113
LABRP, School of Health-Polytechnic of Porto (UP) Portugal

António Correia
LABRP, School of Health-Polytechnic of Porto (UP), Portugal

Javier Pereira Loureiro
 https://orcid.org/0000-0001-9328-0723
CITIC, University of Coruña, Spain

ABSTRACT

Art has a power different from all other human actions; it can produce a variety of human emotions like nothing else. The main purpose of this chapter is to study the

DOI: 10.4018/978-1-7998-3669-8.ch007

relation between media arts and emotions. Virtual environments are increasingly being used by artists; the use of immersive environments allows the media art artist to go further than express himself, allows that through contemplation and interaction the participant also becomes part of the artistic artefact. Immersive environments can induce emotional changes capable of generating states of empathy. Considering an immersive environment as a socio-technical system, where human and non-human elements interact, establishing strong relationships, the authors used actor-network theory as an approach to design an immersive artifact of digital media art. The use of neurofeedback mechanisms during the participant's exposure to immersive environments opens doors to new types of interaction, allowing to explore emotional states to generate empathy.

INTRODUCTION

Art has an unique power, it is the most powerful of human endeavors, it produces a variety of human emotions (Neal, 2013). Emotions are one of the most influential factors to the human mental life. When someone is facing a work of art, feels something. Emotions are a psychological experiment that stimulates the human being. Other than the traditional art, the Media Art involve the audiences in the art works process. With media art, the work of art is no longer just an element of contemplation, the public has become part of it. The concept of immersiveness connects the participant and the artwork, transforming them into a single element (Lee & Hyung, 2014).

This chapter addresses the use of an immersive media art artifact that captures the participant's emotional states to generate empathy. In the first section, this work highlights and relates the role of emotions with media art, addressing the concept of affective computing that results from the combination of different areas of knowledge. Then, a reflection is made about the importance of emotions in the construction of empathy and how the simulated physical acts can influence emotional states and induce empathy.

In the third section Actor-Network Theory concepts were applied as a theoretical and methodological framework in the analysis and design of an immersive artifact of digital media art, the e-EMotion-Capsule.

The next section describes the multidimensional immersive media art artefact based on different interaction experiences that create emotions capable of generating states of empathy. This media art artefact uses three types of immersive environments:

360° video, virtual reality, and mixed reality. The last section refers to the application of neurofeedback mechanisms in immersive media art environments.

This work explores the possibility of using immersive environments to promote emotional states that generate empathy.

MEDIA ART AND EMOTIONS

Three strong words: media, art, and emotion! An era of industrialization of emotions arise. A person gets emotional, seeks emotion, is satisfied with emotion. Perhaps the seventh art has become the maximum exponent in triggering emotions (for the time being): with engaging narratives, and transmedia in some cases; with complex and realistic animation effects, whether they are two-dimensional or three-dimensional; with sound effects ranging from stereo to 8D sound; in short, a whole range of manipulations and expressions (techno artistic) that the digital treatment of audio visual came to allow.

If the information is processed digitally, at some stage of the process we will be faced with the use of a processing machine - the computer. We can consider only the production of content, taking advantage of the tremendous processing capacity of machines that are increasingly evolved, to the point that it is not possible to distinguish the real (filmed) from what is virtual (generated by the computer). But we can also think about the new world that opens due the fact we can interact with machines and they can respond in real time, entering us in such domains like virtual reality and augmented reality. It should be noted at this point that, due to technological constraints, the first one has been more concerned with visualization at the detriment of interaction and the second one more concerned with interaction at the detriment of visualization.

In the context of human-machine interaction, the input and output of the computer have been quite asymmetric. The amount of information or bandwidth that is communicated from the computer to the user has generally been much greater than the bandwidth from the user to the computer (Jacob, 1996). This imbalance influences the intuition and performance of the user's interaction, and the tendency is to improve the bandwidth from the user to the system.

A computer presentation through several channels (output) has become familiar under the designation of Multimedia, a topic that has been extensively explored, e.g. in (Marcos, Bernardes, & Sá, 2002). Input channels or sources, also known as input modes or modalities, are the basis for the type of applications that support the human-computer interaction designated by Multimodal Interaction (Sá, Malerczyk, & Schnaider, 2001).

To develop multimodal interaction systems, it is important to obtain basic models of the interactive process. A good way is to look at the Human Information Processing System with all the capabilities that already exist (highly optimized in this respect). Four levels of observation must be considered: physical (device characteristics), information theoretical (digital bandwidth and digital communication concepts), cognitive, and intentional (Schomaker et al., 1995). Multimodal interaction is related to the cognitive one, which is the level where representational and procedural aspects must be made explicit in syntax and semantic, where pattern recognition processes should take place and, therefore, where information of a more abstract level is addressed. The intentional level is where "goals" and "beliefs" of the involved agents have to be made explicit (Hildebrand & Sá, 2000).

We would say that the fundamental aspect of the media arts then lies in the possibility of interaction, and the reprogramming of that interaction, with audio-visual content, and even vestibular (sense of balance) or tactile. With this technological openness, and education for computational thinking, an unprecedented path is opened for the exploration of emotions. Computers will increasingly understand people and, consequently, create empathy and states of mind. Consequently, affective computing is the emerging topic. "The question is not whether intelligent machines can have any emotions, but whether machines can be intelligent without any emotions. - Marvin Minsky (1927-2016)" (Cambria, 2016).

Affective computing (Picard, 2000) is a multidisciplinary field that involves computer sciences, psychology and cognitive sciences considering emotions and "states of mind" for the development of computer systems. It aims to build tools that somehow simulate human affection, allowing the creation of dialogues with the user considering their emotional state.

In this context, multimodal affect recognition and analysis has become an important topic in the scientific community (especially among computer scientists). Much research has been done to develop information fusion techniques. We can distinguish different classes of multimodal systems, from those who integrates signals at the feature level (early fusion) to those who make that integration at the semantic level (late fusion). One is adequate for closely coupled and synchronized modalities (e.g. speech and lip movements), and the other one.(based on an amodal input) is appropriated when the modes differ substantially in the time scale characteristics of their features (e.g. speech and gesture input) . In the middle ground we can also use hybrid fusion approaches. A list of multimodal fusion techniques can be found in Poria *et al* (2017).

The machine is already beginning to perceive humans. In fact, we can program computers to see, hear and learn from humans. Interactive systems are increasingly complex, making it possible to create, in the field of the arts, a symbiosis between the artist and the tools used as never before. After architecture, painting, music,

sculpture, literature, dance and cinema, interactive media is, consensually, the eighth art. The media art is a new form of art, precisely because of the characteristic of interactivity. Of course, even without interactivity, current audio-visual systems, stereoscopic, with graphics superimposed on real images, etc., allow us to recreate emotional states like never before. However, it is through interaction that the new media arts provide that it is possible to enhance the creation of emotions (Veloso Gomes et al., 2019). In fact, art and emotions are closely linked over time (Silvia, 2005) and are inextricably linked (Lopatovska et al., 2015).

To create emotions, we must understand them (psychology), and when we understand we can systematize knowledge and instruct the computer to analyze them automatically, that is, to get some kind of deduction about emotional states. Now, on the one hand, the computer can better understand emotions, on the other hand, there are hardware and software resources to induce emotions in the user. In this way, conditions are created to produce content whose limit is only our imagination. The application areas are huge, and can have a playful purpose, but they can be used in other contexts such as serious games, for example. Nowadays it is more and more frequent to use serious games in contexts of training or therapies, or even in the context of education through art.

THE IMPORTANCE OF EMOTIONS IN EMPATHY CONSTRUCT

The definition of empathy has been object of extensive debate, over the past few decades. The concept of empathy has been used in different scientific domain's, with diversity of purposes and scopes, among others, as a capacity, a process, a feeling, a mode of perceiving, an inner experience, an action, a tool, as a higher brain function (Hoffman, 1977; Kohut, 1995; Reed, 1984; Sawyier, 1975; Shapiro, 1974).

Currently, empathy is understood as the ability by which we are able to share and understand the another's emotional states and cognitive processes (Cox et al., 2012; Jean Decety & Jackson, 2004; Shamay-Tsoory, Aharon-Peretz, & Perry, 2009). Is the capacity to apprehend or feel what another person is experiencing from within their frame of reference, that is, the capacity to place oneself in another's position (Bellet & Maloney, 1991).

In the psychological sciences, there is general consensus that empathy comprehends at least four components: (1) a vicarious emotional reactivity to others' internal states, termed affective empathy, or the ability to mirror the other's emotional experience. This component has been closely associated with other processes such as emotional contagion, affective resonance, interpersonal linkage, or empathic concern; (2) the recognition of others' experiences, defined as cognitive empathy, comprising perspective taking, theory of mind, and other cognitive abilities. Since

the capacity of experiencing the other's mental states is highly dependent upon many other cognitive abilities, the cognitive empathy is considered a complex and higher-level component; (3) the regulatory component, represented by inhibitory mechanisms necessary for keeping the self-other similarity at a minimal level to avert an emotional overflow. This inhibitory component may be crucial to respond in a supportive way to others' needs; and (4) finally, the fourth component, empathy response, refers to the capacity to communicate our understanding to the other person, of his/her mind states and emotions in an appropriate and self-regulated manner (Brook & Kosson, 2013; Jean Decety & Jackson, 2004, 2006; Jean Decety, Smith, Norman, & Halpern, 2014; Ickes & Hodges, 2013; Shamay-Tsoory et al., 2009).

Recently, advances in modern neuroscience revealed the brain structures and systems associated with these different components of empathy (Cox et al., 2012; Shamay-Tsoory et al., 2009; Völlm et al., 2006). The emotional empathy processes seem to recruit regions such as the inferior frontal gyrus (Shamay-Tsoory et al., 2009), insula (Lamm & Singer, 2010), amygdala, anterior cingulate, and the orbitofrontal cortex (Jean Decety, 2011). The cognitive aspects of empathy may involve brain regions such as the medial frontal cortex (Jean Decety & Jackson, 2006; Shamay-Tsoory et al., 2009), the temporoparietal junction (Jean Decety & Lamm, 2007), and the superior temporal sulcus (Völlm et al., 2006).

Beyond these brain structures, empathy, as other social cognitive processes, draws on a large array of other biological structures and functions which are not limited to the cortex but also include subcortical pathways, the autonomic nervous system, hypothalamic-pituitary-adrenal axis, and endocrine systems that regulate bodily states, emotion and reactivity (Carter, Harris, & Porges, 2009). Moreover, empathy has multiple antecedents within and across levels of organization, and a comprehensive social neuroscience theory of empathy requires the specification of various causal mechanisms producing some outcome variable (e.g. helping behavior), the moderator variables (e.g. implicit attitudes, ingroup/outgroup processes) that influence the conditions under which each of these mechanisms operate, and the unique consequences resulting from each of them (Jean Decety, 2010).

Despite these different components of empathy and biological mechanisms and structures involved, people have different baseline aptitudes and abilities with each, and empathy can be trained and increased. Independent of skill level, empathy can be stimulated by intense emotion, with larger affective intensity leading to higher empathy. There is evidence that carrying out simulated physical acts, more so than imagining them, has the ability to influence emotional states and induce empathy. Empathy can also be attenuated based on the observer's motivation to empathize, the emotion the observed person is feeling, and the familiarity the observer has with the emotion with which they are to empathize.

A SOCIO-TECHNICAL APPROACH IN IMMERSIVE ENVIRONMENTS DEVELOPMENT

The process of building an immersive artifact of digital media art is complex, immersive environments involve a strong technological component and an important human component. These two elements interact with each other not only in the construction process but also during the exhibition and exploration of the artifact. While the technological component has a fundamental role in the representation of the immersive environment, the human element has the primary function of interpretation and interaction with the artifact.

An immersive environment needs an involving digital component that conveys a sense of presence, but it is also necessary that the person be part of that environment and can experience the duality between giving and receiving. It suggests "to enter", "to dive into", "to be part of", but also to "imbue", to impregnate "and "receive it" (Veloso Gomes et al., 2019). To create a virtual reality solution with a strong sense of presence several aspects as emotion, environment and communication must be considered (Donga, Marques, Pereira, & Gomes, 2019).

An artistic immersive environment contributes to an individual process that increases the person's receptivity to the construction of their own emotions. Emotions trigger personalized stimuli, each reaction is personal, because the same stimulus can trigger different emotions in different people, or even different emotions in the same person at different times (Veloso Gomes et al., 2019).

It makes perfect sense to apply the concept of interactive narrative in immersive environments, so the environment can adapt itself to the actions and reactions of each user. The interaction can be made through conscious mechanisms when the user is faced with a situation of choice and chooses a path or make an option. An interactive narrative can predict different consequences for different options.

But art creates sensations, and sensations generate involuntary emotions. Emotions result from an involuntary interpretation process and translate what the user feels when exposed to the immersive environment. If it were possible to somehow identify the type of emotion and quantify that emotion, then emotions could be used as an element of interaction. The incorporation of biofeedback mechanisms in the core of the system responds to this challenge and responds to the needs of an interactive narrative that does not depend only on conscious actions.

The use of biofeedback mechanisms to measure the user's emotions and reaction to stimuli can be used as an element of interaction. The result of this measurement is an element of non-voluntary interaction and allows the environment to adapt to bioreactions. Thus, biofeedback as an element of interaction is essential for the use of interactive narratives.

According to (Marcos et al., 2002), multimedia technology is ideal to register multi-sensorial information. The results of biofeedback measurements can be framed in value scales. The scales can be graduated in ranges of values, each interval is assigned a signal that will trigger a specific type of interaction. This reading is done without the user having to think or make decisions, being able to dedicate all his attention to contemplate and live the immersive experience. Biofeedback mechanisms allow the system to collect information provided unconsciously by the user and can be used in immersive environments as responses to stimuli in interactive narratives, to generate behaviors. This awfully close relationship between the person and the system, in which they merge into a single element, is the central point of the socio-technical system formed by the actor-network.

When thinking about the development of immersive environments (Figure 1), it is necessary to consider the four levels of observation, the theoretical information level and physical level represent the system, the activities (cognitive level) and what is intended (intentional mode) (Hildebrand & Sá, 2000). Interaction in an immersive environment takes place between the physical and virtual environments through natural forms of communication being a multimodal human-computer interaction.

Figure 1. Multidimensional approach to the development of immersive environments.

An immersive environment artistic artefact is a strong socio-technical system where human and non-human elements come together in a heterogeneous network. The Actor-Network Theory (ANT) allows the analysis of artistic immersive environments (Figure 2). ANT offers a different type of analysis, focused on the relational effect of the interaction between human and non-human elements in its heterogeneous networks (Iyamu & Mgudlwa, 2018).

The socio-technical approach used by ANT, considering the material heterogeneity, attributes the same degree of importance to human, non-human and hybrid elements (Figure 2), all of them are part of the system, and have the same degree of importance, interact with each other and depend on each other. They communicate with each

Figure 2. Analysis of an immersive artistic environment from the Actor-Network Theory perspective.

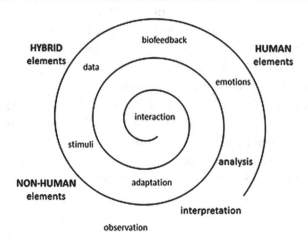

other, establish relationships, exchange information, transmit data, stimulate, make choices, respond, react, and provoke.

THE e-EMotion-CAPSULE ARTEFACT

The e-EMotion-Capsule as an Extended Reality artwork, is a multidimensional immersive media art artefact that explores three types of immersive environments, based on different interaction experiences that create emotions capable of generating states of empathy.

Extended Reality (XR) refers to real and virtual combined environments and human-machine interactions generated by computers and peripherals, includes virtual reality (VR), augmented reality (AR), mixed reality (MR), and similar means of immersion (Fast-Berglund, Gong, & Li, 2018). The artwork described includes those types of immersive environments, so, it represents an extended reality artwork.

Virtual Environments can be used as emotional induction (Marín-Morales et al., 2018). To take advantage of the potential of immersiveness the e-EMotion-Capsule was designed with the 360° interactive narrative concept. During experimentation, a biofeedback device performs the electrophysiological recording of brain activity, transmitting as output the emotions and respective intensities felt by the participant. This output is used as an element of interaction that will trigger new stimuli, making the narrative interactive.

The stimuli are based on the hallucinations experienced by a person with schizophrenia, the response to stimuli is given by the participant's neurofeedback. Sounds, images, voices, and thoughts represent the subconscious of the participant creating a double mental dimension. Real and virtual scenarios contrasting with visual and sound effects involve the participant in an immersive interactive environment (Veloso Gomes et al., 2019).

XR Core Engine System

As a multidimensional Extended Reality artifact, the e-EMotion-Capsule runs three different environments, one of them use the 360º video embodied in VR glasses, other is a completely virtual environment, and the third projects holographic images onto the real scene (Figure 3). All environments are enriched with sound effects that project the voices created by hallucinations and bio sounds that represent the heartbeat and blood pressure.

The XR Core Engine system runs the applications, generates the stimuli that are sent to the participant, interprets the data collected by the biofeedback mechanism and visually externalizes the experimentation experienced by the participant.

Sound stimuli are based on the hallucinations experienced by a person with schizophrenia, they represent the participant's virtual subconscious that whispers voices and thoughts in a spiral of emotions that transport him to a double dimension.

Figure 3. e-EMotion-Capsule Conceptual Model.

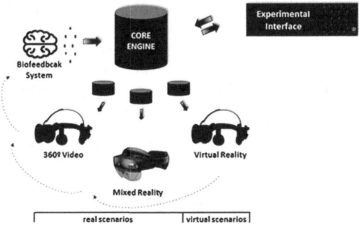

E-EMOTION-CAPSULE – MULTIDIMENSIONAL EXTENDED REALITY ARTIFACT

Bio sounds convey an organic sensation with the purpose of involving and unifying the participant with the environment making the experience more immersive.

The participant's normal daily state is confronted with another dimension generated by the e-EMotion-Capsule, creating a whirlwind of emotions capable of generating empathic states towards people with schizophrenia.

The XR Core Engine system was designed for active participants where the concept of open interactions is present to generate creative, unpredictable, ambiguous, without a clear goal and unlimited interactions (Seevinck, 2011).

360° Interactive Narrative

Experiencing an immersive environment implies being inside, the environment literally surrounds the user. One of the characteristics of an immersive virtual environment is that, as in reality, the person can freely explore the environment around him. Each person perceives and reacts in a personalized way. It is impossible to predict at every moment where the person is looking and where he will direct his attention next. Based on this assumption, a linear narrative is not suitable for this type of system. The 360° interactive narrative concept emerges to answer this challenge. The narrative must be thought and structured in order to explore the entire surrounding space. Stimuli and events must occur in all directions, to capture attention and transport the person to the narrative, regardless of the direction in which the person looks, biofeedback is collected using EEG systems such as Looxid Link™ or Muse™.

The e-EMotion-Capsule allows to experience three distinct autonomous environments that complement each other, 360° video, virtual reality, and mixed reality, which have the application of 360° interactive narratives in common (Veloso Gomes et al., 2019).

360° Video Environment

The immersive environment created through a 360° video, allows to interact and visually exploring the surround responding to visual and sound stimuli, conveying a realistic and intense feeling. This environment runs on head-mounted displays devices as HTC Vive Pro™.

This environment is very dynamic, the 360° camera in motion conveys a sense of realism and movement, the 360° environment gives autonomy and randomness to explore the narrative and organic bio sounds convey a sense of introspection that generates emotions.

The 360° narrative is associated with a dynamic video where the participant takes on the role of another character, experiencing the stimuli produced by his

imagination as if he were himself. The participant is confronted with the duality between the real and the imaginary, for the character that the participant embodies, the imaginary represents his own reality (Veloso Gomes et al., 2019).

Virtual Reality

This immersive environment running on head-mounted displays devices s HTC Vive Pro™, was created entirely in virtual reality represents scenarios of the daily life of a character locked in a world in which the confrontation between the imaginary is confused with the reality. The participant has the autonomy to make decisions, make choices and interact or not with the objects and environment that surround him.

In this environment, the 360° narrative gives the participant a high degree of autonomy. Although there are several stimuli launched by the environment, it is up to the participant to take the initiative to move, interact and trigger new stimuli (Veloso Gomes et al., 2019).

Mixed Reality

This is the most complex of the three immersive environments. When putting on the mixed reality device Microsoft HoloLens 2™ the participant continues to visualize the real environment. In this way the participant can interact with the real environment naturally, doing their normal activities, as if they did not have their glasses on. The intention is to make the participant feel the mental stimuli generated by his own virtual subconscious and incorporate them as if they were his own. Using an augmented reality system, e-EMotion-Capsule launches visual and audible stimuli on the surrounding environment that interfere with vision and hearing, transporting the participant to the imaginary world of the character he takes on (Veloso Gomes et al., 2019).

This mixed reality environment uses a narrative that aims to create sensory stimuli with physical elements in mixed reality to produce more realistic immersive experiences (Nakevska, van der Sanden, Funk, Hu, & Rauterberg, 2017).

The fusion between the real and the virtual makes the virtual intensify the real, and the real increase the virtual (Marín-Morales et al., 2018). The 360° narrative takes place in the real environment in which the participant is. The stimuli launched by e-EMotion-Capsule can be random, or they can be controlled by a human element through an experimental interface that intentionally interferes and interacts through a device with the participant (Veloso Gomes et al., 2019).

NEUROFEEDBACK IN IMMERSIVE
MEDIA ART ENVIRONMENTS

Multimedia content allows the induction of emotions and can be emotionally expressive. Different genres of multimedia induce different emotions and are appealing to their audience in different mood and context (Soleymani, Larson, Pun, & Hanjalic, 2014).

Brain Computer Interfaces (BCI) includes a range of interface and signal processing technologies from direct recordings from brains to electroencephalography (EEG) and functional magnetic resonance imaging MRI. BCI enables a wide range of applications that include helping those with impaired physical function, such as stroke victims, control everyday objects in their environment; analyzing awake and sleep brain states to monitor alertness levels and diagnose brain disorders; and understanding market preferences (National Research Council, 2013).

Following technical and theoretical progresses in neuroscience, computer science, and signal processing, electroencephalogram signals (EEG) have recently been used in new ways (Leslie, Ojeda, & Makeig, 2013; Lin, Duann, Chen, & Jung, 2010). Presently the access to user-friendly and wireless EEG systems is affordable. EEG systems such as Muse™ and others allow to read brain waves, identify emotions, control mechanical devices, graphic interfaces, and other user interfaces using thoughts only. This specific range of application is called neurofeedback or neurotherapy (Gruzelier & Egner, 2005; Thompson, Steffert, Ros, Leach, & Gruzelier, 2008). Neurofeedback enables the voluntary regulation of brain activity, with promising applications to enhance and recover emotion and cognitive processes, and their underlying neurobiology (Lorenzetti et al., 2018).

Several art projects are using EEG as an input or way to produce or modulate artistic content such as animations, music, and choreography (Grandchamp & Delorme, 2016).

Virtual reality systems have become increasingly portable and affordable, increasing the interest in their use by artists and researchers in different areas. VR has many advantages like the immersion and sense of presence, which can trick the subconscious mind of the user, so that he believes he is in a real word. Every change in the virtual environment provokes a modification in the user's affective state. (Kovacevic, Ritter, Tays, Moreno, & McIntosh, 2015).

Using neurofeedback as an interface allows the user of VR systems to manipulate that reality with his thought. Also measuring the brain waves of the user, the developer can create an adaptative virtual world that reacts to the user emotions and can create different states of mind. The art installation becomes a dynamic emotion creation. The artist can direct the user to a specific emotional state and produce different

results depending on the emotions each user has when confronted with the virtual world proposed.

FUTURE RESEARCH DIRECTIONS

The use of biofeedback mechanisms during exposure to immersive environments allows new types of interaction between the participant and the system, the real time interaction based on participants involuntary reaction, collected through non-invasive biofeedback devices, opens unlimited possibilities for media art.

The integration of new elements of interaction in this type of systems, multisensory VR devices such as motorized VR chairs or VR sensitive gloves and smell stimulators, expands the possibility of creating increasingly immersive sensations.

CONCLUSION

Considering an immersive environment as a socio-technical system, where human and non-human elements interact, establishing strong relationships, the authors used Actor-Network Theory as an approach to design an immersive artifact of digital media art, the e-EMotion-Capsule.

Immersive environments can be used to induce emotional changes capable of generating states of empathy, in which the participant puts himself in the place of the other, establishing a strong emotional relationship that allows him to incorporate sensations and feelings that generate understanding and solidarity.

The use of biofeedback mechanisms during the participant's exposure to immersive environments generates data that can be used as an element of interaction between the participant and the system. This biofeedback allows to identify and quantify emotional states and increase the interaction possibilities between the participant and the media art artefact. It also opening doors to new types of interaction and allows to explore the emotional states to generate empathy.

REFERENCES

Bellet, P. S., & Maloney, M. J. (1991). The Importance of Empathy as an Interviewing Skill in Medicine. *Journal of the American Medical Association, 266*(13), 1831–1832. doi:10.1001/jama.1991.03470130111039 PMID:1909761

Brook, M., & Kosson, D. S. (2013). Impaired cognitive empathy in criminal psychopathy: Evidence from a laboratory measure of empathic accuracy. *Journal of Abnormal Psychology, 122*(1), 156–166. doi:10.1037/a0030261 PMID:23067260

Cambria, E. (2016). *Affective computing and sentiment analysis*. Retrieved from www.sas.com/social

Carter, S., Harris, J., & Porges, S. (2009). Neural and evolutionary perspectives on empathy. In J. Decety & W. Ickes (Eds.), The Social Neuroscience of Empathy (pp. 169–182). Cambridge: MIT Press. doi:10.7551/mitpress/9780262012973.003.0014

Cox, C. L., Uddin, L. Q., Di Martino, A., Castellanos, F. X., Milham, M. P., & Kelly, C. (2012). The balance between feeling and knowing: Affective and cognitive empathy are reflected in the brain's intrinsic functional dynamics. *Social Cognitive and Affective Neuroscience, 7*(6), 727–737. doi:10.1093can/nsr051 PMID:21896497

Decety, J. (2010). The neurodevelopment of empathy in humans. *Developmental Neuroscience, 32*(4), 257–267. doi:10.1159/000317771 PMID:20805682

Decety, J. (2011). Dissecting the neural mechanisms mediating empathy. *Emotion Review, 3*(1), 92–108. doi:10.1177/1754073910374662

Decety, J., & Jackson, P. L. (2004). *The functional architecture of human empathy. Behavioral and cognitive neuroscience reviews* (Vol. 3). doi:10.1177/1534582304267187

Decety, J., & Jackson, P. L. (2006). A Social-Neuroscience Perspective on Empathy. Current directions in Psychological Science. *Psychological Science, 15*(2), 54–58. doi:10.1111/j.0963-7214.2006.00406.x

Decety, J., & Lamm, C. (2007). The role of the right temporoparietal junction in social interaction: How low-level computational processes contribute to meta-cognition. *The Neuroscientist, 13*(6), 580–593. doi:10.1177/1073858407304654 PMID:17911216

Decety, J., Smith, K. E., Norman, G. J., & Halpern, J. (2014). A social neuroscience perspective on clinical empathy. *World Psychiatry; Official Journal of the World Psychiatric Association (WPA), 13*(3), 233–237. doi:10.1002/wps.20146 PMID:25273287

Donga, M., Marques, Pereira, & Gomes. (2019). The Sense of Presence through the Humanization Created by Virtual Environments. *Proceedings, 21*(1), 7. doi:10.3390/proceedings2019021007

Fast-Berglund, Å., Gong, L., & Li, D. (2018). Testing and validating Extended Reality (xR) technologies in manufacturing. *Procedia Manufacturing, 25*, 31–38. doi:10.1016/j.promfg.2018.06.054

Grandchamp, R., & Delorme, A. (2016). The Brainarium: An Interactive Immersive Tool for Brain Education, Art, and Neurotherapy. *Computational Intelligence and Neuroscience, 2016*, 1–12. Advance online publication. doi:10.1155/2016/4204385 PMID:27698660

Gruzelier, J., & Egner, T. (2005). Critical validation studies of neurofeedback. *Child and Adolescent Psychiatric Clinics of North America, 14*(1), 83–104. doi:10.1016/j.chc.2004.07.002 PMID:15564053

Hildebrand, A., & Sá, V. (2000). EMBASSI: Electronic Multimedia and Service Assistance. In *Intelligent Interactive Assistance & Mobile Multimedia Computing (IMC 2000)* (pp. 50–59). Retrieved from http://publica.fraunhofer.de/eprints/urn_nbn_de_0011-n-39911.pdf

Hoffman, M. L. (1977). Empathy, its development and prosocial implications. In *Nebraska Symposium on Motivation*. University of Nebraska Press.

Ickes, W., & Hodges, S. D. (2013). Empathic Accuracy in Close Relationships. In J. A. Simpson & L. Campbel (Eds.), The Oxford Handbook of Close Relationships (pp. 348–373). Oxford University Press. doi:10.1093/oxfordhb/9780195398694.013.0016

Iyamu, T., & Mgudlwa, S. (2018). Transformation of healthcare big data through the lens of actor network theory. *International Journal of Healthcare Management, 11*(3), 182–192. doi:10.1080/20479700.2017.1397340

Jacob, R. J. K. (1996). The Future of Input Devices. *ACM Computing Surveys, 28*(4), 138. doi:10.1145/242224.242400

Kohut, H. (1995). Introspection, empathy, and psychoanalysis: An examination of the relationship between mode of observation and theory. Twenty-Fifth Anniversary Meeting of the Chicago Institute for Psychoanalysis (1957, Chicago, Illinois). *The Journal of Psychotherapy Practice and Research, 4*(2), 163–177.

Kovacevic, N., Ritter, P., Tays, W., Moreno, S., & McIntosh, A. R. (2015). 'My Virtual Dream': Collective Neurofeedback in an Immersive Art Environment. *PLoS One, 10*(7), e0130129. doi:10.1371/journal.pone.0130129 PMID:26154513

Lamm, C., & Singer, T. (2010). The role of anterior insular cortex in social emotions. *Brain Structure & Function, 214*(5–6), 579–591. doi:10.100700429-010-0251-3 PMID:20428887

Lee, H., & Hyung, W. (2014). A Study on Interactive Media Art to Apply Emotion Recognition. *International Journal of Multimedia and Ubiquitous Engineering, 9*(12), 431–442. doi:10.14257/ijmue.2014.9.12.37

Leslie, G., Ojeda, A., & Makeig, S. (2013). Towards an affective brain-computer interface monitoring musical engagement. *Proceedings - 2013 Humaine Association Conference on Affective Computing and Intelligent Interaction, ACII 2013*, 871–875. 10.1109/ACII.2013.163

Lin, Y. P., Duann, J. R., Chen, J. H., & Jung, T. P. (2010). Electroencephalographic dynamics of musical emotion perception revealed by independent spectral components. *Neuroreport, 21*(6), 410–415. doi:10.1097/WNR.0b013e32833774de PMID:20300041

Lopatovska, I., Arthur, K. L., Bardoff, C., Diolola, J., Furlow, T., Honor, L. B., … Shaw, J. L. (2015). Engaging digital artworks through emotion: interface design case study. *iConference 2015*. Retrieved from http://hdl.handle.net/2142/73435

Lorenzetti, V., Melo, B., Basílio, R., Suo, C., Yücel, M., Tierra-Criollo, C. J., & Moll, J. (2018). Emotion regulation using virtual environments and real-time fMRI neurofeedback. *Frontiers in Neurology, 9*, 1–15. doi:10.3389/fneur.2018.00390 PMID:30087646

Marcos, A., Bernardes, P., & Sá, V. (2002). Multimedia technology and 3D environments used in the preservation and dissemination of the portuguese cultural heritage. In Méndez Vilas A., J. A. Mesa Gonzáles, & I. Zaldívar Maldonado (Eds.), *Educational Technology : International Conference on Information and Comunication Technologies in Education (ICTE2002)* (pp. 1335–1339). Badajoz: Consejería de Educación, Ciencia y Tecnología.

Marín-Morales, J., Higuera-Trujillo, J. L., Greco, A., Guixeres, J., Llinares, C., Scilingo, E. P., ... Valenza, G. (2018). Interactive Storytelling in a Mixed Reality Environment: The Effects of Interactivity. *Scientific Reports, 8*(1), 1–15. doi:10.103841598-018-32063-4 PMID:29311619

Nakevska, M., van der Sanden, A., Funk, M., Hu, J., & Rauterberg, M. (2017). Interactive Storytelling in a Mixed Reality Environment: The Effects of Interactivity of interactivity on user experiences. *Entertainment Computing, 21*(January), 97–104. doi:10.1016/j.entcom.2017.01.001

National Research Council. (2013). National Academies Keck Future Initiative: The Informed Brain in a Digital World. *National Academies Keck Future Initiative: The Informed Brain in a Digital World*, *130*. Advance online publication. doi:10.17226/18268

Neal, T. J. (2013). *The Relation between Art & Emotion (Plato, Aristotle & Collingwood)*. Retrieved April 20, 2020, from https://timjohnneal.wordpress.com/2013/06/27/the-relation-between-art-emotion-plato-aristotle-collingwood/

Picard, R. W. (2000). *Affective Computing*. MIT Press. doi:10.7551/mitpress/1140.001.0001

Poria, S., Cambria, E., Bajpai, R., & Hussain, A. (2017). A review of affective computing: From unimodal analysis to multimodal fusion. *Information Fusion*, *37*, 98–125. doi:10.1016/j.inffus.2017.02.003

Reed, G. S. (1984). The Antithetical Meaning of the Term "Empathy" in Psychoanalytic Discourse. In J. D. Lichtenberg, M. Bornstein, & D. Silver (Eds.), *Empathy I* (pp. 7–24). Routledge.

Sá, V., Malerczyk, C., & Schnaider, M. (2001). Vision-Based Interaction within a Multimodal Framework. In J. L. Encarnação (Ed.), Selected readings in computer graphics 2001. Stuttgart: Fraunhofer-IRB-Verlag: INI-GraphicsNet.

Sawyier, F. H. (1975). A Conceptual Analysis of Empathy. *The Annual of Psychoanalysis*, *3*, 37–47.

Schomaker, L., Nijtmans, J., Camurri, A., Lavagetto, F., Morasso, P., Benoit, C., … Blauert, J. (1995). A Taxonomy of Multimodal Interaction in the the Human Information Processing System. *Multimodal Integration for Advanced Multimedia Interfaces (MIAMI). ESPRIT III, Basic Research Project, 8579.*

Seevinck, J. (2011). The Concrete of NOW Jen Seevinck. *INTERACTING: Art, Research and the Creative Practitioner*, 242–256. Retrieved from http://research.it.uts.edu.au/creative/linda/CCSBook/Jan 21 web pdfs/Seevinck.pdf

Shamay-Tsoory, S. G., Aharon-Peretz, J., & Perry, D. (2009). Two systems for empathy: A double dissociation between emotional and cognitive empathy in inferior frontal gyrus versus ventromedial prefrontal lesions. *Brain*, *132*(3), 617–627. doi:10.1093/brain/awn279 PMID:18971202

Shapiro, T. (1974). The development and distortions of empathy. *The Psychoanalytic Quarterly*, *43*(1), 4–25. doi:10.1080/21674086.1974.11926657 PMID:4814470

Silvia, P. J. (2005). Emotional responses to art: From collation and arousal to cognition and emotion. *Review of General Psychology*, *9*(4), 342–357. doi:10.1037/1089-2680.9.4.342

Soleymani, M., Larson, M., Pun, T., & Hanjalic, A. (2014). Corpus Development for Affective Video Indexing. *IEEE Transactions on Multimedia*, *16*(4), 1075–1089. doi:10.1109/TMM.2014.2305573

Thompson, T., Steffert, T., Ros, T., Leach, J., & Gruzelier, J. (2008). EEG applications for sport and performance. *Methods (San Diego, Calif.)*, *45*(4), 279–288. doi:10.1016/j.ymeth.2008.07.006 PMID:18682293

Veloso Gomes, P., Marques, A., Pereira, J., Correia, A., Donga, J., & Sá, V. J. (2019). E-EMOTION CAPSULE: As artes digitais na criação de emoções. In *ACM International Conference Proceeding Series*. Braga: Association for Computing Machinery. 10.1145/3359852.3359962

Völlm, B., Taylor, A., Richardson, P., Corcoran, R., Stirling, J., McKie, S., Deakin, J. F. W., & Elliott, R. (2006). Neuronal correlates of theory of mind and empathy: A functional magnetic resonance imaging study in a nonverbal task. *NeuroImage*, *29*(1), 90–98. doi:10.1016/j.neuroimage.2005.07.022 PMID:16122944

Chapter 8
A Serious Game for Geo-Education in the Arouca Geopark Territory

Tiago Martins
*2Ai Lab, School of Technology, Polytechnic Institute of Cávado and Ave, Portugal
& Algoritmi Research Center - Minho University, Portugal*

Júlio Coelho
2Ai Lab, School of Technology, Polytechnic Institute of Cávado and Ave, Portugal

Vitor Carvalho
🆔 https://orcid.org/0000-0003-4658-5844
*2Ai Lab, School of Technology, Polytechnic Institute of Cávado and Ave, Portugal
& Algoritmi Research Center - Minho University, Portugal*

ABSTRACT

This chapter describes the development of a prototype of a serious video game and its maintenance platform for the geo-education in the Arouca Geopark Territory. This serious video game, which is the focus of this project, aims to assist the guides in their visits to the Arouca Geopark, providing an educational and modular tool. It was possible to supply some needs of the Arouca Geopark, identifying which components are necessary for this platform and which tools must be used for its development. A functional prototype of this platform was developed and subjected to usability tests, the results of which were positive and revealed great acceptance by the intervening group. With the development of this technology, it is intended that the guides and visitors of Arouca Geopark can enjoy an educational tool, able to help guides to provide more stimulating guided tours, thereby improving visitors' retention of information.

DOI: 10.4018/978-1-7998-3669-8.ch008

INTRODUCTION

Arouca Geopark, covers all the administrative area of the Municipality of Arouca. Whoever arrives in this territory for the first time, will probably be surprised at each step they take, given the unique experiences they can try: mountain biking, on fabulous trails ripped in the mountains and valleys, accompanying rivers and streams, crossing villages of unique beauty; to venture into the extreme sports of Paiva River; to enjoy gastronomy, handicrafts, folklore, the traditions, which continue to tell the history of this territory. But what makes it internationally registered and led it to deserve the UNESCO World Geopark classification is its exceptional patrimony in the field of Geology, distributed by 41 sites of scientific interest in this area (geosites), of which deserve specific reference Canelas giant trilobites (among which stand out the largest examples of the planet) Pedras Parideiras in Castanheira (unique phenomenon in Portugal and rare in the world) and trace fossils of Vale do Paiva (Geopark Arouca, n. d.).

Taking into account all the diversity and abundance of geological natural resources, it is not surprising that Arouca Geopark, receives a large number of visits from primary and secondary school students, these visits being carried out under the guidance of a guide who, for each visit point, presents an explanation of the place and clarifies doubts that may arise from students or teachers who accompany them (Associação Geoparque Arouca [AGA], 2016).

The authors of this chapter consider that, during these visits, unexpected complex situations can occur, such as: the identification of places where there are greater problems of understanding; the difficulties of visitors; the guide failures at a particular visit or at a particular point in it. However, remembering the dizzying technological evolution currently occurring, and believing that it is possible to make visits more stimulating and, at the same time, to test the knowledge that they provide to participants, the same authors thought that could be useful or develop a serious video game that came to overcome the difficulties that have arisen.

After exchanging information with the Associação Geopark Arouca, it was possible to identify the essential elements for the project, among which stands out the video game. It is necessary this to assume the application format for mobile devices, considering the great incorporation of these technologies in people's daily lives, not only to serve as a form of contact, but also to perform many other tasks. The video game will consist of modules, corresponding each one of these to one of the highlights of the visit. Another element that was considered relevant to include in the project is a database server, to store and aggregate all the information collected by the devices. It was also considered essential to develop a web platform for maintaining the video game, such as, for example, adding new challenges or correcting others.

Therefore, the general objective of this chapter is to describe the development of the modular video game to aid guided tours in the Arouca Geopark territory, as well as the improvement of the associated database and of the web platform.

STATE OF THE ART

Each game reinforces and stimulates any physical or intellectual ability. Through pleasure and obstinacy, which was initially difficult or strenuous becomes easy. These words are a translation of a short extract from a work by Roger Caillois (1991, p. 21), but they certainly deserve the consensus of everyone who sees, in the game, a tool with an enormous potential to optimize the quality of life of people, whatever the area in which it will be applied. And the proof of that is in the proliferation of serious games that is happening recently.

Serious Video Games

The electronic games industry has grown focused on entertainment. However, many of the games released in the market were designed for serious purposes, in diverse sectors, such as education, health, military training, advertising, although the serious games label does not yet exist for them, therefore being considered their closest ancestors. The expression serious games only came to be widely used from 2002 (Djaouti, Alvarez, Jessel & Rampnoux, 2011).

The pioneers revealed a clear predominance of educational games. And although in the universe of those who are part of the current wave of serious games, the market share related to education has been decreasing in favor of the others it continues to deserve a prominent place (Djaouti et al., 2011).

Since the video games that fall within the educational area are oriented towards providing a more stimulating and fun environment, to enhance the user's learning, it seems plausible to frame, in this field, the project that the authors intend to carry out, because the video game to be developed aims to facilitate the acquisition of knowledge and detect problems in guided tours carried out in the Arouca Geopark territory.

Far from seeking an exhaustive list, will be mentioned here only some of the video games that have had, at least in part, positive effects, when they were tried.

Helios: An HTML5 Game Teaching Proportional Reasoning to Child Players

This video game is intended to assist and motivate players, especially children, to learn proportional reasoning. To this end, challenges were created that oblige the player to use proportional reasoning to complete a certain level and move on to the next, more complicated one. The degree of difficulty can never be too high or too low. If the level of the game is too complicated, the player will start to feel frustrated for not being able to complete it and he will lose the motivation to continue playing. If the challenge is too simple, he will lose interest, as there is no difficulty that encourages him to continue, and he will find the video game boring (Christel et al., 2013).

During the video game, the player has medals to collect, in order to increase his motivation (Christel et al., 2013).

During the testing phase, with students from the first, second and third years, there was a great enthusiasm for this video game, thus fulfilling the objective of motivation. However, no effective data were collected that could confirm whether the video game helped or not in the learning of proportional reasoning (Christel et al., 2013).

Learning Physics Through Computer Games

The objective of this video game is to assist and motivate the learning of physics, through some challenges, explaining some physic concepts, such as friction, moment and free fall. In addition to these challenges, the video game has simulators of these same concepts, which allow testing the effects of the variation of the quantities involved in them, through a simulation controlled by the player. An example is the effect of the increasing of the mass of an object that is in free fall. Before the player can make use of these simulators, he must view information panels explaining the concept, and answer a questionnaire about it (Hookway, Mehdi, Hartley, & Bassey, 2013).

As it concerns the physical effects of moving objects, in this video game a great emphasis was placed on simulators, so that the player has a better experience of these effects and a more effective learning (Hookway et al., 2013).

In the end, a positive result was obtained, with the majority of users being satisfied with the difficulty and the fun that the video game provided, as well as with its purpose of assisting in learning. The players believed that it was a good tool, because in addition the concepts were well-presented and simplified, there was then the opportunity to simulate them (Hookway et al., 2013).

A Serious Game for Evacuation Training

This video game was developed with the purpose of teaching how to properly evacuate a burning building, in this case a Hospital. The game focuses on teaching the player new contents (Silva, Almeida, Rossetti, & Coelho, 2013).

A 3D simulator was then carried out, in which the player finds himself in the role of a woman who has to drive a man in a wheelchair to the outside of the building, safely and as quickly as possible. For this, the player must follow the present signs (Silva et al., 2013).

During the challenge, questions are presented for the player to answer, as well as certain informational messages, such as, for example, not using the elevator in case of fire (Silva et al., 2013).

In the end, a positive result was obtained, which proved to be a useful tool, not to replace traditional simulacra, but to complement and improve them (Silva et al., 2013).

Cognitive Rehabilitation Based on Working Brain Reflexes Using Computer Games Over iPad

This video game was developed with the objective to help elderly people, with some kind of impairment, physical or mental, to improve their reflexes (Lopez-Samaniego, Garcia-Zapirain, Ozaita-Araico, & Mendez-Zorrilla, 2014).

The video game challenge consisted of two or more balls, one of which would be the player's ball and the remaining the enemy balls. The player should endure as long as possible, dodging enemy balls, the number of which would increase with the level of difficulty (Lopez-Samaniego et al. 2014).

In the end, it is concluded that this type of video games that stimulate psychomotor skills and the mind have a positive effect on the elderly, as they have the feeling that they are playing just for fun, but at the same time motivated to perform the test with success. This effect, however, is much less significant in the elderly with more severe cognitive problems, because, as a consequence of such problems and also of lower self-esteem and self-confidence, they obtain inferior results, reducing their motivation to perform the task (Lopez-Samaniego et al. 2014).

Critical Review

Based on the studies just mentioned, it is possible to confirm that serious video games have educational advantages, as they provide a relaxing and motivating environment for the user, which can enhance the learning of the data being taught by this means.

One of the biggest and strongest focuses of serious video games is teaching or improving habits, or teaching concepts. Both are usually performed subconsciously, by the player, that is, he is focused on the video game and on getting the highest possible score, while are presented the data that is intended he retains.

The authors of this project also want it to fulfill the objective of teaching facts to those who find themselves playing, and to consolidate the knowledge already acquired with the explanations of the guide present during the visit, but also to make possible to collect the results obtained by the players, to be analyzed later and, thus, help and improve the services of Arouca Geopark.

METHODOLOGY

To realize the project, a survey of the requirements that should characterize it was carried out, the tools used for its development were contextualized, and a comparative study was performed before proceeding to the choice of the same.

Identification of Requirements

As with any project, it has become essential to survey the needs to which it can correspond. This is essential to ensure a more fluid development, which will converge on its success.

First of all, it is necessary to define the target audience, that is, the population on which the study to be carried out will focus. In the present case, it will consist essentially of students from all levels of education, from pre-school to higher education, reaching larger focus in the 3rd cycle and in secondary and university education, since they are the groups with the largest number of visits to the Arouca Geopark territory.

To meet the requirements, the exchange of information was carried out with the Associação Geopark de Arouca, which revealed the need to create a serious video game to be installed on a tablet or smartphone. At the beginning of an interpreted visit, one will be given to each student or each group. The guide responsible for the visit will provide a code to the students, who in turn will enter it into the device to begin the visit. The video game aims to collect data from those who play, for a future analysis, and motivate the visitors, through defiant and fun challenges.

With this information, it was possible to identify two essential elements for the project, which consist of the video game, in an application format for mobile devices, and of a database server, to store and aggregate all the information collected by the devices.

An analysis made led to the conclusion that, due to the extension of the park and to the visits made, it would be impossible for the video game to remain constantly connected to the database server. Thus, one more element necessary for the development of the project was identified: a web server. Through the web services, the necessary data for the visit will be collected at the beginning of the visit, and the results will be sent only at the end.

A last element necessary for the development of the project that was also possible to identify is BackOffice, which has two features: the generation of the visit code to be entered on the mobile device, to start it, and the visualization of the data collected by the video game, while it goes on. In addition to these features, a provision was made for the inclusion of others, responsible for maintaining the platform, such as adding new challenges to the video game and new places to carry out the visit.

Maintenance through BackOffice is intended to be as effective as possible, so that the system has the longest possible longevity, as the number of visits to Arouca Geopark has been gradually increasing, over the last few years

Video Game

The video game being the most important component of this project, since it is the one that will collect the results of the users, it is necessary to choose the best tool for its development. It is necessary that it has a compilation for mobile devices, Android and iOS, and, if possible, also for web platforms, and it must be able to communicate with the database, through an API. In addition, the video game should be visually appealing and as stable as possible, that is errors caused by the game engine cannot arise when compiling the application.

Video Game Engine

The game engine is a tool that aims to make the development of the video game easier, providing the programmer with all the necessary components for it, namely the simulation of the physical behaviour of the game elements. It allows an optimization of all the video game surroundings, providing the user with the most real experience possible. (Bittencourt & Osório, 2006).

There are currently several game engines, which, although they have some common characteristics, also have many differences, as they cover a wide variety of different profiles and user needs, making difficult to decide which one to select. Depending on the situation, the choice to be made may have to fall on a specific type of game engine, as in the case of game engines for mobile devices 3D, or on a specific domain, for example, the surgical training simulation (Christopoulo & Xinogalos 2017).

Unity 3D

The Unity 3D is a game engine that has been highlighted in recent years, due to several factors, such as being very accessible, being easy and intuitive and having a large community that helps in the development. Added to this, the fact that the creators themselves provide tutorials, further facilitating their learning. Another factor is a strong and simple graphic ability, being possible, with a small team, to develop a video game with a professional look. Finally, it is free, allowing small teams to develop a video game with a professional look without great costs (Polsinelli, 2013).

Unity3D was the game engine chosen, because it has all the features and tools necessary for the development of the game, for the platforms Windows Phone, Android and iOS, as well as for PC and browser. It also has the tools that will give the video game the ability to communicate with the server, so that it collects and sends the data obtained in the simplest possible way.

Server

The video game needs to communicate with the database, to collect the data for the challenges of the visit and to save the data obtained during it, as it aims to be a modular application, being possible to add new elements through BackOffice and update existing data. For this communication to be possible, it is necessary to have a server that allows communication between the database and the video game, keeping it updated, without having to change it. Updates will be performed in BackOffice.

This server has to respond to two factors: the possibility of accessing the database, in order to be able to send and receive data from it; have support for restfull, for greater simplicity in the exchange of messages and, consequently, less effort on the part of the network, since some messages can be sent from places with difficult access to the internet.

The server will communicate with the video game through a set of web services.

Web Services

Web services are services made available from one device, usually a server, to another device, such as a mobile phone or computer, over the internet. These services are used to improve interoperability between systems because communication is performed in a simple format common to all systems, such as plain text or xml.

WSO2 –Application Server

There are several protocols and systems for the development of web services. For this project, the WSO2 development tool and the restfull architecture will be used, due to their modernity and functionality.

WSO2 is an open-source web-oriented software. There are multiple advantages that justify its use not only in this project, but in other companies. Being open source, it offers users the possibility to change them as they wish. It is already ready for operation in Cloud and has a simple platform for development (Pronschinske, 2017, Jayathilaka, 2012).

This software operates as a small server that provides services to the Internet through the assigned IP and a specific port. They are http requests or with SOAP protocols, making it possible to support a high number of requests simultaneously (Jayathilaka, 2012).

Database

As the objective of this project is to improve the services of Arouca Geopark, through the collection of information carried out by the video game, it will be necessary to have a database to store that information, for later use. This database will also store other information, such as challenge data, questions and images for each challenge, and information from the guides.

The stored information can be viewed through BackOffice, to make it easier for Arouca Geopark guides to read them.

In choosing a server for the database, the following factors were taken into account: the consistency of the data and the interoperability between the various systems that will be used, that is, the web server and BackOffice.

XAMPP is an application developed by Apache friends that consists of a web server, comprising a good database system, which will be used in this project, an apache application server and in the applications necessary to run applications developed in PHP and PERL languages (Usui et al., 2007).

This application is widely used in web development, for websites and small applications, as it has all the most common tools to carry them out: a server to allocate the website, the applications needed to run PHP, normally used to access the database, and a database, to store information related to the site. In addition, it has the advantage to be open-source and very light for the hardware on which it is found (Usui et al., 2007).

The database server is a version of mysql, the MariaDB, which is a relational database system.

BackOffice

BackOffice is an application/platform with the objective of facilitating the manipulation and visualization of data by an inexperienced user. It is typically used by companies, with the task of controlling their inventories and maintaining them.

For the development of the BackOffice application for this project, the Bootstrap framework will be used, which comes with a strong graphic library, allowing a more simplified development for any device. It also has a Javascript framework (jQuery) that enables a strong elements manipulation and a better interactivity with the website.

Bootstrap is a framework that uses Javascript, CSS and HTML, and aims to facilitate and simplify web development and cross-platform, thanks to a strong graphics library that it has and that adapts to all devices, regardless of their resolution or size. It is also endowed with a strong JavaScript library, which facilitates the development of functionalities for the website (TutorialRepublic, n. d.).

BackOffice will essentially be a website to which all users will be able to access, with only the application having to be installed on the server and an updated browser on the device from which it is intended to be accessed. This makes easier for any user to access BackOffice, as no additional installation is required, and most users are already familiar with web platforms.

DEVELOPMENT STAGES

The stages development of the project start with the planning of its components and end in the development of them.

Development Methodology

For the development of this project, the agile software methodology was used, which essentially consists of six phases: planning, design, development, testing, evaluation and finalization. In the planning phase, the functionalities necessary to meet the requirements of the software are considered. In the design phase, it is thought how these functionalities will be introduced in the software. In the development phase, functionalities in the software are developed. The following is a test phase, to make sure that all the functionalities introduced are error free. Finally, if all tests are completed successfully, the software development is completed, or it may go through new development cycles

Concept Development

As with many creative projects, the development of the idea and concept for the serious video game started from an analysis of the requirements presented by AGA, as well as an analysis and brainstorm among the project members.

As the objective of the video game is to test the knowledge obtained and retained during the interpreted visit, the video game will take the form of a questionnaire or similar challenges, always trying to make the challenges as interesting and motivating as possible, because, one of the goals is also to evaluate the player without him noticing.

The first approach focused on an extended analysis of existing video games and different challenges.

Concept Study

Initially, an analysis was carried out on existing video games that had a similar objective to the present project, that is, to test the knowledge of those who are playing, without they notice they are being tested.

There is already, in mobile device stores, such as the App Store and Google Play, a huge variety of video games known as quiz video games.

This category covers almost all possible themes, from art, music, science and others. In most cases, these games consist of only one challenge, one question with or without an auxiliary image and four answer options, only one of which is correct.

A second large group of games makes use of the general culture knowledge of the player, using images known to the majority of the population, as logos of internationally famous brands, with the goal of the player completing all the challenges. For this, the player must correctly fill in what is intended in the challenge, in some cases the name of the company associated with the logo.

In both cases described above, these video games work locally, saving the user's data on the device itself, so that the user can watch them, if he wants. In some cases, this data is also synchronized to the cloud, where it is possible to observe the results of friends or colleagues and compare the results.

Storyboard and Argument

The storyboard or narrative of a video game usually turns around its characters and the world where they are, and around a narrative. In the specific case of this project this does not happen, as it is a questionnaire-style game, with a simpler storyboard, usually imitating a television game, where the characters have to answer correctly to achieve the greatest possible number of points to win.

The video game will follow a similar storyboard: a quiz game whose objective will be to get the most correct answers. One of the differences is that the video game will follow the storyboard of the visit that is being carried out, referring the questions to the place, its history, or the point of interest in which the player is. Usually the visits are associated with a theme already defined by the park, for the visitors, several of which exist for each of the school grades.

Planning

Prior to the detailed planning of each component of the video game, a general planning was carried out, in which it was decided how the components of the project would interact with each other.

It will be in the database that all information related to the video game will be stored, which is what happens with challenges, with user data, with other information such as logins for BackOffice users, and with the results collected. BackOffice and web services will be the components that will communicate directly with the database. The web service will collect the user's data and insert them into the database and will collect the data of the challenges necessary for the visit, so that they are presented in the video game. BackOffice will allow to insert certain data into the database, such as new BackOffice users and new locations or challenges for the video game, and will present the data collected, so that they can be read and treated in the best way. Finally, the video game will collect the user's data, their responses to the challenges and send the data obtained to the web service, so that it keeps them in the database, receiving the necessary data to the challenges for the visit that he will carry out.

Database

For the development of the system's database, the tables that would be necessary to efficiently store all system data were firstly planned, with a total of seven: "visit", "visitor", "challenge", "results", "local", "guide" and "admin".

The "visit" table will have the objective of keeping the data related to a visit to the park. This will store a unique value that can identify each visit, the identifying value of the guide who coordinated the visit, the date the visit was made, the school of the students who made the visit, their level of education and the number of questions and places that have been visited.

The "visitor" table will store the data relating to the visitor. This table will store the unique value that will identify each visitor, the unique value of the visit he made, the name of the visitor, as well as his age.

The "challenge" table will store all the data necessary for a challenge to be presented in the video game. This table will store the unique value to identify each challenge, the unique value of the location to which this challenge is associated, the type of challenge, the level of education that corresponds to it, the data of the challenge, such as the question that is asked, the responses and the image of the challenge.

The "results" table will store the result obtained by a player in a given challenge. This table will store a unique value for each result, the unique value of the visitor who answered, the unique value of the challenge, as well as the result of the challenge.

The "local" table will store all data related to a reference point. This table will store a unique value for each location, as well as information about the location and its name.

The "guide" table will hold the information related to the Arouca Geopark guides. In this table, informational data for each guide will be stored, so that they are presented in BackOffice.

Finally, in the "admin" table, the logins and all the necessary information for accessing the application's BackOffice will be saved, being this data the user and the user's password.

Video Game

Beyond the playful side, this video game also has a serious side, as the player can not only have fun while playing, but he will also be able to learn and test the acquired knowledge. The video game should be able to collect certain data from each player with the smallest possible margin of error, so challenges involving memory games, among others, cannot be used, where it would be quite expectable that the player would make mistakes in several attempts. Therefore, the challenges to which the player will be subjected must have both components.

Three video game challenges were then planned.

The first is quite common, as it is a challenge that is also used in the education system. It is a multiple-choice question, with an image associated with the question asked. The player must answer this question correctly, having to choose the correct option, by clicking on the button associated with that answer. This is one of the first challenges considered, given its simplicity, since any user is already accustomed to this kind of challenges. It is also a great way to test the knowledge acquired during the visit, as it is a direct question, as shown in Figure 1.

The second challenge that was thought is also quite common and used in the education system. It is a challenge where the player is presented with 3 texts and 3 images related to them, such as, for example, the images of 3 different fossils found in the Arouca Geopark and the name of these same fossils, with the player having to

Figure 1. Multiple choice challenge layout

correctly link the name of the fossil to its image, as shown in Figure 2. This challenge was planned because it is possible to collect data with a small margin of error.

The third challenge that was thought is not as common as the previous ones, but it is also quite simple, being called "game of the intruder". Several images are presented to the player, where only one is not framed in the theme to which all the others are associated. The player has to detect the intruder in the group of images, that is, he has to find out which image is not included in the theme and select it. The use of a large number of images will make the challenge more appealing, from the user's perspective, as shown in Figure 3.

Web Services

The server will provide the necessary endpoints for the video game, to make the connection between it and the database. Endpoints are connection points, where, through HTTP requests, it is possible for any device to exchange data with a web server. These are links for each one of the functionalities and may or may not require auxiliary data to be sent with the order.

The first endpoint will be used to start a visit. For this, the endpoint will receive the visitor data and the visit in which he is.

Figure 2. Outline the challenge of linking the image to the keyword

Figure 3. Outline the challenge of linking the image to the keyword

The second endpoint will generate a set of random challenges for each visitor, which is automatically executed after the user's registration request.

The third endpoint will serve to send to the server the results obtained. Results data will be sent at the end of the visit, together with the user ID. These data will be read by the server, which will insert all the results in the database, to be read and processed by BackOffice.

BackOffice

BackOffice will maintain the platform and the view of the acquired data.

The general layout of the pages will consist of a table with the data corresponding to what the user wants to view, with the options, in each of the lines, which allow to change, remove and add, some of which are not available for certain menus.

The Login menu, which will be the home page of the application, will have only a small form, where the user will perform the login. This will be verified in the database and, if the login is correct, the user will go to the application's dashboard.

The Dashboard menu will be a small information page, where after logging in the user will have access to certain data, such as the last visits made and the counts. On this page he will also have quick access to all the functionalities of the application.

The visits menu will have two functionalities: the visualization of the data of the visits already made, such as the date, the guide who made the visit, the data of the visitors who participated in the visit and the results obtained; the creation of the code to carry out a new visit, through a simple form for the user.

The results menu will have only one functionality, which consists of viewing the data of the results obtained by the visitors. These data will be presented in graph form for easier understanding by the user.

The visitors' menu will have only one functionality, which is to view the data of the results obtained by the visitor, the personal information of the visitor and the visit he made.

The challenge menu will have 4 functionalities. In this menu, it will be possible to add, remove or change challenges, as well as to see the data related to each one, such as, for example, the average percentage of success for the challenge.

There are also 4 functionalities of the geosites menu, which make possible to add, remove or change geosites, and also to see the data related to each one of them.

The guide menu is another one that again presents 4 functionalities, providing the addition, removal or alteration of guides and the visualization of data related to each guide, as well as the last visits made by him.

Finally, the administration menu will have 3 functionalities, which allow adding, removing or changing accesses to BackOffice.

With the exception of the Dashboard, in general all menus will be similar: a sidebar on the left, for a faster and easier navigation, an upper bar with the name of the user who is online, and small functionalities such as alerts for visits to be made that day, and a lower bar, with only informational data regarding the platform.

Development

Prior to the development of the project, it was necessary to install all the necessary components, that is, the database server, the web server and the development tools for all components. After installing all the components, it is necessary to proceed with the development of the project components, that is, the creation of the tables in the database, the development of the web services, the video game and the BackOffice

Database Server

For the installation of the database server, it was only necessary to perform the installation of XAMPP, which, as previously described in this document, is a set of applications with the purpose of hosting a website or a web application and that, for that purpose, in addition to other functionalities, it also has a mySQL database server, which will be used in this project.

It was also necessary to proceed with the installation of a tool for manipulating the database, for a greater simplicity in the creation and preparation of the database. The tool used for this project was HeidiSQL.

After installing these two components, the database was created, using HeidiSQL. Using this software, the necessary tables and links were created in the database.

For the creation of the database and its connections, the HeidiSQL interface was used, which makes it simpler. In this interface, you have to define the connection to the database server you want to manipulate, in this case the XAMMP mySQL server, with the correct credentials.

After the connection is created, it is possible to connect to the server and view all the databases that are on it. There the database for the platform will be created.

After creating the database, it is necessary to obtain, for it, the respective tables. For this, it is necessary to connect the database within the system. At this point, it is essential to define the types of fields for each of the tables, that is, to distinguish whether the field is of the numeric, text, date type, among other possibilities. This step is important for a better optimization of the database and for its more efficient operation, when it has larger amounts of data.

This is also here where we define table links, such as primary keys and foreign keys, and also the tables to which the foreign keys belong.

Finally, after creating all the necessary tables, the code for creating the table in SQL is generated. It is through this code that the tables are created and defined.

After the creation, it is then possible to execute functions of the database, to collect or save data in the tables, which will be done in the web services and in the BackOffice.

Web Server

For the installation of the web server, it was necessary to install the WSO2 Application server, which suggests the web service development or the Eclipse Luna editor with the WSO2 plugin. WSO2, as previously described in this document, is a web service, with which the necessary connections will be created so that the video game can interact with the database, anywhere in the Arouca Geopark territory.

Initially, a class was created to control the connection to the database, in order to perform all operations with bigger security.

Multiple classes were then created to serve as a data model for the transfer of information between the web service and the video game.

Finally, the main class was created, which have the endpoints for communication with devices and an auxiliary class to realize the functionalities necessary for each endpoint.

The first endpoint registers the data of a new visitor, the second endpoint returns the data necessary for a visit and the third endpoint receives and stores the data collected by the device.

After installing the server, it is necessary to install JDBC (Java Database Connectivity), a set of classes and interfaces written in Java that send SQL statements to any relational database, so that it is possible to connect to the database .After installing these elements, the source code for the web services will be developed.

It was necessary to prepare and define the methods to carry out the connection to the database, so a class was created that will contain the information to open and close the connection to the database. Two functions have also been defined, one of which allows recording in the database to occur only when all data has been successfully recorded, and another which cancels recording of data, in case an error occurs when trying to record.

After this conduct, it is necessary to proceed with the creation of an information transfer model, so that the message sent always has a format readable by the video game. Thus, the classes "Challenge", "Visitor" and "Message" emerged.

The "Message" class is responsible for returning an error message, when something incorrect happens, as is the case of failure in validating the keyword; the "Challenge" class, used after registering the player, returns all the challenges to the video game;

as for the class "Visitor", it fulfils the objective of returning the data resulting from the registration of a game, data that are used at the end, to record the player's results.

Video Game

For the development of the video game, the Unity3D software was used. After installation, the development of the necessary classes and elements for the video game was started. In the first phase, the classes and objects were prepared for the flow of the video game. In order to do so, it was necessary to create three video game scenarios: the initial menu, the scenario where the video game takes place with the challenges, and the opening scenario.

In the opening scenario, the components that are present in every moment of the game are initialized. The most important is the DataCollector object that will collect and store data for the video game, from the player's responses to the challenges collected by the web service.

It is not a physical object present in the world of video games, but only a global, unique object, which has the necessary features to communicate with the web service, to perform the collection and recording of data. It also has the functionality to control the flow of the video game, namely the beginning and end of the visit, the management and control of places, and the creation and preparation of all elements for a given point of the visit.

Figure 4. Label of the DataCollector object

So that all the remaining elements of the video game can detect it more easily, this object is marked, through a label, with the name of the object itself, as you can see in Figure 4.

After the creation of this object, the main menu scenario was elaborated, the one where the player will enter his data and the code of the visit to be carried out.

This menu consists of only 2 screens, the initial one where the player is when the device is delivered, and the data entry menu (Figure 5).

Figure 5. Initial menu (left) and the data entry menu (right)

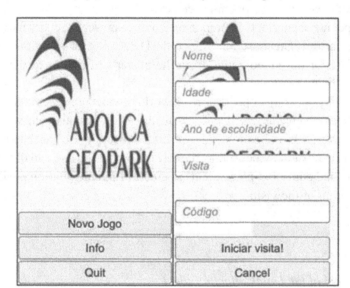

The main menu scenario is where the player inserts his data and the code of the visit that will be performed.

In the game scenario, according to the code that was introduced, the challenges related to the user will be created.

The scenario where the video game takes place is the most important, in the visitor's perspective, as it is there that a didactic-playful part is found, that are shown all the challenges of a given point of the visit and that the player has to answer correctly answer to the challenges. At the end, the player can check the wrong and the correct answers, before moving on to the next place of the visit.

After completed all the challenges for a given point of the visit, the user will be able to visualize their responses and evaluate his own performance for the challenges.

This will be repeated successively for each point of the visit, until at the last point the data collected by the video game are sent to the web service. Figure 6 presents the prototype of the game in the game scenario: on the left image it is possible to see the challenge with a chosen answer and on the right image it is possible to observe the result.

For the realization of this scenario, it was necessary to create two new elements, one to control the menus during the video game, the transition between challenges, the locations and the end of the visit, and an object for the challenges.

The challenge that was initially developed was a multiple choice associated with an image. The challenge object, then, has the image corresponding to the challenge, the question that concerns it and four answer options, only one of which is correct. When the visitor chooses an answer, it has a blue color, which is blocked when he finishes responding, not allowing the answer to be changed. The correct answer will be marked in green and, if the player has the wrong question, his option will appear in red (Figure 6).

Figure 6. Label of the DataCollector object

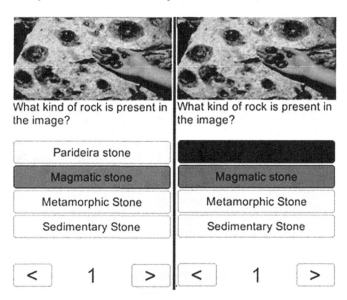

The opening scenario is only for the video game to be able to load all the elements that are necessary, having no interaction with the player.

BackOffice

Once the XAMPP software is installed, the development of BackOffice was the next step. Authentication features have been developed to ensure that unwanted users cannot enter or manipulate the application through a login page to verify the user's real existence, thus allowing multiple logins for different users.

In each successful login, a cookie with the data of the user is stored and for a bigger security the cookie expires every day.

After the login, the user is directed to the Dashboard page. On this page, it has access to all the features of the application, through the side menu and the buttons on the page.

Figure 7 shows the BackOffice prototype in the Dashboard menu and all options available for display.

Figure 7. Label of the DataCollector object

The guide will choose the places that will be visited, the degree of scholarity, among other data. As the guide changes the visits data, a new code is generated.

Another BackOffice functionality is data manipulation. For this the data are presented in a table for a better visualization of the same. It is possible to change these data, delete or add new ones through the forms present in the table.

Finally, it is possible to see the collected data. These are presented in graphs for a better and easier analysis.

TESTING

The usability tests of the project were carried out. Initially, refinement tests were performed on the prototype, only with project members, which were followed by others involving a group of users outside the project.

First Phase – Refinement Tests

After completing the development phase of the application, tests were carried out with the internal members of the project. The purpose of these tests was to ensure the correct behaviour of the application during the following tests. With this in mind, the test flow was followed.

After the prototype was finished, evaluation and usability tests were carried out on the prototype. After the tests were carried out, it was checked whether or not the prototype was approved for testing with external users. If it was not approved, modifications were made to the prototype, to correct the errors or problems found. After the modifications and corrections were made, the evaluation and usability tests were carried out again. This cycle was followed until the prototype was finally considered ready for testing with external users.

The performance of these tests allowed the correction of errors that appeared during the tests, and modifications for a better experience of use for users who performed the following tests. After the application prototype was approved, tests were carried out with external users to the project.

Second Phase – Real Tests Preparations

In order to evaluate the game, usability tests were performed under normal conditions of use.

The sample of users to perform the tests was randomly selected, consisting of 10 users, 2 females and 8 males, aged between 20 and 45 years.

The tasks performed by the users were as follows:

1. Start the video game;
2. Enter its data;
3. Enter the visit code to start the game;
4. Complete the challenges presented during the visit;
5. Finish the visit;
6. Turn off the video game.

Users had the necessary time to complete these tasks.

After completing the tests, a quiz was presented using the format of the technology acceptance model, regarding the video game, in terms of ease, use, utility and attitude towards its use.

Third Phase – Real Tests

The users who carried out the tests in the video game had, for the first time, contact with the video game, during these tests.

They did not have any problems in accomplishing the tasks, completing them successfully, without resorting to any kind of help.

Regarding the use of the video game, they considered it simple and intuitive, filling their data correctly, starting the visit and responding, without problems, to the challenges presented.

All the users found the video game interesting, operating quite intuitively and considered its use interesting, as a support for study visits carried out by younger students.

Regarding their usefulness in relation to the retention of information during the visit, the responses were confusing, with some hesitation as to its didactic usefulness.

The results are satisfactory, showing that the group interacted well with the game, managing to solve all proposed tasks without significant effort (the low value of variance indicates this).

CONCLUSION

As a result of the project's objectives, a platform was created, having as components a serious video game, a database, a web server and a BackOffice. All these components were created in a modular way, so that the intervention of the development team was not necessary to maintain the platform data.

It is concluded that, in a general way, it makes sense to explore the impact of serious video games in teaching, so that they stimulate users to more monotonous, tiring or boring themes, so that students learn from the subject more easily and remain motivated during teaching.

It was also inferred through tests performed with users, they do not show any difficulty when playing the video game.

From the point of view of the work carried out, the first prototype is finished, being ready for tests in guided visits with students, in the Arouca Geopark territory, during an interpreted visit.

FUTURE RESEARCH DIRECTIONS

There is still a lot to do to improve the prototype, both graphically and in functionalities, as there are other challenges that may be interesting for this video game that may be included.

It is also important to carry out more tests, as well as to carry out real tests with players, during a study visit, in order to better understand if the players are really more motivated during the study visit and to check if the project fulfills their ludic and didactic objectives.

Finally, it is possible to verify that the growth of serious video games is expanding, but it remains a very recent concept, when compared to the other technological concepts, so there is much to investigate and explore in the future, mainly with the speed with which these technologies are evolving.

REFERENCES

Arouca Geopark. (n.d.). *Território UNESCO – Um território a descobrir*. Retrieved February 7, 2020, from http://aroucageopark.pt/pt/conhecer/territorio-unesco

Associação Geoparque Arouca. (2016). *Relatório Final 2014/2015*. Author.

Bittencourt, J. R., & Osório, F. S. (2006). *Motores para criação de jogos digitais: gráficos, áudio, interação, rede, inteligência artificial e física*. Retrieved February 11, 2020, from http://osorio.wait4.org/publications/Bittencourt-Osorio-ERI-MG2006.pdf

Caillois, R. (1991). *Les jeux et les hommes: Le masque et le vertige*. Éditions Gallimard.

Christel, M. G., Stevens, S. M., Klishin, A., Brice, S., Champer, M., & Collier, S., … Ni, M. (2013). Helios: An HTML5 game teaching proportional reasoning to child players. In *Proceedings of the 18th International Conference on Computer Games: AI, Animation, Mobile, Interactive Multimedia, Educational & Serious Games (CGAMES 2013)*. Louisville, KY: IEEE. 10.1109/CGames.2013.6632614

Christopoulou, E., & Xinogalos, S. (2017). Overview and comparative analysis of game engines for desktop and mobile devices. *International Journal of Serious Games, 4*(4), 21–36. doi:10.17083/ijsg.v4i4.194

Djaouti, D., Alvarez, J., Jessel, J.-P., & Rampnoux, O. (2011). Origins of serious games. In M. Ma, A. Oikonomou, & L. C. Jain (Eds.), *Serious games and edutainment applications* (p. 2543). Springer-Verlag. doi:10.1007/978-1-4471-2161-9_3

Hookway, G., Mehdi, P. Q., Hartley, D. T., & Bassey, N. (2013). Learning physics through computer games. In *Proceedings of the 18th International Conference on Computer Games: AI, Animation, Mobile, Interactive Multimedia, Educational & Serious Games (CGAMES 2013)*. IEEE. doi:10.1109/CGames.2013.6632617

Jayathilaka, H. (2012). *How to get a cup of coffee the WSO2 way*. Retrieved February 13, 2020, from https://wso2.com/library/articles/2012/09/get-cup-coffee-wso2-way/

Lopez-Samaniego, L., Garcia-Zapirain, B., Ozaita-Araico, A., & Mendez-Zorrilla, A. (2014). Cognitive rehabilitation based on working brain reflexes using computer games over iPad. In *Proceedings of the 2014 Computer Games: AI, Animation, Mobile, Multimedia, Educational and Serious Games (CGAMES)*. Louisville, KY: IEEE.

Polsinelli, P. (2013). *Why is Unity so popular for videogame development?* Retrieved February 11, 2020, from https://designagame.eu/2013/12/unity-popular-videogame-development/

Pronschinske, M. (2017). *WSO2: Open Source SOA in the Cloud*. Retrieved February 13, 2020, from https://dzone.com/articles/wso2-open-source-soa-cloud

Silva, J. F., Almeida, J. E., Rossetti, R. J. F., & Coelho, A. L. A. (2013). Serious Game for EVAcuation training. In *Proceedings of the 2013 IEEE 2nd International Conference on Serious Games and Applications for Health (SeGAH)*. Vilamoura, Portugal: IEEE. 10.1109/SeGAH.2013.6665302

TutorialRepublic. (n.d.). *Bootstrap Tutorial*. Retrieved February 11, 2020, from https://www.tutorialrepublic.com/twitter-bootstrap-tutorial/

Usui, S., Furuichi, T., Miyakawa, H., Ikeno, H., Nagao, S., Iijima, T., ... Ishikane, H. (2007). Japanese Neuroinformatics Node and Platforms. In M. Ishikawa, K. Doya, H. Miyamoto, & T. Yamakawa (Eds.), *Proceedings of the 14th International Conference, ICONIP 2007*. Kitakyushu, Japan: Springer.

ADDITIONAL READING

Johnson, W. L., Vilhjalmsson, H., & Marsella, S. (2005). Serious games for language learning: How much game, how much I? In C. K. Looi, G. McCalla, & B. Bredeweg (Ed.), *Proceedings of the International Conferenc on Artificial Intelligence in Education*. Amsterdam, Netherlands: IOS Pres.

Kent, S. L. (2010). *The ultimate history of video games: From pong to pokémon and beyond – The story behind the craze that touched our lives and changed the world*. Three Rivers Press.

Lanyi, C. S., & Brown, D. J. (2010) Design of Serious Games for Students with Intellectual Disability. In A. Joshi & A. M Dearden (Eds.), *Proceedings of the 2010 International Conference on Interaction Design & International Development*. Swindon, United Kingdom: BCS Learning & Development Ltd. 10.14236/ewic/IHCI2010.6

Michael, D., & Chen, S. (2006). *Serious games: Games that educate, train, and inform*. Thomson Course Technology.

Nauta, H., & Spil, A. M. T. (2011). Change your lifestyle or your game is over: The design of a serious game for diabetes. In *Proceedings of the 2011 IEEE 1st International Conference on Serious Games and Applications for Health (SeGAH)*. Braga, Portugal: IEEE. 10.1109/SeGAH.2011.6165436

Nyitray, K. J. (2011). William A. Higinbotham: Scientist, activist, and computer game pioneer. *IEEE Annals of the History of Computing, 33*(2), 96–101. doi:10.1109/MAHC.2011.48

Paraskevopoulos, I. T., Tsekleves, E., Craig, C., Whyatt, C., & Cosmas, J. (2014). Design guidelines for developing customised serious games for Parkinson's disease rehabilitation using bespoke game sensors. In Y. Pisan, N. Marinos (Eds.), *Entertainment Computing* ICEC – 2014: *Proceedings of the 13th International Conference*, Sydney, Australia: Springer. 10.1016/j.entcom.2014.10.006

Pedraza-Hueso, M., Martín-Calzón, S., Díaz-Pernas, F. J., & Martínez-Zarzuela, M. (2015). Rehabilitation using Kinect -based games and virtual reality. [Monterrey, Mexico: Elsevier.]. *Procedia Computer Science, 75*, 161–168. doi:10.1016/j.procs.2015.12.233

Sik-Lányi, C., & Brown, D. J. (2010). Design of serious games for students with intellectual disability. In A. Joshi & A. Dearden (Eds.), *Proceedings of the 2010 International Conference on Interaction Design & International Development*. Bombay, Índia: BCS Learning & Development Ltd.

Stanton, R. (2015). *A brief history of video games: From Atari to Xbox One*. Robinson.

Vocaturo, E., Zumpano, E., Caroprese, L., Pagliuso, S. M., & Lappano, D. (2019). Educational games for cultural heritage. https://pdfs.semanticscholar.org/ddb8/94 8c585ca3f4477a0cb67e6c67946b524dad.pdf

Westerholt, R., Lorei, H., & Höfle, B. (2020). Behavioural effects of spatially structured scoring systems in location-based serious games—A case study in the context of OpenStreetMap. *ISPRS International Journal of Geo-Information*, 9(2), 129. doi:10.3390/ijgi9020129

Chapter 9
Mobile Applications in Cultural Heritage Context:
A Survey

Manuel Silva
iD https://orcid.org/0000-0003-1122-3560
*Digital Creativity Centre, School of Arts, Portuguese Catholic University,
Portugal*

Diogo Morais
iD https://orcid.org/0000-0002-1913-1276
*Digital Creativity Centre, School of Arts, Portuguese Catholic University,
Portugal*

Miguel Mazeda
iD https://orcid.org/0000-0002-1813-0650
*Digital Creativity Centre, School of Arts, Portuguese Catholic University,
Portugal*

Luis Teixeira
iD https://orcid.org/0000-0002-1206-4576
CITAR, School of Arts, Portuguese Catholic University, Portugal, Portugal

ABSTRACT

*As mobile technology sustains exponential growth and spread to all aspects of our
everyday life and smartphone computational power increases, new promises arise for
cultural institutions and citizens to use these tools for promoting cultural heritage.
This survey proposes to review available smartphone applications (apps) relating
to cultural heritage in three different contexts: cities, street art, and museums. Apps*

DOI: 10.4018/978-1-7998-3669-8.ch009

were identified by searching two app stores: Apple's App Store and Google Play (Android). A data search was undertaken using keywords and phrases relating to cities, street art, and museums. A total of 101 apps were identified (Google Play only= 7, Apple App Store only = 26, both Google Play and Apple App Store = 61, Apple Web Store and Web App = 6). Apps were categorized into the following categories: museums (39), street art (30), and cities (32). The most popular features are photos (96%) and maps (79%), and the most uncommon the 360 (4% – only in museums apps), games (6%), and video (15%).

INTRODUCTION

A smartphone is a mobile phone that includes advanced functionality beyond making phone calls and sending text messages (Christensson, 2010). Most smartphones have the capability to play audio or videos, display photos, and access Web. Modern smartphones, such as the Android and iPhone based phones can run third-party applications that present vast functionality.

The rapid advances of mobile technology and its expansion into the different aspects of our life while they become more reachable and common brings new opportunities for artists and institutions working with Cultural Heritage to use these tools for connecting in new ways and promoting their activities such as the market of tourist services (Madirov & Absalyamova, 2015).

With the advent of 5G mobile technology, these applications will suffer a boom. This chapter presents a survey of mobile apps designed to provide digital experiences in cities, museums and street art events all around the world. It will discuss existing apps in these contexts (e.g multimedia guided tours to the permanent collections or temporary exhibitions, artworks, city apps), the different use of media, and the type of user interaction and involvement they support.

This survey was carried out under the goals of the Cooperative Holistic View on the Internet and Content (CHIC) project. The CHIC project aims to develop a set of digital platforms, based on open formats and interoperable technologies that promote and increase the dynamics of Portuguese media content creation. The author's participation in the CHIC project is focused on content creation for the cultural and historical heritage of Porto city, specifically on museums, cities and urban art applications. The aim is to promote the cultural content of objects, artworks, stories, places, and buildings in the city, by developing a georeferenced

augmented reality platform. To achieve this goal, it is important to have a deeper understanding of the existing solutions that allow users to experience heritage and places, through a mobile application. A good portrayal of current apps, available features, and media use provide feedback to potential users on how to develop new georeferenced apps. These apps provide users with access to a vast number of different experiences in places, such as a city or a museum, using different mediums through their mobile apps.

Understanding the existing characteristics of smartphones in cultural heritage will increase our understanding of what has been created so far, where the potential of mobile technology may be the best use in the future. Thus, in this study, the authors systematically review existing smartphone apps dedicated to cultural heritage, particularly in museums, streets, and cities, available in app stores, to identify trends and current features with potential impact in new apps development. A second goal is to find and study applications with features such as GPS, Live Notifications, Map, Photos, Video, Audio, Games, Augmented Reality, combined into a single app.

BACKGROUND

Cultural Heritage

Cultural Heritage is a broad concept. The International Council on Monuments and Sites (ICOMOS; French: Conseil international des monuments et des sites) defines Cultural Heritage as "an expression of the ways of living developed by a community and passed on from generation to generation, including customs, practices, places, objects, artistic expressions, and values".

Cultural Heritage is expressed as either Intangible (oral traditions, performing arts, rituals) or Tangible Cultural Heritage (movable cultural heritage such as paintings, sculptures, coins, manuscripts; immovable cultural heritage such as monuments, archaeological sites, and so on; and underwater cultural heritage like shipwrecks, underwater ruins, and cities).

Tourism, an economic and social phenomenon has shown exponential growth over the decades. Today, it is an essential factor for socio-economic progress and is intrinsically linked to growth, thus becoming one of the main sources of income for many developing countries. Max Roser presents some tourism figures and estimates from the United Nations World Tourism Organization (UNWTO). In the last 68 years, there has been a growth of 1.4 billion international arrivals per year.

The boost in tourism positively affects major cultural heritage sites through guided tours and cultural events. This association has fostered the research field and is identified as the specific form of consumption with different trends and areas of

research: cultural tourism. Richards (2018) reflected on the emergence of cultural tourism as a social phenomenon and as an object of academic study that can be traced back to post-World War 2, where travel helped to increase cultural understanding.

It was in 1980 (Richards, 2018) that the flow of international tourists to the main sites and attractions allows attaching the title of "cultural tourism" to an emerging market niche, thus emerging the first academic studies and the first definition of the phenomenon by the World Tourism Organization.

Today this definition is much broader, not just referring to places and monuments, but to lifestyles, and creativity with motivations by tourists in terms of learning, discovery, and experience. The term was adapted to a set of intellectual and emotional characteristics of a society that encompasses the creative industries, values, beliefs, and traditions.

This society has many means to share and respond to the need for expression, a human condition. In a search for cultural experiences, tourists have in hands tools to celebrate these moments and that they can play a role in them. In a highly technological world, the authors understand that the use of smartphones and mobile applications increasingly serves the role of travel assistant not only in their planning but also in how to get the most out of it.

These days, people usually have more than one reason to travel (Drule, Chiş, Băcilă & Ciornea, 2012), as well as to look for cultural experiences. This digital aid ends up allowing greater enjoyment of these experiences, whether in museums, artistic installations or cities, and is another attraction for them.

Technology

Day by day it can be seen the growth of the use of mobile computing technology instead of stationary technology (Pandey, Litoriya, & Pandey, 2016). As the use of mobile technology grows, mobile applications follow this path and are being used to contribute to tourism and cities, offering new possibilities to deliver information and knowledge to people (Azevedo & Alturas, 2019; Barroso, De Oliveira, & Macedo, 2016).

The present state of mobile media technology involves text, graphics, images, audio or videos generated by smartphones or other portable devices. Mobile media can be adapted to various screen formats and resolutions. Baker, Schleser & Molga (2009) propose to define an emerging category of Mobile Media Art.

In this survey, the authors focus on the two most used mobile OS's (operating system), Android and iOS (iPhone OS), as shown by Netmarket Share, 2019. Within these OS, the authors' research for mobile applications that contained modules such as, 3D, Videos, Photos, Audio, GPS, Games and Augmented Reality (AR).

Since recent years, mobile devices have been increasing their computing power, features, and new sensors, this allows the developers to create their mobile applications with more innovating content with new technologies, like the AR technology (Gravdal, 2012; Zhang, Chu, Ji, Ke, & Li, 2014). The term "augmented reality" was coined only in 1990 by Tom Caudell and David Mizell (Berryman, 2012).

Augmented Reality refers to the emerging technology that allows the real-time blending of the digital information processed by a computer with information coming from the real world by means of suitable computer interfaces. (Amin & Govilkar, 2015).

AR enhances reality by adding extra content over real-time information. Sometimes can be seen as a disruptive technology, as it overlays the original information, it provides a positive result by engaging with the users (Amin & Govilkar, 2015; Butchart, 2011; Haugstvedt & Krogstie, 2012; Khan, Khusro, Rauf, & Mahfooz, 2015).

AR it's blurring the line between how individuals can distinguish what is real and what is computer-generated over the real environment, it is all about augmenting people skills to see and feel in different ways (Burkard, Fuchs-Kittowski, Himberger, Fischer, & Pfennigschmidt, 2017; Khan et al., 2015).

Over the last ten years, AR has been introduced in the Cultural Heritage field mainly as a valuable technology for supporting visitors inside museums or in heritage sites (Hammady & Temple, 2016; (Pedersen, Gale, Mirza-Babaei, & Reid, 2017). With the use of improved user interaction methods, applications enhance the visitor learning (Bostanci, Kanwal, & Clark, 2015) and allow visitors to explore and understand artworks by helping remove barriers of language or space (Chung, Lee, Kim, & Koo, 2018).

Mobile Augmented Reality (MAR) applications can deliver real-time information based on the visitor's preferences and environment (Chen, 2014). It can also generate revenue or economic returns (Cranmer, Tom Dieck, & Jung, 2017). One example is Pokemon GO from Niantic and Nintendo triggering millions of downloads in one week (Ling, 2017). These applications can be created by using available AR Software Development Kits (SDK) like Vuforia, ARCore, and ARKit, combined with a game engine Unity which is one of the most popular for its Integrated Development Environment (IDE) that can deliver very strong real-time rendering of digital objects. Also, it can easily export and compile applications to all major operating systems, i.e Android and iOS (del Rivero et al., 2015).

Previous Studies

In order to develop and support cultural heritage applications, using effective and efficient approaches (Fidas, Sintoris, Yiannoutsou, Avouris, 2015), the research was started by doing a literature review.

Existing studies point to the use of new technologies such as augmented reality in the context of cultural heritage and cultural tourism (Rupilu, Suyoto, & Santoso, 2018). In 2018, Bekele, Town, Piedicca, Frontoni, Malinverni, presented studies that by combining new media in the application, it can enhance how culture can be experienced. Users thus can benefit from direct access to knowledge and the quality of the diffusion of the knowledge itself.

Cultural heritage applications have been using augmented reality technologies for different purposes, including education, exhibition enhancement, exploration, reconstruction, and virtual museums (Bekele, Town, Pierdicca, Frontoni, & Malinverni, 2018).

From the museum standpoint, since 2009, mobile apps are being introduced in their range of interpretative media and visitor services. As mobile technology continues to develop and permeate all aspects of our life, and the capabilities of smartphones increase while they become more accessible and popular, new possibilities arise for cultural institutions to exploit these tools for communicating in new ways and promoting their exhibitions and programs. (Economou, M., & Meintani, E. (2011)

According to Tillon et al. in 2010, the use of AR applications in artworks helps the visitor to identify relevant facts. It also provides new insight, helping the visitor to understand the artwork that he contemplates in a better way. Nevertheless, the application will not compromise the existence of the artwork itself, only being a complement to it.

FEATURES EXTRACTION AND ANALYSIS

Smartphones have an efficient application distribution channel. Every major smartphone vendor has an app store (e.g., Apple AppStore, Android Market). Apple's App Store and Google Play were launched in 2008. Using this distribution model, startups, research centers, and even individual developers can rapidly create interest in an extraordinarily significant number of users. It is now possible to deliver and provide digital experiments to many users all around the world.

The scope of the survey is to describe and analyze the existing mobile apps targeting museums, street art, and cities. The survey presents key aspects of the apps, focusing on the use of different types of media, especially augmented reality.

The survey is thus envisioned as an important resource for all potentially interested users, from artists to cultural institutions, to tourism operators.

A search was made between January and February of 2019 on the Apple App Store, Google Play Store and Google search engine. The Operating Systems (OS) of the analyzed applications were iOS, Android or both. Developers in mobile apps usually opt for one of three options for making revenue: show ads on the app, direct purchase of an app or the micro-transactions within the application (Ghose & Han, 2014) According to Tomić (2019), microtransactions denote a payment made for the purchase of applications or additional content in video games.

In 2017, worldwide revenue from apps is estimated to be over $240 billion (App Annie 2019). Applications whose installation was free, paid, or with micro-transactions were selected. All the apps were available in the digital app stores at the time of the search.

The following keywords were used: museum, augmented reality, cities, tourism, cultural heritage, and urban art. For each app, the following description information and media features were obtained: Application Name, Year of Release, Delivery, Event, Mode, Community, GPS, Live Notifications, Map, Photos, Video, Audio, Games, Augmented Reality, Operating System, Installation, and Developer / Seller.

Some of the descriptions and features names are self-explanatory, such as Application Name, Year of Release, Live Notifications, Map, Photos, Video, Audio, Games, Augmented Reality. For the others, the authors present our definition.

"Delivery" refers to whether the application is globally available or can only be used in certain locations. Taking that into account the feature "Delivery" was divided into two possibilities: Global or Local.

As for the "Event" category, it can be Single (S) or Continuous (C). This division refers to applications developed for a specific event (S) or to be used over time (C). In some cases, the applications would only be available as long as the exhibition in the museum was available to the public.

The "Mode" is related to the way the application work regarding connectivity. An application may need to be Online (ON), Offline (OFF) or Synchronized (Synch).

"Community" is about how the app deals with its users. It is related to whether it is developed by its developers and they have full control of the information and content provided (Centralized) or whether the app is developed and updated through its users who have the power to contribute its content (Distributed).

Museums

One of the apps most attractive features is the possibility for reaching new audiences through a personal device they have chosen and are familiar with, not only during their museum visit but also before and after the visit, wherever the user chooses to

be (Economou & Meintani, 2011). As museums are continuously exploring new strategies for communicating with current and potential audiences this proves to be a significant way.

The study has allowed determining which elements and features are more popular, unique, and how different media formats are used. The study also focused on how users can use and interact with these features. This new way of exploiting cultural offerings is a competitive advantage and a way of attracting new audiences to mobile technology users and arousing their curiosity (Jankowska et al., 2017).

The creation of mobile apps with museum content is a rapidly expanding area with several institutions around the world experimenting with their potential, particularly their advanced computing abilities and connectivity (Economou & Meintani, 2011). The first application for smartphones launched was the Brooklyn Museum of Art in the U.S and in Europe the Vatican Museums, both dedicated to art. In 2012, among the ten most downloaded applications the sixty percent corresponded to museums or cultural heritage and museums, art most of them were apps of art museums (Benito, 2013).

The advantages that mobile applications can bring to tourists/visitors are manifold. Ease of use, interactivity and immediate availability of information will be of the utmost importance. Various modules in the application, such as GPS, maps, photos, videos, audio, games, and augmented reality can enhance and amplify the user experience. Perhaps the more successful apps may prove to be the type that is not just designed to enhance a physical visit to a museum or gallery but those that take a museum's content and make it relevant to the world outside (Jeater, 2012).

The use of GPS coupled with a museum map can be used to offer the visitor a clear understanding of their location during the visit and the best way to find a specific exhibit, object, or even to receive relevant and site-specific information. The use of photographs, video, and audio allows us to broaden the knowledge of the artwork and open the door to discover other perspectives and stories that may not be available in physical format. The user can thus use these means to be guided by various works through entities such as the curator of the exhibition, a narrator, or the artist himself.

The use of augmented reality, although still rarely used today, allows a greater interaction of users with the artworks, the history of the museum or the art itself. The possibility of incorporating new dimensions in the artworks, such as x-ray or infrared images allows us to view new images and information otherwise invisible to the human eye. Adding new layers of information and content to the artwork enhances the visitor experience. By 2010, Mark Skwarek & Sander Veenhof, the main founders of Manifest.AR challenged the Museum of Modern Art's exclusivity by placing artworks inside and around the museum that would use AR. As a result,

Table 1. Museum applications - 2019.

Name	Year	Delivery	Event	Mode	Community	GPS	Live Not.	Map	Photos	Video	Audio	AR	Games	OS
9/11 Memorial and Museum	2019	Global	C	Synch	Centralized	NO	NO	YES	YES	NO	YES	NO	NO	iOS/Android
Explorer - AMNH NYC	2019	Global	C	OFF	Centralized	YES	YES	YES	YES	YES	NO	NO	YES	iOS/Android
Louvre	2019	Global	C	OFF	Centralized	N/A	NO	YES	YES	NO	YES	NO	NO	iOS/Android
Museu do Douro	2019	Global	C	OFF	Centralized	NO	NO	NO	YES	NO	YES	NO	NO	iOS/Android
Museum Barberini	2019	Global	C	OFF	Centralized	YES	N/A	YES	YES	YES	YES	NO	NO	iOS/Android
Nationalmuseum Visitor Guide	2019	Global	C	OFF	Centralized	NO	NO	YES	YES	NO	YES	NO	NO	iOS/Android
Rijksmuseum	2019	Global	C	OFF	Centralized	YES	N/A	YES	YES	YES	YES	NO	NO	iOS/Android
SFMOMA Audio	2019	Global	C	OFF	Centralized	NO	NO	YES	YES	NO	YES	NO	NO	iOS/Android
The Dali Museum Tour	2019	Global	C	OFF	Centralized	NO	N/A	YES	YES	NO	YES	NO	NO	iOS/Android

on October 9th, 2010 the Manifest.AR exhibition premiered at MoMA NYC. A new reality of museums is emerging.

As a part of understanding how museums are dealing with these new technologies in their mobile applications, the authors analyzed thirty-nine museum applications, mainly from European, Asian and North American Museums, that were created in the last two years. Of the thirty-nine apps that were reviewed, only one is meant to be used only at the location of the museum. Due to time constraints, this application was not tested as its location is at The National Museum of Singapore. Results of museum applications, from 2017 to 2019, are presented in the tables Table 1 (beginning of 2019), Table 2 (2018) and Table 3 (2017).

The survey was conducted at the beginning of 2019. Nevertheless, in 2019, 9 apps were already available in the stores, compared to 23 from 2018 and 5 from 2017. If in 2017 all apps run in iOS and about 40% in Android. In 2019, all apps run both in iOS and Android. With one exception, apps are available over the world and continuously (particularly in 2019). Regardless of the year, developers have full control of the information and content provided for the apps.

The analysis of museum applications has revealed that the majority of them use maps, photographs, and audio. This is mainly due to the use of these applications, in some cases, appearing as "replacements" of traditional audio guides. Few applications use Augmented Reality or Games. Most apps work offline so visitors can download the app before going to the museum or the exhibition. This offline mode allows users to access information even after leaving the museum. In a second step, it was analyzed the media features of each application (Figure 1).

There are only three features that are present in over 50% of applications: Map, Photographs and Audio. Not a single application has all the features combined. The feature 360° was not included in the tables to keep all the tables with the same features since it was only present in Museums apps with 4% of presence. Only

Table 2. Museum applications - 2018.

Name	Year	Delivery	Event	Mode	Community	GPS	Live Not.	Map	Photos	Video	Audio	AR	Games	OS
American Museum of Natural History	2018	Global	C	OFF	Centralized	N/A	N/A	YES	YES	N/A	YES	YES	NO	iOS
Briscoe Museum	2018	Global	C	OFF	Centralized	NO	NO	YES	YES	YES	NO	NO	NO	iOS
FCP Museu e Tour	2018	Global	C	OFF	Centralized	NO	NO	YES	YES	YES	YES	NO	NO	iOS/Android
Folkwang	2018	Global	C	ON	Centralized	YES	YES	YES	YES	YES	YES	NO	NO	iOS/Android
Georgia O'Keeffe Museum Tours	2018	Global	C	OFF	Centralized	YES	N/A	YES	YES	NO	YES	NO	NO	iOS/Android
Gulbenkian	2018	Global	C	OFF	Centralized	NO	NO	YES	YES	NO	YES	NO	YES	iOS/Android
Hermitage Museum	2018	Global	C	OFF	Centralized	NO	NO	YES	YES	NO	YES	NO	NO	iOS
Joan Miró	2018	Global	S	OFF	Centralized	N/A	N/A	NO	YES	NO	NO	NO	NO	iOS
LACMA	2018	Global	C	OFF	Centralized	NO	N/A	NO	YES	NO	NO	NO	NO	iOS/Android
Moma Audio	2018	Global	C	OFF	Centralized	NO	NO	NO	YES	NO	YES	NO	NO	iOS
Morikami Museum & Japanese Gardens	2018	Global	C	OFF	Centralized	YES	N/A	YES	YES	NO	YES	NO	NO	iOS
Musée des Beaux-Arts, Lyon	2018	Global	C	ON	Centralized	NO	NO	NO	YES	NO	YES	NO	NO	iOS/Android
Musée D'Orsay	2018	Global	C	OFF	Centralized	YES	NO	N/A	NO	NO	N/A	N/A	NO	iOS
National Gallery of Art	2018	Global	C	OFF	Centralized	N/A	N/A	YES	YES	N/A	N/A	YES	N/A	iOS
National Museum of Wildlife Art	2018	Global	C	OFF	Centralized	YES	NO	YES	YES	NO	YES	NO	NO	iOS
Pérez Art Museum Miami	2018	Global	C	ON	Centralized	NO	NO	YES	YES	YES	YES	YES	NO	iOS
Second Canvas Thyssen	2018	Global	C	ON	Centralized	NO	YES	YES	YES	NO	YES	NO	NO	iOS/Android
SMK Second Canvas	2018	Global	C	ON	Centralized	NO	YES	NO	YES	NO	YES	NO	NO	iOS/Android
Sorolla Museum AR	2018	Global	C	OFF	Centralized	NO	NO	NO	YES	YES	YES	YES	NO	iOS/Android
Stadel Museum	2018	Global	C	ON	Centralized	NO	YES	NO	YES	NO	YES	NO	NO	iOS/Android
Story Of The Forest	2018	Local	C	OFF	Centralized	NO	NO	NO	YES	NO	YES	YES	NO	iOS/Android
Timken Museum of Art	2018	Global	C	OFF	Centralized	NO	N/A	YES	YES	NO	YES	NO	NO	iOS
Wistariahurst Museum	2018	Global	C	OFF	Centralized	YES	NO	YES	YES	NO	NO	NO	NO	iOS

working and available Apps on the App Store were tested. All tested apps were free or with microtransactions. If a developer offered more than one application, the authors selected the app with more downloads. Examples: *Cuseum* and *eTips*.

In order to give a better insight into how the apps work and are designed, the authors will describe three apps: the British Museum app, *Story of the Forest* and Skin and Bones app.

The British Museum app is a traditional museum app. It provides a map and photos gallery but lacks audio support, a popular feature. The navigation system is very simple. By tapping in the map, and selecting a room, users have access to the highlights of the artwork in that location. By continuing taping in the object, a summarized perspective of the object and history of the artwork pops up.

Table 3. Museum applications - 2017.

Name	Year	Delivery	Event	Mode	Community	GPS	Live Not.	Map	Photos	Video	Audio	AR	Games	OS
British Museum	2017	Global	C	OFF	Centralized	NO	N/A	YES	YES	NO	NO	NO	YES	iOS/Android
Getty360	2017	Global	C	OFF	Centralized	N/A	N/A	N/A	YES	N/A	N/A	N/A	N/A	iOS
MAAS	2017	Global	C	ON	Centralized	NO	YES	YES	NO	NO	YES	NO	NO	iOS/Android
Portrait Stories	2017	Global	C	ON	Centralized	YES	NO	NO	YES	YES	NO	NO	NO	iOS
Skin and Bones	2017	Global	C	OFF	Centralized	NO	NO	YES	YES	YES	YES	YES	NO	iOS

Figure 1. Results of Features in Museums Applications

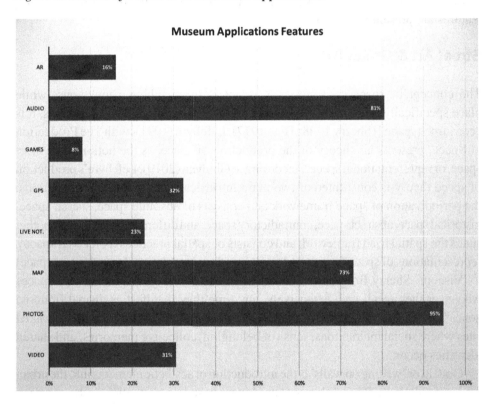

Story of the Forest app is unlike most museum apps. It can only be used and explored at the location and provides photos, audio, and AR. The app is part of an immersive installation that transforms 69 drawings from *William Farquhar Collection of Natural History Drawings* into three-dimensional animations. The artwork touches on various histories, through a virtual and visual landscape.

Skin and Bones app has the traditional characteristics of a museum app (map, photos, and audio) and adds video and AR. Smithsonian Institute has developed the application and it can be used on the National Museum of Natural History. The

Museum has in its collection several skeletons from every major group of vertebral animals. Using the app, the user can compare the skeletons of different animals and see their differences and similarities. It can also show how the specimens move and looked when they were alive.

The analysis of museum applications has revealed that most of them use maps, photographs, and audio. This is mainly due to the use of these applications as "replacements" of traditional audio guides. Regarding Augmented Reality, it was observed that there are few applications that have them. Analyzing the characteristics of the applications, the following data was obtained, and shows how much the features are present in the applications.

Street Art & Urban Art

The concept of space conventionally denotes to something anonymous, while place specifically accounts for the evocative experience of a given site; that is, it is "consumed space" (Sherry 1998; Tuan 1977). Lefebvre (1991), with The Production of Space, presents his theory of the production of space, as the notion of abstract space, or representational space. According to Ghulyan (2019), Lefebvre's production of space theory is constituted of two main intrinsically interrelated constructions: the periodization of space framework and consists of absolute space, sacred space, historical space, abstract space, contradictory space, and differential space; and another states the spatial triad framework and consists of spatial practices (perceived space), representations of space (conceived space), and representational space (lived space)

Visconti, Sherry, Borghini, & Anderson in 2010 define urban scenarios as "spaces whenever they recall and, extensively, any time they manifest as dismal liminoid zones". Visconti et al. also use the term "urban places" to describe appropriated sites where social interactions, sense of belonging, collective memories, and shared identities occur.

Graffiti or 'writing on walls' is the introduction of aesthetic elements into the urban landscape illegally. These elements are letters based on aesthetics or the common logic of graffiti as a culture; they are pieces created for this culture. Modern graffiti is a phenomenon that everyday spreads into more streets, more cities, and more countries (Zieleniec, 2017). Over the past few years, there have been investments in this area, not only on public works that impact the city, but also promotional works that transform the way brands communicate with consumers.

Differentiation between street art and public art is thin: the last is sanctioned and commissioned, controlled and legitimated whilst the earlier is illegal, unconstrained in content, form, and location (Bengtsen, 2013). The acceptance or accommodation of graffiti and street art can also have impacts on urban communities and neighborhoods (Zieleniec, 2017).

Peter Bengtsen (2014) states: "the term Street Art cannot be defined conclusively since what it encompasses is constantly being negotiated." Blanché, in 2015 defines self-authorized pictures, characters, and forms created in or applied to surfaces in the urban space that intentionally seek communication with a larger circle of people as Street Art. Accordingly, Street Art is done in a performative and often site-specific, ephemeral, and participatory way.

The term Urban Art is broader than Street Art. Urban Art seemed more appropriate as an umbrella term for any art in the style of Street Art, Graffiti or Mural Art. Urban Art is Art that is often performed by Street Artists for the purpose of earning a living frequently with techniques of their Street Art pieces without committing illegality. Unlike Public Art, Urban Art can be in a museum or gallery. While a work of Urban Art can be placed in one of these exhibition spaces and be commercialized in this way, a work of Public Art is a "contemporary artwork located outside of galleries and museums as an aesthetic and communicative object in order to democratize access to modern art." (Danko, 2009).

Urban art today is designated as the new public art (Underdogs, 2013) by those who believe that promoting the development of artistic interventions in the urban context is a public service. And it is unmistakably visible today the positive impact on cities and communities of such interventions.

In addition to this impact, there is great potential for the expansion of this type of digital interventions using emerging technologies. Since the emergence and growth of Instagram, many artists have appropriated this social network for sharing and documenting their work (MacDowall & Souza, 2017).

Social networks and technological resources appear as tools to extend this type of work. INSA is one of the artists who have used their own technique and with a complete visualization only in digital media. His work is made by photographing stages of murals deliberately designed with multiple layers, drawing inspiration from the process of stop-motion animation, and then turning the resulting sequence into an animated Graphics Interchange Format (GIF) digital image to be posted and viewed online.

Like INSA, there are many artists who use social networks as a showcase for presentation. Thus, there is a great openness on the part of these artists to use these tools to reach their audience. Using GPS, smartphones allow us to locate anything in the world. Artists and cultural actors use digital technology to document their artistic process and to share their works with everyone, allowing followers to know where the works are located.

In this research, thirty-one mobile applications focused on street art were selected from the Apps Stores and analyzed. If in the previous section the trend was to deploy apps to both iOs and Android platforms, the authors found applications available

Table 4. Street Art & Urban Art applications - 2019 and 2018.

Name	Year	Delivery	Event	Mode	Community	GPS	Live Not.	Map	Photos	Video	Audio	AR	Games	OS
Banksy's Tour Map (London & Bristol)	2019	Local	C	ON	Centralized	YES	NO	YES	YES	NO	NO	NO	NO	Android
Bepart	2019	Global	C	ON	Centralized	YES	NO	YES	YES	NO	NO	YES	NO	iOS/Android
MASA - Murals and Street Art	2019	Global	C	ON	Distributed	YES	NO	YES	YES	NO	NO	NO	NO	iOS
WakingApp	2019	Global	C	ON	Distributed	NO	NO	NO	YES	NO	NO	YES	NO	IOS/Android
AgitÁgueda Urban Art	2018	Local	S	ON	Centralized	NO	NO	YES	YES	NO	NO	YES	NO	iOS/Android
ArtOut - Graffiti & Street Art	2018	Global	C	ON	Distributed	YES	NO	YES	YES	NO	NO	NO	NO	iOS/Android
CANVS Street Art	2018	Global	C	ON	Centralized	YES	YES	YES	YES	NO	NO	NO	NO	iOS
Elas Street Art	2018	Global	C	Synch	Centralized	YES	NO	YES	YES	NO	NO	NO	NO	Android
ENTiTi	2018	Global	C	ON	Distributed	NO	NO	NO	YES	NO	NO	YES	NO	iOS/Android
Leon Keer	2018	Global	C	OFF	Centralized	NO	NO	NO	NO	NO	NO	YES	NO	iOS/Android
R.U.A. Street Art Tour	2018	Local	S	ON	Centralized	NO	NO	YES	YES	YES	NO	NO	NO	Android
Rewriters - Street Art Route	2018	Local	C	Synch	Centralized	YES	NO	YES	YES	NO	YES	NO	NO	iOS/Android
Street Art I SPOTTERON	2018	Global	C	Synch	Distributed	YES	NO	YES	YES	NO	NO	NO	NO	iOS/Android
Street Art Cities	2018	Global	C	ON	Centralized	YES	NO	YES	YES	NO	NO	NO	NO	iOS/Android
Street Art Gallery	2018	Global	C	Synch	Centralized	NO	NO	NO	YES	NO	NO	NO	NO	Android

only for Android or iOS. The following tables show Street Art application features developed at the beginning of 2019 and 2018 (Table 4) and before 2018 (Table 5).

Table 5. Street Art & Urban Art applications - 2017 and earlier.

Name	Year	Delivery	Event	Mode	Community	GPS	Live Not.	Map	Photos	Video	Audio	AR	Games	OS
Banksy Street Art Treasure Map	2017	Global	C	ON	Centralized	YES	NO	YES	YES	NO	NO	NO	YES	iOS
Street Art in Brooklyn, New York Walking Tour	2017	Local	C	Synch	Centralized	YES	NO	YES	YES	NO	NO	NO	NO	iOS/Android
Street Artists	2017	Global	S	OFF	Centralized	NO	NO	NO	YES	NO	NO	NO	NO	Android
STREETART ROMA	2017	Local	C	ON	Centralized	YES	NO	YES	YES	NO	NO	NO	NO	iOS/Android
Urban Art Portugal	2017	Local	C	ON	Centralized	YES	NO	YES	YES	NO	NO	NO	NO	iOS/Android
Lisbon Street Art	2016	Local	C	ON	Centralized	YES	NO	YES	YES	NO	NO	NO	NO	Android
Nuart Festival - Geo Street Art	2016	Local	S	ON	Centralized	YES	NO	YES	YES	NO	NO	NO	NO	iOS
Street Art London	2016	Local	C	ON	Centralized	YES	NO	YES	YES	NO	NO	NO	NO	iOS
Street Art NYC	2016	Local	C	ON	Centralized	YES	NO	YES	YES	NO	NO	NO	NO	iOS
Street Wise the way to discover street art	2016	Local	C	ON	Centralized	YES	NO	YES	YES	NO	NO	NO	NO	iOS
Public Art	2015	Global	C	ON	Centralized	NO	NO	YES	YES	NO	NO	NO	NO	iOS
Street Art Archive Berlin	2015	Local	C	Synch	Centralized	YES	NO	YES	YES	NO	NO	NO	NO	iOS
Street Art Istanbul	2015	Local	C	Synch	Centralized	NO	NO	NO	YES	NO	NO	NO	NO	iOS/Android
Penang Street Art	2013	Local	S	Synch	Centralized	NO	NO	NO	YES	NO	NO	NO	NO	Android

If in the early years, most apps were developed only for iOS mobile phones, since 2018 Android is the most used O.S. It was found several applications with the last update date before 2018 without any update. After 2017, it can observe a trend: community participation as about one-third of the applications. Users can be involved in either the development or to contribute to its content. This could be a strategy to improve support in content updating strategy. Most of the applications are available over time (few associates with only one event).

Before 2018, most apps refer to country capitals: Berlin, Lisbon, London, Rome or Istanbul (table 5). Also, these apps are only available locally. For example, *Bepart* and *AgitÁgueda* Urban Art that have AR allow the user to have the experience on the spot, even though you can get access to the app anywhere. The delivery has changed in more recent applications. The latest applications need to be online or in synch and are available globally.

Only six of the applications are paid or have micro-transactions within them. All others are free. None of the applications documents the production process of the works (except *R.U.A. Street Art Tour*) and none of the apps have contributions from artists. One of the exceptions to this list is the application developed by artist Leon Keer, one of the world's leading artists in anamorphic street art who developed works in 3D with animations in augmented reality in partnership with Joost Spek. In the *ENTiTi* app, you can use the experience held in Dubai by Leon Keer and Joost Spek: *Dubai Canvas 4d street art*.

Figure 2 presents the major features of the Street & Urban Art applications. There are three features that are present in over 50% of the applications: Photographs (93%), Map (73%) and GPS (63%). Some of the features are available in only one application (3%): Live notifications, Video, Audio, and Games. These results raise some questions: why are street and urban art apps, unlike museums, not using the full potential of digital media by restricting the use of audio or video?

To reply to this question, it is crucial to add an additional result of our study: 20% of applications incorporate augmented reality experiences. Street art experience occurs in an open space where audio and video viewing conditions are not optimal. It creates the need to further study this topic. What digital media elements are being used in AR experiences? How are users assess these experiences?

Cities

Today's society is living in a world that provides easy access to many online technologies and services with the aim to make smarter cities (Barbu, Kuhn, Spirescu, Lamorte, & Scanu, 2015). It's quite unlikely for people to find themselves in a situation in which technology cannot support them (Saracco, 2012).

Figure 2. Results of Features in Street & Urban Art Applications

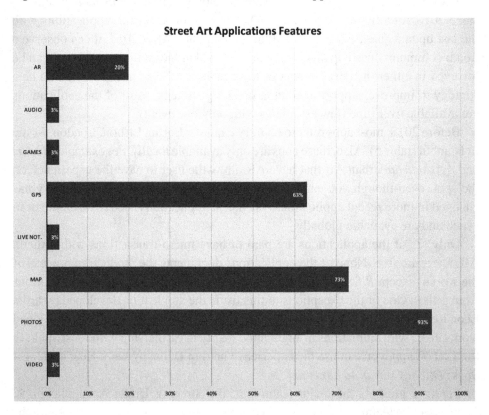

2008 was a key turning point regarding cities and mobile apps for two reasons. It was the first time there was more mobile than fixed broadband subscriptions (Walravens, 2015), and more than half of the global population lives in cities (Burger, 2012; Oteafy, Hassanein, Oteafy, & Hassanein, 2014). The UN estimates that this last number will only increase, to a predicted 70% by 2050 (UN Habitat, 2010). As more citizens (and consumers) move to urban areas and feeling more connected with cities and an urban lifestyle, therefore this means more people want to visit and explore other cities (Postma, Buda, & Gugerell, 2017).

Due to the decrease in travel costs as a result of low-cost airline companies and low-cost accommodation, cities are perceived as attractions and destinations (Postma et al., 2017). In the global economy, tourism is one of the most visible and rising sectors. According to "Travel & Tourism economic impact" report, in 2018, taking into consideration the global economy, tourism accounted, in 2017, for about 10.4% of global gross domestic profit (GDP), 313 million jobs (9.9% of total employment), and 4.5% of total investment (World Travel & Tourism Council, 2018).

Tourists use apps before (Ulrike Gretzel, Daniel R. Fesenmaier, Yoon Jung Lee, 2011), during and after their visits to cities to obtain geographic information (Tussyadiah & Zach, 2012), to mediate tourist sites (Kennedy-Eden & Gretzel, 2012) or to share experiences in social networks. The nature of tourism is to create extraordinary experiences (Pine & Gilmore,1999), thus there is a persistent quest for new tools and innovative technologies to improve the tourist experience.

The following tables show the analyzed Cities applications developed in 2019 (Table 6), 2018 (Table 7) and from 2015 to 2017 (Table 8).

Table 6. Cities applications - 2019.

Name	Year	Delivery	Event	Mode	Community	GPS	Live Not.	Map	Photos	Video	Audio	AR	Games	OS
Art Local	2019	Local	C	Synch	Centralized	YES	YES	YES	YES	NO	NO	NO	NO	iOS
Art Trax	2019	Local	C	ON	Centralized	YES	YES	NO	YES	YES	NO	NO	NO	iOS/Android
Bike Citizens Cycling App	2019	Global	C	Synch	Distributed	YES	YES	YES	YES	NO	NO	NO	NO	iOS/Android
Culture Trip: Explore & Travel	2019	Global	C	Synch	Distributed	YES	YES	YES	YES	NO	NO	NO	NO	iOS/Android
FARET TACHIKAWA ART NAVI	2019	Local	S	Synch	Centralized	YES	YES	YES	YES	YES	YES	YES	NO	iOS/Android
Fever	2019	Global	C	Synch	Distributed	YES	YES	YES	YES	NO	NO	NO	NO	iOS/Android
Guides by Lonely Planet	2019	Global	C	Synch	Centralized	YES	YES	YES	YES	NO	NO	NO	NO	iOS/Android
Nearify	2019	Global	C	Synch	Distributed	YES	YES	YES	YES	NO	NO	NO	NO	iOS/Android
Virginia City	2019	Global	C	Synch	Centralized	YES	YES	NO	YES	YES	YES	NO	YES	iOS/Android

By analyzing the tables, the following data was obtained from 29 applications that show the presence of the features (Figure 3), and the explosive growth since 2017, where the development of mobile applications increased each year.

There are four features that are present above 50% on all applications, and one of these was present in all the applications: GPS (93.75%), Live Notifications (53.13%), Map (96.88%) and Photographs (100%).

The last four features are less present with results below 25%, such as AR (9.38%), Audio (21.88%), Games (6.25%) and Video (12.50%).

Notice that 63.33% of the applications were free and fully tested while 33.33% were with microtransactions and the only one paid (Streetography) was not fully tested.

Most applications for cities rely on GPS, Maps, and Photographs to help people to know better the cities, and use these applications like digital travel itineraries. *FARET TACHIKAWA ART NAVI*, *Pokemon GO*, and *Virginia City* were the only applications to be close to use almost every feature leaving off Games in *FARET TACHIKAWA ART NAVI*, Live Notifications and Video in *Pokemon GO* and Live Notifications and AR in *Virginia City*.

Table 7. Cities applications - 2018.

Name	Year	Delivery	Event	Mode	Community	GPS	Live Not.	Map	Photos	Video	Audio	AR	Games	OS
Art Público Barcelona	2018	Local	C	Synch	Centralized	NO	YES	NO	YES	NO	NO	NO	NO	iOS
Cathedral City: Where ART Lives	2018	Local	C	ON	Centralized	YES	YES	NO	YES	NO	NO	NO	NO	iOS/Android
Cherry Hills Public Art	2018	Local	C	ON	Centralized	YES	YES	NO	YES	NO	NO	NO	NO	iOS/Android
Cultural Places – Travel Guide	2018	Global	C	Synch	Distributed	YES	YES	YES	YES	NO	NO	NO	NO	iOS/Android
DSM Public Art	2018	Local	C	ON	Centralized	YES	YES	NO	YES	NO	NO	NO	NO	iOS
Like a Local	2018	Global	C	Synch	Centralized	YES	YES	YES	YES	NO	NO	NO	NO	iOS
Monument Tracker World Guidea	2018	Global	C	Synch	Distributed	YES	YES	YES	YES	NO	NO	NO	NO	iOS
Musement	2018	Global	C	Synch	Centralized	YES	YES	YES	YES	NO	NO	NO	NO	iOS/Android
Public Art San Francisco	2018	Local	C	ON	Centralized	YES	YES	NO	YES	NO	NO	NO	NO	iOS
SCAPE PUBLIC ART	2018	Local	C	ON	Centralized	YES	YES	NO	YES	NO	NO	YES	NO	iOS/Android
Spotted by Locals - City Guide	2018	Global	C	OFF	Distributed	YES	YES	YES	YES	NO	NO	NO	NO	iOS/Android
Streetography	2018	Global	C	Synch	Centralized	YES	YES	YES	YES	NO	NO	NO	NO	iOS/Android
Sydney Culture Walks	2018	Local	C	ON	Centralized	YES	YES	NO	YES	NO	YES	NO	NO	iOS/Android
Trip by Skyscanner - City & Travel Guide	2018	Global	C	Synch	Distributed	YES	YES	YES	YES	NO	NO	NO	NO	iOS/Android

Table 8. Cities applications - 2015 to 2017.

Name	Year	Delivery	Event	Mode	Community	GPS	Live Not.	Map	Photos	Video	Audio	AR	Games	OS
City of Atlanta's Public Art	2017	Local	C	Synch	Centralized	YES	YES	NO	YES	NO	YES	NO	NO	iOS/Android
Localeur	2017	Global	C	Synch	Distributed	YES	YES	YES	YES	NO	NO	NO	NO	iOS/Android
Manoa Public Art	2017	Local	C	ON	Centralized	YES	NO	NO	YES	NO	NO	NO	NO	iOS/Android
Sidekix	2017	Global	C	Synch	Distributed	YES	YES	YES	YES	YES	NO	NO	NO	iOS/Android
CU Public Art	2016	Local	S	ON	Centralized	YES	YES	NO	YES	NO	YES	NO	NO	iOS/Android
Pokemon GO	2016	Global	C	ON	Centralized	YES	NO	YES	YES	NO	YES	YES	YES	iOS/Android
Field Trip	2015	Global	C	Synch	Centralized	YES	YES	YES	YES	NO	NO	NO	NO	iOS/Android

FARET TACHIKAWA ART NAVI is an application created for the 109 pieces of public art of the *FARET TACHIKAWA ART* group in *Tachikawa City*, *Tokyo Prefecture*. Using photos, text, audio, and video, combining these to navigate to the locations of the artworks using an illustrated map and AR. The Live Notification will only work once you open the application and get near to the artworks.

Pokemon GO is another noticeable example of an application that takes advantage of these features. It was base on the original *Pokemon* game from *Nintendo* where the player as to collect all the *Pokemons* in the game and fight other players with them. Using GPS and AR de developers *Niantic* in partnership with *Nintendo* tried to bring the game into the real world, not making for a specific city, but to use the

Figure 3. Results of Features in Cities Applications

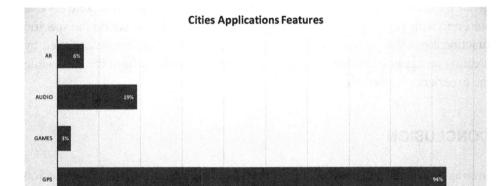

cities around the world as the map of the game, making the users explore the cities in search of *Pokemons* to fight other players.

Virginia City it's an application focusing on the *Comstock's Rich Heritage*. It was created with the objective to let users experience the *Comstock* cultural heritage. The application is filled with information on *Comstock* historic town, points of interest, special events, and audio guide tours.

FUTURE RESEARCH DIRECTIONS

This work should be continuous to keep up with technological advances and to understand how these tools are used within the cultural heritage. This is a survey that developers should be aware of in order to decide the best features to give in the applications they develop.

A next step will be to take questionnaires on how these features affect users and their experiences and see if they see them as useful. This was not possible to

conclude through the feedback received in the app stores, because the information given by users is an insufficient evaluation based on metrics from zero to five stars and with vague comments on the general application and not on the specific functionalities that were of interest to the authors. This can also be achieved by creating an application that can obtain feedback in real-time from the user while the experience is occurring.

CONCLUSION

In an age where society lives so fast and are constantly being targeted for information and want to be always connected (Palumbo, Dominici & Basile, 2014), it makes sense that cultural areas are completed digitally and offer more resources to their actors. With this research, it was possible to see which features are most often found in mobile applications in this field.

In the museum applications, it was observed that they evolved from the traditional audio guides with photographs and audio being the main categories present on them. The authors have found that some work with new media, such as AR and games, is being done in museums apps but it's still in its early days and that only a few have them available.

In applications directed to street art, the authors realized that the most present features are: GPS, maps and photo module. Besides, AR is a growing tool that is beginning to be invested in mobile applications as well as by street artists.

In applications for cities, it was noticed that these applications are being used mostly as digital tourism itineraries, being the prominent features: GPS, Map, and Photographs.

This study has identified that most available apps relating to Cultural Heritage are available free (90%) and from a huge diversity of developers/sellers. About 80% of the apps have less than two years. Thus, Cultural Heritage apps offer a unique opportunity to provide accurate and reliable cultural heritage information and their use as an instrument to promote art, either in public spaces or museums, should be further explored.

ACKNOWLEDGMENT

This article is a result of the project (CHIC - Cooperative Holistic View on Internet and Content (POCI-01-0247-FEDER-024498) and CCD - Centro de Criatividade Digital (NORTE-01-0145-FEDER-022133), supported by Norte Portugal Regional

Operational Programme (NORTE 2020), under the PORTUGAL 2020 Partnership Agreement, through the European Regional Development Fund (ERDF).

REFERENCES

Amin, D., & Govilkar, S. (2015). Comparative Study of Augmented Reality Sdk's. *International Journal on Computational Science & Applications*, *5*(1), 11–26. doi:10.5121/ijcsa.2015.5102

Annie, A. (2019) *The State of Mobile 2019 Report*. Retrieved from https://www.appannie.com/en/go/state-of-mobile-2019/

Azevedo, J. N., & Alturas, B. (2019). *A Realidade Aumentada no Turismo Lisboeta The Augmented Reality in Lisbon Tourism*. Academic Press.

Baker, C., Schleser, M., & Molga, K. (2014). Aesthetics of mobile media art. *Journal of Media Practice*, *10*(2-3), 101–122. doi:10.1386/jmpr.10.2-3.101_1

Barbu, C. M., Kuhn, K. D., Spirescu, A., Lamorte, L., & Scanu, C. (2015). 3cixty: An innovative way to explore cities. *2015 IEEE 1st International Smart Cities Conference, ISC2 2015*, 9–11. 10.1109/ISC2.2015.7366178

Barroso, B. L. K., De Oliveira, R. R., & Macedo, H. T. (2016). Mobile crowdsourcing app for smart cities. *2016 8th Euro American Conference on Telematics and Information Systems, EATIS 2016*, 1–5. 10.1109/EATIS.2016.7520143

Bekele, M. K., Town, C., Pierdicca, R., Frontoni, E., & Malinverni, E. V. A. S. (2018). A Survey of Augmented, Virtual, and Mixed Reality. *ACM Journal on Computing and Cultural Heritage*, *11*(2), 36. doi:10.1145/3145534

Bengtsen, P. (2013). Beyond the public art machine: A critical examination of street art as public art. *Konsthistorisk Tidskrift*, *82*(2), 63–80. doi:10.1080/00233609.2012.762804

Bengtsen, P. (2014). *The Street Art World*. Almendros de Granada Press.

Benito, V. L. (2013). Art museums, mobile media and education: A new way to explain art? *Proceedings of the DigitalHeritage 2013 - Federating the 19th Int'l VSMM, 10th Eurographics GCH, and 2nd UNESCO Memory of the World Conferences, Plus Special Sessions FromCAA, Arqueologica 2.0 et Al.*, *1*, 767. 10.1109/DigitalHeritage.2013.6743840

Berryman, D. R. (2012). Augmented Reality: A Review. *Medical Reference Services Quarterly*, *31*(2), 212–218. doi:10.1080/02763869.2012.670604 PMID:22559183

Blackburn, A. (n.d.). *Emerging Trends in Cyber Ethics and Education* (1st ed.). IGI Global. doi:10.4018/978-1-5225-5933-7

Blanché, U. (2015). Street art and related terms - discussion and working definition. *Street Art and Urban Creativity*, *1*, 32–39.

Bostanci, E., Kanwal, N., & Clark, A. F. (2015). Augmented reality applications for cultural heritage using Kinect. *Human-Centric Computing and Information Sciences*, *5*(1), 20. Advance online publication. doi:10.118613673-015-0040-3

Burger, A. (2012). *ITU Finds Two Times More Mobile Than Fixed Broadband Subscribers*. Retrieved from https://www.telecompetitor.com/itu-finds-two-times-more-mobile-than-fixed-broadband-subscribers/

Burkard, S., Fuchs-Kittowski, F., Himberger, S., Fischer, F., & Pfennigschmidt, S. (2017). Mobile location-based augmented reality framework. *IFIP Advances in Information and Communication Technology*, *507*, 470–483. doi:10.1007/978-3-319-89935-0_39

Chen, W. (2014). Historical Oslo on a handheld device -a mobile augmented reality application. *Procedia Computer Science*, *35*(C), 979–985. doi:10.1016/j.procs.2014.08.180

Christensson, P. (2010, July 30). *Smartphone Definition*. Retrieved, from https://techterms.com/definition/smartphone

Chung, N., Lee, H., Kim, J. Y., & Koo, C. (2018). The Role of Augmented Reality for Experience-Influenced Environments: The Case of Cultural Heritage Tourism in Korea. *Journal of Travel Research*, *57*(5), 627–643. doi:10.1177/0047287517708255

Cranmer, E., Tom Dieck, M. C., & Jung, T. (2017). *How can Tourist Attractions Profit from Augmented Reality?* doi:10.1007/978-3-319-64027-3_2

Danko, D. (2009). Wenn die Kunst vor der Tür steht.Ansätze zu notwendigen Differenzierungen des Begriffs "Kunst im öffentlichen Raum." *Kunst der Gegenwart im öffentlichen Raum.*

Drule, A. M., Chiş, A., Băcilă, M. F., & Ciornea, R. (2012). A New Perspective of Non-Religious Motivations of Visitors to Sacred Sites: Evidence From Romania. *Procedia: Social and Behavioral Sciences*, *62*, 431–435. doi:10.1016/j.sbspro.2012.09.070

Economou, M., & Meintani, E. (2011, May). Promising beginnings? Evaluating museum mobile phone apps. *Rethinking Technology in Museums Conference Proceedings*, 26–27.

Fidas, C., Sintoris, C., Yiannoutsou, N., & Avouris, N. (2016). A survey on tools for end user authoring of mobile applications for cultural heritage. *IISA 2015 - 6th International Conference on Information, Intelligence, Systems and Applications, 5*, 5–9. 10.1109/IISA.2015.7388029

Ghose, A., & Han, S. P. (2014). Estimating demand for mobile applications in the new economy. *Management Science, 60*(6), 1470–1488. doi:10.1287/mnsc.2014.1945

Ghulyan, H. (2019, July 11). *Lefebvre's Production of Space in the Context of Turkey: A Comprehensive Literature Survey*. doi:10.31235/osf.io/r85v9

Gravdal, E. (2012). *Augmented Reality and Object Tracking for Mobile Devices*. Retrieved from https://www.semanticscholar.org/paper/Augmented-Reality-and-Object-Tracking-for-Mobile-Gravdal/cc8af131d3fe1278eda08f3dff0ac9d6fa818deb

Gretzel, U., Fesenmaier, D. R., Lee, Y. J., & Tussyadiah, I. (2011). Narrating Tourist Experiences: The Role of New Media. In Tourist Experiences: Contemporary Perspectives (pp. 171-182). Routledge.

UN Habitat. (2010). *State of the world's cities 2010-2011: Bridging the urban divide - Overview and key findings*. United Nations Human Settlements Programme.

Hammady, R., Ma, M., & Temple, N. (2016). Augmented Reality and Gamification in Heritage Museums. In T. Marsh, M. Ma, M. Oliveira, J. Baalsrud Hauge, & S. Göbel (Eds.), Lecture Notes in Computer Science: Vol. 9894. *Serious Games. JCSG 2016*. Springer. doi:10.1007/978-3-319-45841-0_17

Haugstvedt, A. C., & Krogstie, J. (2012). Mobile augmented reality for cultural heritage: A technology acceptance study. *ISMAR 2012 - 11th IEEE International Symposium on Mixed and Augmented Reality 2012, Science and Technology Papers*, 247–255. 10.1109/ISMAR.2012.6402563

Jankowska, A., Szarkowska, A., Krejtz, K., Fidyka, A., Kowalski, J., & Wichrowski, M. (2017). Smartphone app as a museum guide. Testing the Open Art application with blind, deaf, and sighted users. *Rivista Internazionale Di Tecnica Della Traduzione, 19*(19), 113–130. doi:10.13137/2421-6763/17354

Jeater, M. (2012). Smartphones and site interpretation: the Museum of London's Streetmuseum applications. *Archaeology and Digital Communication. Towards Strategies of Public Engagement*, 56–65.

Kennedy-Eden, H., & Gretzel, U. (2012). A Taxonomy of Mobile Applications in Tourism. *Ereview of Tourism Research, 10*, 47–50.

Khan, A., Khusro, S., Rauf, A., & Mahfooz, S. (2015). Rebirth of Augmented Reality — Enhancing Reality via Smartphones. *Bahria University Journal of Information & Communication Technologies*, *8*(1), 110–121.

Lefebvre, H. (1991). *The production of space* (D. Nicholson-Smith, Trans.). Blackwell.

Ling, H. (2017). Augmented Reality in Reality. *IEEE MultiMedia*, *24*(3), 10–15. doi:10.1109/MMUL.2017.3051517

MacDowall, L. J., & de Souza, P. (2018). 'I'd Double Tap That!!': Street art, graffiti, and Instagram research. *Media Culture & Society*, *40*(1), 3–22. doi:10.1177/0163443717703793

Madirov, E., & Absalyamova, S. (2015). The influence of Information Technologies on the Availability of Cultural Heritage. *Procedia: Social and Behavioral Sciences*, *188*, 255–258. doi:10.1016/j.sbspro.2015.03.385

Oteafy, S. M. A., Hassanein, H. S., Oteafy, S. M. A., & Hassanein, H. S. (2014). Evolution of Wireless Sensor Networks. *Dynamic Wireless Sensor Networks*, 1–8. doi:10.1002/9781118761977.ch1

Palumbo, F., Dominici, G., & Basile, G. (2014). *The culture on the palm of your hand: How to design a user oriented mobile app for museums. In Handbook of research on management of cultural products: E-relationship marketing and accessibility perspectives*. IGI Global.

Pandey, M., Litoriya, R., & Pandey, P. (2016). Mobile applications in context of big data: A survey. *2016 Symposium on Colossal Data Analysis and Networking, CDAN 2016*, 1–5. 10.1109/CDAN.2016.7570942

Pedersen, I., Gale, N., Mirza-Babaei, P., & Reid, S. (2017). More than meets the eye: The benefits of augmented reality and holographic displays for digital cultural heritage. *Journal on Computing and Cultural Heritage*, *10*(2), 1–15. doi:10.1145/3051480

Pine, B. J., & Gilmore, J. H. (1999). *The experience economy: Work is theatre & every business a stage*. Harvard Business School Press.

Postma, A., Buda, D. M., & Gugerell, K. (2017). The future of city tourism. *Journal of Tourism Futures*, *3*(2), 95–101. doi:10.1108/JTF-09-2017-067

Richards, G. (2018). Cultural tourism: A review of recent research and trends. *Journal of Hospitality and Tourism Management*, *36*, 12–21. doi:10.1016/j.jhtm.2018.03.005

Rivero, J. A. S. del, Pérez, M. J. G., Díaz, M. F., Meana, J. G., Igual, M. F., & Álvarez, A. P. (2015). INSIDDE AR application: Bringing art closer to citizens by promoting the use of smartphones and tablets. *2015 Digital Heritage, 1*, 325–328. doi:10.1109/DigitalHeritage.2015.7413893

RoserM. (2019) *Tourism*. Retrieved from https://ourworldindata.org/tourism

Rupilu, M. M., Suyoto, & Santoso, A. J. (2018). The Development of Mobile Application to Introduce Historical Monuments in Manado. *E3S Web of Conferences, 31*, 1–6. doi:10.1051/e3sconf/20183111012

Saracco, R. (2012). Leveraging technology evolution for better and sustainable cities. *Elektrotehniski Vestnik / Electrotechnical Review, 79*(5), 255–261.

Share, N. (2019). *Market Share Statistics for Internet Technologies*. Retrieved from https://netmarketshare.com/operating-system-market-share.aspx?options=%7B%22 filter%22%3A%7B%22%24and%22%3A%5B%7B%22deviceType%22%3A%7B%2 2%24in%22%3A%5B%22Mobile%22%5D%7D%7D%5D%7D%2C%22dateLabel% 22%3A%22Trend%22%2C%22attributes%22%3A%22share%22%2C%22group%22 %3A%22platform%22%2C%22sort%22%3A%7B%22share%22%3A-1%7D%2C%2 2id%22%3A%22platformsMobile%22%2C%22dateInterval%22%3A%22Monthly% 22%2C%22dateStart%22%3A%222018-12%22%2C%22dateEnd%22%3A%222019- 11%22%2C%22segments%22%3A%22-1000%22%7D

Sherry, J. F. (1998). *Servicescapes: the concept of place in contemporary markets.* Retrieved from https://books.google.pt/books?id=ZABBAAAAMAAJ

Tillon, A. B., Marchand, E., Laneurit, J., Servant, F., Marchal, I., & Houlier, P. (2010). A day at the museum: An augmented fine-art exhibit. *9th IEEE International Symposium on Mixed and Augmented Reality 2010: Arts, Media, and Humanities, ISMAR-AMH 2010 - Proceedings, 1*, 69–70. 10.1109/ISMAR-AMH.2010.5643290

Tomić, N. (2019). Economic model of microtransactions in Video Games. *Journal of Economic Science Research, 01*(01), 17–23.

Tuan, Y.-F. (1977). *Space and Place: The Perspective of Experience*. University of Minnesota Press.

Tussyadiah, I. P., & Zach, F. J. (2012). The role of geo-based technology in place experiences. *Annals of Tourism Research, 39*(2), 780–800. doi:10.1016/j. annals.2011.10.003

Underdogs. (2013). *Public Art*. Retrieved from https://www.under-dogs.net/about/

Veenhof S, Skwarek M. (2010). *AR art exhibition MoMA NYC (guerrilla intervention)*. Academic Press.

Visconti, L. M., Sherry, J. F. Jr, Borghini, S., & Anderson, L. (2010). Street Art, Sweet Art? Reclaiming the "Public" in Public Place. *The Journal of Consumer Research, 37*(3), 511–529. doi:10.1086/652731

Walravens, N. (2015). Mobile city applications for Brussels citizens: Smart City trends, challenges and a reality check. *Telematics and Informatics, 32*(2), 282–299. doi:10.1016/j.tele.2014.09.004

World Travel & Tourism Council. (2018). *Travel & tourism global economic impact & issues 2018*. Retrieved from https://dossierturismo.files.wordpress.com/2018/03/wttc-global-economic-impact-and-issues-2018-eng.pdf

Zhang, Q., Chu, W., Ji, C., Ke, C., & Li, Y. (2014). An implementation of generic augmented reality in mobile devices. *2014 IEEE 7th Joint International Information Technology and Artificial Intelligence Conference*, 555–558. 10.1109/ITAIC.2014.7065112

Zieleniec, A. (2017, April). The right to write the city: Lefebvre and graffiti. *Environment and Urbanization, 10*. Advance online publication. doi:10.7202/1040597ar

ADDITIONAL READING

Azuma, R. T. (1997). *A survey of augmented reality*. In Presence. *Presence (Cambridge, Mass.), 6*(4), 355–385. doi:10.1162/pres.1997.6.4.355

Detroz, J. P., Jasinski, M. G., Bosse, R., Berlim, T. L., & Da Silva Hounsell, M. (2014). Virtual reality evolution in brazil: A survey over the papers in the "symposium on virtual and augmented reality." Proceedings - 2014 16th Symposium on Virtual and Augmented Reality, SVR 2014, 210–219. 10.1109/SVR.2014.39

Dickinson, J., Ghali, K., Cherrett, T., Speed, C., Davies, N., & Norgate, S. (2012). Tourism and the Smartphone App: Capabilities, Emerging Practice and Scope in the Travel Domain. *Current Issues in Tourism, 17*, 1–18. doi:10.1080/13683500.2012.718323

Farman, J. (2015). Stories, spaces, and bodies: The production of embodied space through mobile media storytelling. *Communication Research and Practice, 1*(2), 101–116. doi:10.1080/22041451.2015.1047941

Gavalas, D., Konstantopoulos, C., Mastakas, K., & Pantziou, G. (2014). Mobile Recommender Systems in Tourism. *Journal of Network and Computer Applications*, *39*, 319–333. doi:10.1016/j.jnca.2013.04.006

Kim, S. S., Lee, C.-K., & Klenosky, D. B. (2003). The influence of push and pull factors at Korean national parks. *Tourism Management*, *24*(2), 169–180. doi:10.1016/S0261-5177(02)00059-6

Lopes, F. (2000). O programa de incremento do turismo cultural - dos novos conceitos e motivações sobre o património cultural à criação de produtos turísticos de qualidade. *Antropológicas*, *4*, 243–250.

Nayebi, F., Desharnais, J., & Abran, A. (2012) The state of the art of mobile application usability evaluation. *2012 25th IEEE Canadian Conference on Electrical and Computer Engineering (CCECE)*, Montreal, QC, pp. 1-4. 10.1109/CCECE.2012.6334930

Nickerson, R. C., Austreich, M., & Eng, J. (2014). Mobile technology and smartphone apps: A diffusion of innovations analysis. *20th Americas Conference on Information Systems, AMCIS 2014*, 1–12.

KEY TERMS AND DEFINITIONS

App Store: An app store is a type of digital distribution platform for computer software called Applications, often in a mobile context. Apps are normally designed to run on a specific operating system, such as the contemporary iOS, macOS, Windows, or Android.

AR: Augmented reality; integration of elements or virtual information to real world views through a camera and using motion sensors such as gyroscope and accelerometer.

GIF: The graphics interchange format is a bitmap image format. It has come into widespread usage on the World Wide Web due to its wide support and portability between many applications and operating systems.

Graffiti: Letters painted illegally in the form of names based on aesthetics or the common logic of graffiti as a culture.

Microtransactions: This is when users can pay for virtual goods with micropayments in virtual worlds.

Public Art: Contemporary artworks located in public space.

SDK: Is a software development toolkit that enables the creation of applications for a certain software package, framework, hardware platform, computer system, video game console, operating system, or similar development platform.

Street Art: Interventions that can be based on text or image, created illegally in the urban space.

UNWTO: United Nations World Tourism Organization is the responsible agency for the promotion of responsible, sustainable and universally accessible.

Urban Art: Any art in the style of street art, graffiti, or mural art. usually associated with major interventions, almost exclusively legal, usually by order and directed to a general public.

Compilation of References

AIC (American Institute for Conservation of Historic andArtistic Works). (1994). *Code of Ethics and Guidelines for Practice*. Retrieved May 1, 2020 from http://www.conservation-us.org/ethics

Alaoui, F., Jacquemin, C., & Bevilacqua, F. (2013). Chiseling bodies: an augmented dance performance. In *CHI'13 Extended Abstracts on Human Factors in Computing Systems* (pp. 2915–2918). ACM. doi:10.1145/2468356.2479573

Alipour, M. C., Gerardo, B. D., & Medina, R. P. (2019). A Secure Image Watermarking Architecture based on DWT-DCT Domain and Pseudo-Random Number. *ACM International Conference Proceeding Series*, (4), 154–159. 10.1145/3352411.3352436

Amin, D., & Govilkar, S. (2015). Comparative Study of Augmented Reality Sdk's. *International Journal on Computational Science & Applications*, 5(1), 11–26. doi:10.5121/ijcsa.2015.5102

Anderson, J. (1974). *Critics Notebook of the Proscenium Arch and how it Affects Dance*. Retrieved from https://www.nytimes.com/1979/09/04/archives/critics-notebook-of-the-proscenium-arch-and-how-it-affects-dance.html

Annie, A. (2019) *The State of Mobile 2019 Report*. Retrieved from https://www.appannie.com/en/go/state-of-mobile-2019/

Antos, Z., Fromm, A. & Golding, V. (Eds.). (2017). Museums and Innovations. Cambridge Scholars Publishing.

Arnheim, R. (2004). *Art and Visual Perception: A Psychology of the Creative Eye*. University of California Press.

Arouca Geopark. (n.d.). *Território UNESCO – Um território a descobrir*. Retrieved February 7, 2020, from http://aroucageopark.pt/pt/conhecer/territorio-unesco

Associação Geoparque Arouca. (2016). *Relatório Final 2014/2015*. Author.

Austin, S. (Producer), Cameron, J. (Producer), Hurd, G. A. (Producer), Kassar, M. (Producer), Rack, B. J. (Producer), & Cameron, J. (Director). (1991). *Terminator 2: Judgment Day* [Motion Picture]. United States: TriStar Pictures.

Autodesk. (2019). *Fake or Photo* [Website]. Retrieved February 4, 2019 from https://area.com/fakeorphoto

Azevedo, J. N., & Alturas, B. (2019). *A Realidade Aumentada no Turismo Lisboeta The Augmented Reality in Lisbon Tourism*. Academic Press.

Bae, M. (2018). Understanding the effect of the discrepancy between sought and obtained gratification on social networking site users' satisfaction and continuance intention. *Computers in Human Behavior*, *79*, 137–153. doi:10.1016/j.chb.2017.10.026

Baker, C., Schleser, M., & Molga, K. (2014). Aesthetics of mobile media art. *Journal of Media Practice*, *10*(2-3), 101–122. doi:10.1386/jmpr.10.2-3.101_1

Banu, G. (1987). *De l'esthétique de la disparition a la poétique de la mémoire. Le Théâtre dans la Ville*. Éditions du CNRS.

Barbu, C. M., Kuhn, K. D., Spirescu, A., Lamorte, L., & Scanu, C. (2015). 3cixty: An innovative way to explore cities. *2015 IEEE 1st International Smart Cities Conference, ISC2 2015*, 9–11. 10.1109/ISC2.2015.7366178

Barroso, B. L. K., De Oliveira, R. R., & Macedo, H. T. (2016). Mobile crowdsourcing app for smart cities. *2016 8th Euro American Conference on Telematics and Information Systems, EATIS 2016*, 1–5. 10.1109/EATIS.2016.7520143

Barthes, R. (2012). *A Câmara Clara*. Edições 70.

Basinski, W. (n.d.). *About the Artist*. Retrieved from http://www.mmlxii.com/about/, Jan 19, 2019.

Beira, J., Carvalho, R., & Kox, S. (2013). Mixed reality immersive design: a study in interactive dance. In *Proceedings of the 2013 ACM international workshop on Immersive media experiences* (pp. 45-50). 10.1145/2512142.2512147

Bekele, M. K., Town, C., Pierdicca, R., Frontoni, E., & Malinverni, E. V. A. S. (2018). A Survey of Augmented, Virtual, and Mixed Reality. *ACM Journal on Computing and Cultural Heritage*, *11*(2), 36. doi:10.1145/3145534

Bell, B. (Producer), Benattar, R. (Producer), Bruckheimer, J. (Producer), Capone, S. (Producer), Ellison, D. (Producer), Goldberg, D. (Producer), Granger, D. (Producer), Guangchang, G. (Producer), Lane, J. (Producer), Lee, D. (Producer), Murphy, D. (Producer), Oman, C. (Producer), Reid, M. (Producer), Stenson, M. (Producer), & Lee, A. (Director). (2019). *Gemini Man* [Motion Picture]. United States: Paramount Pictures.

Bellet, P. S., & Maloney, M. J. (1991). The Importance of Empathy as an Interviewing Skill in Medicine. *Journal of the American Medical Association*, *266*(13), 1831–1832. doi:10.1001/jama.1991.03470130111039 PMID:1909761

Bengtsen, P. (2013). Beyond the public art machine: A critical examination of street art as public art. *Konsthistorisk Tidskrift*, *82*(2), 63–80. doi:10.1080/00233609.2012.762804

Bengtsen, P. (2014). *The Street Art World*. Almendros de Granada Press.

Benito, V. L. (2013). Art museums, mobile media and education: A new way to explain art? *Proceedings of the DigitalHeritage 2013 - Federating the 19th Int'l VSMM, 10th Eurographics GCH, and 2nd UNESCO Memory of the World Conferences, Plus Special Sessions FromCAA, Arqueologica 2.0 et Al., 1*, 767. 10.1109/DigitalHeritage.2013.6743840

Benjamin, W. (2008). *The Work of Art in the Age of Mechanical Reproduction*. Penguin.

Berryman, D. R. (2012). Augmented Reality: A Review. *Medical Reference Services Quarterly, 31*(2), 212–218. doi:10.1080/02763869.2012.670604 PMID:22559183

Bianchini, S., & Verhagen, E. (Eds.). (2016). Practicable, From Participation to interaction in Contemporary Art. Cambridge, MA: MIT Press.

Bittencourt, J. R., & Osório, F. S. (2006). *Motores para criação de jogos digitais: gráficos, áudio, interação, rede, inteligência artificial e física*. Retrieved February 11, 2020, from http://osorio.wait4.org/publications/Bittencourt-Osorio-ERI-MG2006.pdf

Blackburn, A. (n.d.). *Emerging Trends in Cyber Ethics and Education* (1st ed.). IGI Global. doi:10.4018/978-1-5225-5933-7

Blackburn, S. (1993). *Essays in Quasi-Realism* (Vol. 1). Oxford University Press.

Blair, P. (1994). *Cartoon Animation*. Walter Foster.

Blanché, U. (2015). Street art and related terms - discussion and working definition. *Street Art and Urban Creativity, 1*, 32–39.

Bohr, M., & Sliwinska. (2018). *The Evolution of the Image: Political Action and the Digital Self*. Routledge.

Bokaris, P. A., Gouiffès, M., Caye, V., Chomaz, J. M., & Jacquemin, C. (2020). Gardien du Temple: An Interactive Installation Involving Poetry, Performance and Spatial Augmented Reality. *Leonardo, 53*(1), 31–37. doi:10.1162/leon_a_01569

Bolter, J. D. (2019). *The Digital Plenitude: The Decline of Elite Culture and the Rise of New Media*. MIT Press. doi:10.7551/mitpress/9440.001.0001

Bordwell, D. (1989). *Making Meaning: Inference and Rhetoric in the Interpretation of Cinema*. Harvard University Press.

Bostanci, E., Kanwal, N., & Clark, A. F. (2015). Augmented reality applications for cultural heritage using Kinect. *Human-Centric Computing and Information Sciences, 5*(1), 20. Advance online publication. doi:10.118613673-015-0040-3

Boyd, S. J. (Producer), Denise, D. (Producer), Goetzman, G. (Producer), Hanks, T. (Producer), McLaglen, J. (Producer), Rapke, J. (Producer), Starkey, S. (Producer), Teitler, W. (Producer), Tobyansen, P. M. (Producer), Allsburg, C. V. (Producer), Zemeckis, R. (Producer), & Zemeckis, R. (Director). (2004). *The Polar Express* [Motion Picture]. United States: Castle Rock Entertainment.

Bradshaw, J. (Producer), Starkey, S. (Producer), Zemeckis, R. (Producer), & Zemeckis, R. (Director). (1992). *Death Becomes Her* [Motion Picture]. United States: Universal Pictures.

Brockhoeft, T., Petuch, J., Bach, J., Djerekarov, E., Ackerman, M., & Tyson, G. (2016). Interactive augmented reality for dance. In *Proceedings of the Seventh International Conference on Computational Creativity* (pp. 396-403). Academic Press.

Brook, M., & Kosson, D. S. (2013). Impaired cognitive empathy in criminal psychopathy: Evidence from a laboratory measure of empathic accuracy. *Journal of Abnormal Psychology*, *122*(1), 156–166. doi:10.1037/a0030261 PMID:23067260

Buck, J. (2008). *Brian Eno - Ambient 1: Music For Airports*. Retrieved from http://www.musthear. com/music/reviews/brian-eno/ambient-1-music-for-airports

Buckingham, D. (1993). Children Talking Television: The Making of Television Literacy. London: Falmer Press.

Budgwig, S. (2013). *Site-specific Dance*. Retrieved from https://brooklynrail.org/2014/09/dance/ site-specific-dance

Burger, A. (2012). *ITU Finds Two Times More Mobile Than Fixed Broadband Subscribers*. Retrieved from https://www.telecompetitor.com/itu-finds-two-times-more-mobile-than-fixed-broadband-subscribers/

Burkard, S., Fuchs-Kittowski, F., Himberger, S., Fischer, F., & Pfennigschmidt, S. (2017). Mobile location-based augmented reality framework. *IFIP Advances in Information and Communication Technology*, *507*, 470–483. doi:10.1007/978-3-319-89935-0_39

Cage, J. (1961). The Future of Music: Credo {1958. In J. Cage (Ed.), *Silence: Lectures and Writings*. Wesleyan University Press.

Caillois, R. (1991). *Les jeux et les hommes: Le masque et le vertige*. Éditions Gallimard.

Cambria, E. (2016). *Affective computing and sentiment analysis*. Retrieved from www.sas.com/ social

Cameron, J. (Producer), Breton, B. (Producer), Kalogridis, L. (Producer), Landau, J. (Producer), McLaglen, J. (Producer), Tashjian, J. (Producer), Tobyansen, P. M. (Producer), Wilson, C. (Producer), & Cameron, J. (Director). (2009) *Avatar* [Motion Picture]. United States: Twentieth Century Fox.

Cameron, J. (Producer), Landau, J. (Producer), Valdes, D. (Producer), & Rodriguez, R. (Director). (2019). *Alita: Battle Angel* [Motion Picture]. United States: Twentieth Century Fox.

Capristo, B. A. (2012). *Dance and the use of technology* (Doctoral dissertation). University of Akron.

Carlson, M. (2004). What is performance? In H. Bial & S. Brady (Eds.), *The Performance Studies Reader*. Routledge.

Carter, S., Harris, J., & Porges, S. (2009). Neural and evolutionary perspectives on empathy. In J. Decety & W. Ickes (Eds.), The Social Neuroscience of Empathy (pp. 169–182). Cambridge: MIT Press. doi:10.7551/mitpress/9780262012973.003.0014

Cecchetto, D. (2011). *Deconstructing affect: Posthumanism and Mark Hansen's media theory.* OCAD University Open Research Repository Faculty of Liberal Arts & Sciences. Retrieved August 24, 2019, from https://journals.sagepub.com/doi/abs/10.1177/0263276411411589

Chandler, D. (2000). An Introduction to Genre Theory. The University of Wales. doi:10.1057/jors.1996.182

Chapple, F., & Kattenbelt, C. (Eds.). (2006). *Intermediality in Theatre and Performance.* Rodopi.

Cheetham, M. (2017). Editorial: The Uncanny Valley Hypothesis and beyond. *Frontiers in Psychology*, 8(October), 1–3. doi:10.3389/fpsyg.2017.01738 PMID:29089906

Chen, W. (2014). Historical Oslo on a handheld device -a mobile augmented reality application. *Procedia Computer Science*, 35(C), 979–985. doi:10.1016/j.procs.2014.08.180

Chikofsky, E. J., & Cross, J. H. (1990). Reverse engineering and design recovery: A taxonomy. *IEEE Software*, 7(1), 13–17. doi:10.1109/52.43044

Chilvers, I., & Glaves-Smith, J. (2009). *A Dictionary of Modern and Contemporary Art.* Oxford University Press. doi:10.1093/acref/9780199239665.001.0001

Chion, M. (1994). *Audio-vision: Sound on screen.* Columbia University Press.

Christel, M. G., Stevens, S. M., Klishin, A., Brice, S., Champer, M., & Collier, S., … Ni, M. (2013). Helios: An HTML5 game teaching proportional reasoning to child players. In *Proceedings of the 18th International Conference on Computer Games: AI, Animation, Mobile, Interactive Multimedia, Educational & Serious Games (CGAMES 2013).* Louisville, KY: IEEE. 10.1109/CGames.2013.6632614

Christensson, P. (2010, July 30). *Smartphone Definition.* Retrieved, from https://techterms.com/definition/smartphone

Christopoulou, E., & Xinogalos, S. (2017). Overview and comparative analysis of game engines for desktop and mobile devices. *International Journal of Serious Games*, 4(4), 21–36. doi:10.17083/ijsg.v4i4.194

Chung, N., Lee, H., Kim, J. Y., & Koo, C. (2018). The Role of Augmented Reality for Experience-Influenced Environments: The Case of Cultural Heritage Tourism in Korea. *Journal of Travel Research*, 57(5), 627–643. doi:10.1177/0047287517708255

Chun, W. (2013). *Programmed Visions: Software and Memory.* The MIT Press.

Chun, W. (2017). *Updating to Remain the Same, Habitual New Media.* MIT Press.

Clay, A., Domenger, G., Conan, J., Domenger, A., & Couture, N. (2014). Integrating augmented reality to enhance expression, interaction & collaboration in live performances: A ballet dance case study. In *2014 IEEE International Symposium on Mixed and Augmented Reality-Media, Art, Social Science, Humanities and Design (ISMAR-MASH'D)* (pp. 21-29). IEEE. 10.1109/ISMAR-AMH.2014.6935434

Clay, A., Couture, N., Nigay, L., De La Riviere, J. B., Martin, J. C., Courgeon, M., & Domengero, G. (2012). Interactions and systems for augmenting a live dance performance. In *2012 IEEE International Symposium on Mixed and Augmented Reality-Arts, Media, and Humanities (ISMAR-AMH)* (pp. 29-38). IEEE. 10.1109/ISMAR-AMH.2012.6483986

Clements, J. (2012). Time Out: An exploration of the possibilities for archived time-based media as a tool for exploration within a fine art practice-based research enquiry. *Journal of Media Practice, 13*(3), 239–253. doi:10.1386/jmpr.13.3.239_1

Coeckelbergh, M. (2020). *The Postdigital in Pandemic Times: a Comment on the Covid-19 Crisis and its Political Epistemologies.* Academic Press.

Connerton, P. (1989). *How Societies Remember.* Cambridge University Press. doi:10.1017/CBO9780511628061

Conroy, S. (2018). *The Sawmill Motion Capture Studio: Small Stage in Session.* Academic Press.

Cornell, L., & Halter, E. (Eds.). (2015). Mass Effect, Art and the Internet in the Twenty-First Century. Critical Anthologies in Art and Culture, The New Museum, NY.

Cowell, H. (1996). *New musical resources.* Cambridge University Press. doi:10.1017/CBO9780511597329

Cox, C. L., Uddin, L. Q., Di Martino, A., Castellanos, F. X., Milham, M. P., & Kelly, C. (2012). The balance between feeling and knowing: Affective and cognitive empathy are reflected in the brain's intrinsic functional dynamics. *Social Cognitive and Affective Neuroscience, 7*(6), 727–737. doi:10.1093can/nsr051 PMID:21896497

Coyne, R. (2001). *Technoromanticism, digital narrative, holism, and the romance of the real* (2nd ed.). MIT Press.

Cozzolino, D., Gragnaniello, D., & Verdoliva, L. (2014). Image forgery detection through residual-based local descriptors and block-matching. In *2014 IEEE International Conference on Image Processing (ICIP)* (pp. 5297–5301). 10.1109/ICIP.2014.7026072

Craig, L. (2011). *An Introduction to Object-Oriented Analysis and Design and Iterative Development.* Academic Press.

Cramer, F. (2019). *What is Autonomy? From art to Brexit to Tesla Cars.* Academic Press.

Cranmer, E., Tom Dieck, M. C., & Jung, T. (2017). *How can Tourist Attractions Profit from Augmented Reality?* doi:10.1007/978-3-319-64027-3_2

Cunningham, D. (2010). Kraftwerk and the Image of the Modern. In S. Albiez & D. Pattie (Eds.), *Kraftwerk: Music Non-Stop*. Continuum.

D'Annunzio, G. (1983). Contemplazioni della morte {1912}. In Water and Dreams: An Essay on the Imagination of Matter. Dallas: The Pegasus Foundation.

Daniels, D., & Naumann, S. (Eds.). (2010). *Audiovisuology: Compendium* (Vol. 1). Verlag der Buchhandlung Walther König.

Danko, D. (2009). Wenn die Kunst vor der Tür steht.Ansätze zu notwendigen Differenzierungen des Begriffs "Kunst im öffentlichen Raum." *Kunst der Gegenwart im öffentlichen Raum.*

Decety, J., & Jackson, P. L. (2004). *The functional architecture of human empathy. Behavioral and cognitive neuroscience reviews* (Vol. 3). doi:10.1177/1534582304267187

Decety, J. (2010). The neurodevelopment of empathy in humans. *Developmental Neuroscience*, *32*(4), 257–267. doi:10.1159/000317771 PMID:20805682

Decety, J. (2011). Dissecting the neural mechanisms mediating empathy. *Emotion Review*, *3*(1), 92–108. doi:10.1177/1754073910374662

Decety, J., & Jackson, P. L. (2006). A Social-Neuroscience Perspective on Empathy. Current directions in Psychological Science. *Psychological Science*, *15*(2), 54–58. doi:10.1111/j.0963-7214.2006.00406.x

Decety, J., & Lamm, C. (2007). The role of the right temporoparietal junction in social interaction: How low-level computational processes contribute to meta-cognition. *The Neuroscientist*, *13*(6), 580–593. doi:10.1177/1073858407304654 PMID:17911216

Decety, J., Smith, K. E., Norman, G. J., & Halpern, J. (2014). A social neuroscience perspective on clinical empathy. *World Psychiatry; Official Journal of the World Psychiatric Association (WPA)*, *13*(3), 233–237. doi:10.1002/wps.20146 PMID:25273287

Dill, V., Flach, L. M., Hocevar, R., Lykawka, C., Musse, S. R., & Pinho, M. S. (2012). Evaluation of the uncanny valley in CG characters. Lecture Notes in Computer Science, 7502, 511–513. doi:10.1007/978-3-642-33197-8-62

Dils, A. (2002). The ghost in the machine: Merce Cunningham and Bill T. Jones. *PAJ a Journal of Performance and Art*, *24*(1), 94–104. doi:10.1162/152028101753401820

Dinis, F. (2016). [re]presentation of memory spaces using sound and visual articulation. In POST-SCREEN: Intermittence + Interference. Lisboa: Edições Lusófonas/CIEBA-FBAUL.

Dinis, F. (2017). [re]definitions: Experiências percetivas na performance 'site-specific' através da articulação sonora e visual. In F.M. Oliveira (Ed.), Conceitos e dispositivos de criação em artes performativas. Coimbra: Imprensa da Universidade de Coimbra.

Dixon, S. (1999). Remediating theatre in a digital proscenium. *Digital Creativity*, *10*(3), 135–142. doi:10.1076/digc.10.3.135.3240

Dixon, S. (2007). *Digital performance: a history of new media in theater, dance, performance art, and installation.* The MIT Press. doi:10.7551/mitpress/2429.001.0001

Djaouti, D., Alvarez, J., Jessel, J.-P., & Rampnoux, O. (2011). Origins of serious games. In M. Ma, A. Oikonomou, & L. C. Jain (Eds.), *Serious games and edutainment applications* (p. 2543). Springer-Verlag. doi:10.1007/978-1-4471-2161-9_3

Donga, M., Marques, Pereira, & Gomes. (2019). The Sense of Presence through the Humanization Created by Virtual Environments. *Proceedings, 21*(1), 7. doi:10.3390/proceedings2019021007

Drule, A. M., Chiş, A., Băcilă, M. F., & Ciornea, R. (2012). A New Perspective of Non-Religious Motivations of Visitors to Sacred Sites: Evidence From Romania. *Procedia: Social and Behavioral Sciences, 62,* 431–435. doi:10.1016/j.sbspro.2012.09.070

Economou, M., & Meintani, E. (2011, May). Promising beginnings? Evaluating museum mobile phone apps. *Rethinking Technology in Museums Conference Proceedings,* 26–27.

Elephant. (2019). *The dance troupe testing the limits of technology.* Retrieved from https://elephant.art/86172-2/

Engel, D., & Phillips, J. (2019). Applying conservation ethics to the examination and treatment of software-and computer-based art. *Journal of the American Institute for Conservation, 58*(3), 180–195. doi:10.1080/01971360.2019.1598124

Falcão, P. (2019). *Preservation of Software-based Art at Tate.* Academic Press.

Fan, S., Ng, T. T., Herberg, J. S., Koenig, B. L., & Xin, S. (2012). Real or fake? Human judgments about photographs and computer-generated images of faces. *SIGGRAPH Asia 2012 Technical Briefs, SA 2012, 1*(212), 3–6. doi:10.1145/2407746.2407763

Farid, H., & Bravo, M. J. (2007). Photorealistic rendering: How realistic is it? *Journal of Vision (Charlottesville, Va.), 7,* 9.

Farid, H., & Bravo, M. J. (2012). Perceptual discrimination of computer generated and photographic faces. *Digital Investigation, 8*(3-4), 226–235. doi:10.1016/j.diin.2011.06.003

Fast-Berglund, Å., Gong, L., & Li, D. (2018). Testing and validating Extended Reality (xR) technologies in manufacturing. *Procedia Manufacturing, 25,* 31–38. doi:10.1016/j.promfg.2018.06.054

Favreau, J. (Producer), Bartnicki, J. (Producer), Bossi, D. (Producer), Gilchrist, K. (Producer), Peitzman, T. C. (Producer), Schumacher, T. (Producer), Silver, J. (Producer), Taymor, J. (Producer), Venghaus, D. H., Jr. (Producer), & Favreau, J. (Director). (2019). *The Lion King* [Motion Picture]. United States: Walt Disney Pictures.

Féral, J. (2008). Entre Performance et Théâtralité: le théâtre performatif. *Théâtre/Public, 190,* 28-35.

Feuer, J. (1992): Genre study and television. In Channels of Discourse, Reassembled: Television and Contemporary Criticism. London: Routledge.

Fidas, C., Sintoris, C., Yiannoutsou, N., & Avouris, N. (2016). A survey on tools for end user authoring of mobile applications for cultural heritage. *IISA 2015 - 6th International Conference on Information, Intelligence, Systems and Applications, 5*, 5–9. 10.1109/IISA.2015.7388029

FilmRatings. (2019). Retrieved January 15, 2019 from http://www.filmratings.com

Fineman, M. (2012). *Faking It: Manipulated Photography Before Photoshop*. Yale Univ. Press.

Fiz, S. M. (1986). Del Arte Objectual al Arte de Concepto – Epílogo sobre la sensibilidad "Postmoderna". Madrid: Akal.

Flusser, V. (1998). *Ensaio sobre a fotografia: para uma filosofia da técnica*. Relógio D'Agua.

Fowler, A. (1989). Genre. In E. Barnouw (Ed.), *International Encyclopedia of Communications* (Vol. 2, pp. 215–217). Oxford University Press.

Franz, N. P. S., Sudana, A. O., & Wibawa, K. S. (2016). Application of basic Balinese dance using augmented reality on Android. *Journal of Theoretical & Applied Information Technology, 90*(1).

Freud, S. (1919). The 'Uncanny'. In *The Standard Edition of the Complete Psychological Works of Sigmund Freud, Volume XVII (1917-1919): An Infantile Neurosis and Other Works*, (pp. 217-256). Academic Press.

Gee, D. (2017). Ohad Naharin's Minus 16 is a Masterwork of his. *Style*. https://vancouversun.com/entertainment/local-arts/ohad-naharins-minus-16-is-a-masterwork-of-his-style

Ghose, A., & Han, S. P. (2014). Estimating demand for mobile applications in the new economy. *Management Science, 60*(6), 1470–1488. doi:10.1287/mnsc.2014.1945

Ghulyan, H. (2019, July 11). *Lefebvre's Production of Space in the Context of Turkey: A Comprehensive Literature Survey*. doi:10.31235/osf.io/r85v9

Gledhill, C. (1985). Genre. In P. Cook (Ed.), *The Cinema Book*. British Film Institute.

Goldstone, R. L., & Hendrickson, A. T. (2010). Categorical perception. *Wiley Interdisciplinary Reviews: Cognitive Science, 1*(1), 69–78. doi:10.1002/wcs.26 PMID:26272840

Gomide, J. V. B. (2012). Motion capture and performance. *Scene, 1*(1), 45–62. doi:10.1386cene.1.1.45_1

Gouveia, P. (2009). Narrative paradox and the design of alternate reality games (ARGs) and blogs. *IEEE Consumer Electronics Society's Games Innovation Conference 2009 (ICE-GIC 09) Proceedings*, 231-38. 10.1109/ICEGIC.2009.5293585

Gouveia, P. (2010). Artes e Jogos Digitais, Estética e Design da Experiência Lúdica. Universitárias Lusófonas.

Gouveia, P. (2016). Gaming and VR Technologies, Powers and Discontents. Videojogos'16 Proceedings.

Gouveia, P. (2018a). From black boxes to sand boxes, disruptive processes in gaming culture. In From Bits to Paper. Art Book Magazine.

Gouveia, P. (2018b). Transmedia experiences that blur the boundaries between the real and the fictional world. In Trends, Experiences, and Perspectives on Immersive Multimedia Experience and Augmented Reality. IGI Global.

Gouveia, P. (2019). Play and games for a resistance culture. In *Playmode Exhibition Publication* (pp. 8–27). MAAT, Fundação EDP.

Grandchamp, R., & Delorme, A. (2016). The Brainarium: An Interactive Immersive Tool for Brain Education, Art, and Neurotherapy. *Computational Intelligence and Neuroscience, 2016*, 1–12. Advance online publication. doi:10.1155/2016/4204385 PMID:27698660

Gravdal, E. (2012). *Augmented Reality and Object Tracking for Mobile Devices*. Retrieved from https://www.semanticscholar.org/paper/Augmented-Reality-and-Object-Tracking-for-Mobile-Gravdal/cc8af131d3fe1278eda08f3dff0ac9d6fa818deb

Gretzel, U., Fesenmaier, D. R., Lee, Y. J., & Tussyadiah, I. (2011). Narrating Tourist Experiences: The Role of New Media. In Tourist Experiences: Contemporary Perspectives (pp. 171-182). Routledge.

Griesinger, P. (2016). Process history metadata for time-based media artworks at the Museum of Modern Art, New York. *Journal of Digital Media Management, 4*(4), 331–342.

Grinbaum, A. (2015). Uncanny valley explained by Girard's theory. *IEEE Robotics & Automation Magazine, 22*(1), 150–152. doi:10.1109/MRA.2014.2385568

Grissa, K. (2017). What "uses and gratifications" theory can tell us about using professional networking sites (E.G. Linkedin, Viadeo, Xing, Skilledafricans, Plaxo…). In R. Jallouli, O. R. Zaïane, M. A. Bach Tobji, R. Srarfi Tabbane, & A. Nijholt (Eds.), *Lecture Notes in Business Information Processing* (Vol. 290, pp. 15–28). Springer International Publishing., doi:10.1007/978-3-319-62737-3_2

Grusin, J., & Bolter, R. (2000). *Remediation: Understanding New Media*. MIT Press.

Gruzelier, J., & Egner, T. (2005). Critical validation studies of neurofeedback. *Child and Adolescent Psychiatric Clinics of North America, 14*(1), 83–104. doi:10.1016/j.chc.2004.07.002 PMID:15564053

Guerrilla Girls. (n.d.). Retrieved May 5, 2019, from, https://www.guerrillagirls.com/

Hacking, J. (2012). *Photography: The Whole Story*. Thames and Hudson.

Halbwachs, M. (1992). *On collective memory*. The University of Chicago Press.

Hammady, R., Ma, M., & Temple, N. (2016). Augmented Reality and Gamification in Heritage Museums. In T. Marsh, M. Ma, M. Oliveira, J. Baalsrud Hauge, & S. Göbel (Eds.), Lecture Notes in Computer Science: Vol. 9894. *Serious Games. JCSG 2016*. Springer. doi:10.1007/978-3-319-45841-0_17

Harari, Y. N. (2015). Sapiens, A Brief History of Humankind. Penguin Random House.

Harries, D. (2002). *The New Media Book*. British Film Institute.

Harrison, R. P. (2008). *Gardens: An Essay on the Human Condition*. The University of Chicago Press. doi:10.7208/chicago/9780226317861.001.0001

Haugstvedt, A. C., & Krogstie, J. (2012). Mobile augmented reality for cultural heritage: A technology acceptance study. *ISMAR 2012 - 11th IEEE International Symposium on Mixed and Augmented Reality 2012, Science and Technology Papers*, 247–255. 10.1109/ISMAR.2012.6402563

Hayles, N. K. (1999). *How we became posthuman*. The University of Chicago Press. doi:10.7208/chicago/9780226321394.001.0001

Hayles, N. K. (2001). The Condition of Virtuality. In P. Lunenfeld (Ed.), *The Digital Dialectic* (3rd ed.). MIT Press.

Hayles, N. K. (2002). *Writing Machines*. MIT Press. doi:10.7551/mitpress/7328.001.0001

Hegarty, P. (2007). *Noise/Music: a history*. Continuum International Publishing Group.

Heidegger, M. (1971). Building Dwelling Thinking. In *Poetry, Language, Thought* (A. Hofstadter, Trans.; pp. 143–162). Harper & Row.

Heidegger, M. (2012). *Ensaios e conferências*. Editora Vozes.

Hetherington, R., & McRae, R. (2017). Make-Believing Animated Films Featuring Digital Humans: A Qualitative Inquiry Using Online Sources. *Animation*, *12*(2), 156–173. doi:10.1177/1746847717710738

Hewitt, I. (2016). *The Riot at the rite: The premiere of the Rite of Spring*. Accessed from https://www.bl.uk/20th-century-literature/articles/the-riot-at-the-rite-the-premiere-of-the-rite-of-spring

Hildebrand, A., & Sá, V. (2000). EMBASSI: Electronic Multimedia and Service Assistance. In *Intelligent Interactive Assistance & Mobile Multimedia Computing (IMC 2000)* (pp. 50–59). Retrieved from http://publica.fraunhofer.de/eprints/urn_nbn_de_0011-n-39911.pdf

Hirsch, M. (2008). The Generation of Postmemory. *Poetics Today*, *29*(1), 103–128. doi:10.1215/03335372-2007-019

Hiss, T. (1991). *The Experience of Place: A New Way of Looking at and Dealing with our Radically Changing Cities and Countryside*. Vintage Books.

Hoffman, M. L. (1977). Empathy, its development and prosocial implications. In *Nebraska Symposium on Motivation*. University of Nebraska Press.

Holmes, O., Banks, M. S., & Farid, H. (2016). Assessing and improving the identification of computer-generated portraits. *ACM Transactions on Perception, 13*, 7:1–7:12.

Holmes, O. B. H. (2015). *How realistic is photorealistic?* doi:10.1109/TSP.2004.839896

Hookway, G., Mehdi, P. Q., Hartley, D. T., & Bassey, N. (2013). Learning physics through computer games. In *Proceedings of the 18th International Conference on Computer Games: AI, Animation, Mobile, Interactive Multimedia, Educational & Serious Games (CGAMES 2013).* IEEE. doi:10.1109/CGames.2013.6632617

Hsu, C. C., Lee, C. Y., & Zhuang, Y. X. (2019). Learning to detect fake face images in the wild. *Proceedings - 2018 International Symposium on Computer, Consumer and Control, IS3C 2018,* 388–391. 10.1109/IS3C.2018.00104

Hurd, G. A. (Producer), Ling, V. (Producer), & Cameron, J. (Director). (1989). *The Abyss* [Motion Picture]. United States: Twentieth Century Fox.

Ickes, W., & Hodges, S. D. (2013). Empathic Accuracy in Close Relationships. In J. A. Simpson & L. Campbel (Eds.), The Oxford Handbook of Close Relationships (pp. 348–373). Oxford University Press. doi:10.1093/oxfordhb/9780195398694.013.0016

ICMCC (International Council of Museums Committee for Conservation). (1984). *The Conservator-Restorer: A Definition of the Profession, Section 2.1.* Retrieved May 10, 2020 from www.icom-cc. org/47/ about-icom-cc/definition-of-profession/

IMDb Database. (2019). Retrieved January 15, 2019 from https://www.imdb.com/search/title? genres=animation&certificates=US%3AR,US%3ANC-17.

IMDb. (2019). Retrieved January 15, 2019 from https://www.imdb.com/

Imre, Z. (2005). *Theatre, theatricality and resistance: some contemporary possibilities* (Doctoral dissertation).

Isaac, D. (1971). The Death of the Proscenium Stage. *The Antioch Review, 31*(2), 235–253. doi:10.2307/4637444

Iyamu, T., & Mgudlwa, S. (2018). Transformation of healthcare big data through the lens of actor network theory. *International Journal of Healthcare Management, 11*(3), 182–192. doi:10.1080/20479700.2017.1397340

Jacob, R. J. K. (1996). The Future of Input Devices. *ACM Computing Surveys, 28*(4), 138. doi:10.1145/242224.242400

Jankowska, A., Szarkowska, A., Krejtz, K., Fidyka, A., Kowalski, J., & Wichrowski, M. (2017). Smartphone app as a museum guide. Testing the Open Art application with blind, deaf, and sighted users. *Rivista Internazionale Di Tecnica Della Traduzione, 19*(19), 113–130. doi:10.13137/2421-6763/17354

Compilation of References

Jayathilaka, H. (2012). *How to get a cup of coffee the WSO2 way*. Retrieved February 13, 2020, from https://wso2.com/library/articles/2012/09/get-cup-coffee-wso2-way/

Jeater, M. (2012). Smartphones and site interpretation: the Museum of London's Streetmuseum applications. *Archaeology and Digital Communication. Towards Strategies of Public Engagement*, 56–65.

Johnson, S. (2004). *Emergence, the connected lives of ants, brains, cities, and software*. Scribner.

Jones, B. T., Kaiser, P., Eshkar, S., Girard, M., & Amkraut, S. (1999, July). Ghostcatching. In *ACM SIGGRAPH 99 Electronic art and animation catalog* (p. 143). ACM. doi:10.1145/312379.312948

Kaprow, A. (1966). *Assemblage, environments & happenings*. H. N. Abrams.

Karimi, H. (2019). *Hadi Karimi Website*. Retrieved December 4, 2019 from https://hadikarimi.com/

Katiyar, A., Kalra, K., & Garg, C. (2015). Marker based augmented reality. *Advances in Computer Science and Information Technology*, *2*(5), 441–445.

Kätsyri, J., Mäkäräinen, M., & Takala, T. (2017). Testing the 'uncanny valley' hypothesis in semirealistic computer-animated film characters: An empirical evaluation of natural film stimuli. *International Journal of Human Computer Studies, 97*, 149–161. doi:10.1016/j.ijhcs.2016.09.010

Kätsyri, J., Förger, K., Mäkäräinen, M., & Takala, T. (2015). A review of empirical evidence on different uncanny valley hypotheses: Support for perceptual mismatch as one road to the valley of eeriness. *Frontiers in Psychology, 6*, 1–16. doi:10.3389/fpsyg.2015.00390 PMID:25914661

Katz, E., Blumler, J., & Guretvich, M. (1974). Uses of Mass Communication by the Individual. In J. G. Blumler & E. Katz (Eds.), *The Uses of Mass Communications: Current Perspectives on Gratifications Research* (pp. 19–32). Sage Publications.

Katz, E., Haas, H., & Gurevitch, M. (1973). On the Use of the Mass Media for Important Things. *American Sociological Review, 38*(2), 164. doi:10.2307/2094393

Kee & Farid. (2011). A Perceptual Metric for Photo Retouching. *Proceedings of the National Academy of Sciences of the United States of America*. doi:10.1073/pnas.1110747108

Kember, S., & Zylinska, J. (2014). *Life after New Media: Mediation as a Vital Process*. The MIT Press.

Kennedy, K. (Producer), Molen, G. R. (Producer), & Spielberg, S. (Director). (1993). *Jurassic Park* [Motion Picture]. United States: Universal Pictures.

Kennedy-Eden, H., & Gretzel, U. (2012). A Taxonomy of Mobile Applications in Tourism. *Ereview of Tourism Research, 10*, 47–50.

Khan, A., Khusro, S., Rauf, A., & Mahfooz, S. (2015). Rebirth of Augmented Reality — Enhancing Reality via Smartphones. *Bahria University Journal of Information & Communication Technologies, 8*(1), 110–121.

Klich, R. (2007). *Multimedia theatre in the virtual age* (PhD dissertation). School of Media Film and Theatre, University of New South Wales.

Knowles, J. (2006). Alva Noto. *Filter, 62,* 17–19.

Kohut, H. (1995). Introspection, empathy, and psychoanalysis: An examination of the relationship between mode of observation and theory. Twenty-Fifth Anniversary Meeting of the Chicago Institute for Psychoanalysis (1957, Chicago, Illinois). *The Journal of Psychotherapy Practice and Research, 4*(2), 163–177.

Kovacevic, N., Ritter, P., Tays, W., Moreno, S., & McIntosh, A. R. (2015). 'My Virtual Dream': Collective Neurofeedback in an Immersive Art Environment. *PLoS One, 10*(7), e0130129. doi:10.1371/journal.pone.0130129 PMID:26154513

Kun, J. (2004). File Under: Post-Mexico. *Aztlán, 29*(1), 271–277.

Kunz, S. (2015). The problem of realism in animated characters – has the uncanny valley been crossed? *International Conference in Illustration & Animation,* 74–86. Retrieved from http://repositorio.ucp.pt/handle/10400.14/19661%5Cnhttps://www.academia.edu/11899468/The_problem_of_Realism_in_animated_characters_has_the_Uncanny_Valley_been_crossed

Kurtz, G. (Producer), Lucas, G. (Producer), & Lucas, G. (Director). (1977). *Star Wars* [Motion Picture]. United States: Twentieth Century Fox.

Lamm, C., & Singer, T. (2010). The role of anterior insular cortex in social emotions. *Brain Structure & Function, 214*(5–6), 579–591. doi:10.100700429-010-0251-3 PMID:20428887

Landreth, C. (2013, May 23). *Welcome to the Uncanny Valley: A sneak peek at Chris Landreth's new film, Subconscious Password* [Blog post]. Retrieved November 20, 2019, from https://blog.nfb.ca/blog/2013/05/23/chris-landreth-uncanny-valley-subconscious-password/

Lange, M., Raessens, J., Mul, J., Frissen, V., & Lammes, S. (Eds.). (2015). Playful Identities, The Ludification of Digital Media Cultures. Amsterdam University Press.

Lanier, J. (2017). *Dawn of the New Everything a Journey Through Virtual Reality.* The Bodley Head.

Laurenson, P. (2016). Old media, new media? Significant difference and the conservation of software-based art. In *New collecting: Exhibiting and audiences after new media art* (pp. 73–96). Routledge. doi:10.4324/9781315597898-4

Lazarus, P. N. (Producer), & Crichton, M. (Director). (1973). *Westworld* [Motion Picture]. United States: Metro-Goldwyn-Mayer.

Lee, H., & Hyung, W. (2014). A Study on Interactive Media Art to Apply Emotion Recognition. *International Journal of Multimedia and Ubiquitous Engineering, 9*(12), 431–442. doi:10.14257/ijmue.2014.9.12.37

Lee, J., Kim, Y., Heo, M. H., Kim, D., & Shin, B. S. (2015). Real-time projection-based augmented reality system for dynamic objects in the performing arts. *Symmetry*, *7*(1), 182–192. doi:10.3390ym7010182

Leenhardt, J. (1988). A Querela dos Modernos e dos Pós-Modernos. In Moderno e Pós-Moderno. Revista de Comunicação e Linguagens, Edição do Centro de Estudos de Comunicação e Linguagens (CECL).

Lefebvre, H. (1991). *The production of space* (D. Nicholson-Smith, Trans.). Blackwell.

Leslie, G., Ojeda, A., & Makeig, S. (2013). Towards an affective brain-computer interface monitoring musical engagement. *Proceedings - 2013 Humaine Association Conference on Affective Computing and Intelligent Interaction, ACII 2013*, 871–875. 10.1109/ACII.2013.163

Li, Y., Chang, M. C., & Lyu, S. (2019). In Ictu Oculi: Exposing AI created fake videos by detecting eye blinking. *10th IEEE International Workshop on Information Forensics and Security, WIFS 2018*, 1–7. 10.1109/WIFS.2018.8630787

Lialina, O., & Espenschied, D. (2009). *Digital Folklore, to Computer Users with Love and Respect*. Retrieved May 2, 2019, https://digitalfolklore.org/

Ling, H. (2017). Augmented Reality in Reality. *IEEE MultiMedia*, *24*(3), 10–15. doi:10.1109/MMUL.2017.3051517

Lin, Y. P., Duann, J. R., Chen, J. H., & Jung, T. P. (2010). Electroencephalographic dynamics of musical emotion perception revealed by independent spectral components. *Neuroreport*, *21*(6), 410–415. doi:10.1097/WNR.0b013e32833774de PMID:20300041

Lipkin, J. (2005) *Photography Reborn: Image Making in the Digital Era*. Academic Press.

Lippard, L. (1997). *The Lure of the Local: Senses of Place in a Multicultural Society*. The New Press.

Lopatovska, I., Arthur, K. L., Bardoff, C., Diolola, J., Furlow, T., Honor, L. B., … Shaw, J. L. (2015). Engaging digital artworks through emotion: interface design case study. *iConference 2015*. Retrieved from http://hdl.handle.net/2142/73435

Lopez-Samaniego, L., Garcia-Zapirain, B., Ozaita-Araico, A., & Mendez-Zorrilla, A. (2014). Cognitive rehabilitation based on working brain reflexes using computer games over iPad. In *Proceedings of the 2014 Computer Games: AI, Animation, Mobile, Multimedia, Educational and Serious Games (CGAMES)*. Louisville, KY: IEEE.

Lorenzetti, V., Melo, B., Basílio, R., Suo, C., Yücel, M., Tierra-Criollo, C. J., & Moll, J. (2018). Emotion regulation using virtual environments and real-time fMRI neurofeedback. *Frontiers in Neurology*, *9*, 1–15. doi:10.3389/fneur.2018.00390 PMID:30087646

Lovink, G. (2008). *Zero Comments: Blogging and Critical Internet Culture*. Routledge. doi:10.14361/9783839408049

Lovink, G. (2019). *Sad by Design, On Platform Nihilismo*. Pluto Press. doi:10.2307/j.ctvg8p6dv

Lowery. (2017). *A Ghost Story*. Werckmeister Harmonies.

Luz, F. C. (2010). Digital animation: Repercussions of new media on traditional animation concepts. Lecture Notes in Computer Science, 6249, 562–569. doi:10.1007/978-3-642-14533-9_57

MacDorman, K. F., & Chattopadhyay, D. (2016). Reducing consistency in human realism increases the uncanny valley effect; increasing category uncertainty does not. *Cognition, 146*, 190–205. doi:10.1016/j.cognition.2015.09.019 PMID:26435049

MacDorman, K. F., Green, R. D., Ho, C. C., & Koch, C. T. (2009). Too real for comfort? Uncanny responses to computer generated faces. *Computers in Human Behavior, 25*(3), 695–710. doi:10.1016/j.chb.2008.12.026 PMID:25506126

MacDowall, L. J., & de Souza, P. (2018). 'I'd Double Tap That!!': Street art, graffiti, and Instagram research. *Media Culture & Society, 40*(1), 3–22. doi:10.1177/0163443717703793

MacGillivray, C. (2007). How psychophysical perception of motion and image relates to animation practice. *Computer Graphics, Imaging and Visualisation. New Advances, CGIV, 14*(10), 81–88. doi:10.1109/CGIV.2007.48

Machado, A. (1993). *Máquina e Imaginário: O Desafio Das Poéticas Tecnológicas*. Editora da Universidade de São Paulo.

Madhavji, N. H., Fernandez-Ramil, J., & Perry, D. (Eds.). (2006). *Software evolution and feedback: Theory and practice*. John Wiley & Sons. doi:10.1002/0470871822

Madirov, E., & Absalyamova, S. (2015). The influence of Information Technologies on the Availability of Cultural Heritage. *Procedia: Social and Behavioral Sciences, 188*, 255–258. doi:10.1016/j.sbspro.2015.03.385

Maffesoli, M. (2001). *Sobre o Nomadismo, Vagabundagens Pós-modernas*. Editora Record.

Malabou, C. (2000). *Plasticité*. Paros, Editions Léo Scheer Beau.

Manovich, L. (2001). *The Language of New Media*. MIT Press.

Manovich, L. (2002). *The language of new media*. MIT Press.

Marchese, F. T. (2013). Conserving software-based artwork through software engineering. In *2013 Digital Heritage International Congress (DigitalHeritage)* (Vol. 2, pp. 181-184). IEEE. 10.1109/DigitalHeritage.2013.6744752

Marcos, A., Bernardes, P., & Sá, V. (2002). Multimedia technology and 3D environments used in the preservation and dissemination of the portuguese cultural heritage. In Méndez Vilas A., J. A. Mesa Gonzáles, & I. Zaldívar Maldonado (Eds.), *Educational Technology : International Conference on Information and Comunication Technologies in Education (ICTE2002)* (pp. 1335–1339). Badajoz: Consejería de Educación, Ciencia y Tecnología.

Marín-Morales, J., Higuera-Trujillo, J. L., Greco, A., Guixeres, J., Llinares, C., Scilingo, E. P., ... Valenza, G. (2018). Interactive Storytelling in a Mixed Reality Environment: The Effects of Interactivity. *Scientific Reports*, *8*(1), 1–15. doi:10.103841598-018-32063-4 PMID:29311619

Marra, F., Gragnaniello, D., Cozzolino, D., & Verdoliva, L. (2018). Detection of GAN-Generated Fake Images over Social Networks. *Proceedings - IEEE 1st Conference on Multimedia Information Processing and Retrieval, MIPR 2018*, 384–389. 10.1109/MIPR.2018.00084

Maslow, A. H. (1970). *Motivation and personality* (2nd ed.). Harper & Row.

Meador, W. S., Rogers, T. J., O'Neal, K., Kurt, E., & Cunningham, C. (2004). Mixing dance realities: Collaborative development of live-motion capture in a performing arts environment. *Computers in Entertainment*, *2*(2), 12–12. doi:10.1145/1008213.1008233

Mendes, J. M. (2011). *Introdução às intermedialidades*. Escola Superior de Teatro e Cinema/IPL.

Merleau-Ponty, M. (1964). *The Primacy of Perception and Other Essays on Phenomenological Psychology, the Philosophy of Art, History and Politics*. Northwestern University Press.

Michelson, A. (1984). *Kino-Eye: The Writings of Dziga Vertov*. University of California Press.

Milburn, K. (2013). Futurism and Musical Meaning in Synthesized Landscapes. *Kaleidoscope*, *5*(1), 109–116.

Mitchell, W. (1994). *The Reconfigured Eye: Visual Truth in the Post-Photographic Era*. MIT.

Moles, A. (1971). *Arte e Computador*. Edições Afrontamento.

Moraitou, E., & Kavakli, E. (2018). Knowledge Management Using Ontology on the Domain of Artworks Conservation. In *Digital Cultural Heritage* (pp. 50–62). Springer. doi:10.1007/978-3-319-75826-8_5

Mori, M., MacDorman, K. F., & Kageki, N. (2012). The uncanny valley. *IEEE Robotics & Automation Magazine*, *19*(2), 98–100. doi:10.1109/MRA.2012.2192811

Morin, E. (n.d.). *As Grandes Questões do Nosso Tempo*. Lisboa: Edições Notícias.

Musil, R. (n.d.). *O Homem Sem Qualidades*. Lisboa: Edições Livros do Brasil.

Muybridge, E. J. (1887). Woman Dancing (Fancy): Plate 187 from Animal Locomotion. Museum of Modern Art.

Nakevska, M., van der Sanden, A., Funk, M., Hu, J., & Rauterberg, M. (2017). Interactive Storytelling in a Mixed Reality Environment: The Effects of Interactivity of interactivity on user experiences. *Entertainment Computing*, *21*(January), 97–104. doi:10.1016/j.entcom.2017.01.001

National Research Council. (2013). National Academies Keck Future Initiative: The Informed Brain in a Digital World. *National Academies Keck Future Initiative: The Informed Brain in a Digital World*, *130*. Advance online publication. doi:10.17226/18268

Neal, T. J. (2013). *The Relation between Art & Emotion (Plato, Aristotle & Collingwood).* Retrieved April 20, 2020, from https://timjohnneal.wordpress.com/2013/06/27/the-relation-between-art-emotion-plato-aristotle-collingwood/

Newhall, B. (1984). *The History of Photography: From 1839 to the Present.* The Museum of Modern Art.

Nightingale, S. J., Wade, K. A., & Watson, D. G. (2017). Can people identify original and manipulated photos of real-world scenes? *Cognitive Research: Principles and Implications, 2*(1), 30. doi:10.118641235-017-0067-2 PMID:28776002

Nora, P. (Ed.). *(1984–1992). Les lieux de Mémoire.* Gallimard.

Nosek, J. T., & Palvia, P. (1990). Software maintenance management: Changes in the last decade. *Journal of Software Maintenance: Research and Practice, 2*(3), 157–174. doi:10.1002mr.4360020303

Oliveira, N. (2017). *Do multiculturalismo ao interculturalismo. Um novo modo de incorporação da diversidade cultural?* Academic Press.

Oteafy, S. M. A., Hassanein, H. S., Oteafy, S. M. A., & Hassanein, H. S. (2014). Evolution of Wireless Sensor Networks. *Dynamic Wireless Sensor Networks,* 1–8. doi:10.1002/9781118761977.ch1

Ouellette, J. (2016). *Breaking the Fourth Wall.* Retrieved from https://www.dancemagazine.com/breaking-the-fourth-wall-2307007996.html

Packer, R., & Jordan, K. (Eds.). (2001). *Multimedia: from Wagner to virtual reality.* Norton & Company.

Pallasmaa, J. (2014). Space, Place, and Atmosphere: Peripheral Perception in Existential Experience. In C. Borch (Ed.), *Architectural Atmospheres: On the Experience and Politics of Architecture.* Birkhäuser. doi:10.1515/9783038211785.18

Palumbo, F., Dominici, G., & Basile, G. (2014). *The culture on the palm of your hand: How to design a user oriented mobile app for museums. In Handbook of research on management of cultural products: E-relationship marketing and accessibility perspectives.* IGI Global.

Pandey, M., Litoriya, R., & Pandey, P. (2016). Mobile applications in context of big data: A survey. *2016 Symposium on Colossal Data Analysis and Networking, CDAN 2016,* 1–5. 10.1109/CDAN.2016.7570942

Paul, C. (2019). *The Myth of Immateriality-Presenting & Preserving New Media.* Academic Press.

Paul, C. (2003). *Digital Art.* Thames & Hudson Ltd.

Pedersen, I., Gale, N., Mirza-Babaei, P., & Reid, S. (2017). More than meets the eye: The benefits of augmented reality and holographic displays for digital cultural heritage. *Journal on Computing and Cultural Heritage, 10*(2), 1–15. doi:10.1145/3051480

Pennefather, P., Ryzhov, V., Danenkov, L., Saroyan, J., Rosenbaum, L., Desnoyers-Stewart, J., Stepanova, K., Alzate, H., Yueh, S., Pabon, F., & Ripoli, L. (2019). *Fun Palace: Carnival of mixed realities*. Centre for Digital Media.

Phillips, J. (2015). Reporting iterations: a documentation model for time-based media art. *Revista de historia da arte, 4*, 168-179.

Picard, R. W. (2000). *Affective Computing*. MIT Press. doi:10.7551/mitpress/1140.001.0001

Pine, B. J., & Gilmore, J. H. (1999). *The experience economy: Work is theatre & every business a stage*. Harvard Business School Press.

Pinheiro, J. (2013). *Pós-publicidade : contributo para o estudo do registo de pós-produção fotográfica no domínio da publicidade*. https://repositorioaberto.uab.pt/handle/10400.2/2667

Pinheiro, J. (2018). *Imagética contemporânea e pós-imagem: a marca do software e o uso de ferramentas borderline no caso uturn*. https://repositorioaberto.uab.pt/handle/10400.2/7785

Polsinelli, P. (2013). *Why is Unity so popular for videogame development?* Retrieved February 11, 2020, from https://designagame.eu/2013/12/unity-popular-videogame-development/

Poria, S., Cambria, E., Bajpai, R., & Hussain, A. (2017). A review of affective computing: From unimodal analysis to multimodal fusion. *Information Fusion, 37*, 98–125. doi:10.1016/j.inffus.2017.02.003

Postma, A., Buda, D. M., & Gugerell, K. (2017). The future of city tourism. *Journal of Tourism Futures, 3*(2), 95–101. doi:10.1108/JTF-09-2017-067

Price, S. (2015). Dispersion. In Mass Effect, Art and the Internet in the Twenty-First Century. The New Museum.

Pronschinske, M. (2017). *WSO2: Open Source SOA in the Cloud*. Retrieved February 13, 2020, from https://dzone.com/articles/wso2-open-source-soa-cloud

Puttnam, D. (1999). Keynote speech. In CADE 99 (Computers in Art and Design Education) Conference. University of Teesside.

Quaranta, D. (2018). Art numerique: un art contemporain. In *Les presses du réel*. Espace multimédia Gantner.

Quinn, M. (2017). Intercultural Museum Practice: An Analysis of the of the Belonging Project in Northern Ireland. In Museums and Innovations. Cambridge Scholars Publishing.

Ransom, J., Somerville, I., & Warren, I. (1998, March). A method for assessing legacy systems for evolution. In *Proceedings of the Second Euromicro Conference on Software Maintenance and Reengineering* (pp. 128-134). IEEE. 10.1109/CSMR.1998.665778

Rapke, J. (Producer), Starkey, S. (Producer), Zemeckis, R. (Producer), & Zemeckis, R. (Director). (2007). *Beowulf* [Motion Picture]. United States: Paramount Pictures.

Rauschnabel, P. A. (2018). Virtually enhancing the real world with holograms: An exploration of expected gratifications of using augmented reality smart glasses. *Psychology and Marketing*, *35*(8), 557–572. doi:10.1002/mar.21106

Real, W. A. (2001). Toward guidelines for practice in the preservation and documentation of technology-based installation art. *Journal of the American Institute for Conservation*, *40*(3), 211–231. doi:10.1179/019713601806112987

Reed, G. S. (1984). The Antithetical Meaning of the Term "Empathy" in Psychoanalytic Discourse. In J. D. Lichtenberg, M. Bornstein, & D. Silver (Eds.), *Empathy I* (pp. 7–24). Routledge.

Ribeiro, A. S. (1988). Para uma Arqueologia do Pós-Modernismo: A "Viena 1900". In Moderno e Pós-Moderno. Revista de Comunicação e Linguagens, Edição do Centro de Estudos de Comunicação e Linguagens (CECL).

Richards, G. (2018). Cultural tourism: A review of recent research and trends. *Journal of Hospitality and Tourism Management*, *36*, 12–21. doi:10.1016/j.jhtm.2018.03.005

Ricoeur, P. (2004). *Memory, History, Forgetting*. The University of Chicago Press. doi:10.7208/chicago/9780226713465.001.0001

Rinehart, R. (2007). The media art notation system: Documenting and preserving digital/media art. *Leonardo*, *40*(2), 181–187. doi:10.1162/leon.2007.40.2.181

Risner, D., & Anderson, J. (2008). Digital Dance Literacy: An integrated dance technology curriculum pilot project. *Research in Dance Education*, *9*(2), 113–128. doi:10.1080/14647890802087787

Rivero, J. A. S. del, Pérez, M. J. G., Díaz, M. F., Meana, J. G., Igual, M. F., & Álvarez, A. P. (2015). INSIDDE AR application: Bringing art closer to citizens by promoting the use of smartphones and tablets. *2015 Digital Heritage*, *1*, 325–328. doi:10.1109/DigitalHeritage.2015.7413893

Robinson, D. (2017). *Dancing with holograms: CWRU stages first-of-its-kind mixed-reality dance performance using Microsoft HoloLens*. Retrieved from https://thedaily.case.edu/dancing-holograms-cwru-stages-first-kind-mixed-reality-dance-performance-using-microsoft-hololens/

Rodman, M. (n.d.). *Artist Biography*. Retrieved from https://www.allmusic.com/artist/john-cage-mn0000183867/biography

Roeck, C., Rechert, K., & Noordegraaf, J. (2018). *Evaluation of preservation strategies for an interactive, software-based artwork with complex behavior using the case study Horizons (2008) by Geert Mul*. iPres 2o18.

Rosa, C. (2015). Preserving New Media: Educating Public Audiences through Museum Websites. Art Documentation. *Journal of the Art Libraries Society of North America*, *34*(1), 181–191. doi:10.1086/680572

RoserM. (2019) *Tourism*. Retrieved from https://ourworldindata.org/tourism

Ross, L. (2011). *Spectacular Dimensions-3D Dance Films*. Retrieved from http://sensesofcinema.com/2011/feature-articles/spectacular-dimensions-3d-dance-films/

Roush, P. (2010). From Webcamming to Social Life-Logging: Intimate Performance in the Surveillant-Sousveillant Space. In O. Remes & P. Skelton (Eds.), *Conspiracy Dwellings, Surveillance in Contemporary Art* (pp. 113–128). Cambridge Scholars Publishing.

Rupilu, M. M., Suyoto, & Santoso, A. J. (2018). The Development of Mobile Application to Introduce Historical Monuments in Manado. *E3S Web of Conferences, 31*, 1–6. doi:10.1051/e3sconf/20183111012

Rush, M. (2005). *New Media in Art*. Thames & Hudson.

Russcol, H. (1972). *The liberation of sound: an introduction to electronic music*. Prentice-Hall.

Russolo, L. (1967). *The Art of Noise: futurist manifesto*. London: A Great Bear Pamphlet by Something Else Press.

Rutsky, R. L. (1999). *High techne: art and technology from the machine aesthetic to the posthuman*. University of Minnesota Press.

Sá, V., Malerczyk, C., & Schnaider, M. (2001). Vision-Based Interaction within a Multimodal Framework. In J. L. Encarnação (Ed.), Selected readings in computer graphics 2001. Stuttgart: Fraunhofer-IRB-Verlag: INI-GraphicsNet.

Santaella, L. (2003). *Culturas e Artes Do Pós-Humano*. Paulus.

Saracco, R. (2012). Leveraging technology evolution for better and sustainable cities. *Elektrotehniski Vestnik / Electrotechnical Review, 79*(5), 255–261.

Sawyier, F. H. (1975). A Conceptual Analysis of Empathy. *The Annual of Psychoanalysis, 3*, 37–47.

Schechner, R. (2003). *Performance theory*. Routledge. doi:10.4324/9780203361887

Schneider, R. (2011). *Performing Remains: Art and War in Times of Theatrical Reenactment*. Routledge. doi:10.4324/9780203852873

Schoenherr, J. R., & Burleigh, T. J. (2014). Uncanny sociocultural categories. *Frontiers in Psychology, 5*(OCT), 1–4. doi:10.3389/fpsyg.2014.01456 PMID:25653622

Schomaker, L., Nijtmans, J., Camurri, A., Lavagetto, F., Morasso, P., Benoit, C., … Blauert, J. (1995). A Taxonomy of Multimodal Interaction in the the Human Information Processing System. *Multimodal Integration for Advanced Multimedia Interfaces (MIAMI). ESPRIT III, Basic Research Project, 8579.*

Schwind, V., Wolf, K., & Henze, N. (2018). Avoiding the uncanny valley in virtual character design. *Interaction, 25*(5), 45–49. doi:10.1145/3236673

Searl, A. (2019). *Much of the experience is meant to be horrible': Hito Steyerl review*. Academic Press.

Seevinck, J. (2011). The Concrete of NOW Jen Seevinck. *INTERACTING: Art, Research and the Creative Practitioner*, 242–256. Retrieved from http://research.it.uts.edu.au/creative/linda/CCSBook/Jan 21 web pdfs/Seevinck.pdf

Shamay-Tsoory, S. G., Aharon-Peretz, J., & Perry, D. (2009). Two systems for empathy: A double dissociation between emotional and cognitive empathy in inferior frontal gyrus versus ventromedial prefrontal lesions. *Brain*, *132*(3), 617–627. doi:10.1093/brain/awn279 PMID:18971202

Shapiro, T. (1974). The development and distortions of empathy. *The Psychoanalytic Quarterly*, *43*(1), 4–25. doi:10.1080/21674086.1974.11926657 PMID:4814470

Share, N. (2019). *Market Share Statistics for Internet Technologies*. Retrieved from https://netmarketshare.com/operating-system-market-share.aspx?options=%7B%22filter%22%3A%7B%22%24and%22%3A%5B%7B%22deviceType%22%3A%7B%22%24in%22%3A%5B%22Mobile%22%5D%7D%7D%5D%7D%2C%22dateLabel%22%3A%22Trend%22%2C%22attributes%22%3A%22share%22%2C%22group%22%3A%22platform%22%2C%22sort%22%3A%7B%22share%22%3A-1%7D%2C%22id%22%3A%22platformsMobile%22%2C%22dateInterval%22%3A%22Monthly%22%2C%22dateStart%22%3A%222018-12%22%2C%22dateEnd%22%3A%222019-11%22%2C%22segments%22%3A%22-1000%22%7D

Sherry, J. F. (1998). *Servicescapes: the concept of place in contemporary markets*. Retrieved from https://books.google.pt/books?id=ZABBAAAAMAAJ

Silva, J. F., Almeida, J. E., Rossetti, R. J. F., & Coelho, A. L. A. (2013). Serious Game for EVAcuation training. In *Proceedings of the 2013 IEEE 2nd International Conference on Serious Games and Applications for Health (SeGAH)*. Vilamoura, Portugal: IEEE. 10.1109/SeGAH.2013.6665302

Silvia, P. J. (2005). Emotional responses to art: From collation and arousal to cognition and emotion. *Review of General Psychology*, *9*(4), 342–357. doi:10.1037/1089-2680.9.4.342

Skorton, D., & Bear, A. (Eds.). (2018). The Integration of the Humanities and Arts with Sciences, Engineering, and Medicine in Higher Education: Branches from the Same Tree. Washington, DC: The National Academies Press.

Slater, J. (2015). Post-Net Aesthetics Conversation, London, 2013: Part 3 of 3. In L. Cornell & E. Halter (Eds.), *Mass Effect: Art and the Internet in the Twenty-First Century*. Cambridge, MA: The MIT Press.

Sloterdijk, P. (2011). *Crítica da Razão Cínica*. Edições Relógio de D'Água Editores.

Smith, A. (2001). Digital Paint Systems. *An Anecdotal and Historical Overview*, *23*. doi:10.1109/85.929908

Snook, R. (2015). *Theatre in the round*. Retrieved from http://dictionary.tdf.org/theatre-in-the-round/

Soleymani, M., Larson, M., Pun, T., & Hanjalic, A. (2014). Corpus Development for Affective Video Indexing. *IEEE Transactions on Multimedia*, *16*(4), 1075–1089. doi:10.1109/TMM.2014.2305573

Sommerseth, H. (2007). Gamic realism: Player perception, and action in video game play. *Proceedings of Situated Play, DiGRA 2007 Conference*, 765–768.

Sondheim, S., & Lapine, J. (1991). *Sunday in the Park with George*. Hal Leonard Corporation.

Sparacino, F., Wren, C., Davenport, G., & Pentland, A. (1999). Augmented performance in dance and theater. *International Dance and Technology*, *99*, 25–28.

Spielberg, S. (Producer), Hahn, D. (Producer), Kennedy, K. (Producer), Marshall, F. (Producer), Starkey, S. (Producer), Watts, R. (Producer), & Zemeckis, R. (Director). (1988). *Who Framed Roger Rabbit* [Motion Picture]. United States: Touchstone Pictures.

Strachan, R. (2010). Uncanny Space: Theory, Experience and Affect in Contemporary Electronic Music. *Trans. Revista Transcultural de Música*, *14*, 1–10.

Stump, P. (1997). *Digital Gothic: A Critical Discography of Tangerine Dream*. SAF.

Tanner, E., & Huang, M. (2019). Planning for Time-Based Media Artwork Preservation at the Philadelphia Museum of Art. Art Documentation. *Journal of the Art Libraries Society of North America*, *38*(2), 229–261.

Taylor, J.W. (1887). *Chicago Auditorium Building, interior from balcony*. United States Library of Congress's Prints and Photographs division.

Taylor, K. (2003). Cultural Landscape as Open Air Museum: Borobudur World Heritage Site and Its Setting. *Humanities Report*, *10*(2), 51–62.

The New Yorker. (2002). *Play it again*. Retrieved from https://www.newyorker.com/magazine/2002/01/14/play-it-again

The Swedish History Museum. (2017). Retrieved May 5, 2019, from, https://historiska.se/history-unfolds-en/artists/artur-zmijewski-2/

Thompson, T., Steffert, T., Ros, T., Leach, J., & Gruzelier, J. (2008). EEG applications for sport and performance. *Methods (San Diego, Calif.)*, *45*(4), 279–288. doi:10.1016/j.ymeth.2008.07.006 PMID:18682293

Tillon, A. B., Marchand, E., Laneurit, J., Servant, F., Marchal, I., & Houlier, P. (2010). A day at the museum: An augmented fine-art exhibit. *9th IEEE International Symposium on Mixed and Augmented Reality 2010: Arts, Media, and Humanities, ISMAR-AMH 2010 - Proceedings*, *1*, 69–70. 10.1109/ISMAR-AMH.2010.5643290

Tinwell, A., & Grimshaw, M. (2009). Bridging the Uncanny: An impossible traverse? *Proceedings of the 13th International MindTrek Conference: Everyday Life in the Ubiquitous Era*, 66–73. 10.1145/1621841.1621855

Tinwell, A., Nabi, D. A., & Charlton, J. P. (2013). Perception of psychopathy and the Uncanny Valley in virtual characters. *Computers in Human Behavior*, *29*(4), 1617–1625. doi:10.1016/j.chb.2013.01.008

Tofts, D., Jonson, A., & Cavallaro, A. (Eds.). (2002). *Prefiguring Cyberculture: An Intellectual History*. The MIT Press.

Tomić, N. (2019). Economic model of microtransactions in Video Games. *Journal of Economic Science Research, 01*(01), 17–23.

Tuan, Y.-F. (1977). *Space and Place: The Perspective of Experience*. University of Minnesota Press.

Tudor, A. (1974). *Image and Influence: Studies in the Sociology of Film*. George Allen & Unwin.

Tussyadiah, I. P., & Zach, F. J. (2012). The role of geo-based technology in place experiences. *Annals of Tourism Research, 39*(2), 780–800. doi:10.1016/j.annals.2011.10.003

TutorialRepublic. (n.d.). *Bootstrap Tutorial*. Retrieved February 11, 2020, from https://www.tutorialrepublic.com/twitter-bootstrap-tutorial/

UN Habitat. (2010). *State of the world's cities 2010-2011: Bridging the urban divide - Overview and key findings*. United Nations Human Settlements Programme.

Underdogs. (2013). *Public Art*. Retrieved from https://www.under-dogs.net/about/

Usui, S., Furuichi, T., Miyakawa, H., Ikeno, H., Nagao, S., Iijima, T., ... Ishikane, H. (2007). Japanese Neuroinformatics Node and Platforms. In M. Ishikawa, K. Doya, H. Miyamoto, & T. Yamakawa (Eds.), *Proceedings of the 14th International Conference, ICONIP 2007*. Kitakyushu, Japan: Springer.

Vavakova, B. (1988). Lógica Cultural da Pós-Modernidade. In Moderno e Pós-Moderno. Revista de Comunicação e Linguagens, Edição do Centro de Estudos de Comunicação e Linguagens (CECL).

Veenhof S, Skwarek M. (2010). *AR art exhibition MoMA NYC (guerrilla intervention)*. Academic Press.

Veigl, T. (2011). *Imagery in the 21st Century*. The MIT Press.

Veloso Gomes, P., Marques, A., Pereira, J., Correia, A., Donga, J., & Sá, V. J. (2019). E-EMOTION CAPSULE: As artes digitais na criação de emoções. In *ACM International Conference Proceeding Series*. Braga: Association for Computing Machinery. 10.1145/3359852.3359962

Visconti, L. M., Sherry, J. F. Jr, Borghini, S., & Anderson, L. (2010). Street Art, Sweet Art? Reclaiming the "Public" in Public Place. *The Journal of Consumer Research, 37*(3), 511–529. doi:10.1086/652731

Völlm, B., Taylor, A., Richardson, P., Corcoran, R., Stirling, J., McKie, S., Deakin, J. F. W., & Elliott, R. (2006). Neuronal correlates of theory of mind and empathy: A functional magnetic resonance imaging study in a nonverbal task. *NeuroImage, 29*(1), 90–98. doi:10.1016/j.neuroimage.2005.07.022 PMID:16122944

Voon, C. (2015). *Faced With Digital Ubiquity, Artists Still Cherish Crafting Materials*. Academic Press.

Wachowski, L. (Producer), Wachowski, L. (Producer), Berman, B. (Producer), Forbes, D. (Producer), Hill, G. (Producer), Mason, A. (Producer), Oosterhouse, P. (Producer), Popplewell, V. (Producer), Richards, S. (Producer), Silver, J. (Producer), Wachowski, L. (Director), & Wachowski, L. (Director). (2003). *The Matrix Revolutions* [Motion Picture]. United States: Warner Bros.

Wagner, R. (2001). The artwork of the future {1849. In R. Packer & K. Jordan (Eds.), *Multimedia: from Wagner to virtual reality*. Norton & Company.

Wales, K. (1989). *A Dictionary of Stylistics*. Longman Wellek.

Walravens, N. (2015). Mobile city applications for Brussels citizens: Smart City trends, challenges and a reality check. *Telematics and Informatics, 32*(2), 282–299. doi:10.1016/j.tele.2014.09.004

Wands, B. (2007). *Art of the Digital Age*. Thames & Hudson.

Wardrip-Fruin, N. (2006). *Expressive processing: on process-intensive literature and digital media* (PhD dissertation). Brown University, Providence, RI.

Wardrip-Fruin, N., & Montfort, N. (2003). *The New Media Reader*. The MIT Press.

Wellner, P. (1991, November). The DigitalDesk calculator: tangible manipulation on a desk top display. In *Proceedings of the 4th annual ACM symposium on User interface software and technology* (pp. 27-33). 10.1145/120782.120785

Wells, P. (2002). *Animation: Genre and Authorship. Short Cuts Series: Introduction to Film Studies* (Vol. 99). Academic Press.

Westgeest, H. (2008). The Changeability of Photography in Multimedia Artworks. In H. Van Gelder & H. Westgeest (Eds.), *Photography between poetry and politics: the critical position of the photographic medium in contemporary art*. Leuven University Press.

West, R., & Turner, L. H. (2009). *Understanding interpersonal communication: Making choices in changing times*. Wadsworth/Cengage.

Wolf, W. (1993). *Ästhetische Illusionen und Illusionsdurchbrechung in der Erzählkunst*. Niemeyer. doi:10.1515/9783110927696

World Travel & Tourism Council. (2018). *Travel & tourism global economic impact & issues 2018*. Retrieved from https://dossierturismo.files.wordpress.com/2018/03/wttc-global-economic-impact-and-issues-2018-eng.pdf

Yamada, Y., Kawabe, T., & Ihaya, K. (2013). Categorization difficulty is associated with negative evaluation in the "uncanny valley" phenomenon. *The Japanese Psychological Research, 55*(1), 20–32. doi:10.1111/j.1468-5884.2012.00538.x

Yang, X., Li, Y., & Lyu, S. (2019). Exposing Deep Fakes Using Inconsistent Head Poses. *ICASSP, IEEE International Conference on Acoustics, Speech and Signal Processing - Proceedings*, 8261–8265. 10.1109/ICASSP.2019.8683164

Yeung, T. A., Greenberg, S., & Carpendale, S. (2008). *Preservation of Art in the Digital Realm.* iPRES.

Zhang, Q., Chu, W., Ji, C., Ke, C., & Li, Y. (2014). An implementation of generic augmented reality in mobile devices. *2014 IEEE 7th Joint International Information Technology and Artificial Intelligence Conference*, 555–558. 10.1109/ITAIC.2014.7065112

Zieleniec, A. (2017, April). The right to write the city: Lefebvre and graffiti. *Environment and Urbanization, 10.* Advance online publication. doi:10.7202/1040597ar

Related References

To continue our tradition of advancing information science and technology research, we have compiled a list of recommended IGI Global readings. These references will provide additional information and guidance to further enrich your knowledge and assist you with your own research and future publications.

Adesina, K., Ganiu, O., & R., O. S. (2018). Television as Vehicle for Community Development: A Study of Lotunlotun Programme on (B.C.O.S.) Television, Nigeria. In A. Salawu, & T. Owolabi (Eds.), *Exploring Journalism Practice and Perception in Developing Countries* (pp. 60-84). Hershey, PA: IGI Global. doi:10.4018/978-1-5225-3376-4.ch004

Adigun, G. O., Odunola, O. A., & Sobalaje, A. J. (2016). Role of Social Networking for Information Seeking in a Digital Library Environment. In A. Tella (Ed.), *Information Seeking Behavior and Challenges in Digital Libraries* (pp. 272–290). Hershey, PA: IGI Global. doi:10.4018/978-1-5225-0296-8.ch013

Ahmad, M. B., Pride, C., & Corsy, A. K. (2016). Free Speech, Press Freedom, and Democracy in Ghana: A Conceptual and Historical Overview. In L. Mukhongo & J. Macharia (Eds.), *Political Influence of the Media in Developing Countries* (pp. 59–73). Hershey, PA: IGI Global. doi:10.4018/978-1-4666-9613-6.ch005

Ahmad, R. H., & Pathan, A. K. (2017). A Study on M2M (Machine to Machine) System and Communication: Its Security, Threats, and Intrusion Detection System. In M. Ferrag & A. Ahmim (Eds.), *Security Solutions and Applied Cryptography in Smart Grid Communications* (pp. 179–214). Hershey, PA: IGI Global. doi:10.4018/978-1-5225-1829-7.ch010

Akanni, T. M. (2018). In Search of Women-Supportive Media for Sustainable Development in Nigeria. In A. Salawu & T. Owolabi (Eds.), *Exploring Journalism Practice and Perception in Developing Countries* (pp. 126–149). Hershey, PA: IGI Global. doi:10.4018/978-1-5225-3376-4.ch007

Akçay, D. (2017). The Role of Social Media in Shaping Marketing Strategies in the Airline Industry. In V. Benson, R. Tuninga, & G. Saridakis (Eds.), *Analyzing the Strategic Role of Social Networking in Firm Growth and Productivity* (pp. 214–233). Hershey, PA: IGI Global. doi:10.4018/978-1-5225-0559-4.ch012

Al-Rabayah, W. A. (2017). Social Media as Social Customer Relationship Management Tool: Case of Jordan Medical Directory. In W. Al-Rabayah, R. Khasawneh, R. Abu-shamaa, & I. Alsmadi (Eds.), *Strategic Uses of Social Media for Improved Customer Retention* (pp. 108–123). Hershey, PA: IGI Global. doi:10.4018/978-1-5225-1686-6.ch006

Almjeld, J. (2017). Getting "Girly" Online: The Case for Gendering Online Spaces. In E. Monske & K. Blair (Eds.), *Handbook of Research on Writing and Composing in the Age of MOOCs* (pp. 87–105). Hershey, PA: IGI Global. doi:10.4018/978-1-5225-1718-4.ch006

Altaş, A. (2017). Space as a Character in Narrative Advertising: A Qualitative Research on Country Promotion Works. In R. Yılmaz (Ed.), *Narrative Advertising Models and Conceptualization in the Digital Age* (pp. 303–319). Hershey, PA: IGI Global. doi:10.4018/978-1-5225-2373-4.ch017

Altıparmak, B. (2017). The Structural Transformation of Space in Turkish Television Commercials as a Narrative Component. In R. Yılmaz (Ed.), *Narrative Advertising Models and Conceptualization in the Digital Age* (pp. 153–166). Hershey, PA: IGI Global. doi:10.4018/978-1-5225-2373-4.ch009

An, Y., & Harvey, K. E. (2016). Public Relations and Mobile: Becoming Dialogic. In X. Xu (Ed.), *Handbook of Research on Human Social Interaction in the Age of Mobile Devices* (pp. 284–311). Hershey, PA: IGI Global. doi:10.4018/978-1-5225-0469-6.ch013

Assay, B. E. (2018). Regulatory Compliance, Ethical Behaviour, and Sustainable Growth in Nigeria's Telecommunications Industry. In I. Oncioiu (Ed.), *Ethics and Decision-Making for Sustainable Business Practices* (pp. 90–108). Hershey, PA: IGI Global. doi:10.4018/978-1-5225-3773-1.ch006

Averweg, U. R., & Leaning, M. (2018). The Qualities and Potential of Social Media. In M. Khosrow-Pour, D.B.A. (Ed.), Encyclopedia of Information Science and Technology, Fourth Edition (pp. 7106-7115). Hershey, PA: IGI Global. doi:10.4018/978-1-5225-2255-3.ch617

Azemi, Y., & Ozuem, W. (2016). Online Service Failure and Recovery Strategy: The Mediating Role of Social Media. In W. Ozuem & G. Bowen (Eds.), *Competitive Social Media Marketing Strategies* (pp. 112–135). Hershey, PA: IGI Global. doi:10.4018/978-1-4666-9776-8.ch006

Baarda, R. (2017). Digital Democracy in Authoritarian Russia: Opportunity for Participation, or Site of Kremlin Control? In R. Luppicini & R. Baarda (Eds.), *Digital Media Integration for Participatory Democracy* (pp. 87–100). Hershey, PA: IGI Global. doi:10.4018/978-1-5225-2463-2.ch005

Bacallao-Pino, L. M. (2016). Radical Political Communication and Social Media: The Case of the Mexican #YoSoy132. In T. Deželan & I. Vobič (Eds.), *R)evolutionizing Political Communication through Social Media* (pp. 56–74). Hershey, PA: IGI Global. doi:10.4018/978-1-4666-9879-6.ch004

Baggio, B. G. (2016). Why We Would Rather Text than Talk: Personality, Identity, and Anonymity in Modern Virtual Environments. In B. Baggio (Ed.), *Analyzing Digital Discourse and Human Behavior in Modern Virtual Environments* (pp. 110–125). Hershey, PA: IGI Global. doi:10.4018/978-1-4666-9899-4.ch006

Başal, B. (2017). Actor Effect: A Study on Historical Figures Who Have Shaped the Advertising Narration. In R. Yılmaz (Ed.), *Narrative Advertising Models and Conceptualization in the Digital Age* (pp. 34–60). Hershey, PA: IGI Global. doi:10.4018/978-1-5225-2373-4.ch003

Behjati, M., & Cosmas, J. (2017). Self-Organizing Network Solutions: A Principal Step Towards Real 4G and Beyond. In D. Singh (Ed.), *Routing Protocols and Architectural Solutions for Optimal Wireless Networks and Security* (pp. 241–253). Hershey, PA: IGI Global. doi:10.4018/978-1-5225-2342-0.ch011

Bekafigo, M., & Pingley, A. C. (2017). Do Campaigns "Go Negative" on Twitter? In Y. Ibrahim (Ed.), *Politics, Protest, and Empowerment in Digital Spaces* (pp. 178–191). Hershey, PA: IGI Global. doi:10.4018/978-1-5225-1862-4.ch011

Bender, S., & Dickenson, P. (2016). Utilizing Social Media to Engage Students in Online Learning: Building Relationships Outside of the Learning Management System. In P. Dickenson & J. Jaurez (Eds.), *Increasing Productivity and Efficiency in Online Teaching* (pp. 84–105). Hershey, PA: IGI Global. doi:10.4018/978-1-5225-0347-7.ch005

Bermingham, N., & Prendergast, M. (2016). Bespoke Mobile Application Development: Facilitating Transition of Foundation Students to Higher Education. In L. Briz-Ponce, J. Juanes-Méndez, & F. García-Peñalvo (Eds.), *Handbook of Research on Mobile Devices and Applications in Higher Education Settings* (pp. 222–249). Hershey, PA: IGI Global. doi:10.4018/978-1-5225-0256-2.ch010

Bishop, J. (2017). Developing and Validating the "This Is Why We Can't Have Nice Things Scale": Optimising Political Online Communities for Internet Trolling. In Y. Ibrahim (Ed.), *Politics, Protest, and Empowerment in Digital Spaces* (pp. 153–177). Hershey, PA: IGI Global. doi:10.4018/978-1-5225-1862-4.ch010

Bolat, N. (2017). The Functions of the Narrator in Digital Advertising. In R. Yılmaz (Ed.), *Narrative Advertising Models and Conceptualization in the Digital Age* (pp. 184–201). Hershey, PA: IGI Global. doi:10.4018/978-1-5225-2373-4.ch011

Bowen, G., & Bowen, D. (2016). Social Media: Strategic Decision Making Tool. In W. Ozuem & G. Bowen (Eds.), *Competitive Social Media Marketing Strategies* (pp. 94–111). Hershey, PA: IGI Global. doi:10.4018/978-1-4666-9776-8.ch005

Brown, M. A. Sr. (2017). SNIP: High Touch Approach to Communication. In *Solutions for High-Touch Communications in a High-Tech World* (pp. 71–88). Hershey, PA: IGI Global. doi:10.4018/978-1-5225-1897-6.ch004

Brown, M. A. Sr. (2017). Comparing FTF and Online Communication Knowledge. In *Solutions for High-Touch Communications in a High-Tech World* (pp. 103–113). Hershey, PA: IGI Global. doi:10.4018/978-1-5225-1897-6.ch006

Brown, M. A. Sr. (2017). Where Do We Go from Here? In *Solutions for High-Touch Communications in a High-Tech World* (pp. 137–159). Hershey, PA: IGI Global. doi:10.4018/978-1-5225-1897-6.ch008

Brown, M. A. Sr. (2017). Bridging the Communication Gap. In *Solutions for High-Touch Communications in a High-Tech World* (pp. 1–22). Hershey, PA: IGI Global. doi:10.4018/978-1-5225-1897-6.ch001

Brown, M. A. Sr. (2017). Key Strategies for Communication. In *Solutions for High-Touch Communications in a High-Tech World* (pp. 179–202). Hershey, PA: IGI Global. doi:10.4018/978-1-5225-1897-6.ch010

Bryant, K. N. (2017). WordUp!: Student Responses to Social Media in the Technical Writing Classroom. In K. Bryant (Ed.), *Engaging 21st Century Writers with Social Media* (pp. 231–245). Hershey, PA: IGI Global. doi:10.4018/978-1-5225-0562-4.ch014

Buck, E. H. (2017). Slacktivism, Supervision, and #Selfies: Illuminating Social Media Composition through Reception Theory. In K. Bryant (Ed.), *Engaging 21st Century Writers with Social Media* (pp. 163–178). Hershey, PA: IGI Global. doi:10.4018/978-1-5225-0562-4.ch010

Bucur, B. (2016). Sociological School of Bucharest's Publications and the Romanian Political Propaganda in the Interwar Period. In A. Fox (Ed.), *Global Perspectives on Media Events in Contemporary Society* (pp. 106–120). Hershey, PA: IGI Global. doi:10.4018/978-1-4666-9967-0.ch008

Bull, R., & Pianosi, M. (2017). Social Media, Participation, and Citizenship: New Strategic Directions. In V. Benson, R. Tuninga, & G. Saridakis (Eds.), *Analyzing the Strategic Role of Social Networking in Firm Growth and Productivity* (pp. 76–94). Hershey, PA: IGI Global. doi:10.4018/978-1-5225-0559-4.ch005

Camillo, A. A., & Camillo, I. C. (2016). The Ethics of Strategic Managerial Communication in the Global Context. In A. Normore, L. Long, & M. Javidi (Eds.), *Handbook of Research on Effective Communication, Leadership, and Conflict Resolution* (pp. 566–590). Hershey, PA: IGI Global. doi:10.4018/978-1-4666-9970-0.ch030

Cassard, A., & Sloboda, B. W. (2016). Faculty Perception of Virtual 3-D Learning Environment to Assess Student Learning. In D. Choi, A. Dailey-Hebert, & J. Simmons Estes (Eds.), *Emerging Tools and Applications of Virtual Reality in Education* (pp. 48–74). Hershey, PA: IGI Global. doi:10.4018/978-1-4666-9837-6.ch003

Castellano, S., & Khelladi, I. (2017). Play It Like Beckham!: The Influence of Social Networks on E-Reputation – The Case of Sportspeople and Their Online Fan Base. In A. Mesquita (Ed.), *Research Paradigms and Contemporary Perspectives on Human-Technology Interaction* (pp. 43–61). Hershey, PA: IGI Global. doi:10.4018/978-1-5225-1868-6.ch003

Castellet, A. (2016). What If Devices Take Command: Content Innovation Perspectives for Smart Wearables in the Mobile Ecosystem. *International Journal of Handheld Computing Research*, 7(2), 16–33. doi:10.4018/IJHCR.2016040102

Chugh, R., & Joshi, M. (2017). Challenges of Knowledge Management amidst Rapidly Evolving Tools of Social Media. In R. Chugh (Ed.), *Harnessing Social Media as a Knowledge Management Tool* (pp. 299–314). Hershey, PA: IGI Global. doi:10.4018/978-1-5225-0495-5.ch014

Cockburn, T., & Smith, P. A. (2016). Leadership in the Digital Age: Rhythms and the Beat of Change. In A. Normore, L. Long, & M. Javidi (Eds.), *Handbook of Research on Effective Communication, Leadership, and Conflict Resolution* (pp. 1–20). Hershey, PA: IGI Global. doi:10.4018/978-1-4666-9970-0.ch001

Cole, A. W., & Salek, T. A. (2017). Adopting a Parasocial Connection to Overcome Professional Kakoethos in Online Health Information. In M. Folk & S. Apostel (Eds.), *Establishing and Evaluating Digital Ethos and Online Credibility* (pp. 104–120). Hershey, PA: IGI Global. doi:10.4018/978-1-5225-1072-7.ch006

Cossiavelou, V. (2017). ACTA as Media Gatekeeping Factor: The EU Role as Global Negotiator. *International Journal of Interdisciplinary Telecommunications and Networking*, *9*(1), 26–37. doi:10.4018/IJITN.2017010103

Costanza, F. (2017). Social Media Marketing and Value Co-Creation: A System Dynamics Approach. In S. Rozenes & Y. Cohen (Eds.), *Handbook of Research on Strategic Alliances and Value Co-Creation in the Service Industry* (pp. 205–230). Hershey, PA: IGI Global. doi:10.4018/978-1-5225-2084-9.ch011

Cross, D. E. (2016). Globalization and Media's Impact on Cross Cultural Communication: Managing Organizational Change. In A. Normore, L. Long, & M. Javidi (Eds.), *Handbook of Research on Effective Communication, Leadership, and Conflict Resolution* (pp. 21–41). Hershey, PA: IGI Global. doi:10.4018/978-1-4666-9970-0.ch002

Damásio, M. J., Henriques, S., Teixeira-Botelho, I., & Dias, P. (2016). Mobile Media and Social Interaction: Mobile Services and Content as Drivers of Social Interaction. In J. Aguado, C. Feijóo, & I. Martínez (Eds.), *Emerging Perspectives on the Mobile Content Evolution* (pp. 357–379). Hershey, PA: IGI Global. doi:10.4018/978-1-4666-8838-4.ch018

Davis, A., & Foley, L. (2016). Digital Storytelling. In B. Guzzetti & M. Lesley (Eds.), *Handbook of Research on the Societal Impact of Digital Media* (pp. 317–342). Hershey, PA: IGI Global. doi:10.4018/978-1-4666-8310-5.ch013

Davis, S., Palmer, L., & Etienne, J. (2016). The Geography of Digital Literacy: Mapping Communications Technology Training Programs in Austin, Texas. In B. Passarelli, J. Straubhaar, & A. Cuevas-Cerveró (Eds.), *Handbook of Research on Comparative Approaches to the Digital Age Revolution in Europe and the Americas* (pp. 371–384). Hershey, PA: IGI Global. doi:10.4018/978-1-4666-8740-0.ch022

Delello, J. A., & McWhorter, R. R. (2016). New Visual Literacies and Competencies for Education and the Workplace. In B. Guzzetti & M. Lesley (Eds.), *Handbook of Research on the Societal Impact of Digital Media* (pp. 127–162). Hershey, PA: IGI Global. doi:10.4018/978-1-4666-8310-5.ch006

Di Virgilio, F., & Antonelli, G. (2018). Consumer Behavior, Trust, and Electronic Word-of-Mouth Communication: Developing an Online Purchase Intention Model. In F. Di Virgilio (Ed.), *Social Media for Knowledge Management Applications in Modern Organizations* (pp. 58–80). Hershey, PA: IGI Global. doi:10.4018/978-1-5225-2897-5.ch003

Dixit, S. K. (2016). eWOM Marketing in Hospitality Industry. In A. Singh, & P. Duhan (Eds.), Managing Public Relations and Brand Image through Social Media (pp. 266-280). Hershey, PA: IGI Global. doi:10.4018/978-1-5225-0332-3.ch014

Duhan, P., & Singh, A. (2016). Facebook Experience Is Different: An Empirical Study in Indian Context. In S. Rathore & A. Panwar (Eds.), *Capturing, Analyzing, and Managing Word-of-Mouth in the Digital Marketplace* (pp. 188–212). Hershey, PA: IGI Global. doi:10.4018/978-1-4666-9449-1.ch011

Dunne, D. J. (2016). The Scholar's Ludo-Narrative Game and Multimodal Graphic Novel: A Comparison of Fringe Scholarship. In A. Connor & S. Marks (Eds.), *Creative Technologies for Multidisciplinary Applications* (pp. 182–207). Hershey, PA: IGI Global. doi:10.4018/978-1-5225-0016-2.ch008

DuQuette, J. L. (2017). Lessons from Cypris Chat: Revisiting Virtual Communities as Communities. In G. Panconesi & M. Guida (Eds.), *Handbook of Research on Collaborative Teaching Practice in Virtual Learning Environments* (pp. 299–316). Hershey, PA: IGI Global. doi:10.4018/978-1-5225-2426-7.ch016

Ekhlassi, A., Niknejhad Moghadam, M., & Adibi, A. (2018). The Concept of Social Media: The Functional Building Blocks. In *Building Brand Identity in the Age of Social Media: Emerging Research and Opportunities* (pp. 29–60). Hershey, PA: IGI Global. doi:10.4018/978-1-5225-5143-0.ch002

Ekhlassi, A., Niknejhad Moghadam, M., & Adibi, A. (2018). Social Media Branding Strategy: Social Media Marketing Approach. In *Building Brand Identity in the Age of Social Media: Emerging Research and Opportunities* (pp. 94–117). Hershey, PA: IGI Global. doi:10.4018/978-1-5225-5143-0.ch004

Ekhlassi, A., Niknejhad Moghadam, M., & Adibi, A. (2018). The Impact of Social Media on Brand Loyalty: Achieving "E-Trust" Through Engagement. In *Building Brand Identity in the Age of Social Media: Emerging Research and Opportunities* (pp. 155–168). Hershey, PA: IGI Global. doi:10.4018/978-1-5225-5143-0.ch007

Elegbe, O. (2017). An Assessment of Media Contribution to Behaviour Change and HIV Prevention in Nigeria. In O. Nelson, B. Ojebuyi, & A. Salawu (Eds.), *Impacts of the Media on African Socio-Economic Development* (pp. 261–280). Hershey, PA: IGI Global. doi:10.4018/978-1-5225-1859-4.ch017

Endong, F. P. (2018). Hashtag Activism and the Transnationalization of Nigerian-Born Movements Against Terrorism: A Critical Appraisal of the #BringBackOurGirls Campaign. In F. Endong (Ed.), *Exploring the Role of Social Media in Transnational Advocacy* (pp. 36–54). Hershey, PA: IGI Global. doi:10.4018/978-1-5225-2854-8.ch003

Erragcha, N. (2017). Using Social Media Tools in Marketing: Opportunities and Challenges. In M. Brown Sr., (Ed.), *Social Media Performance Evaluation and Success Measurements* (pp. 106–129). Hershey, PA: IGI Global. doi:10.4018/978-1-5225-1963-8.ch006

Ezeh, N. C. (2018). Media Campaign on Exclusive Breastfeeding: Awareness, Perception, and Acceptability Among Mothers in Anambra State, Nigeria. In A. Salawu & T. Owolabi (Eds.), *Exploring Journalism Practice and Perception in Developing Countries* (pp. 172–193). Hershey, PA: IGI Global. doi:10.4018/978-1-5225-3376-4.ch009

Fawole, O. A., & Osho, O. A. (2017). Influence of Social Media on Dating Relationships of Emerging Adults in Nigerian Universities: Social Media and Dating in Nigeria. In M. Wright (Ed.), *Identity, Sexuality, and Relationships among Emerging Adults in the Digital Age* (pp. 168–177). Hershey, PA: IGI Global. doi:10.4018/978-1-5225-1856-3.ch011

Fayoyin, A. (2017). Electoral Polling and Reporting in Africa: Professional and Policy Implications for Media Practice and Political Communication in a Digital Age. In N. Mhiripiri & T. Chari (Eds.), *Media Law, Ethics, and Policy in the Digital Age* (pp. 164–181). Hershey, PA: IGI Global. doi:10.4018/978-1-5225-2095-5.ch009

Fayoyin, A. (2018). Rethinking Media Engagement Strategies for Social Change in Africa: Context, Approaches, and Implications for Development Communication. In A. Salawu & T. Owolabi (Eds.), *Exploring Journalism Practice and Perception in Developing Countries* (pp. 257–280). Hershey, PA: IGI Global. doi:10.4018/978-1-5225-3376-4.ch013

Fechine, Y., & Rêgo, S. C. (2018). Transmedia Television Journalism in Brazil: Jornal da Record News as Reference. In R. Gambarato & G. Alzamora (Eds.), *Exploring Transmedia Journalism in the Digital Age* (pp. 253–265). Hershey, PA: IGI Global. doi:10.4018/978-1-5225-3781-6.ch015

Feng, J., & Lo, K. (2016). Video Broadcasting Protocol for Streaming Applications with Cooperative Clients. In D. Kanellopoulos (Ed.), *Emerging Research on Networked Multimedia Communication Systems* (pp. 205–229). Hershey, PA: IGI Global. doi:10.4018/978-1-4666-8850-6.ch006

Fiore, C. (2017). The Blogging Method: Improving Traditional Student Writing Practices. In K. Bryant (Ed.), *Engaging 21st Century Writers with Social Media* (pp. 179–198). Hershey, PA: IGI Global. doi:10.4018/978-1-5225-0562-4.ch011

Fleming, J., & Kajimoto, M. (2016). The Freedom of Critical Thinking: Examining Efforts to Teach American News Literacy Principles in Hong Kong, Vietnam, and Malaysia. In M. Yildiz & J. Keengwe (Eds.), *Handbook of Research on Media Literacy in the Digital Age* (pp. 208–235). Hershey, PA: IGI Global. doi:10.4018/978-1-4666-9667-9.ch010

Gambarato, R. R., Alzamora, G. C., & Tárcia, L. P. (2018). 2016 Rio Summer Olympics and the Transmedia Journalism of Planned Events. In R. Gambarato & G. Alzamora (Eds.), *Exploring Transmedia Journalism in the Digital Age* (pp. 126–146). Hershey, PA: IGI Global. doi:10.4018/978-1-5225-3781-6.ch008

Ganguin, S., Gemkow, J., & Haubold, R. (2017). Information Overload as a Challenge and Changing Point for Educational Media Literacies. In R. Marques & J. Batista (Eds.), *Information and Communication Overload in the Digital Age* (pp. 302–328). Hershey, PA: IGI Global. doi:10.4018/978-1-5225-2061-0.ch013

Gao, Y. (2016). Reviewing Gratification Effects in Mobile Gaming. In X. Xu (Ed.), *Handbook of Research on Human Social Interaction in the Age of Mobile Devices* (pp. 406–428). Hershey, PA: IGI Global. doi:10.4018/978-1-5225-0469-6.ch017

Gardner, G. C. (2017). The Lived Experience of Smartphone Use in a Unit of the United States Army. In F. Topor (Ed.), *Handbook of Research on Individualism and Identity in the Globalized Digital Age* (pp. 88–117). Hershey, PA: IGI Global. doi:10.4018/978-1-5225-0522-8.ch005

Giessen, H. W. (2016). The Medium, the Content, and the Performance: An Overview on Media-Based Learning. In B. Khan (Ed.), *Revolutionizing Modern Education through Meaningful E-Learning Implementation* (pp. 42–55). Hershey, PA: IGI Global. doi:10.4018/978-1-5225-0466-5.ch003

Giltenane, J. (2016). Investigating the Intention to Use Social Media Tools Within Virtual Project Teams. In G. Silvius (Ed.), *Strategic Integration of Social Media into Project Management Practice* (pp. 83–105). Hershey, PA: IGI Global. doi:10.4018/978-1-4666-9867-3.ch006

Golightly, D., & Houghton, R. J. (2018). Social Media as a Tool to Understand Behaviour on the Railways. In S. Kohli, A. Kumar, J. Easton, & C. Roberts (Eds.), *Innovative Applications of Big Data in the Railway Industry* (pp. 224–239). Hershey, PA: IGI Global. doi:10.4018/978-1-5225-3176-0.ch010

Goovaerts, M., Nieuwenhuysen, P., & Dhamdhere, S. N. (2016). VLIR-UOS Workshop 'E-Info Discovery and Management for Institutes in the South': Presentations and Conclusions, Antwerp, 8-19 December, 2014. In E. de Smet, & S. Dhamdhere (Eds.), E-Discovery Tools and Applications in Modern Libraries (pp. 1-40). Hershey, PA: IGI Global. doi:10.4018/978-1-5225-0474-0.ch001

Grützmann, A., Carvalho de Castro, C., Meireles, A. A., & Rodrigues, R. C. (2016). Organizational Architecture and Online Social Networks: Insights from Innovative Brazilian Companies. In G. Jamil, J. Poças Rascão, F. Ribeiro, & A. Malheiro da Silva (Eds.), *Handbook of Research on Information Architecture and Management in Modern Organizations* (pp. 508–524). Hershey, PA: IGI Global. doi:10.4018/978-1-4666-8637-3.ch023

Gundogan, M. B. (2017). In Search for a "Good Fit" Between Augmented Reality and Mobile Learning Ecosystem. In G. Kurubacak & H. Altinpulluk (Eds.), *Mobile Technologies and Augmented Reality in Open Education* (pp. 135–153). Hershey, PA: IGI Global. doi:10.4018/978-1-5225-2110-5.ch007

Gupta, H. (2018). Impact of Digital Communication on Consumer Behaviour Processes in Luxury Branding Segment: A Study of Apparel Industry. In S. Dasgupta, S. Biswal, & M. Ramesh (Eds.), *Holistic Approaches to Brand Culture and Communication Across Industries* (pp. 132–157). Hershey, PA: IGI Global. doi:10.4018/978-1-5225-3150-0.ch008

Hai-Jew, S. (2017). Creating "(Social) Network Art" with NodeXL. In S. Hai-Jew (Ed.), *Social Media Data Extraction and Content Analysis* (pp. 342–393). Hershey, PA: IGI Global. doi:10.4018/978-1-5225-0648-5.ch011

Hai-Jew, S. (2017). Employing the Sentiment Analysis Tool in NVivo 11 Plus on Social Media Data: Eight Initial Case Types. In N. Rao (Ed.), *Social Media Listening and Monitoring for Business Applications* (pp. 175–244). Hershey, PA: IGI Global. doi:10.4018/978-1-5225-0846-5.ch010

Hai-Jew, S. (2017). Conducting Sentiment Analysis and Post-Sentiment Data Exploration through Automated Means. In S. Hai-Jew (Ed.), *Social Media Data Extraction and Content Analysis* (pp. 202–240). Hershey, PA: IGI Global. doi:10.4018/978-1-5225-0648-5.ch008

Hai-Jew, S. (2017). Applied Analytical "Distant Reading" using NVivo 11 Plus. In S. Hai-Jew (Ed.), *Social Media Data Extraction and Content Analysis* (pp. 159–201). Hershey, PA: IGI Global. doi:10.4018/978-1-5225-0648-5.ch007

Hai-Jew, S. (2017). Flickering Emotions: Feeling-Based Associations from Related Tags Networks on Flickr. In S. Hai-Jew (Ed.), *Social Media Data Extraction and Content Analysis* (pp. 296–341). Hershey, PA: IGI Global. doi:10.4018/978-1-5225-0648-5.ch010

Hai-Jew, S. (2017). Manually Profiling Egos and Entities across Social Media Platforms: Evaluating Shared Messaging and Contents, User Networks, and Metadata. In V. Benson, R. Tuninga, & G. Saridakis (Eds.), *Analyzing the Strategic Role of Social Networking in Firm Growth and Productivity* (pp. 352–405). Hershey, PA: IGI Global. doi:10.4018/978-1-5225-0559-4.ch019

Hai-Jew, S. (2017). Exploring "User," "Video," and (Pseudo) Multi-Mode Networks on YouTube with NodeXL. In S. Hai-Jew (Ed.), *Social Media Data Extraction and Content Analysis* (pp. 242–295). Hershey, PA: IGI Global. doi:10.4018/978-1-5225-0648-5.ch009

Hai-Jew, S. (2018). Exploring "Mass Surveillance" Through Computational Linguistic Analysis of Five Text Corpora: Academic, Mainstream Journalism, Microblogging Hashtag Conversation, Wikipedia Articles, and Leaked Government Data. In *Techniques for Coding Imagery and Multimedia: Emerging Research and Opportunities* (pp. 212–286). Hershey, PA: IGI Global. doi:10.4018/978-1-5225-2679-7.ch004

Hai-Jew, S. (2018). Exploring Identity-Based Humor in a #Selfies #Humor Image Set From Instagram. In *Techniques for Coding Imagery and Multimedia: Emerging Research and Opportunities* (pp. 1–90). Hershey, PA: IGI Global. doi:10.4018/978-1-5225-2679-7.ch001

Hai-Jew, S. (2018). See Ya!: Exploring American Renunciation of Citizenship Through Targeted and Sparse Social Media Data Sets and a Custom Spatial-Based Linguistic Analysis Dictionary. In *Techniques for Coding Imagery and Multimedia: Emerging Research and Opportunities* (pp. 287–393). Hershey, PA: IGI Global. doi:10.4018/978-1-5225-2679-7.ch005

Han, H. S., Zhang, J., Peikazadi, N., Shi, G., Hung, A., Doan, C. P., & Filippelli, S. (2016). An Entertaining Game-Like Learning Environment in a Virtual World for Education. In S. D'Agustino (Ed.), *Creating Teacher Immediacy in Online Learning Environments* (pp. 290–306). Hershey, PA: IGI Global. doi:10.4018/978-1-4666-9995-3.ch015

Harrin, E. (2016). Barriers to Social Media Adoption on Projects. In G. Silvius (Ed.), *Strategic Integration of Social Media into Project Management Practice* (pp. 106–124). Hershey, PA: IGI Global. doi:10.4018/978-1-4666-9867-3.ch007

Harvey, K. E. (2016). Local News and Mobile: Major Tipping Points. In X. Xu (Ed.), *Handbook of Research on Human Social Interaction in the Age of Mobile Devices* (pp. 171–199). Hershey, PA: IGI Global. doi:10.4018/978-1-5225-0469-6.ch009

Harvey, K. E., & An, Y. (2016). Marketing and Mobile: Increasing Integration. In X. Xu (Ed.), *Handbook of Research on Human Social Interaction in the Age of Mobile Devices* (pp. 220–247). Hershey, PA: IGI Global. doi:10.4018/978-1-5225-0469-6.ch011

Harvey, K. E., Auter, P. J., & Stevens, S. (2016). Educators and Mobile: Challenges and Trends. In X. Xu (Ed.), *Handbook of Research on Human Social Interaction in the Age of Mobile Devices* (pp. 61–95). Hershey, PA: IGI Global. doi:10.4018/978-1-5225-0469-6.ch004

Hasan, H., & Linger, H. (2017). Connected Living for Positive Ageing. In S. Gordon (Ed.), *Online Communities as Agents of Change and Social Movements* (pp. 203–223). Hershey, PA: IGI Global. doi:10.4018/978-1-5225-2495-3.ch008

Hashim, K., Al Sharqi, L., & Kutbi, I. (2016). Perceptions of Social Media Impact on Social Behavior of Students: A Comparison between Students and Faculty. *International Journal of Virtual Communities and Social Networking, 8*(2), 1–11. doi:10.4018/IJVCSN.2016040101

Henriques, S., & Damasio, M. J. (2016). The Value of Mobile Communication for Social Belonging: Mobile Apps and the Impact on Social Interaction. *International Journal of Handheld Computing Research, 7*(2), 44–58. doi:10.4018/IJHCR.2016040104

Hersey, L. N. (2017). CHOICES: Measuring Return on Investment in a Nonprofit Organization. In M. Brown Sr., (Ed.), *Social Media Performance Evaluation and Success Measurements* (pp. 157–179). Hershey, PA: IGI Global. doi:10.4018/978-1-5225-1963-8.ch008

Heuva, W. E. (2017). Deferring Citizens' "Right to Know" in an Information Age: The Information Deficit in Namibia. In N. Mhiripiri & T. Chari (Eds.), *Media Law, Ethics, and Policy in the Digital Age* (pp. 245–267). Hershey, PA: IGI Global. doi:10.4018/978-1-5225-2095-5.ch014

Hopwood, M., & McLean, H. (2017). Social Media in Crisis Communication: The Lance Armstrong Saga. In V. Benson, R. Tuninga, & G. Saridakis (Eds.), *Analyzing the Strategic Role of Social Networking in Firm Growth and Productivity* (pp. 45–58). Hershey, PA: IGI Global. doi:10.4018/978-1-5225-0559-4.ch003

Hotur, S. K. (2018). Indian Approaches to E-Diplomacy: An Overview. In S. Bute (Ed.), *Media Diplomacy and Its Evolving Role in the Current Geopolitical Climate* (pp. 27–35). Hershey, PA: IGI Global. doi:10.4018/978-1-5225-3859-2.ch002

Ibadildin, N., & Harvey, K. E. (2016). Business and Mobile: Rapid Restructure Required. In X. Xu (Ed.), *Handbook of Research on Human Social Interaction in the Age of Mobile Devices* (pp. 312–350). Hershey, PA: IGI Global. doi:10.4018/978-1-5225-0469-6.ch014

Iwasaki, Y. (2017). Youth Engagement in the Era of New Media. In M. Adria & Y. Mao (Eds.), *Handbook of Research on Citizen Engagement and Public Participation in the Era of New Media* (pp. 90–105). Hershey, PA: IGI Global. doi:10.4018/978-1-5225-1081-9.ch006

Jamieson, H. V. (2017). We have a Situation!: Cyberformance and Civic Engagement in Post-Democracy. In R. Shin (Ed.), *Convergence of Contemporary Art, Visual Culture, and Global Civic Engagement* (pp. 297–317). Hershey, PA: IGI Global. doi:10.4018/978-1-5225-1665-1.ch017

Jimoh, J., & Kayode, J. (2018). Imperative of Peace and Conflict-Sensitive Journalism in Development. In A. Salawu & T. Owolabi (Eds.), *Exploring Journalism Practice and Perception in Developing Countries* (pp. 150–171). Hershey, PA: IGI Global. doi:10.4018/978-1-5225-3376-4.ch008

Johns, R. (2016). Increasing Value of a Tangible Product through Intangible Attributes: Value Co-Creation and Brand Building within Online Communities – Virtual Communities and Value. In R. English & R. Johns (Eds.), *Gender Considerations in Online Consumption Behavior and Internet Use* (pp. 112–124). Hershey, PA: IGI Global. doi:10.4018/978-1-5225-0010-0.ch008

Kanellopoulos, D. N. (2018). Group Synchronization for Multimedia Systems. In M. Khosrow-Pour, D.B.A. (Ed.), Encyclopedia of Information Science and Technology, Fourth Edition (pp. 6435-6446). Hershey, PA: IGI Global. doi:10.4018/978-1-5225-2255-3.ch559

Kapepo, M. I., & Mayisela, T. (2017). Integrating Digital Literacies Into an Undergraduate Course: Inclusiveness Through Use of ICTs. In C. Ayo & V. Mbarika (Eds.), *Sustainable ICT Adoption and Integration for Socio-Economic Development* (pp. 152–173). Hershey, PA: IGI Global. doi:10.4018/978-1-5225-2565-3.ch007

Karahoca, A., & Yengin, İ. (2018). Understanding the Potentials of Social Media in Collaborative Learning. In M. Khosrow-Pour, D.B.A. (Ed.), Encyclopedia of Information Science and Technology, Fourth Edition (pp. 7168-7180). Hershey, PA: IGI Global. doi:10.4018/978-1-5225-2255-3.ch623

Karataş, S., Ceran, O., Ülker, Ü., Gün, E. T., Köse, N. Ö., Kılıç, M., ... Tok, Z. A. (2016). A Trend Analysis of Mobile Learning. In D. Parsons (Ed.), *Mobile and Blended Learning Innovations for Improved Learning Outcomes* (pp. 248–276). Hershey, PA: IGI Global. doi:10.4018/978-1-5225-0359-0.ch013

Kasemsap, K. (2016). Role of Social Media in Brand Promotion: An International Marketing Perspective. In A. Singh & P. Duhan (Eds.), *Managing Public Relations and Brand Image through Social Media* (pp. 62–88). Hershey, PA: IGI Global. doi:10.4018/978-1-5225-0332-3.ch005

Kasemsap, K. (2016). The Roles of Social Media Marketing and Brand Management in Global Marketing. In W. Ozuem & G. Bowen (Eds.), *Competitive Social Media Marketing Strategies* (pp. 173–200). Hershey, PA: IGI Global. doi:10.4018/978-1-4666-9776-8.ch009

Kasemsap, K. (2017). Professional and Business Applications of Social Media Platforms. In V. Benson, R. Tuninga, & G. Saridakis (Eds.), *Analyzing the Strategic Role of Social Networking in Firm Growth and Productivity* (pp. 427–450). Hershey, PA: IGI Global. doi:10.4018/978-1-5225-0559-4.ch021

Kasemsap, K. (2017). Mastering Social Media in the Modern Business World. In N. Rao (Ed.), *Social Media Listening and Monitoring for Business Applications* (pp. 18–44). Hershey, PA: IGI Global. doi:10.4018/978-1-5225-0846-5.ch002

Kato, Y., & Kato, S. (2016). Mobile Phone Use during Class at a Japanese Women's College. In M. Yildiz & J. Keengwe (Eds.), *Handbook of Research on Media Literacy in the Digital Age* (pp. 436–455). Hershey, PA: IGI Global. doi:10.4018/978-1-4666-9667-9.ch021

Kaufmann, H. R., & Manarioti, A. (2017). Consumer Engagement in Social Media Platforms. In *Encouraging Participative Consumerism Through Evolutionary Digital Marketing: Emerging Research and Opportunities* (pp. 95–123). Hershey, PA: IGI Global. doi:10.4018/978-1-68318-012-8.ch004

Kavoura, A., & Kefallonitis, E. (2018). The Effect of Social Media Networking in the Travel Industry. In M. Khosrow-Pour, D.B.A. (Ed.), Encyclopedia of Information Science and Technology, Fourth Edition (pp. 4052-4063). Hershey, PA: IGI Global. doi:10.4018/978-1-5225-2255-3.ch351

Kawamura, Y. (2018). Practice and Modeling of Advertising Communication Strategy: Sender-Driven and Receiver-Driven. In T. Ogata & S. Asakawa (Eds.), *Content Generation Through Narrative Communication and Simulation* (pp. 358–379). Hershey, PA: IGI Global. doi:10.4018/978-1-5225-4775-4.ch013

Kell, C., & Czerniewicz, L. (2017). Visibility of Scholarly Research and Changing Research Communication Practices: A Case Study from Namibia. In A. Esposito (Ed.), *Research 2.0 and the Impact of Digital Technologies on Scholarly Inquiry* (pp. 97–116). Hershey, PA: IGI Global. doi:10.4018/978-1-5225-0830-4.ch006

Khalil, G. E. (2016). Change through Experience: How Experiential Play and Emotional Engagement Drive Health Game Success. In D. Novák, B. Tulu, & H. Brendryen (Eds.), *Handbook of Research on Holistic Perspectives in Gamification for Clinical Practice* (pp. 10–34). Hershey, PA: IGI Global. doi:10.4018/978-1-4666-9522-1.ch002

Kılınç, U. (2017). Create It! Extend It!: Evolution of Comics Through Narrative Advertising. In R. Yılmaz (Ed.), *Narrative Advertising Models and Conceptualization in the Digital Age* (pp. 117–132). Hershey, PA: IGI Global. doi:10.4018/978-1-5225-2373-4.ch007

Kim, J. H. (2016). Pedagogical Approaches to Media Literacy Education in the United States. In M. Yildiz & J. Keengwe (Eds.), *Handbook of Research on Media Literacy in the Digital Age* (pp. 53–74). Hershey, PA: IGI Global. doi:10.4018/978-1-4666-9667-9.ch003

Kirigha, J. M., Mukhongo, L. L., & Masinde, R. (2016). Beyond Web 2.0. Social Media and Urban Educated Youths Participation in Kenyan Politics. In L. Mukhongo & J. Macharia (Eds.), *Political Influence of the Media in Developing Countries* (pp. 156–174). Hershey, PA: IGI Global. doi:10.4018/978-1-4666-9613-6.ch010

Krochmal, M. M. (2016). Training for Mobile Journalism. In D. Mentor (Ed.), *Handbook of Research on Mobile Learning in Contemporary Classrooms* (pp. 336–362). Hershey, PA: IGI Global. doi:10.4018/978-1-5225-0251-7.ch017

Kumar, P., & Sinha, A. (2018). Business-Oriented Analytics With Social Network of Things. In H. Bansal, G. Shrivastava, G. Nguyen, & L. Stanciu (Eds.), *Social Network Analytics for Contemporary Business Organizations* (pp. 166–187). Hershey, PA: IGI Global. doi:10.4018/978-1-5225-5097-6.ch009

Kunock, A. I. (2017). Boko Haram Insurgency in Cameroon: Role of Mass Media in Conflict Management. In N. Mhiripiri & T. Chari (Eds.), *Media Law, Ethics, and Policy in the Digital Age* (pp. 226–244). Hershey, PA: IGI Global. doi:10.4018/978-1-5225-2095-5.ch013

Labadie, J. A. (2018). Digitally Mediated Art Inspired by Technology Integration: A Personal Journey. In A. Ursyn (Ed.), *Visual Approaches to Cognitive Education With Technology Integration* (pp. 121–162). Hershey, PA: IGI Global. doi:10.4018/978-1-5225-5332-8.ch008

Lefkowith, S. (2017). Credibility and Crisis in Pseudonymous Communities. In M. Folk & S. Apostel (Eds.), *Establishing and Evaluating Digital Ethos and Online Credibility* (pp. 190–236). Hershey, PA: IGI Global. doi:10.4018/978-1-5225-1072-7.ch010

Lemoine, P. A., Hackett, P. T., & Richardson, M. D. (2016). The Impact of Social Media on Instruction in Higher Education. In L. Briz-Ponce, J. Juanes-Méndez, & F. García-Peñalvo (Eds.), *Handbook of Research on Mobile Devices and Applications in Higher Education Settings* (pp. 373–401). Hershey, PA: IGI Global. doi:10.4018/978-1-5225-0256-2.ch016

Liampotis, N., Papadopoulou, E., Kalatzis, N., Roussaki, I. G., Kosmides, P., Sykas, E. D., ... Taylor, N. K. (2016). Tailoring Privacy-Aware Trustworthy Cooperating Smart Spaces for University Environments. In A. Panagopoulos (Ed.), *Handbook of Research on Next Generation Mobile Communication Systems* (pp. 410–439). Hershey, PA: IGI Global. doi:10.4018/978-1-4666-8732-5.ch016

Luppicini, R. (2017). Technoethics and Digital Democracy for Future Citizens. In R. Luppicini & R. Baarda (Eds.), *Digital Media Integration for Participatory Democracy* (pp. 1–21). Hershey, PA: IGI Global. doi:10.4018/978-1-5225-2463-2.ch001

Mahajan, I. M., Rather, M., Shafiq, H., & Qadri, U. (2016). Media Literacy Organizations. In M. Yildiz & J. Keengwe (Eds.), *Handbook of Research on Media Literacy in the Digital Age* (pp. 236–248). Hershey, PA: IGI Global. doi:10.4018/978-1-4666-9667-9.ch011

Maher, D. (2018). Supporting Pre-Service Teachers' Understanding and Use of Mobile Devices. In J. Keengwe (Ed.), *Handbook of Research on Mobile Technology, Constructivism, and Meaningful Learning* (pp. 160–177). Hershey, PA: IGI Global. doi:10.4018/978-1-5225-3949-0.ch009

Makhwanya, A. (2018). Barriers to Social Media Advocacy: Lessons Learnt From the Project "Tell Them We Are From Here". In F. Endong (Ed.), *Exploring the Role of Social Media in Transnational Advocacy* (pp. 55–72). Hershey, PA: IGI Global. doi:10.4018/978-1-5225-2854-8.ch004

Manli, G., & Rezaei, S. (2017). Value and Risk: Dual Pillars of Apps Usefulness. In S. Rezaei (Ed.), *Apps Management and E-Commerce Transactions in Real-Time* (pp. 274–292). Hershey, PA: IGI Global. doi:10.4018/978-1-5225-2449-6.ch013

Manrique, C. G., & Manrique, G. G. (2017). Social Media's Role in Alleviating Political Corruption and Scandals: The Philippines during and after the Marcos Regime. In K. Demirhan & D. Çakır-Demirhan (Eds.), *Political Scandal, Corruption, and Legitimacy in the Age of Social Media* (pp. 205–222). Hershey, PA: IGI Global. doi:10.4018/978-1-5225-2019-1.ch009

Manzoor, A. (2016). Cultural Barriers to Organizational Social Media Adoption. In A. Goel & P. Singhal (Eds.), *Product Innovation through Knowledge Management and Social Media Strategies* (pp. 31–45). Hershey, PA: IGI Global. doi:10.4018/978-1-4666-9607-5.ch002

Manzoor, A. (2016). Social Media for Project Management. In G. Silvius (Ed.), *Strategic Integration of Social Media into Project Management Practice* (pp. 51–65). Hershey, PA: IGI Global. doi:10.4018/978-1-4666-9867-3.ch004

Marovitz, M. (2017). Social Networking Engagement and Crisis Communication Considerations. In M. Brown Sr., (Ed.), *Social Media Performance Evaluation and Success Measurements* (pp. 130–155). Hershey, PA: IGI Global. doi:10.4018/978-1-5225-1963-8.ch007

Mathur, D., & Mathur, D. (2016). Word of Mouth on Social Media: A Potent Tool for Brand Building. In S. Rathore & A. Panwar (Eds.), *Capturing, Analyzing, and Managing Word-of-Mouth in the Digital Marketplace* (pp. 45–60). Hershey, PA: IGI Global. doi:10.4018/978-1-4666-9449-1.ch003

Maulana, I. (2018). Spontaneous Taking and Posting Selfie: Reclaiming the Lost Trust. In S. Hai-Jew (Ed.), *Selfies as a Mode of Social Media and Work Space Research* (pp. 28–50). Hershey, PA: IGI Global. doi:10.4018/978-1-5225-3373-3.ch002

Mayo, S. (2018). A Collective Consciousness Model in a Post-Media Society. In M. Khosrow-Pour (Ed.), *Enhancing Art, Culture, and Design With Technological Integration* (pp. 25–49). Hershey, PA: IGI Global. doi:10.4018/978-1-5225-5023-5.ch002

Mazur, E., Signorella, M. L., & Hough, M. (2018). The Internet Behavior of Older Adults. In M. Khosrow-Pour, D.B.A. (Ed.), Encyclopedia of Information Science and Technology, Fourth Edition (pp. 7026-7035). Hershey, PA: IGI Global. doi:10.4018/978-1-5225-2255-3.ch609

McGuire, M. (2017). Reblogging as Writing: The Role of Tumblr in the Writing Classroom. In K. Bryant (Ed.), *Engaging 21st Century Writers with Social Media* (pp. 116–131). Hershey, PA: IGI Global. doi:10.4018/978-1-5225-0562-4.ch007

McKee, J. (2018). Architecture as a Tool to Solve Business Planning Problems. In M. Khosrow-Pour, D.B.A. (Ed.), Encyclopedia of Information Science and Technology, Fourth Edition (pp. 573-586). Hershey, PA: IGI Global. doi:10.4018/978-1-5225-2255-3.ch050

McMahon, D. (2017). With a Little Help from My Friends: The Irish Radio Industry's Strategic Appropriation of Facebook for Commercial Growth. In V. Benson, R. Tuninga, & G. Saridakis (Eds.), *Analyzing the Strategic Role of Social Networking in Firm Growth and Productivity* (pp. 157–171). Hershey, PA: IGI Global. doi:10.4018/978-1-5225-0559-4.ch009

McPherson, M. J., & Lemon, N. (2017). The Hook, Woo, and Spin: Academics Creating Relations on Social Media. In A. Esposito (Ed.), *Research 2.0 and the Impact of Digital Technologies on Scholarly Inquiry* (pp. 167–187). Hershey, PA: IGI Global. doi:10.4018/978-1-5225-0830-4.ch009

Melro, A., & Oliveira, L. (2018). Screen Culture. In M. Khosrow-Pour, D.B.A. (Ed.), Encyclopedia of Information Science and Technology, Fourth Edition (pp. 4255-4266). Hershey, PA: IGI Global. doi:10.4018/978-1-5225-2255-3.ch369

Merwin, G. A. Jr, McDonald, J. S., Bennett, J. R. Jr, & Merwin, K. A. (2016). Social Media Applications Promote Constituent Involvement in Government Management. In G. Silvius (Ed.), *Strategic Integration of Social Media into Project Management Practice* (pp. 272–291). Hershey, PA: IGI Global. doi:10.4018/978-1-4666-9867-3.ch016

Mhiripiri, N. A., & Chikakano, J. (2017). Criminal Defamation, the Criminalisation of Expression, Media and Information Dissemination in the Digital Age: A Legal and Ethical Perspective. In N. Mhiripiri & T. Chari (Eds.), *Media Law, Ethics, and Policy in the Digital Age* (pp. 1–24). Hershey, PA: IGI Global. doi:10.4018/978-1-5225-2095-5.ch001

Miliopoulou, G., & Cossiavelou, V. (2016). Brands and Media Gatekeeping in the Social Media: Current Trends and Practices – An Exploratory Research. *International Journal of Interdisciplinary Telecommunications and Networking*, 8(4), 51–64. doi:10.4018/IJITN.2016100105

Miron, E., Palmor, A., Ravid, G., Sharon, A., Tikotsky, A., & Zirkel, Y. (2017). Principles and Good Practices for Using Wikis within Organizations. In R. Chugh (Ed.), *Harnessing Social Media as a Knowledge Management Tool* (pp. 143–176). Hershey, PA: IGI Global. doi:10.4018/978-1-5225-0495-5.ch008

Mishra, K. E., Mishra, A. K., & Walker, K. (2016). Leadership Communication, Internal Marketing, and Employee Engagement: A Recipe to Create Brand Ambassadors. In A. Normore, L. Long, & M. Javidi (Eds.), *Handbook of Research on Effective Communication, Leadership, and Conflict Resolution* (pp. 311–329). Hershey, PA: IGI Global. doi:10.4018/978-1-4666-9970-0.ch017

Moeller, C. L. (2018). Sharing Your Personal Medical Experience Online: Is It an Irresponsible Act or Patient Empowerment? In S. Sekalala & B. Niezgoda (Eds.), *Global Perspectives on Health Communication in the Age of Social Media* (pp. 185–209). Hershey, PA: IGI Global. doi:10.4018/978-1-5225-3716-8.ch007

Mosanako, S. (2017). Broadcasting Policy in Botswana: The Case of Botswana Television. In O. Nelson, B. Ojebuyi, & A. Salawu (Eds.), *Impacts of the Media on African Socio-Economic Development* (pp. 217–230). Hershey, PA: IGI Global. doi:10.4018/978-1-5225-1859-4.ch014

Nazari, A. (2016). Developing a Social Media Communication Plan. In G. Silvius (Ed.), *Strategic Integration of Social Media into Project Management Practice* (pp. 194–217). Hershey, PA: IGI Global. doi:10.4018/978-1-4666-9867-3.ch012

Neto, B. M. (2016). From Information Society to Community Service: The Birth of E-Citizenship. In B. Passarelli, J. Straubhaar, & A. Cuevas-Cerveró (Eds.), *Handbook of Research on Comparative Approaches to the Digital Age Revolution in Europe and the Americas* (pp. 101–123). Hershey, PA: IGI Global. doi:10.4018/978-1-4666-8740-0.ch007

Noguti, V., Singh, S., & Waller, D. S. (2016). Gender Differences in Motivations to Use Social Networking Sites. In R. English & R. Johns (Eds.), *Gender Considerations in Online Consumption Behavior and Internet Use* (pp. 32–49). Hershey, PA: IGI Global. doi:10.4018/978-1-5225-0010-0.ch003

Noor, R. (2017). Citizen Journalism: News Gathering by Amateurs. In M. Adria & Y. Mao (Eds.), *Handbook of Research on Citizen Engagement and Public Participation in the Era of New Media* (pp. 194–229). Hershey, PA: IGI Global. doi:10.4018/978-1-5225-1081-9.ch012

Nwagbara, U., Oruh, E. S., & Brown, C. (2016). State Fragility and Stakeholder Engagement: New Media and Stakeholders' Voice Amplification in the Nigerian Petroleum Industry. In W. Ozuem & G. Bowen (Eds.), *Competitive Social Media Marketing Strategies* (pp. 136–154). Hershey, PA: IGI Global. doi:10.4018/978-1-4666-9776-8.ch007

Obermayer, N., Csepregi, A., & Kővári, E. (2017). Knowledge Sharing Relation to Competence, Emotional Intelligence, and Social Media Regarding Generations. In A. Bencsik (Ed.), *Knowledge Management Initiatives and Strategies in Small and Medium Enterprises* (pp. 269–290). Hershey, PA: IGI Global. doi:10.4018/978-1-5225-1642-2.ch013

Obermayer, N., Gaál, Z., Szabó, L., & Csepregi, A. (2017). Leveraging Knowledge Sharing over Social Media Tools. In R. Chugh (Ed.), *Harnessing Social Media as a Knowledge Management Tool* (pp. 1–24). Hershey, PA: IGI Global. doi:10.4018/978-1-5225-0495-5.ch001

Ogwezzy-Ndisika, A. O., & Faustino, B. A. (2016). Gender Responsive Election Coverage in Nigeria: A Score Card of 2011 General Elections. In L. Mukhongo & J. Macharia (Eds.), *Political Influence of the Media in Developing Countries* (pp. 234–249). Hershey, PA: IGI Global. doi:10.4018/978-1-4666-9613-6.ch015

Okoroafor, O. E. (2018). New Media Technology and Development Journalism in Nigeria. In A. Salawu & T. Owolabi (Eds.), *Exploring Journalism Practice and Perception in Developing Countries* (pp. 105–125). Hershey, PA: IGI Global. doi:10.4018/978-1-5225-3376-4.ch006

Olaleye, S. A., Sanusi, I. T., & Ukpabi, D. C. (2018). Assessment of Mobile Money Enablers in Nigeria. In F. Mtenzi, G. Oreku, D. Lupiana, & J. Yonazi (Eds.), *Mobile Technologies and Socio-Economic Development in Emerging Nations* (pp. 129–155). Hershey, PA: IGI Global. doi:10.4018/978-1-5225-4029-8.ch007

Ozuem, W., Pinho, C. A., & Azemi, Y. (2016). User-Generated Content and Perceived Customer Value. In W. Ozuem & G. Bowen (Eds.), *Competitive Social Media Marketing Strategies* (pp. 50–63). Hershey, PA: IGI Global. doi:10.4018/978-1-4666-9776-8.ch003

Pacchiega, C. (2017). An Informal Methodology for Teaching Through Virtual Worlds: Using Internet Tools and Virtual Worlds in a Coordinated Pattern to Teach Various Subjects. In G. Panconesi & M. Guida (Eds.), *Handbook of Research on Collaborative Teaching Practice in Virtual Learning Environments* (pp. 163–180). Hershey, PA: IGI Global. doi:10.4018/978-1-5225-2426-7.ch009

Pase, A. F., Goss, B. M., & Tietzmann, R. (2018). A Matter of Time: Transmedia Journalism Challenges. In R. Gambarato & G. Alzamora (Eds.), *Exploring Transmedia Journalism in the Digital Age* (pp. 49–66). Hershey, PA: IGI Global. doi:10.4018/978-1-5225-3781-6.ch004

Passarelli, B., & Paletta, F. C. (2016). Living inside the NET: The Primacy of Interactions and Processes. In B. Passarelli, J. Straubhaar, & A. Cuevas-Cerveró (Eds.), *Handbook of Research on Comparative Approaches to the Digital Age Revolution in Europe and the Americas* (pp. 1–15). Hershey, PA: IGI Global. doi:10.4018/978-1-4666-8740-0.ch001

Patkin, T. T. (2017). Social Media and Knowledge Management in a Crisis Context: Barriers and Opportunities. In R. Chugh (Ed.), *Harnessing Social Media as a Knowledge Management Tool* (pp. 125–142). Hershey, PA: IGI Global. doi:10.4018/978-1-5225-0495-5.ch007

Pavlíček, A. (2017). Social Media and Creativity: How to Engage Users and Tourists. In A. Kiráľová (Ed.), *Driving Tourism through Creative Destinations and Activities* (pp. 181–202). Hershey, PA: IGI Global. doi:10.4018/978-1-5225-2016-0.ch009

Pillay, K., & Maharaj, M. (2017). The Business of Advocacy: A Case Study of Greenpeace. In V. Benson, R. Tuninga, & G. Saridakis (Eds.), *Analyzing the Strategic Role of Social Networking in Firm Growth and Productivity* (pp. 59–75). Hershey, PA: IGI Global. doi:10.4018/978-1-5225-0559-4.ch004

Piven, I. P., & Breazeale, M. (2017). Desperately Seeking Customer Engagement: The Five-Sources Model of Brand Value on Social Media. In V. Benson, R. Tuninga, & G. Saridakis (Eds.), *Analyzing the Strategic Role of Social Networking in Firm Growth and Productivity* (pp. 283–313). Hershey, PA: IGI Global. doi:10.4018/978-1-5225-0559-4.ch016

Pokharel, R. (2017). New Media and Technology: How Do They Change the Notions of the Rhetorical Situations? In B. Gurung & M. Limbu (Eds.), *Integration of Cloud Technologies in Digitally Networked Classrooms and Learning Communities* (pp. 120–148). Hershey, PA: IGI Global. doi:10.4018/978-1-5225-1650-7.ch008

Popoola, I. S. (2016). The Press and the Emergent Political Class in Nigeria: Media, Elections, and Democracy. In L. Mukhongo & J. Macharia (Eds.), *Political Influence of the Media in Developing Countries* (pp. 45–58). Hershey, PA: IGI Global. doi:10.4018/978-1-4666-9613-6.ch004

Porlezza, C., Benecchi, E., & Colapinto, C. (2018). The Transmedia Revitalization of Investigative Journalism: Opportunities and Challenges of the Serial Podcast. In R. Gambarato & G. Alzamora (Eds.), *Exploring Transmedia Journalism in the Digital Age* (pp. 183–201). Hershey, PA: IGI Global. doi:10.4018/978-1-5225-3781-6.ch011

Ramluckan, T., Ally, S. E., & van Niekerk, B. (2017). Twitter Use in Student Protests: The Case of South Africa's #FeesMustFall Campaign. In M. Korstanje (Ed.), *Threat Mitigation and Detection of Cyber Warfare and Terrorism Activities* (pp. 220–253). Hershey, PA: IGI Global. doi:10.4018/978-1-5225-1938-6.ch010

Rao, N. R. (2017). Social Media: An Enabler for Governance. In N. Rao (Ed.), *Social Media Listening and Monitoring for Business Applications* (pp. 151–164). Hershey, PA: IGI Global. doi:10.4018/978-1-5225-0846-5.ch008

Rathore, A. K., Tuli, N., & Ilavarasan, P. V. (2016). Pro-Business or Common Citizen?: An Analysis of an Indian Woman CEO's Tweets. *International Journal of Virtual Communities and Social Networking, 8*(1), 19–29. doi:10.4018/IJVCSN.2016010102

Redi, F. (2017). Enhancing Coopetition Among Small Tourism Destinations by Creativity. In A. Kiráľová (Ed.), *Driving Tourism through Creative Destinations and Activities* (pp. 223–244). Hershey, PA: IGI Global. doi:10.4018/978-1-5225-2016-0.ch011

Reeves, M. (2016). Social Media: It Can Play a Positive Role in Education. In R. English & R. Johns (Eds.), *Gender Considerations in Online Consumption Behavior and Internet Use* (pp. 82–95). Hershey, PA: IGI Global. doi:10.4018/978-1-5225-0010-0.ch006

Reis, Z. A. (2016). Bring the Media Literacy of Turkish Pre-Service Teachers to the Table. In M. Yildiz & J. Keengwe (Eds.), *Handbook of Research on Media Literacy in the Digital Age* (pp. 405–422). Hershey, PA: IGI Global. doi:10.4018/978-1-4666-9667-9.ch019

Resuloğlu, F., & Yılmaz, R. (2017). A Model for Interactive Advertising Narration. In R. Yılmaz (Ed.), *Narrative Advertising Models and Conceptualization in the Digital Age* (pp. 1–20). Hershey, PA: IGI Global. doi:10.4018/978-1-5225-2373-4.ch001

Ritzhaupt, A. D., Poling, N., Frey, C., Kang, Y., & Johnson, M. (2016). A Phenomenological Study of Games, Simulations, and Virtual Environments Courses: What Are We Teaching and How? *International Journal of Gaming and Computer-Mediated Simulations, 8*(3), 59–73. doi:10.4018/IJGCMS.2016070104

Ross, D. B., Eleno-Orama, M., & Salah, E. V. (2018). The Aging and Technological Society: Learning Our Way Through the Decades. In V. Bryan, A. Musgrove, & J. Powers (Eds.), *Handbook of Research on Human Development in the Digital Age* (pp. 205–234). Hershey, PA: IGI Global. doi:10.4018/978-1-5225-2838-8.ch010

Rusko, R., & Merenheimo, P. (2017). Co-Creating the Christmas Story: Digitalizing as a Shared Resource for a Shared Brand. In I. Oncioiu (Ed.), *Driving Innovation and Business Success in the Digital Economy* (pp. 137–157). Hershey, PA: IGI Global. doi:10.4018/978-1-5225-1779-5.ch010

Sabao, C., & Chikara, T. O. (2018). Social Media as Alternative Public Sphere for Citizen Participation and Protest in National Politics in Zimbabwe: The Case of #thisflag. In F. Endong (Ed.), *Exploring the Role of Social Media in Transnational Advocacy* (pp. 17–35). Hershey, PA: IGI Global. doi:10.4018/978-1-5225-2854-8.ch002

Samarthya-Howard, A., & Rogers, D. (2018). Scaling Mobile Technologies to Maximize Reach and Impact: Partnering With Mobile Network Operators and Governments. In S. Takavarasha Jr & C. Adams (Eds.), *Affordability Issues Surrounding the Use of ICT for Development and Poverty Reduction* (pp. 193–211). Hershey, PA: IGI Global. doi:10.4018/978-1-5225-3179-1.ch009

Sandoval-Almazan, R. (2017). Political Messaging in Digital Spaces: The Case of Twitter in Mexico's Presidential Campaign. In Y. Ibrahim (Ed.), *Politics, Protest, and Empowerment in Digital Spaces* (pp. 72–90). Hershey, PA: IGI Global. doi:10.4018/978-1-5225-1862-4.ch005

Schultz, C. D., & Dellnitz, A. (2018). Attribution Modeling in Online Advertising. In K. Yang (Ed.), *Multi-Platform Advertising Strategies in the Global Marketplace* (pp. 226–249). Hershey, PA: IGI Global. doi:10.4018/978-1-5225-3114-2.ch009

Schultz, C. D., & Holsing, C. (2018). Differences Across Device Usage in Search Engine Advertising. In K. Yang (Ed.), *Multi-Platform Advertising Strategies in the Global Marketplace* (pp. 250–279). Hershey, PA: IGI Global. doi:10.4018/978-1-5225-3114-2.ch010

Senadheera, V., Warren, M., Leitch, S., & Pye, G. (2017). Facebook Content Analysis: A Study into Australian Banks' Social Media Community Engagement. In S. Hai-Jew (Ed.), *Social Media Data Extraction and Content Analysis* (pp. 412–432). Hershey, PA: IGI Global. doi:10.4018/978-1-5225-0648-5.ch013

Sharma, A. R. (2018). Promoting Global Competencies in India: Media and Information Literacy as Stepping Stone. In M. Yildiz, S. Funk, & B. De Abreu (Eds.), *Promoting Global Competencies Through Media Literacy* (pp. 160–174). Hershey, PA: IGI Global. doi:10.4018/978-1-5225-3082-4.ch010

Sillah, A. (2017). Nonprofit Organizations and Social Media Use: An Analysis of Nonprofit Organizations' Effective Use of Social Media Tools. In M. Brown Sr., (Ed.), *Social Media Performance Evaluation and Success Measurements* (pp. 180–195). Hershey, PA: IGI Global. doi:10.4018/978-1-5225-1963-8.ch009

Škorić, M. (2017). Adaptation of Winlink 2000 Emergency Amateur Radio Email Network to a VHF Packet Radio Infrastructure. In A. El Oualkadi & J. Zbitou (Eds.), *Handbook of Research on Advanced Trends in Microwave and Communication Engineering* (pp. 498–528). Hershey, PA: IGI Global. doi:10.4018/978-1-5225-0773-4.ch016

Skubida, D. (2016). Can Some Computer Games Be a Sport?: Issues with Legitimization of eSport as a Sporting Activity. *International Journal of Gaming and Computer-Mediated Simulations*, 8(4), 38–52. doi:10.4018/IJGCMS.2016100103

Sonnenberg, C. (2016). Mobile Content Adaptation: An Analysis of Techniques and Frameworks. In J. Aguado, C. Feijóo, & I. Martínez (Eds.), *Emerging Perspectives on the Mobile Content Evolution* (pp. 177–199). Hershey, PA: IGI Global. doi:10.4018/978-1-4666-8838-4.ch010

Sonnevend, J. (2016). More Hope!: Ceremonial Media Events Are Still Powerful in the Twenty-First Century. In A. Fox (Ed.), *Global Perspectives on Media Events in Contemporary Society* (pp. 132–140). Hershey, PA: IGI Global. doi:10.4018/978-1-4666-9967-0.ch010

Sood, T. (2017). Services Marketing: A Sector of the Current Millennium. In T. Sood (Ed.), *Strategic Marketing Management and Tactics in the Service Industry* (pp. 15–42). Hershey, PA: IGI Global. doi:10.4018/978-1-5225-2475-5.ch002

Stairs, G. A. (2016). The Amplification of the Sunni-Shia Divide through Contemporary Communications Technology: Fear and Loathing in the Modern Middle East. In S. Gibson & A. Lando (Eds.), *Impact of Communication and the Media on Ethnic Conflict* (pp. 214–231). Hershey, PA: IGI Global. doi:10.4018/978-1-4666-9728-7.ch013

Stokinger, E., & Ozuem, W. (2016). The Intersection of Social Media and Customer Retention in the Luxury Beauty Industry. In W. Ozuem & G. Bowen (Eds.), *Competitive Social Media Marketing Strategies* (pp. 235–258). Hershey, PA: IGI Global. doi:10.4018/978-1-4666-9776-8.ch012

Sudarsanam, S. K. (2017). Social Media Metrics. In N. Rao (Ed.), *Social Media Listening and Monitoring for Business Applications* (pp. 131–149). Hershey, PA: IGI Global. doi:10.4018/978-1-5225-0846-5.ch007

Swiatek, L. (2017). Accessing the Finest Minds: Insights into Creativity from Esteemed Media Professionals. In N. Silton (Ed.), *Exploring the Benefits of Creativity in Education, Media, and the Arts* (pp. 240–263). Hershey, PA: IGI Global. doi:10.4018/978-1-5225-0504-4.ch012

Switzer, J. S., & Switzer, R. V. (2016). Virtual Teams: Profiles of Successful Leaders. In B. Baggio (Ed.), *Analyzing Digital Discourse and Human Behavior in Modern Virtual Environments* (pp. 1–24). Hershey, PA: IGI Global. doi:10.4018/978-1-4666-9899-4.ch001

Tabbane, R. S., & Debabi, M. (2016). Electronic Word of Mouth: Definitions and Concepts. In S. Rathore & A. Panwar (Eds.), *Capturing, Analyzing, and Managing Word-of-Mouth in the Digital Marketplace* (pp. 1–27). Hershey, PA: IGI Global. doi:10.4018/978-1-4666-9449-1.ch001

Tellería, A. S. (2016). The Role of the Profile and the Digital Identity on the Mobile Content. In J. Aguado, C. Feijóo, & I. Martínez (Eds.), *Emerging Perspectives on the Mobile Content Evolution* (pp. 263–282). Hershey, PA: IGI Global. doi:10.4018/978-1-4666-8838-4.ch014

Teurlings, J. (2017). What Critical Media Studies Should Not Take from Actor-Network Theory. In M. Spöhrer & B. Ochsner (Eds.), *Applying the Actor-Network Theory in Media Studies* (pp. 66–78). Hershey, PA: IGI Global. doi:10.4018/978-1-5225-0616-4.ch005

Tomé, V. (2018). Assessing Media Literacy in Teacher Education. In M. Yildiz, S. Funk, & B. De Abreu (Eds.), *Promoting Global Competencies Through Media Literacy* (pp. 1–19). Hershey, PA: IGI Global. doi:10.4018/978-1-5225-3082-4.ch001

Toscano, J. P. (2017). Social Media and Public Participation: Opportunities, Barriers, and a New Framework. In M. Adria & Y. Mao (Eds.), *Handbook of Research on Citizen Engagement and Public Participation in the Era of New Media* (pp. 73–89). Hershey, PA: IGI Global. doi:10.4018/978-1-5225-1081-9.ch005

Trauth, E. (2017). Creating Meaning for Millennials: Bakhtin, Rosenblatt, and the Use of Social Media in the Composition Classroom. In K. Bryant (Ed.), *Engaging 21st Century Writers with Social Media* (pp. 151–162). Hershey, PA: IGI Global. doi:10.4018/978-1-5225-0562-4.ch009

Ugangu, W. (2016). Kenya's Difficult Political Transitions Ethnicity and the Role of Media. In L. Mukhongo & J. Macharia (Eds.), *Political Influence of the Media in Developing Countries* (pp. 12–24). Hershey, PA: IGI Global. doi:10.4018/978-1-4666-9613-6.ch002

Uprety, S. (2018). Print Media's Role in Securitization: National Security and Diplomacy Discourses in Nepal. In S. Bute (Ed.), *Media Diplomacy and Its Evolving Role in the Current Geopolitical Climate* (pp. 56–82). Hershey, PA: IGI Global. doi:10.4018/978-1-5225-3859-2.ch004

Van der Merwe, L. (2016). Social Media Use within Project Teams: Practical Application of Social Media on Projects. In G. Silvius (Ed.), *Strategic Integration of Social Media into Project Management Practice* (pp. 139–159). Hershey, PA: IGI Global. doi:10.4018/978-1-4666-9867-3.ch009

van der Vyver, A. G. (2018). A Model for Economic Development With Telecentres and the Social Media: Overcoming Affordability Constraints. In S. Takavarasha Jr & C. Adams (Eds.), *Affordability Issues Surrounding the Use of ICT for Development and Poverty Reduction* (pp. 112–140). Hershey, PA: IGI Global. doi:10.4018/978-1-5225-3179-1.ch006

van Dokkum, E., & Ravesteijn, P. (2016). Managing Project Communication: Using Social Media for Communication in Projects. In G. Silvius (Ed.), *Strategic Integration of Social Media into Project Management Practice* (pp. 35–50). Hershey, PA: IGI Global. doi:10.4018/978-1-4666-9867-3.ch003

van Niekerk, B. (2018). Social Media Activism From an Information Warfare and Security Perspective. In F. Endong (Ed.), *Exploring the Role of Social Media in Transnational Advocacy* (pp. 1–16). Hershey, PA: IGI Global. doi:10.4018/978-1-5225-2854-8.ch001

Varnali, K., & Gorgulu, V. (2017). Determinants of Brand Recall in Social Networking Sites. In W. Al-Rabayah, R. Khasawneh, R. Abu-shamaa, & I. Alsmadi (Eds.), *Strategic Uses of Social Media for Improved Customer Retention* (pp. 124–153). Hershey, PA: IGI Global. doi:10.4018/978-1-5225-1686-6.ch007

Varty, C. T., O'Neill, T. A., & Hambley, L. A. (2017). Leading Anywhere Workers: A Scientific and Practical Framework. In Y. Blount & M. Gloet (Eds.), *Anywhere Working and the New Era of Telecommuting* (pp. 47–88). Hershey, PA: IGI Global. doi:10.4018/978-1-5225-2328-4.ch003

Vatikiotis, P. (2016). Social Media Activism: A Contested Field. In T. Deželan & I. Vobič (Eds.), *R)evolutionizing Political Communication through Social Media* (pp. 40–54). Hershey, PA: IGI Global. doi:10.4018/978-1-4666-9879-6.ch003

Velikovsky, J. T. (2018). The Holon/Parton Structure of the Meme, or The Unit of Culture. In M. Khosrow-Pour, D.B.A. (Ed.), Encyclopedia of Information Science and Technology, Fourth Edition (pp. 4666-4678). Hershey, PA: IGI Global. doi:10.4018/978-1-5225-2255-3.ch405

Venkatesh, R., & Jayasingh, S. (2017). Transformation of Business through Social Media. In N. Rao (Ed.), *Social Media Listening and Monitoring for Business Applications* (pp. 1–17). Hershey, PA: IGI Global. doi:10.4018/978-1-5225-0846-5.ch001

Vesnic-Alujevic, L. (2016). European Elections and Facebook: Political Advertising and Deliberation? In T. Deželan & I. Vobič (Eds.), *R)evolutionizing Political Communication through Social Media* (pp. 191–209). Hershey, PA: IGI Global. doi:10.4018/978-1-4666-9879-6.ch010

Virkar, S. (2017). Trolls Just Want to Have Fun: Electronic Aggression within the Context of E-Participation and Other Online Political Behaviour in the United Kingdom. In M. Korstanje (Ed.), *Threat Mitigation and Detection of Cyber Warfare and Terrorism Activities* (pp. 111–162). Hershey, PA: IGI Global. doi:10.4018/978-1-5225-1938-6.ch006

Wakabi, W. (2017). When Citizens in Authoritarian States Use Facebook for Social Ties but Not Political Participation. In Y. Ibrahim (Ed.), *Politics, Protest, and Empowerment in Digital Spaces* (pp. 192–214). Hershey, PA: IGI Global. doi:10.4018/978-1-5225-1862-4.ch012

Weisberg, D. J. (2016). Methods and Strategies in Using Digital Literacy in Media and the Arts. In M. Yildiz & J. Keengwe (Eds.), *Handbook of Research on Media Literacy in the Digital Age* (pp. 456–471). Hershey, PA: IGI Global. doi:10.4018/978-1-4666-9667-9.ch022

Weisgerber, C., & Butler, S. H. (2016). Debranding Digital Identity: Personal Branding and Identity Work in a Networked Age. *International Journal of Interactive Communication Systems and Technologies*, 6(1), 17–34. doi:10.4018/IJICST.2016010102

Wijngaard, P., Wensveen, I., Basten, A., & de Vries, T. (2016). Projects without Email, Is that Possible? In G. Silvius (Ed.), *Strategic Integration of Social Media into Project Management Practice* (pp. 218–235). Hershey, PA: IGI Global. doi:10.4018/978-1-4666-9867-3.ch013

Wright, K. (2018). "Show Me What You Are Saying": Visual Literacy in the Composition Classroom. In A. August (Ed.), *Visual Imagery, Metadata, and Multimodal Literacies Across the Curriculum* (pp. 24–49). Hershey, PA: IGI Global. doi:10.4018/978-1-5225-2808-1.ch002

Yang, K. C. (2018). Understanding How Mexican and U.S. Consumers Decide to Use Mobile Social Media: A Cross-National Qualitative Study. In K. Yang (Ed.), *Multi-Platform Advertising Strategies in the Global Marketplace* (pp. 168–198). Hershey, PA: IGI Global. doi:10.4018/978-1-5225-3114-2.ch007

Yang, K. C., & Kang, Y. (2016). Exploring Female Hispanic Consumers' Adoption of Mobile Social Media in the U.S. In R. English & R. Johns (Eds.), *Gender Considerations in Online Consumption Behavior and Internet Use* (pp. 185–207). Hershey, PA: IGI Global. doi:10.4018/978-1-5225-0010-0.ch012

Yao, Q., & Wu, M. (2016). Examining the Role of WeChat in Advertising. In X. Xu (Ed.), *Handbook of Research on Human Social Interaction in the Age of Mobile Devices* (pp. 386–405). Hershey, PA: IGI Global. doi:10.4018/978-1-5225-0469-6.ch016

Yarchi, M., Wolfsfeld, G., Samuel-Azran, T., & Segev, E. (2017). Invest, Engage, and Win: Online Campaigns and Their Outcomes in an Israeli Election. In M. Brown Sr., (Ed.), *Social Media Performance Evaluation and Success Measurements* (pp. 225–248). Hershey, PA: IGI Global. doi:10.4018/978-1-5225-1963-8.ch011

Yeboah-Banin, A. A., & Amoakohene, M. I. (2018). The Dark Side of Multi-Platform Advertising in an Emerging Economy Context. In K. Yang (Ed.), *Multi-Platform Advertising Strategies in the Global Marketplace* (pp. 30–53). Hershey, PA: IGI Global. doi:10.4018/978-1-5225-3114-2.ch002

Yılmaz, R., Çakır, A., & Resuloğlu, F. (2017). Historical Transformation of the Advertising Narration in Turkey: From Stereotype to Digital Media. In R. Yılmaz (Ed.), *Narrative Advertising Models and Conceptualization in the Digital Age* (pp. 133–152). Hershey, PA: IGI Global. doi:10.4018/978-1-5225-2373-4.ch008

Yusuf, S., Hassan, M. S., & Ibrahim, A. M. (2018). Cyberbullying Among Malaysian Children Based on Research Evidence. In M. Khosrow-Pour, D.B.A. (Ed.), Encyclopedia of Information Science and Technology, Fourth Edition (pp. 1704-1722). Hershey, PA: IGI Global. doi:10.4018/978-1-5225-2255-3.ch149

Zervas, P., & Alexandraki, C. (2016). Facilitating Open Source Software and Standards to Assembly a Platform for Networked Music Performance. In D. Kanellopoulos (Ed.), *Emerging Research on Networked Multimedia Communication Systems* (pp. 334–365). Hershey, PA: IGI Global. doi:10.4018/978-1-4666-8850-6.ch011

About the Contributors

Celia Soares is a university professor and researcher. Is Invited Professor at the Communication Sciences and Information Technologies Department, University Institute of Maia (ISMAI), Portugal, Invited Professor at at Higher School of Technology and Management, Polytechnic Institute of Maia (IPMAIA), Portugal and Invited Professor at School of Technology and Management, Polytechnic Institute of Viana do Castelo(ESTG-IPVC) . She focuses and develops her research in the "Information and Communication in Digital Platforms" area - "Information Systems and Usability" context. She is involved in practice-based research on projects such as "teaching foreign language for children with dyslexia using immersive technologies and Virtual reality" and she also develops research focused on digital art preservation in obEMMa - Scientific Observatory of Electronic Music and Media Art - UP (Porto University). She is member of CITCEM-Digital Culture Research Department (UP), Portugal, CITEI - Research Center for Technologies and Intermedia Studies (ISMAI), Portugal and Ni2- Research Center (IPMAIA), Portugal.

Emília Simão is Vice-Director and Professor of Multimedia and Arts at Gallaecia University - ESG (PT) and also invited Professor of Multimedia at Portuguese Catholic University- UCP (PT) and Visual Aesthetics at Polytechnic Institute of Guarda (IPG). PhD in Information and Communication in Digital Platforms by Porto University (UP), MSc in Multimedia by the Portuguese Catholic University (UCP) and in Art Studies by the Superior Artistic School of Porto (ESAP). She focus her research on Electronic Dance Music Cultures, Psychedelic Culture, Post-modern Aesthetics, Media Arts, Art and Technology, Digital Culture and New Media. Coordinator of ObEMMA-Scientific Observatory of Electronic Music and Media Art, member of CITCEM-Transdisciplinary Research Centre for Culture, Space and Memory (UP) and CiESG-Research Center on Multimedia and Arts (ESG), Portugal.

* * *

Rodrigo Assaf holds a master's degree in computer science from the Federal University of São Carlos (UFSCar). He is a digital media researcher at Portuguese Catholic University with the following research interests: Human-Computer Interaction, Animation, Uncanny Valley and Computer Graphics.

Vitor H. Carvalho received in 2008 his PhD in degree in industrial electronics, in the option of industrial informatics. He is currently working as associate (tenured) professor at the Polytechnic Institute of Cávado and Ave (IPCA), Barcelos, Portugal as well as integrated researcher of the Applied Artificial Intelligence Laboratory at IPCA and collaborator of the Algoritmi Research Centre at Minho University. He is also the Head of the School of Technology at IPCA and President of the Pedagogical Council at the School of Technology (IPCA). His main fields of interest are related with data acquisition systems, serious games and machine learning. He has published more than 200 papers, being also a member of the editorial board of several international conferences and journals. He has a total of 804 (h index 16) citations in Google Scholar and 488 (h index 11) citation in Scopus. He has supervised several PhD and Master students in the related fields of interest.

Júlio Coelho received in 2018 his master degree in Computer Science and engineering. He is currently working as a software developer at Wave Solutions Si, Barcelos, Portugal. His main fields are related with serious games and Internet of Things.

António Correia has a degree in Multimedia by the School of Media Arts and Design of Polytechnic of Porto. Researcher at Psychosocial Rehabilitation Laboratory affiliated with the School of Health of the Polytechnic of Porto and the Faculty of Psychology and Education Science of the University of Porto. He is also a Guest Assistant Professor in the School of Health of the Polytechnic of Porto. His main areas of research are Virtual and Augmented Reality, Serious Games, Computer Graphics, Immersive Environments and Digital Media Art.

Frederico Dinis is a Portuguese intermedia composer, AV performer, media arts theorist and researcher that seeks to represent a figurative space-time, combining sound and visual narratives with unusual spaces. He is a researcher of the Centre for 20th Century Interdisciplinary Studies of the University of Coimbra (Coimbra, PT) and member of EASTAP - European Association for the Study of Theatre and Performance (Paris, FR). As a researcher his creation projects relate to specific places, exploring throughout the research and creation process the intersection between art, technology, identity and space, seeking to reflect about the importance of site-specific and sense of place.

João Donga has a degree in Computing and Systems Engineering, a Title of Specialist in Media and Audiovisual Production is a member of Multimedia Department at School of Media Arts and Design, Polytechnic of Porto, a member of LabRP, Psychosocial Rehabilitation Laboratory affiliated with the School of Health of the Polytechnic of Porto and the Faculty of Psychology and Education Science of the University of Porto and member of Elearning department of Polytechnic of Porto. Research interests centre on multimedia, virtual worlds, neurofeedback and elearning. At present is Pedagogic Council President at School of Media Arts and Design.

Paulo Veloso Gomes is MSc in Information Management and has an Advanced Studies Diploma in Social and Medical Sciences and Scientific Documentation. Researcher in Psychosocial Rehabilitation Laboratory affiliated with the School of Health of the Polytechnic of Porto and the Faculty of Psychology and Education Science of the University of Porto. Experienced Professor in the School of Health of the Polytechnic of Porto, with a demonstrated history of working in the higher education industry. Strong education professional skilled in Computer Science, Health Communication, Health Literacy, Virtual and Augmented Reality, Web Creation Contents, Knowledge Management, Information Management, Information Systems and Digital Media Art.

Patrícia Gouveia is Associate Professor and Multimedia Art Department Director at the Fine Arts Faculty at Lisbon University [Faculdade de Belas-Artes da Universidade de Lisboa]. She is also member of ITI – Interactive Technologies Institute / LARSyS, Laboratory for Robotics and Engineering Systems, IST, Lisbon.

Claudia Krebs is the faculty lead for a health education innovation and visualization space. She teaches both gross anatomy and neuroanatomy for a broad range of students: in the MD undergraduate program, allied health professions and biomedical engineering. She develops and implements a wide range of xR visualization tools to illustrate complex anatomical relationships and concepts. She is the principal author of Lippincott's Illustrated Reviews: Neuroscience and the accompanying Flashcard set.

Sahra Kunz holds a degree in painting from the Fine-Arts School in Oporto (FBAUP), a masters degree in Digital Arts from the School of Arts (Portuguese Catholic University) and a PhD in drawing from the University of the Basque Country (UPV/EHU). Her research interests are: Drawing; Drawing Theory; Ancillary Drawing; 2D & 3D Animation, Animation History; Animation Theory; Uncanny Valley http://artes.porto.ucp.pt/pt/cv-sahra-kunz.

Javier Pereira Loureiro, associate professor at the Faculty of Health Science from the Universidade da Coruña (UDC), Spain. He received his Msc in Computer Science from the UDC in 1995 and in 1997 he received his Master degree in Computer Science. He also received his Ph.D. in Computer Science from the UDC in 2004. Currently he is deputy director of Research Center on Information and Communication Technologies (CITIC) and Head of Master of Bioinformatic. His research interests include medical informatics, wearables and self-quantification. Participatory medicine. Telemedicine and tele-diagnostic, accessibility and assistive technologies for people with disabilities. Artificial intelligence. Citizen empowerment. Mental health and Information Technologies. ORCID: 0000-0001-9328-0723 Publons: D-5343-2012 https://scholar.google.es/citations?user=-nEjPG8AAAAJ&hl=es.

António Marques, Ph.D. in Psychology, is currently the director of the Psychosocial Rehabilitation Laboratory. He's also, co-coordinator of the Porto Interactive Neuroscience Group, of the Psychiatric Rehabilitation Research Group of the São João Hospital, and of Porto Metropolitan Area Network of Psychosocial Rehabilitation Institutions. He´s also member of the directive board of National Federation of Rehabilitation Entities for Mental Ill, P.PORTO Virtual and Augmented Reality Competencies Center and of the Center for Rehabilitation Research (CIR). His main research areas are mental health and psychosocial rehabilitation, and virtual and augmented reality, being responsible for several postgraduate courses, I&D projects, master and Ph.D. theses in these fields.

Tiago Martins is PhD in Electronic and Computer Engineering by University of Minho. He is a professor in Catholic University of Portugal and Institute of Cávado and Ave (IPCA). He is a researcher collaborator in the Algoritmi Research Centre at University of Minho and in Applied Artificial Intelligence Laboratory at IPCA. His work has focused in serious games, artificial intelligence and computer vision areas.

Miguel Mazeda (b. 1995) is a portuguese artist who started his connection to art interacting with the urban environment in 2011 under the name of Guel as a graffiti writer. He is from Vila Nova de Gaia, graduated in Sound and Image and Master in Creative Industries Management by Universidade Católica Portuguesa. He gathers, in his curriculum, a vast portfolio with works for nationally and internationally renowned entities and brands such as Adidas, BMW, H&M, Prozis, Vitória Sport Clube, Zippy, among others. A diligent dissatisfied, he performed scientific research at Universidade Católica Portuguesa in a European project (CHIC) with a high economic impact in the audiovisual and multimedia sector. In 2019, he was responsible for the new look of Estádio D. Afonso Henriques, directing a project to transform the interior's visual aspect in partnership with Vitória Sport Clube.

He is a leader by nature, an irreverent passionate about art, organized and versatile. Method, professionalism and determination are values that guide you.

Patrick Pennefather is a founding faculty member at the Master of Digital Media Program where he designs, teaches and mentors emerging technology projects and is co-appointed in Film and Theatre Production at UBC. His research and scholarly activities are focused on sound design, project-based learning, and emerging technologies such as Virtual, Augmented and Mixed Reality. He also investigates mixed reality performances and installations. His research and production experience, integrates prototyping with persistent user-testing for public events. He has mentored, managed and designed instruction and case study research with the following client collaborators: InTransit BC, Anthymn, Bateman Centre Interactive Visualization Project (BCIVP), Big Bertha Studios, Business Simulation Training, Carbon Chaos 2010, Chinchilla, Clarity Toolkit: Bringing Business Back To Its Senses, CODEstruction, CoLab, Community Pulse, Curate Your Own Collection, CyberPatient, D-Sign Touchless Interactive Systems, Digital Decisions, Eagle Eye, Fashion Game, GO, kindamals, Man Kind, Man Up Canada, Mirage, Monsterholic, O:N Studios, Precipice, Pwny Arcade, RAMsquared, RDM, Redshift, Shift Seven Interactive, Sofa So Good, Studio 777, TaxiCity: Vancouver, Team Labyrinth, The Road Less Travelled, THESIX, Timber, UBC Fisheries Project, V-Track Project, Virtual Rainforest Initiative, WOMP!, YATTA.

Jose Pinheiro is a researcher at CIAC (Research Center in Communication Sciences and Arts from Open University/Algarve University), Portugal. Has a PhD in Digital Media Arts. Research fields: Post-image, Digital Media Arts, Image in Computational Environments, Digital Media History.

Vítor J. Sá has a degree in Systems and Informatics Engineering, Master in Informatics (pre-Bologna) and PhD in Information Systems and Technologies. Teaching activity in several higher education institutions (University of Minho, Portuguese Catholic University, Polytechnic Institute of Porto and Polytechnic Institute of Viana do Castelo). Development of multimedia product launched in the Portuguese market by Porto Editora. Consulting/training in various national and international companies. Visiting Researcher at the Institute of Computer Graphics (Fraunhofer IGD) in Darmstadt - Germany, in the area of Multimodal Interaction and Ambient Intelligence. Member of the Order of Engineers, the Project Management Institute (PMI) and the European Association for Computer Graphics (Eurographics). Member of the scientific committee of several international conferences, publication of several articles, books and book chapters. Organization of international conferences such as the Eurographics Symposium on Parallel Graphics and Visualization (EGPGV

- 2006), the International Conference on Global Security, Safety and Sustainability (ICGS3 - 2010) and the International Conference on Digital and Interactive Arts (2019). Currently, Assistant Professor at the Portuguese Catholic University, with research activity at the ALGORITMI Center of the University of Minho. He was a member of the advisory board by the Portuguese Catholic University for Braga to UNESCO Creative City contest in the Media Arts category. Founding partner of Khnum Inovação, Lda.

Julie-Anne Saroyan kicked off the series Dances for a Small Stage in Vancouver in 2002. Since then, she has produced over 50 instalments of the series Small Stage. More than 400 artists have performed at Small Stage including Crystal Pite, Emily Molnar and Margie Gillis. Saroyan approaches dance in non-conventional and entrepreneurial way - connecting audiences to dance in both traditional and non-traditional venues, mentoring next generation artists, and more recently experimenting with dance in digital realms. Ms. Saroyan has gained a reputation for her artistic curation which has developed the dance sector in Canada and propelled and encouraged artists' careers by creating unique live experiences for over 110,000 people since its debut in 2002.

Manuel Silva is a PhD student associate in the CITAR centre, School of Arts, Universidade Catolica Portuguesa (UCP). He is currently a member of the Cooperative Holistic view on Internet and Content (CHIIC) project. He has been active in the field of sound design. His current research interests lie in digital creativity and augmented and virtual reality content production for cultural heritage.

Luis Teixeira is a senior research associate in the CITAR centre, School of Arts, Universidade Catolica Portuguesa (UCP). He is currently a member of the UCP Digital Creativity Center (CCD) where he is coordinating CHIC - Cooperative Holistic view on Internet and Content, and CCD - Digital Creativity Center - PIN-FRA / 22133/2016 projects. He has been active in the field of signal processing, computer graphics, digital and cinematics arts, and creative industries. His current research interests lie in digital creativity and augmented and virtual reality content production for cultural heritage.

Index